DUTCH LANDSCAPE

THE EARLY YEARS
Haarlem and Amsterdam 1590 – 1650

= DUTCH =
LANDSCAPE

THE EARLY YEARS
Haarlem and Amsterdam 1590 – 1650

An Exhibition at The National Gallery, London,
September 3rd – November 23rd 1986

CHRISTOPHER BROWN

Exhibition catalogue supported by
Amsterdam–Rotterdam Bank N.V.
and Unilever

© The National Gallery 1986
Published for the Trustees

BRITISH LIBRARY CATALOGUING IN PUBLICATION DATA
Brown, Christopher, *1948–*
Dutch landscape: the early years.
1. Landscape painting, Dutch 2. Landscape
painting – 17th century – Netherlands
I. Title II. National Gallery
758/.1/09492 ND1359.3

ISBN 0 947645 05 5

Designed by Vassoula Vasiliou
The National Gallery Design Studio

Printed by Westerham Press

National Gallery Publications
The National Gallery London

Front cover illustration:
Jacob van Ruisdael, *Bentheim Castle* (detail), Private collection, U.K.
Back cover illustration:
Willem van Nieulandt, *A Wooded Mountain Road* (detail), British Museum

Contents

Director's Foreword	7
Preface and Acknowledgements	9
Introduction: Dr. Christopher Brown	11
Appendix: Three contemporary discussions of landscape painting	
1 Carel van Mander (1604)	35
2 Samuel Ampzing (1628)	43
3 Constantijn Huygens (c.1629/30)	44
Techniques of the Early Dutch Landscape Painters: David Bomford, National Gallery	45
Hendrick Goltzius and His Conception of Landscape: Professor E. K. J. Reznicek, University of Utrecht	57
Seascape into Landscape: Dr. Margarita Russell, Senior Research Fellow, National Gallery of Art, Washington D.C.	63
Nature and Landscape in Dutch Literature of the Golden Age: Dr. M. A. Schenkeveld-van der Dussen, University of Utrecht	72
The Dutch Rural Economy and the Landscape: Professor Jan de Vries, University of California at Berkeley	79
Catalogue:	
1 Precursors in Antwerp and Rome	89
2 The Flemish Immigrants	115
3 Haarlem: The First Generation	131
4 Amsterdam: The First Generation	187
5 Haarlem: The Second Generation	199
6 Amsterdam: The Second Generation	221
Bibliography	234
List of Lenders	239

Landscape, wrote Edward Norgate in the seventeenth century, one of the earliest Englishmen to write on the subject in terms of art, is a word borrowed by us from the Dutch – fittingly enough, he said, because landscape is 'their owne Child'.

To the fascinating genesis and growth of that 'child' this exhibition is devoted. The resulting art is one that has for long attracted British collectors, British painters and the public generally. A country like ours, so much obsessed with the topic of the weather, could hardly fail to respond to paintings which often wonderfully convey the moody quality of atmosphere and season, as well as scenery, and where light is often seized not at its firm brightest but at its most subtle, unsettled and shifting. Thus sky and water – as much as landscape proper – go to make up the subject these artists observed and depicted.

But questions about the way the subject evolved are not easily answered. One of the chief merits of this exhibition, ably organized and catalogued by my colleague Christopher Brown, is to investigate and illustrate the influences felt by the pioneer figures. The emigration of talented Flemish artists to cities like Amsterdam and the part played in the development of naturalistic landscape by prints (richly represented in the exhibition by very generous loans from the British Museum) are here shown to have been of considerable significance. Christopher Brown's Introduction provides a strong guiding thread to the works assembled from a wide variety of sources for this exhibition, and other essays in the catalogue approach the subject from absorbing, specialized aspects.

I am greatly indebted to Christopher Brown for his wholehearted commitment to the exhibition and should like to thank warmly the other contributors to the catalogue. We are also much indebted to the generosity of lenders, public and private, in this country and abroad, especially the Netherlands. All have responded most helpfully and thoughtfully, feeling doubtless that this would indeed be a remarkable event. Without their kind co-operation it would certainly not have been possible to offer it to our public.

As always on these occasions, I am conscious of the debt the Gallery owes to its own small yet expert and engaged staff in various departments. Very sincerely do I thank them all, proud as well as grateful for what they achieve.

Finally, a special debt of gratitude must be recorded to the joint sponsors of this catalogue, the Amsterdam–Rotterdam Bank NV acting with Unilever. Thanks to their generosity, this exhibition has at once a guide and a memorial to it which is handsome, substantial and of lasting value.

Michael Levey
Director

September 1986

Preface and Acknowledgements

The greatest period of seventeenth-century Dutch landscape painting is generally taken to be the years between 1650 and 1675, the period that witnessed the maturity of Jacob van Ruisdael, Meindert Hobbema, Aelbert Cuyp, Philips Koninck, Jan Wijnants, Philips Wouwermans and a host of other immensely talented painters. This has been characterized as the 'classical phase' of Dutch landscape painting. The present exhibition concerns itself with the sixty years leading up to that period, years in which the convention of stylized Flemish landscape gave way to a more realistic and modest account, based on observation of the landscape of the United Provinces itself. The abandonment of landscape conventions was an erratic, complex and long-drawn-out process – these were years of restless experimentation – but there can be no doubt that the landscapes painted in Haarlem in 1650 were more realistic than those painted in the same town sixty years earlier. It is this process of change that the exhibition explores. Many significant developments took place in the more experimental media of drawings and prints before they were adopted in the more traditional medium of painting and for this reason this exhibition, unusually for one held at the National Gallery, contains a considerable number of both. I am particularly anxious to stress the crucial rôle played by prints: with their wide distribution, prints carried new ideas from artist to artist, town to town and country to country far more effectively than paintings ever could. In certain cases – for example, the landscape prints by the so-called Master of the Small Landscapes – they were used almost as pattern books by painters.

The choice of paintings has been made not only to illustrate the exhibition's subject but also to introduce to a wider public the work of a number of little-known Dutch landscape painters. The names of Reyer Claesz. Suycker, Anthonie van der Croos, Maerten Frans van der Hulst and Joost de Volder are scarcely familiar even to those professionally concerned with Dutch painting, but these are all painters who were at their best capable of work which is both technically accomplished and compositionally adventurous.

I have interpreted both the temporal and geographical limitations of the exhibition title with some latitude. There are, in the *Precursors* section, works dating from as early as the 1550s and the exhibition closes with two landscapes of 1651 – Jacob van Ruisdael's *Bentheim Castle* and Rembrandt's *The Goldweigher's Field*. The great majority of the works were made in Amsterdam and Haarlem but the exhibition includes others painted, drawn and designed in places as far apart as Rome, Prague and The Hague.

The exhibition is modest in both size and scope. Its one hundred and thirty-eight items have been fitted with great flair and sympathetic skill into just one gallery and an exhibition room in the National Gallery by the designer, Sally McIntosh, who has dealt with an expansionist organizer with remarkable forbearance. The catalogue has been designed by a member of her department, Vassoula Vasiliou, with a striking combination of imaginative understanding and professional care. I am deeply grateful to them both, as I am to Joanne Ennos and Tim Holton of the Gallery's Publications Department who guided the catalogue expertly through the press. Many people in the Gallery have given generously of their time and energies in the planning of the exhibition and the production of this catalogue: I would particularly like to mention Louise Woodroff, Karen Wright, Claire Nunns, Lindsey Callander and the Registrar Margaret Stewart who has dealt deftly and enthusiastically with the very considerable burden of the large number of overseas loans.

Outside the Gallery, my greatest debt is naturally to the lenders, who are listed at the back of the catalogue. My colleagues in museums and galleries in this country and in the Netherlands, West Germany and France have helped me to realize the exhibition and the private lenders in the United Kingdom, Europe and America have uncomplainingly parted with treasured possessions.

I have received very great assistance from scholars who have read and corrected sections of the catalogue: in particular I should like to thank Pieter Biesboer, George

Keyes, Joaneath Spicer, Martin Royalton-Kish, Seymour Slive, Clare Ford-White and, not least, my father-in-law, David Stockton. My greatest debt must be to those who have contributed essays to the catalogue: whatever value it may have will be a consequence of their original and thought-provoking work. The appendix to my own introductory essay, which principally consists of a translation of Van Mander's chapter on landscape from *Den Grondt der Edel Vry Schilder-const* was a collaborative effort: the basic translation was done by Willemien de Koning with great skill; I then reworked some passages and it was read and corrected by Peter King, Hessel Miedema, Ivan Gaskell and Charles Ford. I am immensely grateful to them all. My editor, Anthony Turner, has been a model of care and precision.

My final and greatest personal debt in the organization of this exhibition and, indeed, all other exhibitions I have organized at the National Gallery, is to the Director, Sir Michael Levey. This will be the last loan exhibition to be mounted at the Gallery before he retires at the end of 1986. I would like to acknowledge my immense personal and professional debt by dedicating this catalogue to him. He has written with great understanding about the work of Salomon and Jacob van Ruisdael and I feel that an appropriate way to thank him for his inspirational leadership during the last thirteen years is simply to quote his moving account of one of the Gallery's finest Dutch landscape paintings, Jacob van Ruisdael's *Pool Surrounded by Trees:*

'Some twenty years later, and on a much bigger scale, Ruisdael returned to virtually the same subject, treating it in paint. It is the work of an artist become fully a master of the landscape, and this magisterial picture might well stand for the essence of Ruisdael . . . Less excited by the concept of a romantically overgrown and almost gesticulating woodland, Ruisdael nevertheless is still concerned with nature's sombre dominance. He responds with keener sensibility to its moods, seeming to penetrate deeper even while achieving an extraordinary response to the surface appearance of natural things. He has come to prefer – as many other pictures bear witness – cloudy skies and a muted, faintly melancholic light, a sort of luminous gloom which the eye only slowly explores, lying over the whole landscape. Breaking it, with something of the effect of a snapping twig in a silent forest, are unexpected shafts of steely brightness – capricious flashes of a personal lightning which here, for instance, illuminate the hound leaping after the hare swimming desperately through the pool and at the right strike the trunks of the two silver birches.

'Seldom is nature seen as quite still, and even the quietest landscape is disturbed by the shifting play of restless light. It is as if Ruisdael longed to seize the unseizable, to convey not one moment but the passage of time, the actual, gradual drift of thick cloud over the sky and the accompanying darkening of the landscape, the stir of leaves as a wind gets up, or the sudden glitter of grass and the often uncanny intensifying of the outlines at the approach of a storm.'

Christopher Brown

July 1986

Introduction

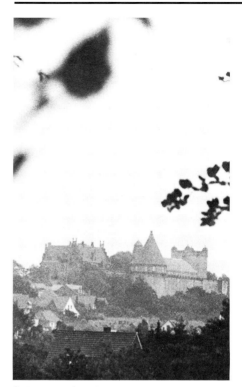

fig 1 View of Bentheim Castle (modern photograph).

Remarkable landscapes have inspired remarkable landscape painters – Claude's delicate evocations of the Roman Campagna and Altdorfer's primeval Danube valley forests come to mind – but, as the modern traveller who takes the short train journey from Amsterdam to Haarlem knows, the landscape of the province of Holland, which inspired one of the greatest of all schools of landscape painting, is remarkable only for its lack of prominent geographical features. The flat, low-lying fields are separated by straight ditches and high-sided dykes which are raised above the surrounding countryside. Extensive, open vistas are broken only by cattle, clumps of trees, farms and barns and the profiles of villages and small towns, dominated now, as they were in the seventeenth century, by church spires.

The subject of this exhibition is the early years of this school of landscape painting, the years between 1590 and 1650 when Dutch artists were exploring a variety of ways in which to record the appearance of nature. It is primarily concerned with two related questions. How was it that in this part of the Netherlands at this time there developed a new type of painting which rejected earlier formulaic accounts of landscape in favour of greater naturalism? And what were the factors – artistic, social, economic, agricultural and religious – which influenced this development?

In visual terms the first question can be addressed by comparing two paintings in the exhibition, Joos de Momper's *Mountainous Landscape with the Story of Naaman* (cat.no.19), painted in Antwerp in about 1620, and Jacob van Ruisdael's *Bentheim Castle* (cat.no.106), painted in Haarlem in 1651. De Momper was the heir to the Antwerp school of landscape painting whose principles had been established by Joachim Patinir and Herri met de Bles a hundred years earlier. It was characterized by a high viewpoint, dizzyingly steep rocks set in the landscape, and a restricted colour scheme. The landscape was invariably a setting for religious subjects, although these were often dwarfed by it. Joos de Momper continued this tradition in a self-consciously decorative manner. He clearly saw no need to move toward a greater degree of naturalism of the kind which was developing at that time in Haarlem and Amsterdam; indeed, he was entirely happy to accept the restrictions of traditional landscape formulae and work within them, at times apparently delighting in their artificiality. When looking at the work of an artist like De Momper it is important to remember that a convincingly naturalistic account of landscape was not his aim. In his *Mountainous Landscape with the Story of Naaman* it was his intention to provide a decorative backdrop to the figures painted by Frans Francken the Younger. Individual features – mountains, rivers, trees – needed to be recognizable, but only in the most general terms.

Jacob van Ruisdael's *Bentheim Castle*, painted thirty years later, is very different. To begin with, it shows an actual site. In 1650, the year before it was painted, the artist had travelled to Westphalia on the border between the Netherlands and Germany and made drawings of the castle and the surrounding countryside.[1] These he took back to his studio in Haarlem and used as the basis of this painted landscape which is entirely credible within the conventions of naturalistic representation. The viewer is, nevertheless, always aware that this is a constructed two-dimensional account of a visual experience; he is conscious of the unnaturally high viewpoint, the deliberate choice of the angle from which the picturesque castle is seen, the careful placing of the riders within the composition and in particular the splash of red made by one rider's coat amidst the greys and greens. The viewer is aware of the manipulating intelligence of the artist at work and yet entirely satisfied by the realistic appearance of the castle and the surrounding countryside. In fact, Ruisdael's view is deliberately misleading: Bentheim Castle sits on a low hill (fig.1) and he has exaggerated its height in order to dramatize his subject. However that may be, it is the *convincingness* of *Bentheim Castle* which I want to stress here because it is the abandonment of the stylized landscape of the Antwerp school and the development of convincing naturalistic landscape which is the subject of this exhibition.

An unusual feature of this exhibition for the National Gallery is the inclusion of a

1 None of Ruisdael's drawings of Bentheim survive, although a drawing of the castle by his companion on the trip, Nicolaes Berchem, does. It is signed and dated 1650 and the location identified by an inscription in the artist's hand. (Frankfurt, Städelsches Kunstinstitut.) For a recent discussion of Ruisdael's paintings of Bentheim, see The Hague/Cambridge, Mass. 1981/2, 12, 13, 14.

large number of drawings and prints. It has long been recognized that experimentation and innovation in Dutch landscape art took place in drawings and prints far earlier than in the longer-established, technically more complex and more traditional medium of painting. That artists were inclined to be more experimental when using charcoal on paper is self-evident but the place of printmaking within this development requires explanation. In the first years of the seventeenth century Dutch printmakers abandoned the technique of engraving in favour of etching when making landscape prints. The process of etching allows the artist a lightness of touch and a greater immediacy which is closer to drawing than engraving. The etching needle is used on the surface of the plate whereas the burin, which is used for engraving, has to make deep incisions into it. The adoption of the etching technique allowed for greater freedom in terms of experimentation as well as the creation of new atmospheric effects. In seventeenth-century Holland paintings were relatively cheap and naturalistic landscapes were among the cheapest. Prints were cheaper still and (with the exception of those by Hercules Segers) were produced in large editions of about five hundred. They were published commercially and so were geared to the requirements of a large, popular market. It seems likely that some of the purchasers of such prints, many of whom would not have had an education of the traditional classical-humanist type, favoured convincing and familiar naturalistic landscape rather than Italianate landscapes peopled by mythological figures. It should not, therefore, surprise us that some of the most successful Dutch landscape artists of the first half of the seventeenth century were printmakers such as Jan van de Velde and Hercules Segers or painters who also designed or made prints such as Willem Buytewech, Esaias van de Velde, Pieter de Molijn and Jacob van Ruisdael. In the exhibition ideas first tried out – sometimes tentatively – in drawings and prints will later be seen making their appearance in paintings. For this reason an account of the early years of Dutch landscape painting must include a substantial representation of drawings and prints.

* * *

Any examination of the reasons for the development of naturalistic landscape in the north Netherlands in the early seventeenth century must begin by stressing the uniqueness of this type of landscape art. The first section of this exhibition is entitled *Precursors: Antwerp and Rome* and considers the influence of the Flemish landscape tradition, of paintings by Elsheimer and prints after Titian and Muziano on the development of landscape art in Holland. Yet it must be emphasized that there is nothing in contemporary European art remotely like the landscapes of the Haarlem painters Esaias van de Velde, Cornelis Vroom, Pieter de Molijn and Salomon van Ruysdael. The idyllic landscapes of Claude, the dramatic landscapes of Salvator Rosa, the idealized landscapes of Annibale Carracci, the peasant landscapes of the Le Nain brothers, the visionary landscapes of Collantes, the lyrical landscapes of Rubens – all are quite different from Dutch landscape in technique, subject-matter and, most important, in the attitude towards natural appearances that they reveal. All are, to a greater or lesser degree, ideal landscapes: all these artists subscribed to the conventional Renaissance view that natural appearances should be improved upon: that the best painting of a landscape, like the best painting of a naked goddess, was one which took different elements from a number of examples, whether landscapes or women, and combined them artfully to the greatest effect. This idea, which has its beginnings in classical art theory and is enshrined in Pliny, was repeated by all Renaissance writers on the arts. It was already Michelangelo's complaint (as recorded by Francesco da Hollanda) that northerners, whose speciality was landscape, painted it 'without reason or art, without symmetry or proportion, without skilful choice or boldness'.[2] If he was horrified by the lack of skilful choice of individual landscape motifs in the work of his northern contemporaries, Patinir and Herri met de Bles, how much more would he have railed against the Haarlem painters of the early seventeenth century. They did, of course, both select and reject: they selected wooden footbridges across rivers, groups of dilapidated farm buildings, ferries, fishermen, skaters and so on, but they selected them from a very restricted range of

2 Francesco da Hollanda, *Four Dialogues on Painting* (translated by A.F.G. Bell), London, 1928, pp.15/16 (First Dialogue).

familiar subjects and they made their selection not in order to create ideal beauty in Michelangelo's sense but to create picturesque effect. The art of the Haarlem landscape painters is unique: it differs from that of their European contemporaries in its treatment of humble and everyday subjects – a cart driving along a deeply rutted track, people skating on a frozen canal, fishermen leaning over a bridge – in a convincingly naturalistic manner. What, then, were the artistic antecedents of this modest art which emerged in the north Netherlands in the early years of the seventeenth century?

The Antwerp tradition and Pieter Bruegel the Elder

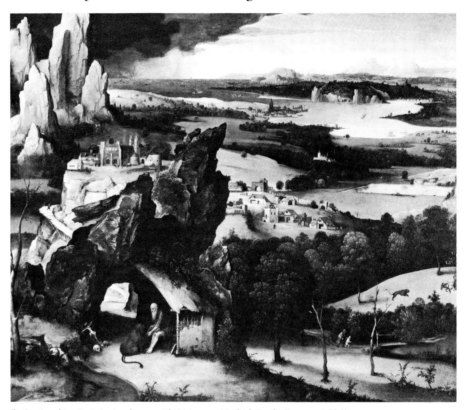

fig 2 Joachim Patinir, *Landscape with St. Jerome*, Madrid, Prado (Inv. no. 1614).

As has already been said, landscape was considered to be a northern speciality in Italy during the Renaissance. Michelangelo is reported to have said that 'in Flanders they paint with a view to external exactness or such things as may cheer you and of which you cannot speak ill, as for example saints and prophets. They paint stuffs and masonry, the green grass of the fields, the shadow of trees and rivers and bridges, which they call landscapes, with many figures on this side and many figures on that'.[3] He was presumably thinking of the Antwerp landscape style created by Joachim Patinir (c.1475–1524) and developed by Herri met de Bles (c.1500–c.1550/9), Cornelis Massys (born between 1505/08 and 1511/12, died after 1557) and the unidentified artist of the so-called Errera Sketchbook.[4] It was in this tradition that Pieter Bruegel the Elder was trained. In the work of Patinir (fig.2) and Herri met de Bles (fig.3) this style is characterized by the use of a 'bird's-eye view' to show an extensive, flat landscape punctuated by steep outcrops of rock. To a modern eye, it is a highly stylized landscape, naturalistic only in its treatment of detail – trees, farmhouses, paths and rivers. In their paintings these artists used a formulaic colour scheme – brown for the foreground, green for the middle ground, and blue for the background. They also introduced appropriate religious scenes or figures. Although it is possible to place these

3 Ibid., p.16.

4 The complex arguments about the attribution and the identification of various hands said to be present in the Errera Sketchbook have been most recently summarized in Berlin 1975, 181. For the purposes of this essay the drawings in the sketchbook are taken to be the work of a single Antwerp artist of c.1530/40.

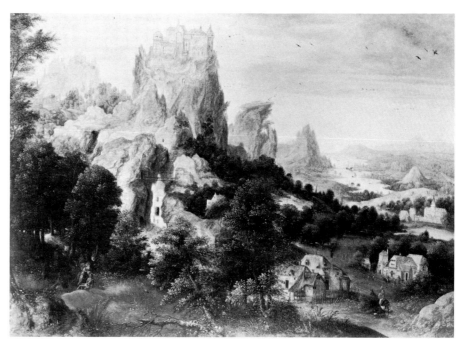

fig 3 Herri met de Bles, *Landscape with the Good Samaritan*, Vienna, Kunsthistorisches Museum.

fig 4 *The Errera Sketchbook*, Folio 24, Brussels, Musée Royal des Beaux Arts.

fig 5 *The Errera Sketchbook*, Folio 17, Brussels, Musée Royal des Beaux Arts.

Antwerp artists within a tradition of religious painting so that landscape can be considered simply as an element lending greater visual weight to religious subjects, it is important to stress that Patinir was thought of by contemporaries as a landscape painter. The religious subjects treated by him and his followers, such as the Rest on the Flight to Egypt, the Apostles on the Road to Emmaus and various hermit saints, were chosen because they required a landscape setting rather than because the landscape setting was demanded by the subject. A number of the engravings in Pieter Bruegel the Elder's *Large Landscapes* series, which he designed in 1555 and 1556, such as the *Pagus Nemorosus* (cat.no.5), make use of this well-worn formula. However, during the years of Bruegel's apprenticeship in Antwerp, other artists in the city were experimenting (particularly in their drawings and engravings) with more naturalistic accounts of landscape. In about 1540 Herri met de Bles made an accurate topographical drawing of Dinant; such drawings, however, belong to the related but different category of town views and more significant in this context are the Errera Sketchbook and the landscape drawings of Cornelis Massys, second son of the great religious painter of Antwerp, Quentin Massys. The Errera Sketchbook, named after a former owner, is the work of an unidentified Antwerp artist of about 1530/40 and although some pages display the formulaic rock formations and fantastic buildings of Patinir, others contain remarkably naturalistic pen and wash landscape drawings (figs.4,5). It is difficult to know whether such drawings were made with the sketchbook resting on the artist's knee in the open air; in a painting in the National Gallery (fig.6) from the circle of Patinir an artist can be seen sitting high above a Patiniresque river valley, drawing from nature. If the drawings in the Errera Sketchbook were made from nature we should note the extent to which Patinir's formulae affected the artist's visual response to landscape – an unnaturally high viewpoint is retained in many of them, recession is conveyed by the devices of emphasizing winding tracks and carefully placing appropriately scaled figures, and the height of hills and banks is apparently exaggerated. If the drawings were made in the studio, we cannot fail to be impressed by the realistic treatment of detail which goes far beyond that found in Patinir and Herri met de Bles. Cornelis Massys' drawings, some dated in the 1540s, display a similar combination of formula and fresh observation (fig.7). It is noteworthy, however, that in Massys'

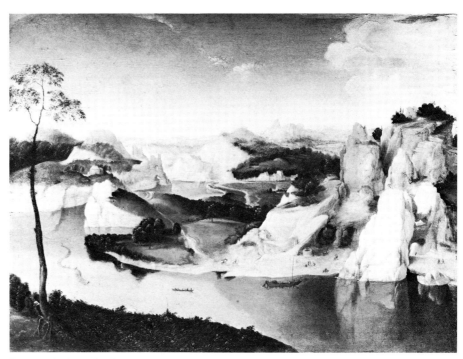

fig 6 Netherlandish School, *Landscape: a River among Mountains*, Panel, 50.8 × 68.6cm, London, National Gallery (Inv. no. 1298).

drawings which are preparatory to engravings, and in his paintings, religious figures, sheer outcrops of rocks and the 'bird's-eye view' reassert themselves.

Pieter Bruegel the Elder continued and developed this process. His role as an innovator in the development of landscape painting in the Netherlands has been misunderstood in the past but it is certainly true that he exerted a widespread influence through the extensive circulation of his prints in the north.[5] Bruegel's trip to Italy in the 1550s was of central importance to his treatment of landscape in two respects: his

5 Bruegel's influence can now be seen not to have been on the development of extensive landscapes but rather on that of the forest landscapes of Jan Brueghel, Coninxloo and others. See Arndt 1972; Gerszi 1976.

fig 7 Cornelis Massys, *Mountainous Landscape with Village Houses*, 1541, Berlin-Dahlem, Kupferstichkabinett.

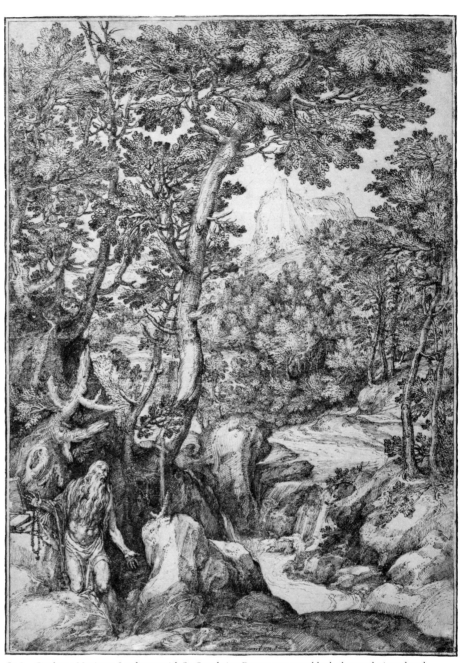

fig 8 Girolamo Muziano, *Landscape with St. Onophrius*, Brown pen over black charcoal, signed and
 dated 1574, 523 × 385mm, Fondation Custodia, Institut Néerlandais, Paris (Inv. no. 4482A).

excited discovery of the Alps and his contact with Italian artists concerned with
landscape. In a famous remark in his life of Bruegel, Carel van Mander wrote (in 1604)
that 'on his journeys Bruegel did many views from nature so that it was said of him,
when he travelled through the Alps, that he had swallowed all the mountains and rocks
and spat them out again, after his return, on to his canvases and panels, so closely was
he able to follow nature here and in her other works.'[6] Certainly in Bruegel's Alpine
views there is a remarkable intensity of response to his subject – and yet it is also true
that in the Alps Bruegel, to some extent, discovered Patinir's formulae in nature. Here
the sheer outcrops of rock are real – although perhaps exaggerated by the artist – and
not the product of his imagination. Of greater significance for the development of

6 Grossmann, p.9

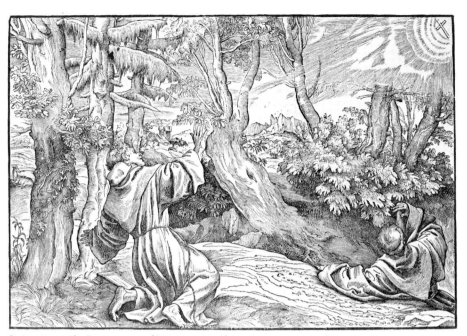

fig 9 Titian, *The Stigmatization of St. Francis*, Woodcut, Boston, Museum of Fine Arts.

fig 10 Domenico Campagnola, *Two Goats at the Foot of a Tree*, Woodcut, London, British Museum, Department of Prints and Drawings (Inv. no. 1881–7–9–80).

landscape in the Netherlands was Bruegel's contact with the landscape woodcuts of Titian, Domenico Campagnola and Girolamo Muziano. Titian and Campagnola were working in Venice (which he did not visit) during Bruegel's years in Italy but the Venetian Muziano had been in Rome since about 1548; in 1555 he is known to have painted a now destroyed fresco of *St. Francis in the Countryside* in the church of the SS. Apostoli in the city. Bruegel could well have come into contact with Muziano. It was the Venetian artist's dense forest landscapes, with tangled branches and overlapping leaves, which Bruegel admired and which were also to influence later generations of Flemish painters (fig.8). (Rubens owned two of the preparatory drawings – of 1574 – for Muziano's extremely successful and widely distributed series of penitent saints set in landscape.) Titian's landscape woodcuts were also admired by Bruegel. Titian's home town of Cadore is in the foothills of the Dolomites, and the typical compositional layout of his landscapes shows a foreground plain crossed by streams, gentle hills in the middle ground and rocky peaks in the background. For Bruegel, however, far more important was the detailed treatment of trees and their branches in a woodcut like *The Stigmatization of St. Francis* of about 1530 (fig.9). Of the three Italian landscape artists the most directly influential on the young Bruegel appears to have been Domenico Campagnola. A woodcut like the *Two Goats at the Foot of a Tree* (fig.10) must have been the prototype for a series of drawings by Bruegel of groups of trees in a forest (cat.no.11), in which he meticulously explores the complex of sinuous roots at their bases. These studies of trees in forest landscapes were to have a great influence on later generations of Antwerp painters, notably Pieter Bruegel's son Jan the Elder, Roelandt Savery, and the painters of the Frankenthal School. It is a tradition that continues in Jacob van Ruisdael's early landscapes incorporating detailed studies of trees and their roots, such as that of 1646 in the exhibition (cat.no.103).

Pieter Bruegel's single greatest achievement in landscape is his series of *The Months*, of which only five survive, painted for Nicolaes Jonghelinck in 1565. And yet for all their elegance of design, subtlety of colour and vivacity of technique, they are not really innovative in their approach to the naturalistic depiction of landscape. All five use the device of a foreground figure group placed on a hill beyond which stretches an extensive landscape. In the *Return of the Herd* (which illustrates October or November) (fig. 11) the distant landscape is a river valley bordered by high mountains of a

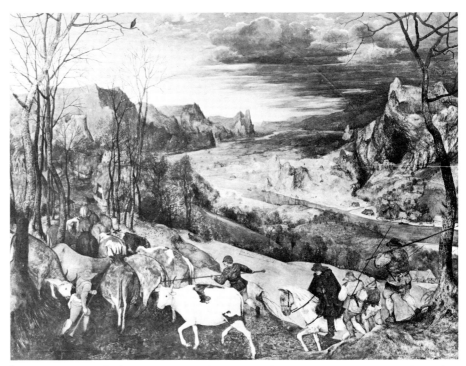

fig 11 Pieter Bruegel, *The Return of the Herd*, 1565, Panel, 117 × 159cm, Vienna, Kunsthistoriches Museum.

conventional Patiniresque type. The importance of the series in terms of the development of landscape painting does not lie in any originality of composition but in the abandonment of the traditional brown-green-blue colour scheme (although, as we have seen, it is still in use by De Momper in 1620) and the prominence given to the intensely individualized figures. In many respects, Pieter Bruegel's *The Months* can be considered as the high point of the Antwerp tradition, rather than a precocious example of naturalistic landscape.

The Master of the Small Landscapes

Far more important as precursors of the new Dutch landscape – and a prime example of the importance of prints as an innovating medium – are two series of prints published by Hieronymous Cock in Antwerp in 1559 and 1561 (cat.no.18).[7] The anonymous artist, known as the Master of the Small Landscapes, entirely abandoned the 'bird's-eye view' in favour of a conventional eye level but even more significant is his choice of subject-matter. His prints show scenes of everyday rural life: villages and hamlets, small groups of thatched cottages and barns, a manor house with cattle grazing in a field in the foreground, a village street with a herd of cattle being driven along it while a woman walks past with a pail of milk on her head. The subjects are self-consciously picturesque, carefully selected and carefully rearranged to delight the eye (in particular the urban eye) but nevertheless have an authentic air of nature closely observed and naturalistically described. When they were first published these landscapes had little impact on contemporary Flemish artists but they were re-edited and republished in Antwerp in 1601 by Theodore Galle and again by Claes Jansz. Visscher in Amsterdam in 1612. (It is engravings from this last edition which are included in the exhibition.) Their republication was a part of the so-called 'Bruegel Renaissance' in the early years of the seventeenth century.[8] In Visscher's edition, in which they were attributed to the enormously admired Pieter Bruegel the Elder, their impact was immediate and far-reaching. Visscher himself had in 1611 published a series of eleven landscapes

7 The complicated history of their publication and republication and the various attributions proposed for them are summarized on p.110.

8 For the 'Bruegel Renaissance' see Gerszi 1976 and 1982.

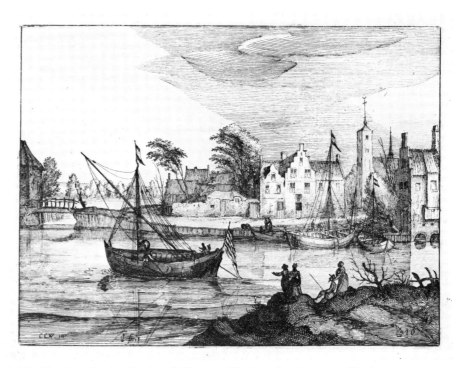

fig 12 Claes Jansz. Visscher after Cornelis Claesz. van Wieringen, from *Amoeniores Aliquot Regiunculae* (1613), London, British Museum, Department of Prints and Drawings (Inv. no. 1853–12–10–830).

which display this influence[9], as do those he commissioned from Cornelis van Wieringen and published in 1613[10] (fig.12). In practice these two series by Visscher and Van Wieringen apply the descriptive manner of the Master of the Small Landscapes to a greater variety of subject-matter. As well as village and farm scenes, there are harbours, ice scenes, windmills, river landscapes with fishermen and so on. Taken together, these three series of prints published by Visscher in 1611, 1612 and 1613 treat almost all the subjects depicted in Dutch landscape painting up until about 1640. It is scarcely an exaggeration to consider these print series as pattern books for the representation of landscape, and particularly landscape art in Haarlem, in the first four decades of the seventeenth century.

Flemish Immigrants in Amsterdam

The half century between the first publication of the Master's works in Antwerp and their republication by Visscher in Amsterdam were years of war with Spain, religious persecution in Flanders and the consequent large-scale movement of population from the southern to the northern Netherlands. The publishing history of these modest prints is symptomatic of the shift in economic power from south to north, as these years saw the continuing decline of Antwerp and the dramatic rise of Amsterdam. The northern Netherlands, the rebel United Provinces led by the dominant province of Holland and its economic heart, the city of Amsterdam, was transformed from being a distant, backward province of the great Hapsburg empire into a leading European power which was later to challenge the maritime supremacy of England and defend itself successfully against the might of Louis XIV's France. A new society was being formed: Protestant, prosperous and urban, it called into being new forms of art.

 Among the mass of emigrants from Flanders to the north in the second half of the sixteenth century were many artists. They moved for two quite different reasons. Some artists who were devout Protestants would be liable to religious persecution in Flanders,

9 They were published under the title *Plaisante Plaetsen . . . ghelegen buijten de ghenoechelijke stadt, Haerlem . . .* and show well-known landmarks near Haarlem.

10 The fourteen prints were published under the title *Amoeniores Aliquot Regiunculae.*

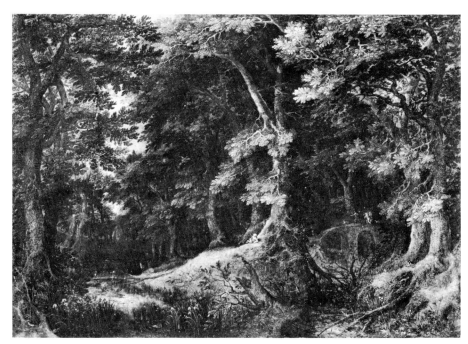

fig 13 Gillis van Coninxloo, *Forest Landscape*, 1598, Panel, 44 × 63cm, Vaduz, Collection of the Prince of Liechtenstein.

particularly after the reconquest of Antwerp by the Spanish in 1585. This was the reason for the emigration of the so-called Frankenthal school of landscape painters. Others, less idealistically, travelled to the north to get work. The economic dislocation caused by the war put artists out of a job: this is the reason given by Carel van Mander for his move from his native Courtrai to Haarlem. And this movement of Flemish artists to the north, which has recently been so expertly chronicled,[11] naturally had the effect of transplanting Flemish ideas to a new and vigorous environment.

A number of the most important landscape artists settled in Amsterdam. Gillis van Coninxloo, who was born into a famous family of Antwerp painters, was the key figure of the Frankenthal school.[12] On fleeing from Antwerp, this group of landscape painters took temporary refuge in Frankenthal, in the Protestant German state of the Palatinate, before finally settling in the north Netherlands. Coninxloo was in Amsterdam by 1595 and became a much admired painter and influential teacher in the city. He specialized in dense forest landscapes in which the small figures are almost lost amidst a mass of closely packed trees. They represent a development of the forest scenes of Pieter Bruegel the Elder (which are known only from drawings) and his son, Jan Brueghel the Elder. Coninxloo precisely delineated tree trunks, branches and leaves, and the whole intricate pattern of interlacing foliage is streaked with sunlight and shadow. An outstanding example of his art is the *Forest Landscape* of 1598 – painted shortly after his arrival in Amsterdam – in the collection of the Prince of Liechtenstein (fig.13). When his fellow-immigrant Carel van Mander published his lives of the Netherlandish artists in 1604 he said of Coninxloo that he was the best landscape painter in Holland at that time and that his style was beginning to be widely followed to such extent that 'the trees which were a little bare and defoliated have become leafier and more developed, though some Builders and Planters are reluctant to admit this'. (This last phrase in Dutch involves a play on words: by 'Builders and Planters' he means artists.)[13] David Vinckboons, who was also the son of an Antwerp painter, settled in Amsterdam in 1586 and is of especial importance in the development of genre painting in Holland. The landscape settings of his genre and religious scenes reflect his close contact with Coninxloo. Vinckboons, too, was an important teacher; among his pupils were the landscape painters Gillis d'Hondecoeter and Esaias van de Velde. Among

11 J.G.C.A. Briels, *De Zuidnederlandse immigratsie in Amsterdam en Haarlem omstreeks 1572–1630*, diss., University of Utrecht, 1976. A number of Flemish artists passed through – or settled in – Middelburg in Zeeland. For a valuable survey see the ex. cat. *Masters of Middelburg*, Waterman Gallery, Amsterdam, 1984.

12 For the Frankenthal school, see Franz.

13 Fol.268: *Want om cort maken en mijn meenighe van zijn constighe wercken to segghen soo weet ick dees tijt geen beter landtschap-maker: en sie dat in Hollandt zijn handelinghe seer begint naeghevolght te worden: en de boomen die hier wat dorre stonde worden te wassen na de zijne so veel als sy goelijcr mogen hoewel het sommighe Bouwers oft Planters noch noode souden bekennen.*

Flemish immigrants whose landscape painting style was affected by that of Coninxloo was Roelandt Savery, who was in Amsterdam by about 1591. Twelve years later he travelled to Prague and, in the service of the Emperor Rudolf II, visited the Tyrol, drawing the precipitous valleys, pine forests and dramatic waterfalls of the region. These natural features had a strong affinity with the principal elements of the Antwerp tradition and with the dense forests of Coninxloo: Savery's mature landscape style is an amalgam of all three. After his return to the Netherlands, animals came to occupy an increasingly important role in his compositions and he is an influential precursor of the peculiarly Dutch genre of animal paintings.

Into the stimulating environment of Amsterdam, to which these and other Flemish immigrant artists were transposed, came other influences, notably from Rome. Paul Bril, a landscape painter from Antwerp, had settled there by 1582 and worked in the city for more than forty years. His refined and delicate landscape style, which represents a blend of northern description and Italian idealization, was transmitted to the Netherlands principally through the medium of engravings. Engravings also were the form in which the Netherlands became acquainted with the small, atmospheric landscapes of the Frankfurt painter Adam Elsheimer, who had also settled in Rome. In his case the engravings, by the Dutchman Hendrick Goudt, are not simply reproductive prints but outstanding works of art in their own right. Elsheimer's powerfully linear style and his distinctive treatment of trees, each branch and leaf being precisely described, profoundly influenced not just Amsterdam history painters like Pieter Lastman but also the early Haarlem landscape artists, Willem Buytewech and Jan van de Velde. One particular compositional scheme favoured by Elsheimer, a diagonal screen of trees placed behind his figures, recurs again and again in early Haarlem landscapes.

Haarlem: 1612 and after

After the death of Coninxloo in 1607, it was in Haarlem, only thirty kilometres to the west of Amsterdam, and the second largest city of the province of Holland, that naturalistic landscape painting was to flourish. How and why particular circumstances and personalities should have combined in that place and at that time to produce a novel and unique art form it is the main purpose of this exhibition to explore. Hendrick Goltzius' precocious panoramic drawings of 1603 were one contributory factor, discussed by E.K.J. Reznicek in his essay in this catalogue. The Haarlem marine painting style of Hendrick Vroom, which is considered by Margarita Russell in her essay, was another. What is certain is that these local factors, together with those already outlined here – the Antwerp tradition and its development by Pieter Bruegel the Elder, the innovations of the Master of the Small Landscapes, the presence of Flemish immigrants in Amsterdam, the work of Bril and Elsheimer – combined to produce a new, realistic landscape art in Haarlem. Its most notable practitioners in the first generation were Willem Buytewech, Hercules Segers, Esaias van de Velde, Jan van de Velde, Cornelis Vroom, Pieter de Molijn and Salomon van Ruysdael. The exhibition aims to provide a context in which their achievements can be recognized and assessed.

1612 was the *annus mirabilis* for landscape painting in Haarlem. In that year Willem Buytewech, who was a native of Rotterdam, Esaias van de Velde, who came from Amsterdam where he had been a pupil of Coninxloo, and Hercules Segers, who had been born in Haarlem but had also been a pupil of Coninxloo in Amsterdam, were all admitted to the guild of St. Luke of Haarlem as master painters. Jan van de Velde, Esaias' cousin, who was a printmaker, joined two years later; Pieter de Molijn, who had been born in London of Flemish parents, was admitted in 1616. Cornelis Vroom's date of entry into the guild is not known, but his first dated landscape is from 1622; Salomon van Ruysdael, like Vroom a native of Haarlem, was admitted in 1623. It was an extraordinary concentration of talent, and to group their work together under the label 'early naturalistic landscape' does less than justice to their individuality. The

fantastic landscape prints of Segers, in particular, fit uncomfortably within such a designation. The special qualities and achievements of each artist are discussed in detail in the catalogue entries. Yet they do (with the exception of Segers in some of his prints) share a common aim: the *convincing* representation of a familiar landscape, with no attempt at strict topographical accuracy (although it might incorporate recognizable landmarks such as a church spire), but a landscape of a generic type with which the citizens of Haarlem would be well acquainted through their own experience of walking in the nearby countryside or viewing it from the ramparts.

The earliest years of Haarlem landscape, typified by the colourful, animated panels of Esaias van de Velde, the delicate, lyrical prints of Jan van de Velde, the complex rock formations and extensive panoramas of Hercules Segers, the elegant frond-like trees of Willem Buytewech and the strongly atmospheric forests and river valleys of Cornelis Vroom, were followed by an artistic phenomenon which modern art historians have christened 'the tonal phase'. This description is applied to the landscapes painted by Pieter de Molijn, Salomon van Ruysdael and Jan van Goyen in the 1620s and 1630s: they are drained of colour and in them sea, sky, woods and fields are all rendered in striations of greys, greens, yellows, browns and blues which give an impression of a unified, almost drab tonality. It is an intriguing and often extremely effective exercise in a self-imposed restriction of means. It became a kind of local artistic fashion since it was also adopted by contemporary still-life painters in Haarlem, notably Pieter Claesz. and Willem Heda.

Such a restrictive style could not last for long and in the late 1630s and 1640s colour was reappearing – brighter blues, deeper greens, pure whites and arresting touches of red, yellow and black. In Haarlem the 1640s witnessed the emergence of a new generation of painters who built on the achievements of their predecessors. By this date what might be called the vocabulary of naturalistic landscape had long been mastered and in the work of this new generation – and in particular of its leading representative, Jacob van Ruisdael, who was also the greatest of all Dutch landscape painters – it was used to more ambitious effect. Ruisdael joined the Haarlem guild in 1648 and so this exhibition, whose historical deadline is 1650 (or, to be strictly accurate, 1651), includes only his earliest work. In 1650 Jacob van Ruisdael was probably only 22 years old. He was, however, a remarkably precocious artist and in *The Banks of a River* of 1649 (cat.no.105) and *Bentheim Castle* (cat.no.106) we can see him employing the naturalistic language of Haarlem landscape painting to achieve bold effects of a kind undreamt of by Esaias van de Velde and Cornelis Vroom.

Landscape art in Amsterdam: from Coninxloo to Rembrandt

Painting in Haarlem, and in this particular context landscape painting in Haarlem, possesses a coherence which is absent from that of Amsterdam. As we have seen, Amsterdam played a prominent rôle in the development of landscape painting at the very beginning of the seventeenth century, when a number of Flemish artists settled there. Its sheer size, its rapid growth in the first half of the century and its decentralized institutions acted against the emergence of a 'school' in the sense of a group of like-minded artists developing a particular style through the exchange of ideas. Amsterdam, as by far the largest and richest city in the United Provinces, supported a large number of artists and acted as a magnet for artists from smaller towns who wanted to take advantage of the greater financial opportunities it provided. Rembrandt from Leiden, Jacob van Ruisdael from Haarlem and Pieter de Hooch from Rotterdam (via Delft) are simply the best-known of a mass of talented provincial artists who moved to the metropolis of Amsterdam.

Early in the century Pieter Lastman, who had spent several years in Italy, was the leading history painter in the city. In Rome he had come into contact with Elsheimer, and for the landscape backgrounds to his religious and mythological subjects he created a personal interpretation of Elsheimer's distinctive landscape manner. The

Pastoral Landscape (cat.no.84) is one of the very few paintings by Lastman in which the landscape is more prominent than the figures. Claes Cornelisz. Moeyart is another Amsterdam history painter who is associated with the so-called Pre-Rembrandtists of whom Lastman was the leading figure. In his paintings, however, and more remarkably in his etchings, landscape plays a major part in the composition. Moeyart's conception of landscape is also profoundly indebted to Elsheimer; it is lyrical and Arcadian in mood. Nothing could be more different from the landscapes of the native Amsterdamer, Arent Arentsz. His landscapes, often winter scenes showing skaters or country views with peasants and hunters, are based on those of Hendrick Avercamp, who after his training in Amsterdam with one of the Flemish immigrant painters (perhaps David Vinckboons) returned to work in provincial Kampen. His style – and consequently that of the attractive but essentially derivative Arentsz. – is based on that of the Flemish followers of Pieter Bruegel the Elder and does not significantly develop it in the direction of greater naturalism.

The developments in Haarlem had a significant impact on the next generation of Amsterdam artists; Aert van der Neer and Pieter van Santvoort treat familiar landscape subjects in a convincingly naturalistic manner, abandoning any Flemish or Elsheimeresque conventions. By contrast, Rembrandt's painted landscapes, with a few notable exceptions, remain within the Antwerp school tradition (fig.14). A high viewpoint, formulaic mountains and hills, and a deliberately restricted brown tonality characterize his landscape style; and it was this style that he passed on to his pupils in the 1630s and 1640s, notably to Govaert Flinck whose recently discovered signed and dated landscape of 1637 has been purchased by the Louvre (fig.15). Nowhere is the difference between the conservatism of painting and the freedom of printmaking more striking than in Rembrandt's landscape art. For while he was content to work within Flemish conventions in his paintings, his drawn and etched landscapes are remarkably direct responses to observed nature. The 1640s were a particularly productive decade for Rembrandt's landscape etchings and four of the best are included

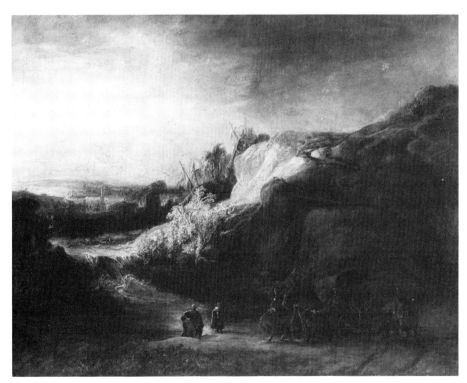

fig 14 Rembrandt, *Landscape with the Baptism of the Eunuch*, 1636, Canvas, 85.5 × 108cm, Hannover, Landesmuseum (on loan).

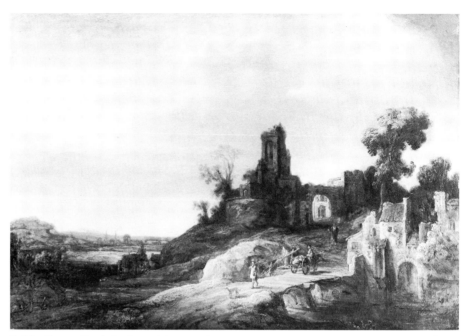

fig 15 Govaert Flinck, *Landscape*, 1637, Panel, 49.5 × 75cm, Paris, Musée du Louvre (RF 1985–82).

in the exhibition, one of them the so-called *Jan Six's Bridge*, which in the prominence given to the motif of the wooden bridge clearly demonstrates its indebtedness to the landscape artists of Haarlem.

The exhibition, which begins with two engravings from Pieter Bruegel the Elder's *Large Landscapes* series published in 1556, ends with two landscapes of almost a century later, appropriately a painting and a print. Jacob van Ruisdael's *Bentheim Castle* (cat.no.106) and Rembrandt's *The Goldweigher's Field* (cat.no.115) are both dated 1651 and were made in Haarlem and Amsterdam respectively. In each one, the vocabulary of the naturalistic representation of the countryside formulated in Haarlem thirty years before is now employed with absolute assurance to create two of the greatest works of art to emerge from seventeenth-century Holland.

* * *

Having outlined the formal development of naturalistic landscape in the north Netherlands, I should now like to consider some of the non-artistic factors which influenced this development.[14] In the first place Protestantism, in particular the Calvinism of the Dutch Reformed Church which was established as the dominant religion in the United Provinces under the terms of the Union of Utrecht in 1579, encouraged the emergence of secular art forms, including landscape art. Calvin had condemned the decoration of churches with images of holy figures; former Catholic churches were stripped of altarpieces and religious sculpture during the iconoclasm and their interiors whitewashed. This had the effect of removing one of the mainstays of the painter's profession throughout Catholic Europe – the painting of altarpieces and other religious images to be displayed in churches. As late as 1678 Samuel van Hoogstraten would complain in his *Inleyding tot de Hooge Schoole der Schilderkonst* that 'art, since the iconoclasm of the previous century, is not entirely destroyed in Holland, although the best careers, namely in the decoration of churches, are closed to us as a result and most painters devote themselves to meagre matters'.[15] Hoogstraten included landscape among the 'meagre matters' but Calvin had specifically urged painters to turn from religious to secular subject matter. In his *Institutes of Christian Religion* (Geneva, 1566) he had written: 'Since there is no sense in portraying God in a physical likeness, how much less should an image or idol of God be worshipped. It therefore follows

14 This was attempted by A. Bengtsson, *Studies on the Rise of Realistic Landscape Painting in Holland 1610–1625*, Uppsala, 1952. Although pioneering in its approach, Bengtsson's account is muddled, naive and often inaccurate.

15 p.257: *Om echte te toonen, dat de konst, sedert de Beeltstorming in de voorgaende eeuw, in Holland niet geheel vernietigt is, schoon ons de beste loopbaenen, naementlijk de kerken, daer door geslooten zijn, en de meeste schilders zich dieshalven tot geringe zaeken, jae zelfs tot beuzelinge te schilderen, geheelijk begeeven, . . .*

that a painter should only represent what he has seen with his own eyes. And as the majesty of God is too exalted for human view, it should not be corrupted by phantoms, which have nothing in common with it. As to those who paint or engrave, there are stories to be represented, portraits, images of animals, townscapes and landscapes.'[16]

There was then no room for doubt as to which subjects the Calvinist artist was permitted to depict and it is no accident that many of those leading landscape artists of seventeenth-century Holland whose religious affiliations we know were Calvinists or members of other Protestant sects. Coninxloo and his fellow Protestants of the Frankenthal school fled Antwerp because of fear of persecution: Coninxloo painted only landscapes, although he sometimes included Old Testament or mythological figures. Gillis d'Hondecoeter, who specialized in landscape, and David Vinckboons, who painted genre scenes and landscape, were members of Protestant refugee families from the south. Paulus Potter, the landscape and animal painter, was a Calvinist and Aelbert Cuyp, the great landscape painter of Dordrecht, was an Elder of the Reformed Church. Jacob van Ruisdael was a member of the Mennonites, a Protestant sect. And the decision of these artists to specialize in landscape was not simply a reaction against Catholic religious art. There is also a sense in which landscape painting, as the representation of God's creation, was a celebration of Divine benevolence. The idea of immanence revealed through nature is to be found in much devotional Dutch literature in the seventeenth century: it is one of the themes that Maria Schenkeveld-van der Dussen discusses in her essay in this catalogue. There can be little doubt that devout Protestant artists like Gillis van Coninxloo and Jacob van Ruisdael thought of the act of painting landscape as akin to an act of worship.

For non-Protestant artists or those whose religious belief was less crucial, the move to landscape was less idealistic: in a Calvinist society there was a demand for non-religious subject-matter and they simply catered for this demand. It is important to remember that Dutch painting and printmaking were uniquely responsive to popular demand. Nowhere else in Europe was there an art market of a recognizably modern type with all the now familiar apparatus of dealers and auctions.[17] Many foreigners commented on this situation which meant that – with low prices – sections of society such as a modestly affluent artisan class were able to afford paintings which those in comparable social groups elsewhere in Europe could not afford or which would not be available to them. Evidence for detailed comparison is difficult to find and collate but it seems likely that whereas an artisan household in France, Spain or Italy might be decorated by woodcuts, engravings or very crude paintings of religious subjects and particularly of the Virgin and Child, a comparable household in the north Netherlands would not only have a larger disposable income but would choose to spend part of that income on the purchase of cheap paintings of secular subjects – genre, landscape and still-life. Such paintings might well be, from a modern standpoint, of very considerable quality. We know that, in 1641, thirteen paintings by Isaak van Ostade were valued at 27 guilders;[18] two guilders for a painting would be within the pocket of an artisan. In genre paintings landscapes can be seen hanging in relatively humble domestic interiors (figs.16,17). Prices were apparently calculated according to the cost of materials, to which was added a very small profit, and reflect the popular view of this type of painting as a craft rather than an art. Low prices for paintings encouraged speed, repetition and avoidance of radical innovation. All these features can be found to a greater or lesser extent in the work of the Haarlem landscape painters of the early seventeenth century.

Esaias van de Velde and Salomon van Ruysdael, to take two examples, produced large numbers of paintings which are very similar in composition. Their technique, which is analysed by David Bomford in his essay in this volume, is consistent with speed of execution. It seems that once a Dutch painter had hit upon a successful idea, he would repeat it with minor variations. Some artists did little more than repeat such subjects throughout their careers and there is so little development in their work that it is very difficult to tell a painting of, say, the 1640s from one of the 1670s. The situation in

16 Jean Calvin, *Institutions de la Religion Chrétienne*, Geneva, 1956, vol.I, chapter IX, paragraph 12.

17 The standard study of the Dutch art market in the seventeenth century is still H. Floerke, *Studien zur Niederländischen Kunst- und Kulturgeschichte: Die Formen des Kunsthandels, das Atelier und die Sammler in den Niederländen vom 15.–18. Jahrhundert*, Leipzig, 1905 (Reprint: Soest, 1972).

18 Floerke, op.cit., p.22.

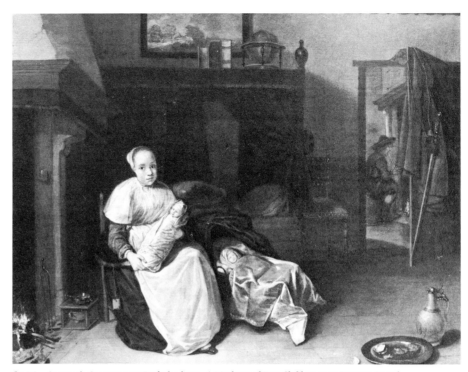

fig 16　Quiringh Gerritsz. van Brekelenkam, *A Mother and Two Children in an Interior*, Panel, 18 × 23ins. Present whereabouts unknown.

contemporary Italy, where much greater stress was laid on originality, was very different.

One popular subject for a Haarlem or Amsterdam landscape artist of this period was a convincing naturalistic landscape like, for example, the numerous river landscapes painted by Salomon van Ruysdael in the early 1630s; one, painted in 1631, is included in the exhibition (cat.no.55). What was it about these modest scenes that made them more attractive to the citizen of Amsterdam or Haarlem than, for example, the decorative, stylized works of Joos de Momper? This question raises complex and elusive issues pertaining to the responses to particular images of a seventeenth-century public – a public which did not give any written account of those responses. Some suggestions have already been made: it seems reasonable to assume that a Calvinist-dominated society would favour secular subject-matter and that the relatively unsophisticated section of that society which could afford the low prices asked for landscape paintings would prefer naturalistic landscape to Italianate landscape peopled with mythological figures. The level of literacy in Holland in the seventeenth-century was, in European terms, very high; but the Latin schools were effectively restricted to the better-off and the town schools laid less emphasis on familiarity with the classics.[19]

A number of other contributory factors, though hard to assess, can be cited. The first is the nostalgia for the countryside – a countryside which was itself undergoing radical change – of a society which was rapidly becoming urbanized. Both these processes – the growth of Holland's towns and the alterations in the appearance of the Dutch countryside brought about by changes in patterns of crop cultivation and the reclamation of the polders – are described by Jan de Vries in his essay in this volume. In *Les Délices de la Hollande* (Leiden, 1678) Parival commented on the popularity of outings into the countryside as a recreation amongst Dutch town-dwellers. 'Whenever one goes here [that is, into the countryside,]' he noted, 'one finds as many people as would be seen elsewhere in a public procession. All these excursions end up at one of the inns which are to be found everywhere . . . These inns are always packed with visitors, and the confused murmur of many voices is like the sound in a city square. These are inexpensive pleasures which all, even the humblest labourer, can share.'[20]

19　For literacy levels in Holland in the seventeenth century, see G. Parker, *Europe in Crisis 1598–1648*, 1979, p.303 ff.

20　Quoted by P. Zumthor, *Daily Life in Rembrandt's Holland*, London, 1962, pp.163–4.

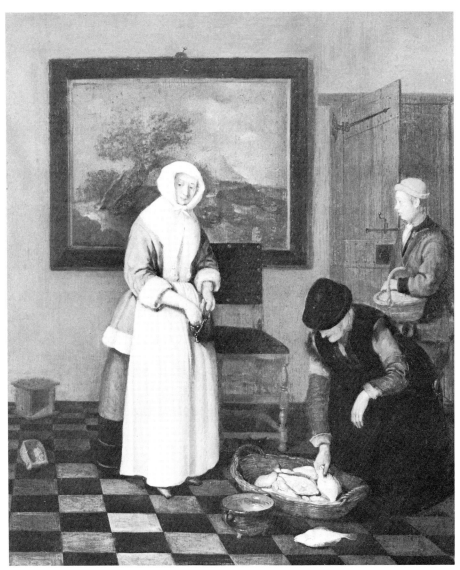

fig 17 Quiringh Gerritsz. van Brekelenkam, *The Fish Seller*, Panel, 53 × 44cm, signed and dated
 1662. With A. Brod, London, 1966.

Another and relatively inexpensive pleasure for the first-generation town-dweller was
the purchase of a painting which would transport him in his imagination from the
insanitary, crowded conditions of Amsterdam or Haarlem to his native village or
countryside. Even if they lacked this particular imaginative association, there can be
little doubt that paintings and prints were, for the town-dweller, the equivalent of
Parival's excursions to the countryside. There are close literary parallels to this
phenomenon, poems which transport the reader into the countryside, as Maria
Schenkeveld-van der Dussen reveals in her essay. The act of looking through a series of
prints of the countryside by Visscher or Buytewech was intended in the same way to
conjure up such an excursion. Their titles make this clear: 'Delightful views . . .', ' Very
pleasant views to delight the eyes . . .', etc. (cat.nos.38,74,75). In his *Plaisante plaetsen*
. . . series of 1611 Visscher is even more specific: the title page declares that they are
for *Liefhebbers die geen tyt en hebt om veer te reijsen* (art lovers who have no time to
travel far).

 In addition to this urban craving for the countryside, which prompted the rich to
build country houses along the Vecht and in the Beemster and other citizens to make

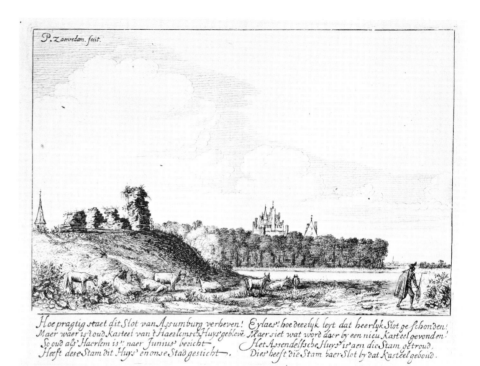

fig 18 Jan van der Velde after Jan Saenredam, *Brederode Castle*, Etching, from Ampzing's *Beschryvinge ende Lof der Stad Haerlem* (1628), London, British Museum.

weekend excursions, there was an intense local and national pride which may have found expression in the purchase of landscape paintings. During the entire period with which this exhibition is concerned, the United Provinces of the north Netherlands were at war with Spain. A truce was arranged in 1609 which lasted until 1621 when hostilities recommenced. They continued until the war ended with a *de jure* recognition of the independence of the United Provinces by Spain at the Treaty of Münster in 1648. The war engendered an atmosphere of great patriotic fervour, particularly in its early years when in the early 1570s Spanish armies laid siege to Haarlem (which fell in July 1573), Alkmaar and Leiden (both of which held out). The patriotism of the new Protestant nation struggling to throw off the yoke of Catholic tyranny was expressed in poetry and prose, sermons and pamphlets, as well as in paintings which commemorated Dutch victories on land and at sea and the cruelty and destructiveness of the Spanish armies. The Batavian Revolt against the Romans, which is described by Tacitus, was taken as a model for the Dutch struggle against the Spanish, and the leader of the Revolt, Claudius Civilis, was identified with the leader of the Dutch Revolt, William I of Orange. There were also patriotically inspired literary celebrations of the Dutch countryside and of particular buildings and towns. There may be a visual equivalent of this literary phenomenon in the artists' choice of certain locations. For example, in Buytewech's *Verscheijden Lantschapjes* (cat.nos.38a–g) two of the sites chosen had dramatic associations with the war. Both Brederode Castle and the Huis te Kleef had been destroyed by the Spanish armies during the siege of Haarlem. Were they for Buytewech simply picturesque ruins or did they evoke a sense of patriotic outrage in both artist and viewer? It is striking that certain sites, including these two, were depicted again and again. The Huis te Kleef was one of Visscher's *Plaisante Plaetsen* and was also the subject of an etching by Pieter Saenredam. Brederode Castle was drawn by Goltzius and etched by Saenredam for Samuel Ampzing's *Beschryvinge ende Lof der Stad Haerlem* of 1628. In the inscription beneath Saenredam's distant view of the castle set in an extensive landscape (fig.18), Ampzing laments the destruction of the castle and longs for the day when the noble family of Brederode will return and restore it to its former glory.

Ampzing's book, which he himself describes on the title page as a collection of 'random chronicles, charters, letters, memoirs and recollections' about Haarlem is itself an expression of intense civic pride. Other *Beschryvingen* of particular towns – Delft, Leiden, Amsterdam, etc. – were compiled in these years and all reflect pride in the history, appearance and achievements of these thriving towns and their citizens. (Each contains an account of the local school of painting and these are important sources for our knowledge of seventeenth-century painters.) The population of the towns of Holland was expanding rapidly, many new buildings were going up, the towns were prosperous and – to a degree – politically independent. Their prosperity, elegance and cleanliness were commented upon by foreign visitors such as Sir William Temple who in 1673 praised 'the strength and beauty of their towns, the commodiousness of travelling in their country by their canals, bridges and cawseys [causeways]; the pleasantness of their walks, and their grafts [canals] in and around all their cities: and, in short, the beauty, convenience and sometimes magnificence of all public works'.[21] Civic pride was one of the principal causes of the emergence of the genre of townscape in the second half of the seventeenth century: among the best-known townscapes are Gerrit Berckheyde's views of the Grote Markt at Haarlem and Jan van der Heyden's delicate paintings of the *grachten* of Amsterdam. A feature of many landscapes of the earlier period is the distant town view: profiles of Haarlem, Rhenen and Arnhem can be seen in paintings in this exhibition (cat.nos.57,48). Were these town profiles included by the artist to evoke in the viewer not just simple recognition but a feeling of civic pride?

Finally, to what extent do landscape paintings reflect the economic importance of the countryside? There was, in the seventeenth century, a revolution in agrarian techniques which enabled Dutch farmers to be far more efficient and prosperous than many of their European contemporaries.[22] There may be a sense in which the more successful cultivation of the land and its consequently greater value, as well as its crucial role in efficiently feeding the growing urban population, are reflected in landscape painting, although surprisingly few Dutch landscapes show farmers at

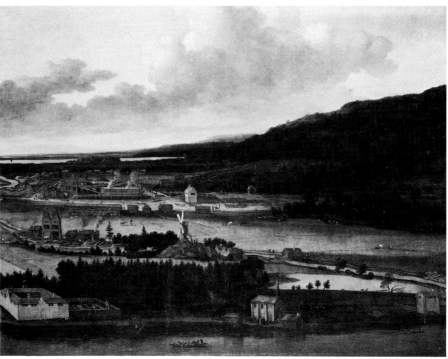

21 Ed. G.N. Clark, Sir William Temple, *Observations upon the United Provinces of the Netherlands*, Oxford, 1972, p.87.

22 See J. de Vries, *The Dutch Rural Economy in the Golden Age, 1500–1700*, New Haven and London, 1974.

fig 19 Allart van Everdingen, *The Arms Factory of Julitabroeck in Södermanland*, Canvas, 194 × 225cm, Amsterdam, Rijksmuseum (Inv. no. 906).

work. For the most part, the view of landscape is recreational rather than agricultural. More significant in this respect are landscapes which may have been commissioned by landowners as records of their own estates. For example, the house in the centre of Rembrandt's etching known as *The Goldweigher's Field* (cat.no.115) is Saxenburg, which in 1657 belonged to Christoffel Thijsz with whom Rembrandt had business dealings. We cannot be sure, but it is possible that the view was commissioned by Thijsz as a record of his country estate – a repayment in kind of money owed by Rembrandt. The best-known example of such a commission is the view of the arms factory at Julitabroek (fig.19) executed by the landscape painter Allart van Everdingen to hang in the Trippenhuis in Amsterdam.[23] It contains reminiscences of the journey Everdingen made to Norway and Sweden in the 1640s. (It was a journey which had a major impact on Dutch landscape painting by introducing to Dutch painters, and in particular to Jacob van Ruisdael, the roaring waterfalls and pine forests of Scandinavia.) It is quite likely that a number of Dutch landscapes record property ownership in this way. However, the vast majority of Dutch landscapes of the period with which this exhibition is concerned were painted specifically for the art market and were purchased for relatively low prices by town dwellers who wished, in the words of Peter Mundy who was in Amsterdam in 1640, 'to adorn their houses, especially the outer or street rooms, with costly pieces. Butchers and bakers not much inferior in their shops, which are fairly set forth, yet many times blacksmiths, cobblers etc., will have some picture or other by their forge and in their stall. Such is the general notion, inclination and delight that these country natives have to paintings.'[24]

Drawing and Painting from Nature: Theory and Practice

How did the landscape painters and printmakers of Haarlem and Amsterdam go about their work? How many made drawings from nature, and of those who did, how did they use those drawings on their return to the studio? Did they work – to use the terminology of Carel van Mander – *naer het leven* (literally, after the life) or *uyt de geest* (from the spirit, or imagination)? These questions are tackled from a technical viewpoint in David Bomford's essay in this catalogue, which reveals the results of detailed examinations of paintings in the National Gallery's collection. In this final section of the Introduction, I should like to make some observations on the theoretical background to artistic procedures.

The only extended theoretical account of landscape written in Dutch during the period with which this exhibition is concerned is that by Carel van Mander (1548–1606). Van Mander was a practising painter who had been born and trained in Flanders. He had worked in Italy and in Vienna and subsequently settled in Haarlem in 1583. He was a key figure in the history-painting style known as Haarlem mannerism: it was he who introduced the elegant, tortured figures of Bartholomäus Spranger to Hendrick Goltzius and Cornelis van Haarlem. The three artists formed an academy in Haarlem, the exact nature of which is unclear but which seems to have involved meeting to draw from antique casts and perhaps also from models. Van Mander's *Schilderboeck* (Book of Painting), which was published in Haarlem in 1604, has three principal sections: a treatise on painting, *Den Grondt der Edel Vry Schilder-const*, the lives of the artists in three parts, classical, Italian and Netherlandish, and a translation of Ovid's *Metamorphoses* with an explanation of the allegories it contains. Van Mander's discussion of landscape is the eighth chapter of *Den Grondt*: a complete translation of its forty-seven stanzas is given in the Appendix which follows this introduction. Van Mander encourages young painters to draw from nature: they should get up early and go into the countryside with their sketchbooks. On their return to the studio, however, drawings made from nature have to be transformed by the imagination of the artist into paintings. Van Mander subscribed to the idea, already mentioned above, that the artist should improve upon natural appearances by the imaginative combination of different elements from nature.

23 A.I. Davies, *Allart van Everdingen*, New York/London, 1978, 98. The dates of Everdingen's trip or trips to Scandinavia have been extensively discussed: the various arguments are summarized by Davies who proposes a date in the 1660s for the painting.

24 Ed. R.C. Temple, *The Travels of Peter Mundy*, vol.II, London, 1924, p.71.

Van Mander extravagantly admired the lush forest landscapes of Coninxloo; and so it is not surprising to find that the type of landscape which Van Mander advocates, with its marked ground divisions, large tree-trunks in the foreground, distant high horizon and view of mountains, hills and towns, and precise manner of leaf painting, corresponds closely to that of Coninxloo and his fellow Flemish immigrants in Amsterdam. Coninxloo rarely, if ever, drew directly from nature. His drawings are for the most part preparatory to the paintings and prints of leafy forests which he created in his imagination (cat.no.21). For Van Mander, then, drawings from nature were a desirable training for the young artist but in the studio they were to be used in an imaginative combination of observed and recorded landscape. In fact drawings from nature were not necessary to the creative process of an established painter like Coninxloo, whose imagination was rich enough to dispense with them altogether.

The other rare writings on landscape in the period with which we are concerned, such as those by Constantijn Huygens and Samuel Ampzing which are also translated in the Appendix, are entirely conventional in their terms of praise. Their interest for us lies not in any account of artistic procedures they might give, but as the opinions of informed contemporaries as to the relative standing and special qualities of individual artists.

Van Mander's notion of imaginative landscape is restated in all the important writings on landscape painting in Holland in the seventeenth century. The two most significant treatises, Samuel van Hoogstraten's *Inleyding tot de Hooge Schoole der Schilderkonst* (Introduction to the High School of the Art of Painting) of 1678 and Gerard de Lairesse's *Het Groot Schilderboek* (The Great Book of Painting) of 1707, were both written in the last quarter of the century and do not directly concern us here. The authors, both practising artists, condemn the slavish imitation of nature and call for its improvement by the artist's hand. Lairesse, writing at a time when Dutch painting, and indeed Dutch cultural life as a whole, was coming under strong French classicist influence, argues that landscape should be dotted with classical ruins and obelisks and that its highest function is to act as an appropriate background for classical, mythological and religious subjects.

An interesting application of theoretical ideas about landscape painting is found in Hoogstraten's *Inleyding*.[25] (It is repeated almost word for word in the *Lives of the Dutch Artists* written in the first years of the eighteenth century by the classicizing painter Arnold Houbraken.)[26] Hoogstraten describes a competition between three painters – François van Knibbergen (fig.20), Jan van Goyen (cat.nos.46–9) and Jan Porcellis (fig.21), a marine painter. The purpose of the competition was to establish which was the greatest painter. Knibbergen, according to Hoogstraten, sat down in front of his panel, selected his brush and began to paint his landscape straight away. 'Light, the distant prospect, trees, mountains and dramatic waterfalls all flowed from his brush as do the letters from the pen of a skilled calligrapher.' In other words, individual landscape features took shape more or less from the moment the artist put brush to panel. Jan van Goyen's approach was quite different. He covered his panel with rough, broad strokes of the brush, making one area light, another dark, so that the total effect was like agate. Only after a considerable time did recognizable features – houses, ships, figures – appear. Van Goyen conjured these up from the apparent chaos, as if the random strokes of the preparatory painting had suggested them to him. The third painter, Jan Porcellis, 'the Raphael of marine painting', had yet another approach. Spectators, writes Hoogstraten, were amazed to see how slowly he handled his brush, as if he did not know how to begin. This was, he explains, because Porcellis first created the painting in his mind before he put any paint on his panel. Having done so, he set it down without hesitation. That Porcellis' was the best method was shown by the result: although Knibbergen's picture was the largest, Van Goyen's packed with incident, it was Porcellis who was judged the winner. His painting was said to have *meerder natuurlykheid* (more naturalness).

Hoogstraten's story should not be taken at face value. Although historically possible

25 Hoogstraten, p.274.

26 Houbraken, I, p.166–8.

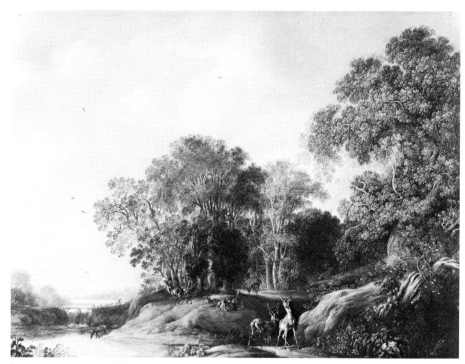

fig 20 François van Knibbergen, *Landscape with Deer*, Panel, 44.5 × 60cm, London, Wellington Museum, Apsley House (Inv. No. WM1577–1948).

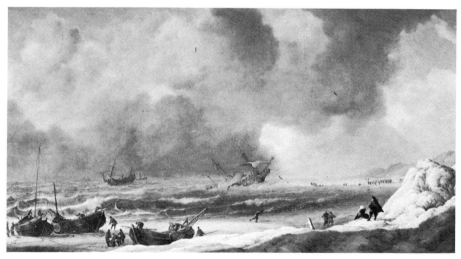

fig 21 Jan Porcellis, *Beach Scene*, 1625, Panel, 36.2 × 66.7cm, The Hague, Mauritshuis.

in that all three painters lived in or near Leiden in the 1620s, the idea of a competition between painters is a conceit, a *topos*, taken from classical literature. It provided Hoogstraten with the narrative means to compare three distinct methods of painting: the careful, detailed painting of particular landscape features; the rough application of paint in which the shapes seem to appear as if of their own volition (which Hoogstraten compares with seeing forms in the flames of a fire); and, thirdly, the creation of *een vast denkbeeld* (the term used by Houbraken in his version of the story: literally, a complete thought-picture). The desirable objective of 'naturalness' is best achieved by the last method, the creation of the painting in the mind before it is set down. Neither

Hoogstraten nor Houbraken discusses the role of drawings from nature but it is clear that if such drawings played any part at all in the creation of a *denkbeeld*, it was subsidiary to the exercise of the painter's imagination.

If we turn from the theory to the practice and examine the working methods of the Amsterdam and Haarlem landscape artists represented in this exhibition, we discover that in general they followed the precepts of Van Mander. Many of them made drawings from nature – there are drawings in the exhibition which were presumably made in front of their subjects by Willem van Nieulandt (cat.no.26), Roelandt Savery (cat.no.28), Willem Buytewech (cat.no.36), Hendrick Goltzius (cat.no.41), Jan van Goyen (cat.no.49), Claes Jansz. Visscher (cat.no.74), Cornelis Vroom (cat.no.80) and Claes van Beresteyn (cat.nos.91,92), as well as three pages from a sketchbook which Guilliam du Bois carried with him into the countryside near Haarlem (cat.nos.95a,b,c). Back in the studio these drawings were used in the creation of painted landscapes but were not directly copied in oil on to panel and canvas.

An analysis of surviving drawings reveals great variations in procedure between landscape artists. Jan van Goyen, for example, was an indefatigable sketcher from nature; not only do more than 800 individual drawings survive but a number of his sketchbooks are still in existence (fig.22).[27] He seems never to have left the house without his sketchbook and his drawings contain a wealth of ideas to which he turned, often years later, as the raw material for paintings. They vary from the slightest of sketches to elaborate topographical views, although his favoured medium for them all is black chalk. However, Van Goyen had no qualms about altering nature: buildings, trees, boats and bridges were all rearranged in the studio to suit his compositional requirements. In contrast to Van Goyen's mass of extant drawings, none at all have ever been securely attributed to Salomon van Ruysdael. One reason for this, as David Bomford reveals, is his use of extensive underdrawings in his paintings. It is unlikely, however, that drawing on paper played no part at all in his procedure. There may well be drawings by him in print rooms and private collections which have not been recognized because they are neither signed nor related to known paintings. Almost a hundred drawings by Salomon's nephew, Jacob van Ruisdael, have been identified to date but; if we try to relate these to his 700 surviving paintings, we find that only about twenty can be thought of as even the slightest of *aide-memoire* (fig.23).[28]

While it is interesting to observe such variance in artistic procedures – particularly at a time when an important part of an artist's training was imitation of his master's techniques – and while it is important to be aware of the precepts of the respected and widely read Van Mander, neither takes us much further forward in our consideration of

27 For Van Goyen's drawings, see Beck I.

28 For Ruisdael's drawings, see S. Slive, 'Notes on three drawings by Jacob van Ruisdael', in *Album Amicorum J.G. van Gelder*, The Hague, 1973, pp.274–6; J. Giltay, 'De tekeningen van Jacob van Ruisdael', *OH*, 94, 1980, pp.141–209.

fig 22 Jan van Goyen, *Single page from sketchbook*, drawing 125 × 246mm, London, British Museum, Department of Prints and Drawings (Inv. no. 1946–7–13–1076 (131)).

fig 23 Jacob van Ruisdael, *View towards Haarlem across the Dunes*, Black chalk and grey wash,
89 × 148mm, Amsterdam, Rijksmuseum (Inv. no. 1961:43).

the development of the new naturalistic landscape art of Haarlem. It was not that Van
Mander was ignored, simply that his ideas about landscape were loose enough to
encompass the very different paintings of Coninxloo and Keirincx, Esaias van de Velde
and Cornelis Vroom. The impetus towards greater naturalism arose not from
theoretical writings but from other factors – artistic, social, economic and religious –
which have already been discussed. And yet however carefully we analyse and describe
these factors, however precisely we can pinpoint particular influences and exchanges
of ideas, the mysterious fact remains that at a certain place and time, Haarlem in
1612, a group of prodigiously talented individuals happened to come together to effect
an apparently modest yet highly significant change in both the perception and the
representation of the visible world.

Dr. Christopher Brown
Curator of Dutch and
Flemish Seventeenth-Century Paintings,
The National Gallery

1 Carel van Mander (1604)

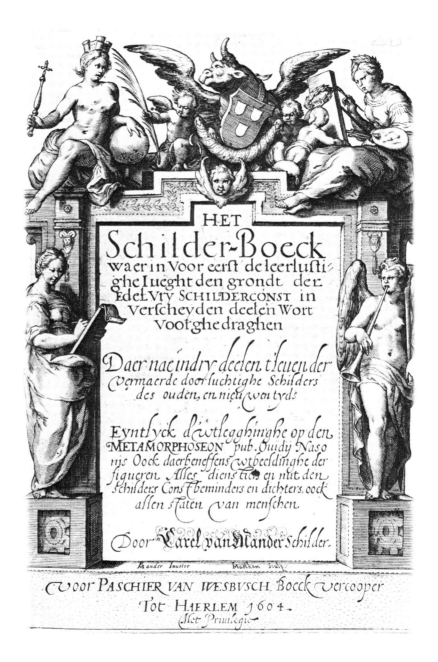

Van Mander's *Het Schilderboeck*, published in 1604, is by far the most important treatise on painting published in the north Netherlands in the first half of the seventeenth century. It consists of three distinct sections: a theoretical treatise written in the verse form *ottava rime – Den Grondt der Edel Vry Schilder-const* (The Foundation of the Noble, Free Art of Painting); the lives of the artists, ancient, Italian and Netherlandish; and a study of Ovid's *Metamorphoses*. One of the chapters in *Den Grondt*, chapter 8, is devoted to landscape. Van Mander's ornate poetic diction is difficult to translate: here a clear, plain prose translation is provided. The sentences in brackets are summaries of the argument which Van Mander placed in the margin of the printed page.

Chapter Eight of *Den Grondt der Edel Vry Schilder-const*

(Young painters need to practise landscape painting too. Therefore they should rise early if convenient, and go out of town to look at nature and spend time making sketches.)

1 Stop, you young painters. who have sat for a long time hunched up, so involved in your continuous studies of art that, ever eager to learn more, you have worn down your senses to insensitivity and bluntness. You have ploughed enough for the time being. Lay aside the yoke of labour while there is still time, for even strong men need rest. The bow cannot always be kept taut.

(It is recommended to go early to bed during summer and rise as soon as the birds start to sing.)

2 As soon as you see Hesperus[1] in the distance, bringing the black cloak for the father of Morpheus,[2] the dreamer, make sure your eyes are sprinkled with the water of Lethe's[3] stream. During the short nights of the summer which is rich with flowers, after taking a frugal dinner, let your weary memory and dulled senses regain strength and the desire to work again, through a pleasant sleep.

3 Come let us, soon as the city gate opens, while away the time together and enlighten our minds by going to see the beauty outside, where beaked musicians sing in the open. There we will look at many views, all of which will help us to create a landscape either on canvas or on solid Norwegian oak panels. Come, you will – I am sure – be pleased with the journey.

(The bride of Tithonus is Aurora, Dawn.)

4 Note, first of all, how over there the bride of old Tithonus[4] rises from her saffron bed to announce the approach of the torch of day, and see how the four piebald horses, soaked with water, rise panting from the shallows of the Ocean. See how the little purple clouds become tinged with pinkish red; and how beautifully Eurus'[5] bright home is adorned, ready to receive Phoebus.[6]

(Give attention to the appearance of Dawn.)

5 Look now at what they are painting up there! Such an increase of beauty, so many different colours; and such a blending of colours! Can you believe that liquid gold in a melting-pot shines as brightly as those small scattering clouds? The blue distant mountains prepare themselves to carry the ensign of the new sun, approaching on her wheels, encrusted with precious stones.

(Tellus is the earth, and her hair is made up of grasses and herbs which are sprinkled with dew.)

6 Look, on the other side, Dawn has covered the vaults of heaven with a bright blue cloth under which she conceals those lights which illuminate the night. She has also covered the blazing glow of the Bearer of Light,[7] so that the braided hair of Tellus might be sprinkled with dew, and the rolling grass carpet of the green earth be covered with water-drops like pearls.

(Especially as one looks into the sun, the fields appear bluish-green with the dew, in which one can see the footsteps of hunters and dogs who have walked across them.)

7 Look, the orange-yellow, round sphere of the sun has already risen; it happened quickly, while we were looking the other way. See, there in front of us, hunters are walking with their dogs through the green dewy fields: see how that trodden dew turns a lighter tone of green, showing their footprints, and so giving away their route.

1 The planet Venus as the Evening Star.

2 God of dreams and son of Hypnos (Somnus), god of sleep.

3 River of Forgetfulness in the Underworld.

4 Son of Laomedon, king of Troy; carried off by Eos (Aurora, 'Dawn') to be her husband. He was granted immortality but not eternal youth: hence 'old' Tithonus.

5 The east wind.

6 'The Shining One'; title of Apollo as god of the sun.

7 Literal translation of the Latin *Lucifer*, i.e. the planet Venus as the Morning Star.

(Let the landscape recede smoothly into the distance, or let it gradually merge into the sky.)

8 See how that hazy landscape in the distance begins to look like the sky, and almost merges into it. Solid mountains seem to be moving clouds. Notice how the ditches and furrows in the field taper and converge at the same vanishing point, looking just like a tiled floor. Do not get bored taking it all in, as it will give a convincing sense of space to your own background.

(Attention should be given to foreshortening. The horizon is where sky and water touch or where earth and air meet.)

9 I want you to pay attention to foreshortening and reducing as you see it in nature. Although it is not architecture for which you need to follow accurate rules, you still need to fix your focal or vanishing point on the horizon, that is to say, on the top line of the water. Everything below that line will appear as if seen from above, while everything else will appear as if seen from below.

10 You cannot show the distance too vaguely. Here you should be less generous in applying shadows than highlights. Take into account the thickness of the air which contains a blue substance, obstructing sight, and forming a haze through which it is impossible to see really clearly. Occasionally one can show sunbeams filtering through the clouds and shining on towns and mountains.

(On the obscuring of hills and towns by clouds; and on showing clouds in the water.)

11 In addition one ought sometimes to obscure a town entirely, or partly, as it might be overshadowed by clouds. (Notice the way in which the clouds and sky are reflected in their true colours in the water, and show it.) Try, as has been done in the past, to let the sky sometimes gradually change colour from the top until it merges with the reflections in the water. This works well and even sunshine can be captured in this way.

(Apelles[8] painted with four colours only, as Pliny says, and he showed thunder and lightning and comparable things; we, who have so many colours, should feel the urge to copy nature in everything.)

12 Those extreme weather conditions such as fierce storms stirring up the sea and rivers are, of course, an exception. Sometimes I wonder when I think how Apelles' paints could render thunder and lightning with so few colours. Why do we, who have so many, more refined, and more appropriate for showing such unusual things, lack the urge to imitate nature?

(On the painting of thunderstorms, storms at sea, thunder and lightning.)

13 So, let roaring waves, stirred up by Aeolus'[9] messengers, appear as black, thundery skies, monstrously ugly. And have jagged streaks of lightning, sent by the highest of the gods, shoot across a darkened stormy sky, so that mortal creatures may appear frightened by such an occurrence.

(On the painting of winter landscapes, snow, hail, dark weather and fog.)

14 One should try to express in paint, the snow, hail, rainy squall, ice, hoar frost, and impenetrable fog. These are all needed to show gloomy winter days, for when we try to see distant spires, houses and towns, we realize that we cannot see further than a stone's throw.

(Painters are accused of never painting beautiful weather, and always showing the sky cloudy.)

8 Celebrated Greek painter of the late fourth century B.C., much honoured by Alexander the Great; he wrote a three-volume treatise on painting which was still extant in the time of Pliny the Elder (A.D. 23/4–79).

9 God of the winds.

15 There are nations who blame us for never illustrating pleasant weather, always showing instead a showery sky with clouds, scarcely allowing Apollo even a peep-hole to look down to his mother,[10] although this displeases him. And the flowers who love him try in vain to capture his bright light.

(The creation of very pure blue skies which become gradually lighter moving down.)

16 Let us, to avoid all these criticisms, reduce the number of clouds, and sometimes even show a completely clear sky with the purest blue of azurite or smalt at the top. Make sure to use clean brushes so the paint does not get spoilt, and use lighter tones gradually as you come down so as to place the lightest part of the sky next to the heavy element of earth.

(The painting of the sun; and that one cannot come close to showing its brightness.)

17 If we want to show the golden sun we should surround it with a light lake-red (*lakrood*), rather purplish, which merges fluently with the colour of the surrounding sky. We will, however, always lack sufficiently clear and bright materials to do justice to the subject. This is the point at which our art fails, however proud and beautiful it might otherwise be. We may even rail against our work, whose radiance is unable to render such bright light.

(On the dividing up of the ground planes within the landscape.)

18 Otherwise, we should, following the descriptions of the poets, succeed in imitating Prometheus' secret theft from a chariot drawn by four horses.[11] But fearing punishment, let us instead descend to the low level of the earth and straightaway deal with the ground appearing within the landscape. Both on canvas or panel the ground is usually divided into three or four parts.

(Dominant foregrounds with something large in them.)

19 First of all it is important to show clear contrasts in the foreground, as it pushes the other planes into the background. Ensure that something large is painted in the foreground, as was done by Bruegel and other great artists who are acclaimed for their contribution to landscape painting. Since they often place enormous tree-trunks in the foreground let us enthusiastically strive to follow their example.

(On how to make the ground planes unified.)

20 Now I urgently need to deal with matters which will enhance the harmony of our work. From the foreground the next sections of the ground ought to be painted as if they were intricately entwined. As in Neptune's domain, where the waves merge smoothly into one another, so too the landscape sections should fuse together to create a swaying and oscillating movement in the distance. So do not just pile one layer on top of another.

(If the ground planes are successfully linked together, the landscape will show an effective recession. Do not abruptly juxtapose a ground section, or anything else, with a light area.)

21 If we construct the planes of the ground in this way, letting them flow from one into the other, making them resemble the squirming of an adder, then we can be assured that the sense of space will work well, for the background will of itself recede smoothly into the distance. We must avoid juxtaposing the dark, powerful mountains, hills and dykes, with delicate soft light. Those contrasts call for a mid-tone (*mezza tint*).

(Big houses in the foreground – this does not look beautiful. Rather some beautiful plants, but not too many.)

10 'Apollo's mother' is here obviously intended to denote the Earth; strictly speaking, Earth was not the mother of Apollo (who was the son of Zeus and Leto) but of Hyperion ('he that goes overhead'), another name for the Sun. By Van Mander's time, however, the names and personalities of the various classical sun gods (Apollo, Helios/Sol, Hyperion) had long been interchangeable.

11 Prometheus obtained fire for men by stealing it from the blazing chariot of the Sun and carrying it down to earth concealed in a fennel stalk; for this crime, amongst others, he was chained to a rock in the Caucasus where an eagle fed daily on his liver, which was renewed every night.

22 We should not place houses in the foreground, unless we feel the need to illustrate a narrative with a balance between the landscape and the figures shown. If the narrative requires houses, put them in but avoid giving them undue prominence as it will spoil the spatial relationships. Instead, we should ensure that the ground is covered appropriately, but not excessively, with beautiful plants.

(Too many mountains, towns, houses and the distance does not look well.)

23 We must aim, wisely and knowledgeably, for a great variety of both colour and form, as this will result in beautiful work, worthy of praise. Moreover, we must avoid showing at random and without careful thought, too many towns, houses or mountains and such like; for too many things, even if only in the distance, generally prevent the achievement of harmony.

(The few, yet gifted, Italian landscape painters usually show one viewpoint into the distance, and they are accomplished at painting balanced ground planes and buildings.)

24 The very few, but yet ingenious and almost incomparable, Italian landscape painters mostly show only one prospect of the distance to which they firmly attach the planes of the ground, buildings, and everything else they depict. Even greater than Tintoretto is the very gifted Titian, whose woodcuts may instruct us in this matter: as can the work of the painter from Brescia.

(Bruegel's landscapes and prints as an example.)

25 As if it were a contest, I could also praise Bruegel's beautifully coloured and ingeniously composed paintings and prints. These appear so natural, and teach us how to render with much ease those angular, rocky Alps, and views into steep-sided valleys as well as precipitous cliffs, and pine-trees kissing the sky, or long vistas with murmuring streams.

(On how to differentiate, with colour, the mountains and valleys.)

26 Do not paint those high hills with their scant vegetation in a bright, bluish-green, as in low-lying meadows in the valleys, where Cynthius'[12] radiating arrows, even in the seasons under Scorpio, Leo or Virgo, hardly if at all change or reduce their bright green colour, resembling in moist areas the colour of the stone from the land of the Medes.[13]

(Streams which meander through the meadows.)

27 During the joyful spring time we should notice the land's adornment with colours of precious stones, and endeavour to paint the emerald green and sapphire blue cover of the land with its subtle variegation. And through the midst of this let the crystal-clear, murmuring stream meander between its green and grassy banks.

(On the embellishment of the banks of ponds, lakes and stretches of water with lilies and other foliage. Hinnides are goddesses of the meadows, or marshy pasture lands, as mentioned by Tommaso Porcacchi.)

28 On either side of the winding stream, where fishes drink, we will plant gentle rushes, reeds, and sword-like irises. We will brighten up the stagnant ponds so that they reflect the overgrown banks, while the most generous messenger of Aeolus, and his lovely companion,[14] will play and be merry on the rich carpets of the Hinnides.

(Water always low down; castles on cliffs.)

29 The rivers with their sweeping bends, winding through the marshy fields, should also be depicted. Moreover, let the water always search for the lowest level and, to heighten the artistic effect, build sea-towns stretching up to higher grounds, with

12 A surname of Apollo, from his birthplace Mount Cynthus, on Delos.

13 Malachite: see Pliny, *Natural History*, book XXXVII, 18.

14 'The most generous messenger of Aeolus' (see note 8) is Zephyrus, the west wind. The 'lovely companion' of Zephyrus is Chloris (Flora), goddess of flowers.

In't veldt/ floten/ bomen/ wat wy aenschouwen/
Doch achterwaert al inloopen en nouwen/
Dit acht te nemen laet u niet verdrieten/
Want t'doet u achter-gronden seer verschieten.
 Op vercorten en verminderen letten/
Ghelijck men in't leven siet/ ick bespreke/
Al ist geen metselrie/ die nauwe Wetten
Behoeft/ soo moet ghy doch weten te setten
Op den Orisont recht u oogh' oft streke/
Dat is/ op des waters opperste streke/
Al watter onder is sietmen dan boven/
En t'ander sietmen van onder verschoven.
 Achter niet te flauw en meurhop't beschicken/
Soo mildt in't diepen niet zijn/ als in't hooghen/
Bedenckende t'blaeu-lijvich Lochts verdicken/
Dat daer tusschen t'ghesichte comt bestricken/
En gantsch bedommelt t'scherp begrijpich pooghen/
Spaerlijck salmen somtijts hier oft daer tooghen/
Als of de Sonne de wolcken doorstraelde/
En door soo op Steden/ en Berghen daelde.
 Daer neffens salmen oock bedinstermissen/
Somtijts gheheel/ somtijts half maer de Steden
Beschaduwt van wolcken/ noch salmen gissen/
T'spieghelijck water niet te laten missen/
T'Hemels aenschijns verwen/ naer d'oude zeden/
Ghedeelde Lochten/ somtijts daer beneden
Van boven aerdich in te doen verdwijnen/
Staet wel/ en somtijts oock het Sonneschijnen.
 Doch t'hardtwindich weder hier uptghesondert/
Als beroert zijn Zee/ en Beken fonteynich:
Nu maeckt my t'bedencken somtijts verwondert/
Hoe soo gheblixemt hebben en ghedondert
Appellis verwen/ wesende soo weynich/
Daer wyder in hebben seer veel en reynich/
Bequamer t'uptbeelden soo vreemde dinghen/
Hoe comt ons lust tot naervolgh oock niet dringhen?
 Laet somtijts dan rasende golven vochtich
Naebootsen/ beroert door Eolus boden/
Swarte donders wercken/ leelijck ghedrochtich/
En cromme blixems/ door een doncker-lochtich
Stormich onweder/ comende ghevloden
Wt de handt van den oppersten der Goden/
Dat de sterflijcke Siel-draghende dieren
Al schijnen te vreesen door sulck bestieren.
 Met verwe moetmen oock wesen beproevich/
Te maken snee/ haghel/ en reghen-vlaghen/
Hijssel/ rijm/ en smoorende misten droevich/

C iij XI

Op de vercor-
tinge behoeft
ghemerckt.

Den Orifont
is, daer Hemel
en water
fcheyden, oft
fomtijts daer
Aerde en
locht fchey-
den.

Van over-
fchaduwen
Berghen oft
Steden met
den wolcken,
en den wolc-
ken in't water
te laten fien.

Appellesfchil-
derde maer
met vier ver-
wen, foo Pli-
nius feght, en
maecte blixe,
donder, en
fulcke ander
dinghen: wy
die foo veel
verwen heb-
ben, moften
oock luft heb-
ben de natue-
re in alles te
volghen.

Vã onweders,
Zee-ftormen,
donder en bli-
xem te fchil-
deren.

Van winterẽ,
fnee, haghel,
doncker we-
der, en miften
te fchilderen.

castles on the cliff-tops where they are difficult to destroy. As we climb slightly higher, let us now skilfully divide the expanse of land in fields.

(Fields and their crops through which the wind blows.)

30 While we can see the blond-haired Ceres[15] at one side, the other field is filled with unripened oats. It is here that Eurus[16] floats in, who passes the time by turning the fields into a sea of green waves and whispering sounds. Over here are vetch flowers, while over there are buckwheat and clover. There are also red and blue flowers among the corn and wheat and the useful, sky-blue flax.

(Over here and over there ploughed fields, and tracks. However, one should be able to see where they begin and where they end. On strange farms and shepherds' huts.)

31 Ploughed fields, too, hatched with furrows, or here and there fields, with harvested crops; then too, fields and meadows with the ditches, hedges and winding paths belonging to them. Yet again we might introduce strange and quaint shepherds' huts or farm hamlets in caves or hollow trees or sometimes even built on stakes.

15 Goddess of corn; here used for corn itself.

16 See note 5.

(Do not paint roofs in bright, strong colours, like vermilion or red-lead, but show everything as is seen in reality.)

32 Roofs and walls ought not to be shown with bright red bricks, but rather in turf, reeds, or straw, holed and patched. You can also plaster them in a fantastic manner, and show moss growing on them. In the distance our blue-coloured woods are painted on a ground of azurite, brushed out white with blue applied when dry, to form a contrast. Draw the tree-trunks delicately in light strokes and place them increasingly close to each other, towards the centre of the wood.

(Give cliffs and everything else their own colours.)

33 The smallest trees only need a slight stippling of paint. But let us, before approaching the trees in the foreground, climb those steep cliffs which are moistened and washed in their uppermost crowns by the wet lips of the floating clouds. Usually these are painted in a light greyish colour and sometimes the bare peaks protrude from a dense pine-wood.

34 Those gruesome rocks which are scattered throughout Switzerland, and divide France from Italy, are the target of the northern wind, and are full of white flecks. These rocks appear in our landscape too, and we can see them sometimes jutting up through clouds, and supporting castles. You brushes, be like Echo here and imitate the sound of water, which fiercely rushes down between the weathered rocks.

35 Notice these irregularly shaped stones in the waterfall, hanging like icicles from the rocks and covered with green moss. The cascade tumbles circuitously hither and thither like a drunken man, and arriving at the bottom follows a similarly tortuous path, now like a snake. Look, over here are some tall fir-trees, while the ones over there have fallen down so awkwardly you could scarcely believe it in a dream.

(On trees and dark woods. Attempt to acquire proficiency in the painting of leaves.)

36 We have now arrived, to dispel sorrow, at the shaded area of the *Hamadryads*,[17] I mean, of course, the trees, which embellish our work when they are painted well, but ruin it if they are not. Therefore, I advise you to practise and acquire a technique of painting leaves that is both natural and skilled in its composition. In that lies your power and therefore you must be able to do it.

(Leaves, hair, air, and fabric are difficult to learn, because they are spiritual things.)

37 Despite continued practice it is very difficult to show the elegant movement of glowing leaves. Even if we try in many ways steadily copying the visible world or the works of artists on coloured papers with ink washes – to paint leaves in flowing movement, hoping to reach success in due time – unlike using the muscles of the body, it is not a skill which can be learnt perfectly. Leaves, like hair, air and fabrics, are spiritual things and can only be conceived and reproduced by the imagination *(geest)*.

(A variety of foliage and colours of trees. Tree-tops not rigidly cut round.)

38 It is possible to show various kinds of leaves and in doing so we should employ a wide range of colours: yellow-green *(geelgroen)* leaves of oaks, pale *(bleke)* leaves of willow bushes. Tree-tops should not be shown as completely rounded as if they were neatly trimmed. The branches should grow out of the tree-trunks on all sides, and thickest at the base and thinner higher up.

(On trunks and branches.)

39 We should also master typical tree-trunks which are heavy at the base and slight at the top, standing upright. Show a distinction between the pale, thin birches and

17 Woodland nymphs.

41

limes, and let the wrinkled oak bark be overgrown with creeper and green ivy. Show also tree-trunks straight enough to hang sails on, in which the wind can blow. All these trunks should be covered with their green foliage.

(On a careful arrangement of trees.)

40 It is important to group the trees effectively, either to show hazy woods or high forests. Some are more yellow, while others are greener. Show how the foliage, when seen from beneath, has an underside. To avoid staleness in your work you should not paint tiny leaves. Do try, as you paint foliage, to show thin twigs, either painting upwards, or bending down haphazardly.

(It is a good thing to know your narrative beforehand. Small figures next to large trees.)

41 It is useful to know beforehand the narrative, whatever you may choose from Biblical stories or subjects from the poets, in order to adapt your landscape accordingly. However, you must not forget, under any circumstance, to place small figures next to huge trees. Show them either ploughing or mowing, or loading up a cart further away. Elsewhere you may show them in the act of fishing, sailing, catching birds or hunting.

(On figures in action in the landscape.)

42 Show how those farm girls beside the green banks ease out fountains of milk with their hands. Show how Tityrus,[18] with his flute, entertains Amaryllis, his beloved among women, resting beneath an oak tree, while even his flock enjoys the pleasant sound. Show the countryside, town and water filled with activity, and make your houses look inhabited and your roads walked on.

(Here the example of Ludius: Pliny's *Natural History*, book XXXV, 116–117. Read about it in his biography.)

43 It is appropriate to tell you here about Ludius. He lived during the reign of the Emperor Augustus and was the first to discover how to paint on outside walls or in rooms in a skilled and beautiful way. His competent hands were able to paint anything you asked for, including farmhouses, homesteads, vineyards, country roads, dense woods, high hills, ponds, streams, rivers, harbours and beaches.

(An example of how to decorate the landscape with figures.)

44 Within the landscape he placed people who were enjoying themselves by going for a walk. Others would pass their time pleasantly on the water. In landscapes without water he would paint fully laden carts and asses in the fields and paths, near the houses and farmyards, and other agricultural implements.

45 On some occasions he would show people catching fish with fishing rods and deceiving bait; or others who found pleasure in catching birds or hunting fast-running hare or deer and boar; or those picking grapes. It achieved his purpose to paint with a steady hand, these things in the countryside. An artistic gift enables us to do remarkable things.

(Cleverly thought out those muddy roads with sliding figures who fall down.)

46 The achievement for which he received the highest general acclaim at that time was his depiction of a marshy low-lying piece of land in which he painted a couple of farms and muddy, almost impassable, slippery roads. He showed this very explicitly by painting women slipping and falling down.

18 A shepherd character in Virgil's *Eclogues*.

47 He had painted some of them walking very warily, trembling with the fear of falling down hard, while others stood, bending forward as if they were loading something heavy on top of their heads and shoulders. Anyway, in short, he knew how to scatter ten thousand graphic details throughout his work. Now I will leave you to invent as many.

2 Samuel Ampzing (1628)

BESCHRYVINGE ENDE LOF

DER STAD

HAERLEM

IN HOLLAND:

In Rijm bearbeyd: ende met veele oude ende nieuwe stuckers buyten Dicht uyt verscheyde Kronijken/Handvesten/Brieven/ Memorien ofte Geheugenszen/ ende diergelijke Schriften verklaerd / ende bevestigd.

DOOR

SAMVEL AMPZING, van Haerlem.

Mitsgaders

PETRI SCRIVERII

LAVRE-KRANZ

Voor

LAVRENS KOSTER

Van Haerlem,

Eerste Vinder vande

BOEK-DRVCKERYE.

De Voor-rede aen den Leser geeft enig onderwijs van onse Nederduytsche Sprake, ende Spellinge, in desen gebruykt, onder den Tytel ofte Opschrift van Nederlandsch Tael-Bericht: handeld ook een weynig van de Rijm-konste, tot nut ende lust der weet-gierigen,

TE HAERLEM,

By Adriaen Rooman, Ordinaris Stads-Boekdrucker/

cIɔ Iɔ c. XXVIII.

Samuel Ampzing, *Beschryvinge ende Lof der Stad Haerlem in Holland: In Rijm bearbeyd: ende met veele oude en nieuwe stucken buyten Dicht uyt verscheyde Kronijken Handvesten Brieven Memorien ofte Geheugeniszen ende diergelijke schriften verklaerd ende bevestigd.* (Description and praise of the town of Haerlem in Holland: written in verse: and with many old and new literary accounts from various chronicles, charters, letters, memoirs and recollections and *diergelijke* writings explained and corroborated.)
 Haarlem, 1628.

In Ampzing's book there is a large section devoted to the *Vermaerde Schilders der Stad Haerlem* (Famous Painters of the Town of Haarlem). It is preceded by quotations from Van Mander praising the artists of Haarlem and noting that *'Daer word ook geseyd en getuygd uyt de monden der oudste schilders dat te Haerlem is van-ouds onstaen en begonnen de beste en eerste maniere van landschap te maken'*. (There it is said and evidence from the mouths of the oldest painters is given that long ago in Haarlem the best and first manner of landscape painting was begun and established.)

For the early period Ampzing quotes the relevant passages from Van Mander's *Lives*, interspersing them with eulogistic verse. Of greater potential interest are his accounts of those of his Haarlem contemporaries who are featured in this exhibition: these are on pages 372 and 373. In fact his praise is disappointingly conventional:

> And from the bold brush and skilful hand of *Molijn*,
> who in the art of painting is the equal of two brave painters.
>
> *Pynas* has also lived here within our walls.
> What can his hand not do? Who can he not please?
>
> How could I not mention *Reijer Zuycher*
> How could I neglect *Blieker* and *Rustdael* [sic]
> Who are good at landscapes with small figures in them
> And *diergelijk* paint landscapes?
>
> How worthy *Velde* is active in this art
> As he has shown so richly in my book
> He need yield to no-one in his engraving
> skill! He is as good as the best
> What will he be capable of in time
> When day by day his art becomes better known
> He is equally skilful in cutting with the etching-needle:
> Also his pen is a valuable gift

3 Constantijn Huygens (c. 1629/30)

The manuscript of Constantijn Huygens' autobiography, written in Latin, is in the Royal Library in The Hague. It was composed in 1629 and 1630, and contains a substantial section on painting. Huygens was to become artistic adviser to the Prince of Orange and a significant patron in his own right, and so played an extremely important rôle in Dutch artistic life. The passage referred to is a very rare account by a well-connected and observant connoisseur of the contemporary artistic situation in Holland. It was published in a modern Dutch translation by A.H. Kan (*De Jeugd van Constantijn Huygens door hemzelf beschreven*, Rotterdam, 1971) and it is from that publication that this translation into English of the relevant passage is taken:

'The crop of landscape-painters (as I shall call them here, by whom I mean to include those who paint woods, fields, mountains and villages) is in our Netherlands so very great and so famous, that if I was to mention them all here, I would fill a small book. The rest I shall allow to plead their own reputations – and those of Van Poelenburgh, Uyttenbroek, Van Goyen and others are truly extraordinary enough already – ; in place of all of them I will only mention two here, Jan Wildens and Esaias van de Velde and place them nearly equal with Paul Bril, who although a Netherlander died abroad. One can say that in the work of these clever men, that as far as naturalness is concerned, nothing is lacking except the warmth of the sun and the movement caused by the gentle breeze.'

Detail from Portrait by T. de Keyser, 1627, London, National Gallery.

The study of painting techniques follows certain standard – and, frequently, rather well-worn – pathways. The primary source is examination of the paintings themselves, and much work has been done on the materials and methods of seventeenth-century Dutch painters in general, although rather little on the earlier landscape painters in particular. Documentary sources are also valuable, in the form of writings by and about practising painters. Probably many such notebooks and treatises have not survived or are yet to be found, but there are a few important writings which throw light directly and indirectly on the methods of landscape painting during this period. Notebooks, too, can form part of the third source of information, the record that painters left of the circumstances in which they produced their paintings, their studio organization, materials and equipment. Much is learned about these aspects of painters' lives from a remarkable number of genre paintings depicting studios, often showing procedures in great detail. In addition, local archives, inventories, accounts and so on are helpful in revealing circumstantial details of the painters' working lives.

Documentary Sources

There are two principal works in Dutch relating to the practice of painting in seventeenth-century Holland. The first is Carel van Mander's *Het Schilderboeck* published in 1604 (which is mainly a series of biographies of Dutch and Flemish painters going back as far as Van Eyck). In that sense it is a retrospective book, reflecting the painters and methods of the previous two centuries, but it was also intended as a guide and inspiration for living painters, and there is no doubt that its influence was considerable, both in the Netherlands and also, later, in Britain.

Its relevance to painters of the seventeenth century was largely confined to the first part of the book, a didactic verse treatise, *Den Grondt der Edel Vry Schilder-const*, in which he set down guiding principles for young painters entering the profession ('. . . first seek a good master . . .') and also quite specific instructions concerning various aspects of the painter's art. Thus the importance of drawing ('the father of painting') is stressed, especially from life. As far as landscape is concerned, Van Mander advises arising early in the morning, leaving the city with a sketchbook and studying in the open, while at the same time listening to the birds and watching colours reflected by dew on the grass.

References to landscape painting are mostly confined to the section of *Den Grondt* devoted to landscape,[1] but occur also in, for example, the section on composition. Sketching from nature is stressed, and then the composition or design of ideal landscapes defined: the corners of such paintings should be filled with foliage, an open space left in the centre and figures placed in front of a distant background – the effect to be theatrical. The edges of the composition are also important and figures and cattle should not be cut off by the frame.

Van Mander recommends close observation of colour effects in nature: how, for example the colour of all things near the horizon seems grey, how the colours of dawn and sunset, storms and rainbows may be painted. Variations in weather – cloudy skies, cloudless skies, rain and snow – must be recorded, as well as streams and meadows and muddy roads.

All this advice is rather more philosophical than practical and it is true that in parts of his verse treatise Van Mander adopted a high moral tone, commenting on such matters as controlling one's emotions, marrying a bride ten years younger than oneself, the right inns to stay in when travelling, eating breakfast early in the morning and avoiding melancholy. But, as well as telling the aspiring painter what to look for, what to record and how to compose a landscape or other painting, Van Mander is also quite precise in some sections about the use of specific materials – although, as ever, his instructions are firmly rooted in the traditions of the previous two centuries.

Thus, he describes how to draw the outline of a design on a primed panel with colour or a drypoint as the earlier Netherlandish painters would have done. He refers to

1 See Appendix to the Introduction (pp. 35–43).

problems with pigments such as smalt and massicot, says that orpiment and verdigris should be avoided and recommends pigment mixtures for particular passages: '. . . in painting peasants, shepherds and mariners, spare not yellow ochre with your vermilion . . . be careful not to light up the flesh tints in either sex with too much white; no pure white is visible in the living subject'. Skies should sometimes be shown 'completely clear . . . with the purest blue of azurite or smalt at the top'. The golden sun should be surrounded 'with a light lake-red, rather purplish, which merges fluently with the colour of the surrounding sky'. Within the landscape, 'do not paint roofs in bright strong colours, like vermilion or red-lead, but show everything as is seen in reality . . . In the distance, blue-coloured woods are painted on a ground of azurite, brushed out white with blue applied when dry, to form a contrast.' On pigments in general, he advises laying up a store of choice colours, implying that the opportunity to acquire them should be seized whenever they are available.

Although in many ways *Het Schilderboeck* was anachronistic, its influence on the Dutch landscape painters of the seventeenth century was undoubtedly significant, not least in providing a link with earlier masters of the subject such as Bruegel (who, in common with Jan van Amstel, 'made the ground of his panel or cloth tell, by painting loosely over it'). There is evidence, too, that it was known by and influenced writers of technical treatises in seventeenth-century England where Dutch landscapes were already much admired. Sections on landscape in *The Art of Drawing with the Pen* by Henry Peacham (first published 1606)[2] and in Edward Norgate's *Miniatura* (first published ca. 1621–26)[3] bear striking similarities to Van Mander's observations but it is not known whether either author had seen or could even understand *Het Schilderboeck*. The first known record of an Englishman having read it is provided by a notebook belonging to William Carter[4] containing, in a section 'Of Landskip', summaries of the relevant parts of *Den Grondt*; however, this appears to date from the 1630s and therefore cannot be directly connected with the works of Peacham or Norgate.

The connection between the Dutch landscape painters and, for example, Norgate may not be a direct one but the conclusion must be drawn that theoretical approaches to landscape in England and Holland were moving along almost identical lines. Passages from the *Miniatura* relating to landscape, although referring mainly to watercolour painting, seem to find direct expression in Dutch paintings of the following decades: 'let not your landscape rise heigh and lift itselfe upp in ayre . . . let them rather lye low and under the eyes, which is more gracefull and naturall'. Norgate also gives specific instructions for the painting of skies, clouds, distant mountains, trees and 'cataracts and terrable faules of waters' recommending some pigments and warning against others just as Van Mander did.[5]

Another valuable source of detailed information on contemporary painting materials, although again not specific to Holland, is Sir Theodore Turquet de Mayerne, a physician who wrote extensively on medicine and, in two of his surviving manuscripts dating from 1620 onwards, on painting.[6] 'His most celebrated observations concern the techniques of such painters as Rubens and Van Dyck whom he met while court physician in England. He has a considerable amount to say on the painting of landscapes, breaking them down into their constituent parts – air, earth and water. These are then subdivided further – the earth into trees, houses, fields and fixtures; water into still, rough and frozen; and air at sunrise, midday, when it is raining, and so on. He goes on to describe in some detail how such phenomena might be painted. At sunrise, for example, '. . . un peu plus hault des nuées avec Esmail [smalt], Lacque, et un peu d'ocre jaune et au bas de la nuée ou les rayon du soleil donnent, esclaircissés avec blanc, ocre jaune et un peu de Lacque . . .'; trees should be highlighted with massicot, and so on. De Mayerne assembled all these observations and, more important, all the detailed recipes for preparation of pigments and other materials during the course of many contacts with practising painters. His manuscript thus forms one of the most revealing documents on northern European painting techniques in the first half of the seventeenth century.

2 H. Peacham, *The Art of Drawing with the Pen, and Limning in Water-colours, more exactlie then heretofore taught and enlarged: with the true manner of painting upon glasse. . . etc.*, London, 1606.

3 E. Norgate, *Miniatura or the Art of Limning*, ed. Martin Hardie, Oxford, 1919.

4 British Library, Ms Sloane 141.

5 See also H. Ogden, *English Taste in Landscape in the Seventeenth Century*, Ann Arbor, 1955, Appendix, p.169.

6 British Library, Mss Sloane 1990 and 2052. Published (with notes in Dutch) in: J. A. van de Graaf, *Het de Mayerne Manuscript als Bron voor de Schildertechniek van de Barok*, Mijdrecht, 1958.

The second key work in Dutch is Samuel van Hoogstraten's *Inleyding tot de Hooge Schoole der Schilderkonst* (Introduction to the elevated school of painting). Published in 1678, it provides the best account we have of the theory and practice of painting in seventeenth-century Holland. Although published after the period of the earlier landscape painters and therefore in no sense an influence on them, the *Inleyding* reflects much of the general theory that governed them, both in the particular chapter on landscape[7] and elsewhere. Hoogstraten was particularly interested in perspective and emphasizes repeatedly the importance of painters conveying it correctly in their works. (His peepshow of a Dutch interior in the National Gallery is a demonstration of his own mastery of vanishing points.) In landscape paintings, the correct use of perspective is necessary to give depth and suggest recession. This is not only done with colour, which becomes paler in the distance, but also by diminishing distant objects and giving them less and less shadow the further away they are.

In common with other treatises on painting, the *Inleyding* has occasional remarks on specific painting materials. Hoogstraten lists blue pigments available, laments the lack of a reliable green, disapproves of lampblack and describes with simple accuracy his varnish: 'our varnish, consisting of turpentine, spirit of turpentine and pulverized mastic dissolved is sufficiently convenient for our works'. He also has opinions on the handling of paint which, one suspects, derive directly from his master, Rembrandt, but which could apply equally to some of the earlier landscape painters: 'It is above all desirable that you should accustom yourself to a lively mode of handling so as to smartly express different planes or surfaces; giving the drawing due emphasis and the colouring, when it admits of it, a playful freedom, without ever proceeding to polishing or blending . . . it is better to aim at softness with a well-nourished brush . . . for, paint as thickly as you please, smoothness will, by subsequent operations, creep in of itself.'[8]

Producing the paintings: the studio

There is no evidence that the early landscape painters in Holland painted out of doors, as later painters were to do. They might, it is true, paint directly from nature if it was a prospect from their own window, but it seems certain that most landscapes were painted in the studio. Drawings, of course, were made copiously from nature as many surviving sketchbooks reveal, but the process of transfer on to panel or canvas was done indoors.

We know a great deal about the routine of the painter's studio in Holland at that time, from contemporary records, inventories, notebooks and paintings. The old workshop ideal of the master painter and the team of apprentices who carried out all the preparation for him was already beginning to change. Panels, for example, were not usually made in the studio, but by specialist craftsmen, members of the joiners' and cabinet-makers' guild who, by a restrictive charter, jealously guarded this right. There seems to have been a standard range of sizes, often referred to directly by their cost ('guilder-size' and so on).

Canvases, too, could be bought ready prepared, but were usually stretched by assistants in the studio; application of the ground layer to both canvases and panels might be done either by specialists (de Mayerne records a formula used by a Walloon 'Imprimeur' in the 1620s and 30s[9]) or, again, by apprentices, to the master's own specification. The first recorded general supplier of artists' materials in Holland seems to have been the painter and dealer Volmarijn who, in 1643, established a shop in Leyden for 'prepared and unprepared colours, panels, canvas, brushes and painting utensils of every kind'.[10]

Scenes of working studios such as those by Adriaen van Ostade (fig. 1) and Molenaer (fig. 2) show how the painting progressed. Canvases were often stretched and laced inside a larger wooden frame, rather than turned over and tacked to a strainer as was the general practice later. Panels, sometimes quite large and thin, with bevelled edges for fitting into frames, were sometimes held within temporary grooved battens to protect

7 Hoogstraten, pp.135 & 231.

8 Ibid., p.233.

9 J. A. van de Graaf, op. cit., p.138.

10 W. Martin, 'Een "Kunsthandel" in een Klappermanswachthuis', *OH*, 19, 1901, pp.86–8.

fig 1 A.v. Ostade, *Studio Scene*, Dresden, Albertinum.

and strengthen them (fig. 3). Easels were quite simple, just like modern blackboard easels, with holes and pegs to vary the height of the work.

Unfinished pictures are sometimes shown, those with dark grounds appearing to have a white underdrawing in chalk or paint. Most landscapes, however, had light-coloured grounds and, if drawn at all, were sketched in with charcoal or some other dark material.

Painting equipment has changed very little since the seventeenth century. Flat wooden palettes for holding and mixing oil paints, shaped with a thumb-hole to fit the painter's hand, look surprisingly modern. Assistants would prepare a number of palettes with fresh colours (in a standard order) to hand to the master when the one he was using ran out. Brushes, too, look unchanged, although the modern metal ferrule was then a section of quill, with miniver, badger or hog hairs tied inside it.[11] The painter rested his brush hand on a mahl-stick, braced against the edge of the painting, to steady himself and avoid touching the wet paint.

Painting materials – bottles of oil, jars of pigments, brushes and so on – were often stored in painters' cabinets, which might be fairly simple chests or quite elaborate pieces of furniture. One particularly attractive cabinet is that attributed to the painter A. van Croos (Rijksmuseum, Amsterdam) (fig. 4). In the present context it is of great interest because it is entirely painted with a series of landscapes containing figures, animals and battle scenes – on the back, sides, lid and across the drawer-fronts.

11 R. D. Harley, 'Artists' brushes – historical evidence from the 16th to the 19th century', *Conservation and Restoration of Pictorial Art* (eds. N. Bronmelle and P. Smith), London, 1976, pp.61–66.

48

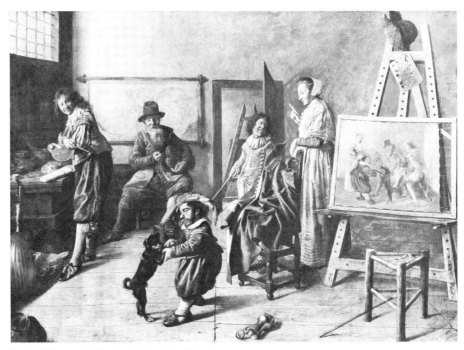

fig 2 Molenaer, *Studio Scene*, Berlin, Gemäldegalerie.

fig 3 Rembrandt, *Artist in his Studio*, Boston, Museum of Fine Arts.

fig 4 Attributed to A. van Croos, *Painter's cabinet*, Amsterdam, Rijksmuseum.

The layout of the studio was arranged for the particular requirements of the painter. If he was right-handed, he would sit with a window on his left, so that his hand and arm did not cast a shadow over his work. Portrait and genre painters often had at least two windows on the left side, one to illuminate the painting, the other for the subject, with various shutters and curtains to control the direction of the light. Ideally the windows should be north-facing so that direct sunlight did not shine on the painting. Apparently painters liked to live and work on east–west streets so that either the back or the front windows would face north.[12]

The duties of assistants and apprentices ranged from stretching canvases to cleaning palettes. They would also spend much time grinding colours on a stone with a flat-bottomed muller. Oil colours were stored in bladders, and pigments for water colour were placed on shells. Some painters (Coninxloo, for example) are known to have had mechanical colour mills for grinding pigments.[13]

Some members of the studio were paying pupils who, while assisting with routine tasks, would also spend time copying casts, lay figures and pictures. They would spend at least two years with a master (during which time any work they did was the master's property) before they could be admitted to a guild of painters as free masters themselves.

Van Mander had much advice for the young painter. Once he had found a 'good master', he should 'learn properly to compose, sketch, shade and work up neatly first with charcoal and then with chalk or pen'. Cleanliness was also important: 'have a care of the master's palette and brushes and of mixing and preparing the colours, have a care of canvas and panels, grind the colours right fine and see to it that they are kept clean'.

Clean surroundings were an obvious priority in the studio, since the surface of smooth and finely detailed paintings would be spoiled by dust or hairs. In the Adriaen van Ostade studio scene there is a sheet suspended by its corners above the painter and his easel: this may have served a secondary function in reflecting light downwards, but its undoubted purpose was to prevent dust and debris falling from the rafters on to the

12 W. Martin, 'The Life of a Dutch Artist in the Seventeenth Century', parts 1–3, *BM*, 7, 1905, pp.125–28, 416–27; 8, 1905/6,pp.13–24.

13 W. Martin, op. cit. (ref.12).

painting. Gerard Dou is recorded as having dust-catching arrangements of this kind in his studio and even, on occasion, as having an open umbrella fastened to the top of his easel.[14]

Some paintings examined

The materials and techniques of seventeenth-century Dutch painters in general have been well documented in a number of technical studies.[15] The landscape painters, although of course specific in their subject matter, were just one strand of this broad tradition, and constructed their paintings in ways that were not materially different to the methods of the genre painters, the history painters or the portrait painters. They all had access to the same pigments, media and supports and all inherited the same technical traditions from the early Netherlandish painters of the previous two centuries.

Nevertheless, the visual effects that some landscape painters wanted to achieve were quite different to those of, say, the genre painter, and materials common to both could be used in very different ways. In, for example, Van Goyen's *Windmill by a River* (cat. no. 47) the palette of colours is very muted and limited in tone and the fluid, loosely painted brush-strokes allow the dull pink ground to show through everywhere. The ground is very thin and, as in many of Van Goyen's panels, the grain of the oak gives a texture to the whole painting. (So prominent is the wood grain in some of his paintings, that it has been suggested that he painted on unprepared panels, but there invariably seems to be a thin ground of some kind.) This sort of painting, while using much the same range of materials, is quite different in effect to the colourful, ivory-smooth, intricately detailed surface of a contemporary genre or history painting.

But other landscape painters were not so interested in textural effects. Pynas, for example, in his *Landscape with Narcissus* (cat. no. 89) worked on a much smoother preparation (also pinkish in colour, seen uncovered in the landscape just above Narcissus's head) in a careful formalized technique. The figure is thin and flatly painted and the landscape and trees are constructed in a very methodical way. The surface of the Avercamp *Scene on the Ice* (cat. no. 83) is similarly much more carefully worked than the Van Goyen.

What were the basic materials used by these and other landscape painters to achieve these effects? Supports were usually oak panels (radially sawn) or stretched canvas, as we have seen. Occasionally copper supports were used. These were more readily available than one might imagine, because of the constant need for etching plates: indeed, the *Tobias and the Angel* after Elsheimer (cat. no. 12) is painted over the etched design of a coat of arms and the intaglio image is clearly visible beneath the paint if viewed in raking light.

Grounds of landscape paintings were usually light-coloured, either based on chalk and glue for panels in the manner of the earlier Netherlandish painters, or of plain or tinted lead white in oil for panels and canvases. On chalk grounds, Van Mander recommends a thin oil priming (the *primuersel*)[16] to make the ground less absorbent and impart a desired colour and such a layer is undoubtedly present in some cases. The grounds observed in landscape paintings so far examined seem to be either white or off-white (e.g. Vroom, *Landscape with a River by a Wood*, cat. no. 76) or else the pinkish-buff colour already mentioned above. In many paintings the ground shines through between the brush-strokes and imparts an overall coolness or warmth to the paint layers.

The next stage of the painting would be the sketching out of the composition, marking in the main forms. In some pictures this was quite clearly done only at the painting stage: in the Pynas *Narcissus* and the Vroom *Landscape with a River by a Wood* the landscape and trees are constructed directly in paint, in a rather stiff, formal style.

On other paintings, however, remarkable underdrawings have been revealed by recent technical photography. The use of infrared photography to detect underdrawings, especially in early Netherlandish paintings, is well known. Infrared

14 W. Martin, op. cit. (ref.12).

15 For example, E. van de Wetering, 'Painting Materials and Working Methods', in *A Corpus of Rembrandt Paintings*, 1, 1982, pp.11–33.

16 J. A. van de Graaf, op. cit., p.22.

fig 5 E. van de Velde, *Winter Landscape* – whole picture (pan.)

radiation is able to penetrate the paint layers and reveal what is present just below the visible surface of the picture. If there is a light-coloured ground and an underdrawing done in carbon-black of some kind, and if the paint layers are sufficiently thin and transparent to radiation of the correct wavelength, then the underdrawing can be recorded on infrared-sensitive film.

These conditions are met perfectly in the *Winter Landscape* by Esaias van de Velde (fig. 5; cat. no. 66) and an infrared photograph reveals a very free charcoal underdrawing (fig. 6). It is most clearly seen in the landscape background which has been sketched in with a few careless loops and long curves outlining the distant trees and horizon line. In front of that, the fence by the water's edge was drawn with just one curving vertical and two horizontals somewhat above its final painted position. Closer examination shows drawing lines under all the main landscape features, the house and the trees on either side. The figures, however, are not drawn but painted directly at a late stage in the composition – the initial drawing lines of the road and foreground are seen to pass straight through them. The drawing of the nearer trees is more detailed, the twisted trunks and individual branches being outlined quite precisely. The trees near the left edge appear to have been taller and to have overshadowed the house more at the drawing stage than in the final version. The house, too, is clearly outlined, as are the low banks and bushes in front of it.

The practice of drawing the main structural elements of a landscape but not the figures within it is also found in the earlier works of Salomon van Ruysdael. His early *River Landscape* of 1631 (fig. 7; cat. no. 55) has the most spectacular underdrawing found so far in paintings of this period. Here the drawing was revealed by the technique of infrared reflectography in which an infrared vidicon television camera is connected directly to a monitor and the image is photographed from the screen. A complementary technique to conventional infrared photography, it is much more sensitive at longer wavelengths and will allow penetration of areas (principally those

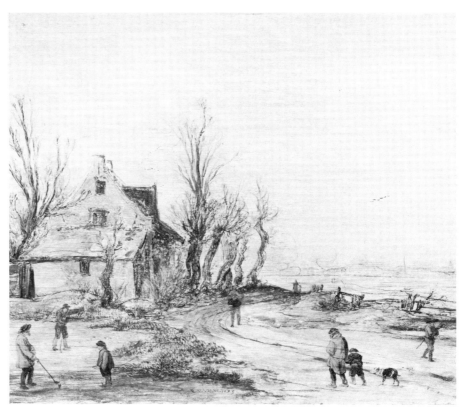

fig 6 E. van de Velde, *Winter Landscape* – whole picture (infra-red)

containing green and blue pigments) which are quite opaque to infrared film. In addition, it has the advantage of instantaneous imaging, but the recorded image is always slightly blurred and has to be built up from a succession of small frames.

Since the Ruysdael *River Landscape* is predominantly green in tone, reflectography was needed to penetrate the paint layers. The composite image (fig. 8) reveals an extensive and highly characteristic charcoal underdrawing. Trees and bushes are drawn with rapid but tightly controlled loops and curls, vividly summarizing the outlines and structure that were to be superimposed on them. The horizon and river-bank are drawn with a succession of bold overlapping horizontals. One can almost see the hand holding the charcoal moving a little way across the panel, then correcting, picking up a new line, experimenting with a higher or lower horizon. With the same deft, fragmented strokes a cottage is suggested at the right and, at the focus of the painting, a rustic bridge with leaning sides, over a shadowed culvert (fig. 9). The whole brilliant, improvised drawing would have taken no more than a minute or two to execute.

The revelation of this spirited underdrawing is given particular significance by the fact that no independent drawings by Salomon van Ruysdael are known. The only evidence we have of his draughtsmanship is this image on a television screen. He apparently made no preliminary studies for his landscapes but drew straight on to his panels in the studio: this would seem perfectly reasonable for an imaginary river landscape, but what of paintings of real places?

Examination of the later (1648) panel, *View of Rhenen* (cat. no. 57) by infrared reflectography shows that there is no underdrawing present at all. It must, therefore have been painted directly, either from the life (which, as we have seen, would be highly unusual), from memory or perhaps from an engraving: some topographical inaccuracies would seem to confirm that it was not a direct study.

The technique of the *View of Rhenen* is quite different to that of the early *River*

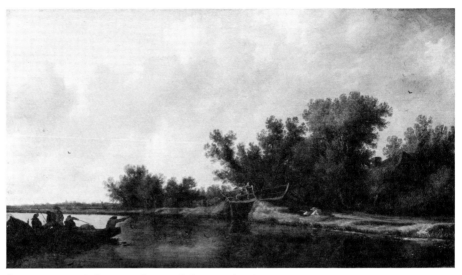

fig 7 S. van Ruysdael, *River Landscape* – whole picture (pan.)

fig 8 S. van Ruysdael, *River Landscape* – reflectogram assembly

Landscape. Apart from the complete lack of underdrawing, it is much more fluid and painterly and on a dark pink ground which provides very little luminosity: the brightness of the picture is all on the surface, unlike the earlier picture in which the light ground shines through.

The two styles, separated by almost twenty years, are quite distinct, but it is possible to see a transition beginning, even among the early river landscape series. Examination by infrared reflectography of two others in the National Gallery collection (not in the present exhibition) shows one (no.6419, dated 1632) to have a very similar underdrawing to the *River Landscape* illustrated above, perhaps even slightly more detailed, but again with the figures painted, not drawn. The other (no.5846, undated) has a much wilder, more rudimentary drawing, only under the trees at one side. This may well show Ruysdael beginning to dispense with the need for drawing and beginning to interpret his ideas directly in paint.

On canvas, Ruysdael seems to have only used his later, painterly style with no preliminary drawing. As for other painters, quite detailed underdrawings have been reported elsewhere on Van Goyen panels, but are certainly not present in the *Windmill by a River* (cat. no. 47) in the present exhibition. Neither have any underdrawings yet been detected on the panels or canvases of Jacob van Ruisdael.

For their paint layers, the Dutch landscape painters would have used the standard range of pigments then available, although some were apparently difficult to obtain. Moreover, certain colours presented technical problems: and, unfortunately for the

fig 9 S. van Ruysdael, *River Landscape* – reflectogram of bridge

landscape painters, the most problematic were blues and greens. Blue pigments were either scarce and expensive, or inherently unsatisfactory. The most commonly used blue was *smalt*, a blue cobalt glass first manufactured in Holland (the Dutch fought a twenty-year legal battle to prevent its being patented in London, but lost).[17] The best quality was a deep violet blue, the worst a pale powder blue, and the poorer grades had an unfortunate tendency to discolour to a greyish-yellow in oil paints. This is seen in the skies of many Dutch landscapes. Van Goyen, for example, was already the subject of comment on this point in the early eighteenth century: Weyerman remarked that the monotonous grey observed in Van Goyen's works 'was not altogether his fault; but in his time a [perishable] colour was in fashion called Haarlem blue'.[18] The precise identity of 'Haarlem blue' is not clear, but it seems likely that the discoloration of smalt is, in fact, being referred to.

There were no wholly satisfactory green pigments. In a much quoted extract from the *Inleyding*, Hoogstraten says 'terre verte is too weak, verdigris is too crude and green bice is not durable'.[19] Greens were usually made by mixing or glazing blue with yellow which, with perishable blues and fading yellow lakes, could present problems of a different kind: in occasional landscapes and flower pieces, leaves once green have become bright blue.[20]

With red and white pigments, the Dutch painters were better provided for. The best vermilion in Europe at that time was produced in Holland and also, by the seventeenth century, the Dutch were the most advanced growers of madder (for red lake pigments) in Europe. In addition, lead white was made in large quantities by the 'Dutch' or 'stack' process, and formed the basic material on every landscape painter's palette.

The mediums of the Dutch landscape painters have not been identified specifically but, in general, linseed and walnut oils would be expected. Paintings were varnished, as Hoogstraten has told us, with mastic dissolved in turpentine, although repeated

17 See R. D. Harley, *Artists' Pigments c. 1600–1835*, (2nd ed.), London, 1982, p.197.

18 Quoted in Eastlake's *Methods and Materials of Painting*, New York, 1960, 1, p.453.

19 Hoogstraten, p.221.

20 A well-known example is Pynacker's *Landscape with Sportsmen and Game* (Dulwich Picture Gallery).

cleanings of these landscapes over the last three centuries make it most unlikely that any original varnishes can now be detected.

Much work remains to be carried out on the techniques of the earlier Dutch landscape painters – not so much in terms of identification of pigments and media as in elucidating features of the layer structure, such as ground type or underdrawing. Detection of underdrawings by infrared techniques promises, as the results described above demonstrate, to be particularly useful, both in establishing chronologies of attributed paintings and, perhaps, in attributing unsigned works.

David Bomford
Restorer
The National Gallery

Hendrick GOLTZIUS and his conception of landscape.

In the artistic history of the sixteenth century in Italy little or no attention was paid to landscape. It may therefore seem surprising that in his great didactic poem of 1604, *Den Grondt der Edel Vry Schilder-const*, the great admirer and propagandst of Italian art and culture, Carel van Mander, should devote a whole chapter to the painting of landscape.

How can Van Mander's theoretical approach to the painting of landscape be characterized? He opens the chapter with didactic and somewhat technical instructions on how to paint particular elements of a landscape such as a rising sun, atmospheric effects, the weather, foreground, middle ground and background, the use of different greens, the depiction of rivers, trees, woods and other features. For him landscape was not an independent iconographic theme, but rather the backdrop for mythological or religious subjects. As Miedema has noted in his commentary to *Den Grondt*, there are some Italian precedents for such an approach: similar ideas can be found, for example in the writings of Lancillotti (1509). Van Mander's debt to the Italian Renaissance is clear: explicitly quoting Pliny (*Natural History book* XXXV, 116–117), he cites Ludius as a classical example for the contemporary landscape painter. In this regard his theory is *retardataire* for 1604, but it is nevertheless important as a stimulus for the future development of Dutch realistic landscape. Van Mander urges young painters to follow the examples of Pieter Bruegel's landscapes and woodcuts after Titian. At the very beginning of the chapter, the margin contains an exhortation: 'Young painters need to practise landscape painting, too. Therefore they should rise early if convenient, and go out of town to look at nature and spend time making sketches.' Such a directive was, to the best of my knowledge, new in 1604. Hendrik Goltzius, Jan Claesz. Visscher, Willem Buytewech, Jan and Esaias van de Velde and Jan van Goyen all followed Van Mander's advice. Similarly Van Mander himself, in a poem dedicated to Haarlem, gave a sensitive and realistic description, unprecedented in Dutch literature, of the landscape surrounding that city.

Reading through chapter eight of *Den Grondt*, one might think that as an artist Van Mander was himself an enthusiastic landscapist. His paintings certainly contain vast, fantastic background landscapes, rendered in the style of Flemish painters such as Gillis van Coninxloo. However, it cannot be fortuitous that the realistic Dutch conception of pure landscape is entirely absent from Van Mander's own *oeuvre*. He does not even seem to have made drawings after daily life, portraits, drawings of people in domestic settings, or sketches of animals or plants. This is because, just like the Italians before him, Van Mander gave priority to instructive histories – i.e. mythological and religious subjects – and after that to allegories and finally, following in the footsteps of Bruegel, to scenes of peasant life. Realistic landscape and portraiture were of minor importance to him. In his *Schilderboeck*, the drawings of peasant farmhouses made before 1604 by Abraham Bloemaert in the countryside surrounding Utrecht were described as *drollig*, literally meaning 'farcical.' The drawing of naturalistic landscapes was to be considered no more than a form of amusement.

Van Mander would probably have agreed with Armenini, who wrote in *De Veri Precetti della Pittura* (1537) that a true painter should do far more than merely imitate reality. He would also have found support for his ideas from Sir Philip Sidney: in his *Apology for Poetry* (1583), Sidney compared poets without inspiration to painters who 'conterfet only such faces as are sette before them'. It has often been remarked that Van Mander's credo was Horace's adage *ut pictura poesis*.

Van Mander, a Flemish refugee who lived first in Haarlem and later in Amsterdam, was aware of emerging naturalistic trends in Dutch art from about 1600, and objectively reported this new but slow development until his death in 1606. In Van Mander's circle it was Hendrick Goltzius and Jacques de Gheyn II who started to make drawings from the life, and the emergence of this conception of nature was an important shift in the history of European art. Van Mander's contribution to it was, however, probably not as important as one might think.

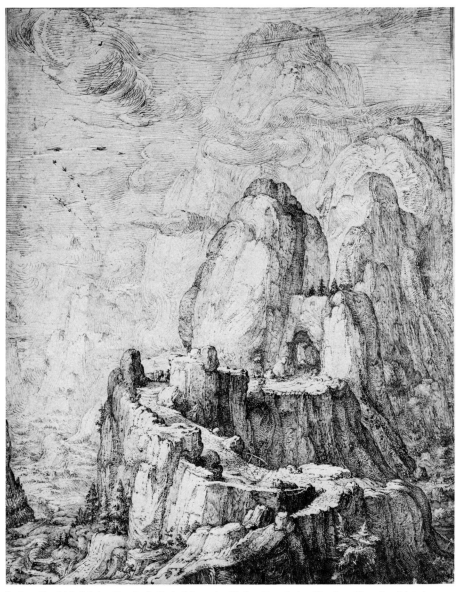

In north Netherlandish art of about 1580 landscape served only as a backdrop, the scenery behind a story. Pure landscape was still non-existent. The leading artists of that period, such as Anthonie Blocklandt, Dirk Barendsz. and Cornelis Ketel, were history painters and portraitists, not landscapists. The representation of landscape, begun by Goltzius after his trip to Italy in 1590–91, was a new phenomenon in Holland, whereas in the southern Netherlands the situation was different. Thanks to Patinir and especially to Bruegel, a strong tradition of landscape art already existed.

In my 1961 monograph on Goltzius' drawings, I catalogued eighteen landscapes by the artist. Only one other landscape drawing by him has since come to light, being published by A. E. Popham in the *Burlington Magazine* for September 1962. In four of these drawings the figures, such as Venus and Adonis and Mercury, are dominated by the landscape. In the other fifteen drawings, fantastic, pseudo-realistic and realistic, pure landscape is represented.

Two distinct techniques can be identified. One is the refined, analytical penwork of

fig 1b Detail of 1a

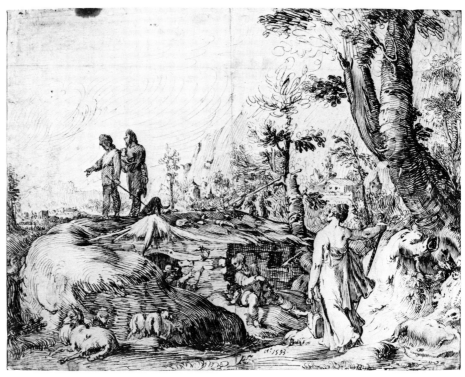

fig 2 Hendrick Goltzius, *Arcadian Landscape with Figures*, Collection of the Duke of Devonshire, Chatsworth House. Signed and dated 1593.

Pieter Bruegel; the other is the broad manner of sketching with a rough feather pen comparable to woodcuts after Titian, such as those made by Domenico Campagnola. It is difficult to say whether Goltzius was closely following the advice of Van Mander as given in his didactic poem, or whether Van Mander was inspired by the drawings of his close friend Goltzius.

Sometimes these two styles or *modi* are intertwined, merging into one another, but they can also be utterly different. One need only compare the *Pass in the Rocky Mountains*, dated 1594, in the Teylers Foundation in Haarlem (fig.1, A and B), a work which is clearly made in emulation of Bruegel, and the *Arcadian Landscape with Figures* at Chatsworth, dated 1593 (fig.2), which is reminiscent of the Venetian conception of landscape. Goltzius was clearly using the two different styles at around the same time.

The magnificent *Pass in the Rocky Mountains* may show an actual location seen by Goltzius during his trip across the Alps, or it may, more probably, be a visionary drawing based on experience. With regard to the iconography Bruegel was also the *auctor intellectualis*. We know that Bruegel made Alpine drawings on the spot, but such drawings by Goltzius are unknown. This drawing by Goltzius from 1594 seems to be the first Dutch landscape made as an independent work of art, lacking any religious or mythological figures, or symbolic implications.

The meaning of the *Arcadian Landscape with Figures* (fig.2) is obscure. Who is the woman seen from behind who carries a kind of satchel and a long walking-stick, and what does the head of the talking man signify? This drawing with its vast, extraordinary landscape may seem a *cosa fantastica*, but probably represents a still unidentified Arcadian story.

The two drawings call to mind a remark by Van Mander in his *Schilderboeck*, to the effect that Jacques de Gheyn *'bevondt seer noodigh/veel nae t'leven/en met eenen uyt den gheest te doen'* (found it necessary to work a great deal after life and directly from memory). The distinction, seen in Goltzius' two drawings, is comparable to Vincenzo Danti's *imitare e ritrarre*, the *due strade* of art.

Goltzius was familiar with the art theory of Federigo Zuccaro, whose *Idea de' Pittori, Scultori ed Architetti* was published in 1607. He had met Zuccaro in Rome at his house near the church of Santa Trinità and, according to Van Mander, made a portrait of him. This was not a large drawing in coloured chalks like his portraits of Giovanni Bologna in Haarlem and Pietro Francavilla in Amsterdam, but a small silverpoint drawing now in Berlin and dating from 1591. The work was recently identified convincingly as Zuccaro's portrait (fig. 3). Zuccaro's ideas had a lasting effect on the artistic phenomenon known – misleadingly – as Haarlem mannerism. He stated, among other things, that an artist must work independently, without a model, to create free inventions of various *capricci e cose varie e fantastiche*. According to Zuccaro, poetic imagination and the deceptive emulation of nature were the proper purposes of the art of painting.

fig 3 Hendrick Goltzius, *Portrait of Federigo Zuccaro*, Kupferstichkabinett, Staatliche Museen, Berlin-Dahlem. Signed and dated 1591.

The greatest achievement of Goltzius' landscape drawing lies in the application of this dual approach. In some of his drawings, such as the *Pass in the Rocky Mountains*, the fantastic emulation of nature is so strong that we seem to be on the very borderline between fantasy and realism. Zuccaro would have been pleased by this. A landscape drawing like the *Ruins of Brederode Castle* in Amsterdam shows an actual topographical view, but Goltzius uses coloured washes to create a poetic, fantastic atmosphere and so weaken the realistic effect.

Goltzius made only a few topographical drawings out of doors, *en plein air*. Three of these showing the environs of Haarlem have survived. The exhibition contains one from the Institut Néerlandais (cat. no.41); the other two are in the Boymans-van Beuningen Museum in Rotterdam (figs. 4 and 5). Two are dated 1603; the third must date from about the same time.

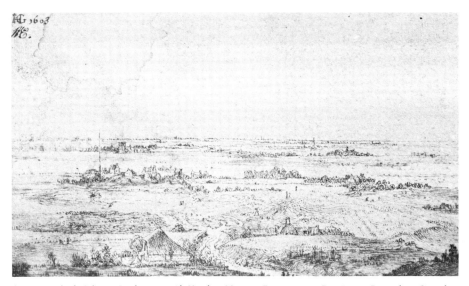

fig 4 Hendrick Goltzius, *Landscape outside Haarlem*, Museum Boymans-van Beuningen, Rotterdam. Signed and dated 1603.

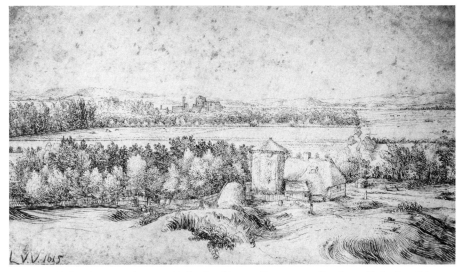

fig 5 Hendrick Goltzius, *Landscape outside Haarlem*, Museum Boymans-van Beuningen, Rotterdam. False monogram of Lucas van Uden and false date, 1615.

Where do these surprising, extremely refined pen drawings stand in the history of realistic landscape art in Holland? They owe their existence and character to at least three different circumstances. First of all, Goltzius' health had been poor for many years. He was consumptive, and Van Mander reports that he took long constitutionals in the then still beautiful outskirts of Haarlem. Goltzius certainly took note of Van Mander's advice to artists to amuse themselves with drawing outside the city.

Second, the significance of the emigration to the north – actually a mass invasion of Holland by Flemish landscape painters – cannot be over-stressed. Despite their significance as gems of direct observation of nature, the three drawings referred to above are not very original in technique. Their graphic style is based upon that of Pieter Bruegel. It was not in the northern but in the southern Netherlands that poetic realistic landscape was born: the two print series of 1559 and 1561 by the Master of the Small Landscapes were examples of this new approach to landscape.

The third determining factor was Goltzius' own earlier endeavours in the field of the *chiaroscuro* woodcut – a technique which has a special importance in the history of Dutch graphic art. Goltzius began to make his superb prints in this medium as early as 1588, even before he left for Italy. The inspiration for his experiments with different-coloured wood blocks came from Germany (Baldung Grien among others) and Italy (Ugo da Carpi, Antonio da Trento, Nicolo Vincentino). Goltzius' *chiaroscuro* woodcuts include four landscapes, one seashore view and two seascapes. They are difficult to date precisely, but this is not a crucial problem; they reflect the general tendency in the northern Netherlands at this time toward a changing conception of landscape. Such woodcuts as the *Arcadian Landscape* (cat. no.45), a combined assimilation of Bruegel, Paul Bril and Coninxloo, were presumably made before 1600, in all likelihood between 1595 and 1600. They were to prove important for Hercules Segers and his strange vision of landscape. The *Landscape with Peasant Dwelling* (cat. no.44) anticipates the realistic landscapes of, for example, Esaiais van de Velde and can be dated shortly after 1600. The realistic impression here is again weakened by the employment of poetic colours, the blue Venetian paper used in the first state and the brown sepia or different shades of green blocks used in the second.

We finally return to the three landscapes that Goltzius made *en plein air* in the countryside surrounding Haarlem (figs. 4 and 5). The drawing on exhibition from the Institut Néerlandais, dated 1603 (cat. no.41), is a swallow which did not make a summer immediately, but was a harbinger of one of the most splendid developments in Dutch art of the seventeenth century.

Professor E. K. J. Reznicek
University of Utrecht

Seascape into Landscape *

This exhibition demonstrates the great variety of stylistic sources from which Dutch seventeenth-century landscape art evolved. In the early seventeenth century Amsterdam artists maintained a strong link with the Flemish landscape tradition, though imbuing it with new life and vigour. Developments in Haarlem might have been expected to run on parallel lines, but artists working in Haarlem seemed inspired to experiment with new and unconventional ideas. The highly individual character of Dutch seventeenth-century landscape, which differs greatly from contemporary trends in Flanders, evolved from these experiments, mainly in the graphic arts. Haarlem's reputation as 'the cradle of Dutch seventeenth-century landscape' has never been challenged, but the reasons for Haarlem's pioneering position have hitherto remained elusive.[1]

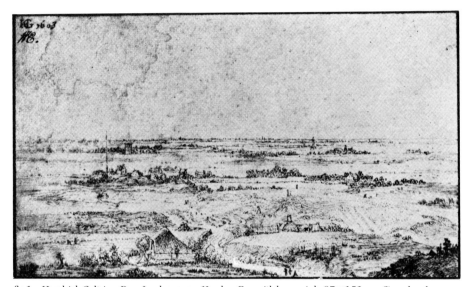

fig 1 Hendrick Goltzius, *Dune Landscape near Haarlem*. Pen with brown ink, 87 × 153mm. Signed and dated *HG 1603*. Rotterdam, Museum Boymans-van Beuningen, Inv. no.HG.253.

The acknowledged precursor of the new landscape developments in Haarlem was Hendrick Goltzius. In the last two decades of the sixteenth century, and later, this artist produced a series of graphic works still conceived in the spirit of the mountain scenes after Pieter Bruegel the Elder, and paying tribute to the landscape style of Paul Bril. However, in 1603 Goltzius made a series of drawings of the dunes near Haarlem which mark a radical departure from all traditional concepts (fig.1).

These drawings encapsulate the novel outlook on nature which was to be further developed by a group of young artists who settled in Haarlem from c.1610, notably Esaias and Jan van de Velde, Hercules Segers, and William Buytewech.

The most startling innovation in Goltzius' dune landscapes is the treatment of space. Flemish landscape of the seventeenth century still relies on the traditional sixteenth-century scheme of a 'vista', framed by 'coulisses' of trees, rocks or buildings, and closed in depth by a screen of hills or woods along a high horizon, leaving little space for the sky. By contrast the space of Goltzius' dune landscapes is unrestricted laterally and wide open in depth, with a lowered horizon line suggesting the flatness of the land and the dominance of the sky characteristic of real Dutch scenery. The drawings, with their continuous flow of space in all directions, are the prototypes of a quintessentially Dutch view of nature, the 'extensive landscape'.

Unlike Flemish landscape which is constructed to focus on motifs and vistas contained within the picture, the Dutch extensive landscape has no focus; it presents us with only a slice cut out from a space that *expands*, or *extends* everywhere. The

*This essay is based on research carried out at the Center for Advanced Study in the Visual Arts, National Gallery of Art, Washington D.C., where I was an Ailsa Mellon Bruce Visiting Senior Fellow in 1985. The full results of my research are being prepared for publication.

1 Åke Bengtsson, 'Studies in the rise of realistic landscape painting in Holland 1610–1625', *Figura*, series 1, vol. 3, 1952, attempted to answer the question why Dutch naturalistic landscape should have developed in Haarlem and not elsewhere. His discussion of cultural, economic and religious conditions in Haarlem, however, fails to identify any visual sources which might have stimulated the new trends.

Extensive Landscape format determined the approach to nature of many Dutch artists, including Rembrandt, and it culminated in the paintings of Jacob van Ruisdael and Philips Koninck. The exhibition includes several extensive landscapes, a uniquely Dutch contribution to landscape art.

The concept of an extensive landscape which evolved in Haarlem from Goltzius' drawings marks a decisive break with the past and the question must here be asked why the artist quite late in his career should have taken an abrupt departure from tradition that constituted almost a new philosophy of landscape and established new criteria not pursued elsewhere. For an answer we must look to any significant developments in Haarlem or personal experiences of the artist that might have provided a stimulus for Goltzius' surprising experiments with a new approach to nature.

There is no need to look very far. In 1603, the year of his dated dune landscapes, Goltzius had become a next-door neighbour of Hendrick C. Vroom, the first specialized marine painter and founder of the Dutch school of marine painting. Records establish that the two artists were friends[2], and since they were both closely associated with Carel van Mander their friendship was probably long standing. The figure of Hendrick Vroom and the art of marine painting has until recently been ignored, or received only scant attention in most art-historical discussions of Dutch landscape painting. There used to be a general assumption that marine painting followed in the wake of Dutch landscape painting, making no original contribution of its own. Marine painting, however, preceded the development of Dutch landscape painting by more than two decades.

When Hendrick Vroom settled in Haarlem in c.1591, after extensive travels and a three-year stay in Italy, the twenty-five-year-old artist was already known to Carel van Mander for his proficiency in painting ships.[3] Lucrative commissions for the designs of the 'Armada Tapestries', commissioned by Lord Howard of Effingham, and the 'Middelburg Tapestries' for the Province of Zeeland, were consequences of this acquaintance.[4]

In 1594 Vroom produced his first known dated marine painting, featuring the harbour of Dordrecht (fig.2), but this could only have been one of many similar works and was certainly not the earliest example. The City of Haarlem in that year exempted Vroom from military duty 'because of his unique skill in painting of marine subjects in which he excels all others'.[5] This unique skill is also extolled by Carel van Mander in his biography of Vroom in the *Schilderboeck*, first published in 1604. Van Mander reports that:

> 'At home again, following the advice of the painters
> there, he [Vroom] applied himself to painting more
> ships and became more and more proficient in this
> art. And since there is a lot of shipping in Holland,
> people began to like these ship paintings more and
> more.'[6]

Undoubtedly Vroom's new speciality was a popular success with the Dutch, who had such close links with the sea and shipping. Other artists working in Haarlem could hardly fail to notice this success and observe the way in which Vroom approached the stylistic problems inherent in rendering ships in the open sea or close to harbour. Prior to his return to the Netherlands Vroom had been befriended by Paul Bril in Rome and, no doubt, benefited from the advice the older artist is said to have bestowed on him.[7] But Paul Bril's example offered no solution to the problem of portraying ships sailing in the open sea. The new call for naturalism, relying on studies from nature – *naer het leven* – as recommended by Van Mander, was not lost on young Vroom. A portrayal of ships, plausibly suggesting their movement across the water, required first and foremost space in which the ships could move. Hence Vroom dispensed with the lateral framing devices that limited the space in landscapes by Paul Bril and other Flemish artists.[8] Any lateral 'wings' or visual limitations would seem to impede the progress of the sailing

2 Reznicek 419; O.Hirschmann, *Hendrick Goltzius*, Leipzig, 1919, p.177, records a visit between the two artists' families in 1605.

3 Van Mander, fol. 287 a–b, relates the life of Hendrick Vroom (translated into English in Russell, pp.91–93).

4 Van Mander, ibid. For an account of the tapestry series, with full illustrations, see Russell, p.116 ff.

5 *Memoriael van Burgomeesteren van Haarlem*, 7 February 1594. Bredius, K. I., VII, p.273.

6 Van Mander, loc. cit. (see note 3).

7 Ibid.

8 Lateral motifs, such as rocks or buildings, were sometimes retained by marine painters for the sake of picturesqueness or topographical identification. They were usually placed on one side of the picture only, and often set back into the middle distance, to leave the flow of water uninterrupted in the first plane (fig.9).

fig 2 Hendrick Vroom, *Ships in the Harbour of Dordrecht*. Canvas, 106 × 169cm. Previously in Schwerin, Staatliches Museum. Destroyed 1945.

ships and destroy their credibility. In a painting such as *Dutch Man-of-War and Fishing Boat in a Breeze*, the ships sail across a limitless expanse of ocean, free of any impediments (fig.3). Some marine paintings retained a residue of the diagonal foreground elevation which serves as a *repoussoir* in many Flemish landscapes, but in place of the hills or rocks in Flemish paintings there is only a low strip of shore or river-bank to set off the expanse of water beyond (fig.2). This *repoussoir* device is used in many works by later Dutch marine and landscape painters. An oblong horizontal format was best suited to a composition showing ships in profile view, which enabled the artist to portray all their characteristic features. Paintings of ships in the open sea were subdivided horizontally into two sections of water and sky, with the dividing horizon line often placed in a near central position (fig.2), but sometimes even lower (fig.3).

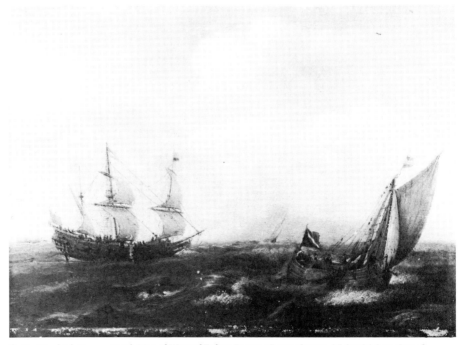

fig 3 Hendrick Vroom, *Dutch Man-of-War and Fishing Boat in a Breeze*. Copper, 15.9 × 24.8cm. Signed *VROOM*. Greenwich, National Maritime Museum.

fig 4 Hendrick Vroom, *Landing at Philippine*. Pen and brown ink, 34 × 99cm, Rotterdam, Museum Boymans-van Beuningen, Inv. no.HCV2.

Goltzius must have become increasingly aware of the stylistic innovations of the work of Hendrick Vroom and his close followers. The commercial success of the paintings and graphics by Hendrick Vroom, such as the drawing and engraving of the *Landing at Philippine, 1600* (fig.4),[9] must have helped to draw attention to the stylistic solutions chosen by the marine artist. The long horizontal format with the free lateral flow of space, and the straight horizon line, articulated only by diminutive profiles of buildings, trees and dunes, presents the same compositional scheme as Goltzius' dune drawings of two years later. The background of the *Philippine* drawing places the naval action in its topographical context. As he had done in his tapestry designs, Vroom here chose the space system of panoramic maps to clarify the location of the event.[10] The tiny coastal profiles along the horizon were a constant feature of pilots' guidebooks, with which a navigation expert like Vroom would have been very familiar. Vroom used these horizon profiles in his tapestries and in many of his paintings and graphics. From there they found their way into the 'extensive' landscapes of Dutch seventeenth-century artists, beginning with Goltzius' drawings of dunes.

In compositions that placed an emphasis on topographical information, surveying a large territory, Vroom retained the high skyline of panoramic maps, while in other contemporary paintings and graphics he lowered his skyline considerably (fig.3), and his scenes of ports, beaches, shipping and ship portraits from the start introduced a low or median horizon (figs.2,3,6). A low horizon line was desirable to show the ships as if viewed from a 'natural', only slightly raised, vantage point, such as the crest of a dune, making their sails and flags sparkle against the light airy background of the sky.

The essential structure of a marine painting such as fig.3, with its strict horizontality and austere simplicity of composition, is very close to the essence of Goltzius' drawing of dunes (fig.1). Even the structure of the 'ground' in both scenes is very similar, though Vroom's painting features water and Goltzius' drawing firm ground. It is interesting to note how frequently the graphic works of the early landscape artists, led by Goltzius, render the firm ground in undulating lines resembling the waves of the sea. In his monograph on Goltzius' drawings, Reznicek observed this phenomenon and referred to it as *Bodenwelle* (ground wave). The undulating movement of the ground in Goltzius' woodcut *Landscape with a Peasant Dwelling* (cat.no.44), for instance, is almost identical with the real waves in his related woodcut *Cliff on the Seashore* (fig.5), where waves and ground merge imperceptibly in the same rhythmic motion. Many paintings

9 Vroom's design commemorates Prince Maurits gathering the Dutch fleet in preparation for the Battle of Nieuwpoort. Vroom was paid 100 guilders by the States General for his drawing and additionally did a lucrative trade in prints after the composition. Van Mander, loc. cit.

10 Panoramic maps had long played a part in sixteenth-century topographical landscapes, and Hendrick Vroom relied on them whenever he wished to define the location of marine actions, such as the Landing at Philippine. Neither Vroom's nor Goltzius' panoramic scenes, nor those of Ruisdael and other exponents of the 'extensive landscape', can be associated with a peculiarly Dutch 'mapping impulse', which has recently been claimed as an essential ingredient of Dutch landscape art (S. Alpers, *The Art of Describing*, Chicago, 1983, p.139 ff.).

fig 5 Hendrick Goltzius, *Cliff on the Seashore*. Woodcut (Holl. 381). Washington D.C. National Gallery of Art.

and drawings of the 'extensive landscape' type reflect this interchangeability of land and water first observed in the graphics of Goltzius. The diagonally flowing 'ground waves' of the landscapes by Hercules Segers were later emulated by Jan van Goyen, Salomon van Ruysdael and others. Pieter de Molijn's *Extensive Landscape* (cat.no.50) depicts the fields like an expanse of choppy sea, complete with coastal profiles on the horizon. Jacob van Ruisdael and Philips Koninck, and even Rembrandt, expressed the close relationship of land and water in Dutch scenery through the flowing wave-like rhythms in which they rendered fields and dunes.

However, compositional structure and the emphasis on undulating rhythms to depict the ground were not the only features which the early Haarlem landscapists absorbed from marine painting. Haarlem was the place where artists first studied the sky, the clouds and the weather and tried to render them true to nature. Vroom appears to have been the first Dutch artist who went to the beach, sketchbook in hand, to observe not only the ships and boats but also the weather conditions in which they sailed:

> 'Vroom, who is very skilled in rendering ships and improves daily, has made an almost countless number of pictures, such as beach scenes with fish, fishermen and other small figures Not only does he understand the construction of ships, their ropes and rigging, the direction of the winds, the sails and other relevant matters, but he also excels in all other aspects, such as backgrounds, landscapes, cliffs, trees, skies, water, waves, castles, villages, towns and other subjects which enliven and enhance his ships.'[11]

When preparing his designs for the Middelburg Tapestries Vroom is recorded to have sailed in a storm near Zierikzee to experience personally the conditions faced by sailors in these waters.[12] Personal observation of water, sky and clouds is clearly demonstrated

11 Van Mander, loc. cit.

12 Letter by Hendrick Vroom to his employer, the weaver Hendrick de Maecht, dated 1599. Published in G.T. van Ysselsteyn, *Geschiedenis der Tapijtweverijen in de Noordelijke Nederlanden*, Leiden, 1936, I, p.243 ff.

fig 6 Hendrick Vroom, *Fishing off the Coast*. Pen and brown ink, 107 × 179mm, London, Victoria & Albert Museum, Dalton Bequest, Inv. no.D1104–1900.

in Vroom's drawings and paintings from an early date. His drawing *Fishing off the Coast* (fig.6), which must date from c.1600, is remarkable for the way the artist integrates the movement of the clouds with the direction in which the sails, flags and waves are driven. An engraving dating from the same time as the boat trip at Zierikzee shows the interaction of sails and waves and clouds even more clearly (fig.8).

Vroom was praised by Van Mander for understanding the direction of the winds, the sails and 'other relevant matters'. Wind, of course, cannot be painted, but Vroom knew how to indicate its presence through the unified movement of clouds, sails, flags and waves. The many sails in the *Landing at Philippine* (fig.4) are seen to be swelled by the same wind and lit by the same sun with scientific exactitude. Although nowadays we take such matters for granted, artists prior to Vroom did not attempt to show ships in the same composition as sailing in the same wind. In the engraving of *Sixteen Ships* after Pieter Bruegel the Elder (VB 102), the ships are each propelled by winds blowing from different directions.[13] Vroom's observations of wind and weather conditions as they affect the sailing of ships also extended to the formations of clouds, whose shapes and suggested movement had to indicate the direction and strength of the prevailing wind. Clouds for the first time assumed an identity of their own. With their volume occupying space in the sky, they were moved from merely providing a backdrop to share the middle and first plane with the ships and the waves. Eventually, in the marines of Jan Porcellis, clouds would fill the whole of the sky, creating the 'vault of the sky', a distinctive feature of Dutch marine and landscape paintings of the mature period.[14]

Vroom and his followers were the first artists to depict scientifically correct shapes of clouds. Cloud formations, such as cumulus, nimbus and stratocumulus in their various combinations, are clearly discernible in their marines (figs. 6, 7, 8).

Vroom's interest in clouds and weather conditions was not shared by Goltzius, but Claes Jansz. van Wieringen, a follower of both Vroom and Goltzius, became a very sensitive observer of weather, particularly in his graphics. In the woodcut *Three Sailing Vessels* (fig. 8), dating from about the same time as Goltzius' *Cliff on the Seashore* (fig. 5), and in other graphics, Van Wieringen demonstrates his profound understanding of

13 The series of ship engravings by F. Huys after Pieter Bruegel the Elder anticipates to some extent the developments in Dutch marine painting. But space is treated differently in these prints, and inconsistencies in the treatment of light, as well as a certain rigidity of composition, betray the fact that these designs must have been based on prints of ships and not on personal observation. Vroom's approach to his subject does not suggest a connection with the prints.

14 See Hans Jantzen, 'De ruimte in de hollandsche zeeschildering', *Onze Kunst*, XVII, 1910, p.653 ff.

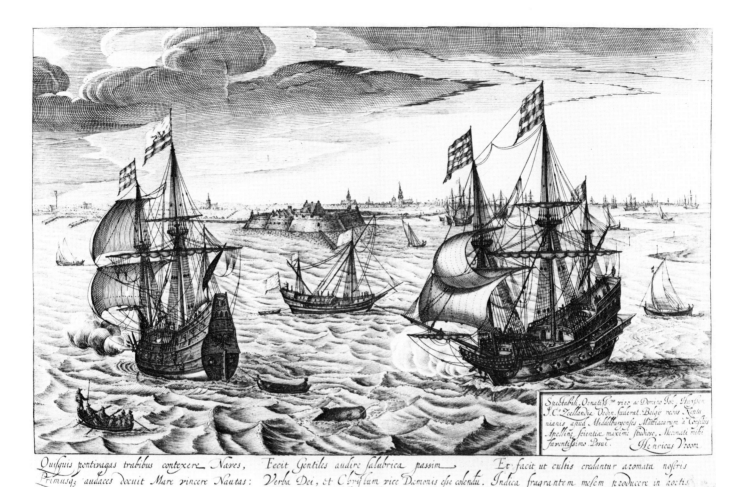

Ouisquis pontivagas trabibus contexere Naves, Fecit Gentiles audire salubrica passim Et facit ut cultis credantur aromata nostris
Primusq audaces docuit Mare vincere Nautas: Verba Dei, et Chrysum vice Damonis esse colendu. Indica fragrantem mosem producere in hortis
 Cornelius Nicolai. excud.

fig 7 Hendrick Vroom, *Shipping at Middelburg Harbour*, engraved by R.W. de Baudous (Holl. 78), Brussels, Bibliothèque Royale.

weather conditions as they affect the sailing of ships. Clouds, sails and waves are all clearly seen to be driven by the same wind; the sails are correct in these conditions, with the main topsail fully hoisted and the fore topsail lowered to half mast. The light is coming from the same direction as the wind, i.e. from the right.[15] As a new refinement Van Wieringen adds the well-observed effect of *crepuscular* rays of the sun, a phenomenon he liked to depict in other graphics as well.

Vroom's and his close followers' early observations of clouds and weather conditions were the beginning of the Dutch landscape painters' fascination with sky and clouds. Painters of the younger generation in Haarlem, particularly Jan Porcellis, Jan van Goyen and Salomon van Ruysdael, continued and refined the rendering of skies, and ultimately Jacob van Ruisdael and Philips Koninck brought the art of 'skyscape' to a peak of perfection. The great skies are the glory of Dutch seventeenth-century landscape and their beauty is based on the truth of observations initiated by the marine painters. Meteorologists have pointed out that 'clouds were not taken seriously in landscape until the Dutch school in the seventeenth century'.[16] Contemporary Flemish landscapes do not share the Dutch artists' understanding of clouds and atmosphere. A glimpse at Rubens' much admired landscape, *The Château de Steen*, in the National Gallery will confirm this observation. 'His [Rubens'] clouds are an arbitrary backdrop and are scarcely recognizable in meteorological terms,' complains the weather expert, while admiring the realism and beauty of clouds by Jacob van Ruisdael.[17]

The marine painters' observation of the sky ensured that in Dutch landscape and marine paintings sunlight always falls from the same direction. Rubens' 'artistic

15 Light is usually shown by marine artists as coming from the left, but the printing process reverses this direction. The wind is also most frequently shown from the same direction as the light. Light and wind coming from opposite directions, as in fig.6, betray the artist's attempt at introducing novel effects. I am indebted to Michael Robinson for his generous help with the analysis of weather and sailing conditions in various Dutch paintings and graphics.

16 J.E. Thornes, 'Landscape and Clouds', *Geographical Magazine*, 51, 7, April 1979.

17 Ibid.

licence' in showing shadows falling from opposite directions in the same landscape composition[18] would have been unthinkable for a contemporary Dutch artist. Willem van de Velde the Younger, in an inscription on his sketch *Studies of Wind and Sun*, insisted that 'whatever you do, observe carefully the direction of the wind and the sun'.[19] Van de Velde, who left many notes and sketches with precise instructions on wind and weather conditions, was clearly not the first Dutch artist to undertake such studies; he was preceded by Hendrick Vroom and other marine painters, notably his own father, Willem van de Velde the Elder. His instruction sums up the important principles introduced by the early Dutch marine painters in Haarlem and carefully observed by Dutch marine and landscape painters ever since.

The interrelationship of Dutch marine and landscape painting is hardly surprising when we consider the character of the Dutch land, which is close to water and flat as the water almost everywhere. Ludovico Guicciardini, the Florentine humanist who visited to the Netherlands in the 1550s, was one of the earliest travel writers to observe the low position of the land and discuss the dependence of the Low Countries on the sea. In his *Discourse of the Sea* Guicciardini comments that 'the sea may well be termed not only a neighbour but also a member of these Low Countries', adding that 'in the Province of Holland you shall see the Sea far above the land, yet repulsed by these banks [the dykes]'.[20]

Once the artists had established a relationship with their native environment they reacted like Guicciardini when depicting water and land as equal 'members' of a unity. Land and water lie so close together in the flat expanse of the 'low lands' that visually they can hardly be separated. Rembrandt's etching known as *Jan Six's Bridge* (cat.no.114) shows the surface of the canal as level with the grassy bank, so that the boat seems to float on water and land simultaneously. This scene conveys realistically the strange experience visitors to Holland have when observing the water of canals virtually at the same level as the surrounding flat fields, so that boats from a distance appear to float on the ground.

The landscapists of the early Haarlem school were the first to depict the vast flat expanses of the land as described by Guicciardini. Much of this land had been reclaimed and still echoed the character of the sea. These artists followed the lead of the marine painters who had made the Dutch native scene, previously scorned as a subject, an accepted motif for painting. The painters of ships, beaches and water, led by

18 Peter Paul Rubens, *The Return from the Harvest*, Florence, Galleria Pitti.

19 Willem van de Velde the Younger, *Studies of Wind and Sun in a Heavy Sea*, Pen and brown ink over pencil, 185 × 266mm. Greenwich, National Maritime Museum. See M. Robinson, *Van de Velde Drawings*, Cambridge 1974, I, p.61, 1411, illustrated II, p.318.

20 Ludovico Guicciardini, *Description of the Low Countries*, London 1593 (translated into English from *Descrittione di tutti i paesi bassi*, Antwerp, 1567). The text is here quoted in modern English.

fig 8 Claes Jansz. van Wieringen, *Three Sailing Vessels*. Woodcut, 135 × 215mm, Rijksmuseum.

Hendrick Vroom, encouraged the landscape painters to look at the sea, the canals and rivers, and when doing so they only had to turn round to observe that the land, seen from the same vantage point of a dune or a dyke, presented a view not very different from that over water. The low horizons, the prominent skies and the flat expanse of land or water were almost interchangeable as pictorial motif. In this way the Haarlem painters first discovered the expansiveness of land, water and sky, and allowed these qualities to dominate their landscapes and seascapes. The flatness of the Dutch countryside, echoing the ever present proximity of water, which earlier painters had felt to be a disadvantage, was turned into a triumph of Dutch seventeenth-century landscape painting.

Haarlem became the cradle of Dutch landscape because it had earlier been the cradle of Dutch marine painting. Indeed, a case could be made for a parent-child relationship, since marine painting had been flourishing in Haarlem for almost a generation when Dutch landscape painting, in the second decade of the seventeenth century, was still in its infancy. Because his speciality, the painting of ships, had no tradition, Hendrick Vroom, the 'father of marine painting', had to invent a new pictorial language. This language took its cues from purely Dutch motifs – the sea, the shore, the low horizons, the cloud-filled skies, with which Vroom 'enhanced his ships'. Eventually Dutch landscape painting followed suit, adapting the new ideas for its own purposes. In this way, at the dawn of their political independence, Dutch artists developed a new autonomous approach to nature unrivalled anywhere else.

Dr Margarita Russell
Senior Research Fellow
National Gallery of Art, Washington D.C.

Nature and Landscape in Dutch Literature of the Golden Age *

For the literary historian who is invited to contribute an essay to a catalogue concerned with the pictorial arts in the seventeenth century, Horace's adage *ut pictura poesis* – which equated the arts of poetry and painting – is an invitation to attempt a confrontation of the two sister arts. And, indeed, relationships between the accounts of nature and landscape given by Dutch poets and painters are not hard to find.

The present exhibition deals with the period 1590–1650, and it was at the beginning of that period that the eighth chapter of *Den Grondt der Edel Vrij Schilder-const* ('Introduction to the Noble and Free Art of Painting') was written by the painter-poet Carel van Mander. In this work, which dates from about 1600, he uses poetry to teach his pupils how to paint landscape. The reader is immediately struck by the high-flown literary manner in which the journey through the landscape begins. The pupils are told to be wide awake at day-break in order to witness the dawn. One would expect that the budding painters would first be urged to study the sunrise by close physical observation. In fact, Van Mander instructs them to think in terms of mythological imagery:

> First see how there, out of her saffron bed,
> The bride of old Tithonus is arising
> Announcing that the torch of day is near
> And next, how, washed in th' oceanic pond,
> Four neighing, piebald horses are emerging.
> Lo, and behold how slowly rosy-rimmed
> The purple clouds become, how nobly trimmed
> Is Eurus' clear house, to welcome Phoebus.[1]

It is only after this highly self-conscious literary start[2] that more factual observations are in order, and Van Mander now draws attention to some particularly striking details:

> Yonder behold those huntsmen with their dogs
> Walking the verdant, dewdrop-laden fields.
> See how the trodden dew tells a clear tale,
> And with a greener green gives indication,
> Showing the track of the men's destination.

However, when – a little further on – a panoramic scene is depicted, the poet again presents it in a mythological guise:

> To the one side, Ceres, with fairest ears,
> To th' other yet the field with unripe oats
> Wherein the playful Eurus now descends
> Changing the field into a blue-green sea
> Billowing with a softly rustling sound.
> Here vetches blossom, there buckwheat and clover.
> Red and blue flowers amidst rye and wheat
> And useful flax paint heavenly colours.
> The furrowed land where ploughs had just been wielded
> Or sometimes plots with crops that they had yielded,
> Meadows and fields, most aptly divided
> By ditches, hedges and roads, ever-winding.[3]

From passages such as these it is evident that poets and painters, although using different idioms, understand each other's language. For instance, while the painter will not show a scene as Van Mander describes it – he will not paint a blonde Ceres but a field of golden grain – the terminology chosen by Van Mander does serve to conjure up the landscape in a lively and impressive way for his readers, among whom, as he expressly states on the title page, there would be painters. By his own evocative means the poet is able to compete with the painter.

*I would like to thank Dr A.F. Harms for his translation of this essay.

1 Carel van Mander, *Den Grondt der Edel Vry Schilder-const* (ed. H. Miedema), 2 vols., Utrecht, 1973, I, pp.204–5. A translation of the entire chapter (which does not attempt to imitate Van Mander's poetic diction) is given in the Appendix to the Introduction.

2 For the literary context with, for example, an allusion to Virgil, see Miedema, op. cit., II, p.540.

3 Ibid., I, pp.212–13.

In connection with this idea of competition another passage is of interest. Following the dawn, when the sun has to be shown, the painters admit defeat:

> We shall be always lacking such beauteous,
> Shining material, it is beyond our powers.[4]

Nor does Van Mander, as a poet, venture to depict the sun.

To my knowledge the radiant sun is not to be found anywhere in seventeenth-century painting,[5] but some poets did attempt to evoke it. Vondel, for example:

> Thus climbs the Prince of Light at dawn, before he starts
> His journey, by the light of the bright morning star
> That urges ev'ry eye to look out from afar
> For that prime jewel, Sun, that after the soft light
> Of gay and pretty dawn, shall prance to Zenith's height
> Driving its radiant throne, the golden chariot
> With rubies, glowing red, and sparkling diamonds set.[6]

Where the brush of the painter fails, the pen of the poet succeeds. Whether this implies that a real contest or *paragone* is in progress, I am not sure; but the possibility should be kept in mind, especially since Vondel, a fellow Mennonite and acquaintance of Van Mander, used and imitated his work more than once.[7] The notion of a contest between poetry and painting in the evocation of landscape is explicitly mentioned by the poet R. Anslo towards the end of this period. As we shall see, the outcome is very different. The starting point for Anslo's ideas might well have been a passage in Van Mander's landscape chapter. After his colourful description of the dawn, he continues:

> But do observe, the painting in the heavens
> What greater splendour, by such different colours,
> So many mixtures.

Nature, or God, is seen as the painter *par excellence*, the great example for all painters. The idea was taken up by many poets. In Vondel's long didactic poem *Bespiegelingen van Godt en Godtsdienst* ('Reflections on God and Religion') we encounter it in a way that strikingly recalls Van Mander's description of a panoramic landscape. After the curtains of the celestial stage have been drawn aside, God's spectacle stands revealed:

> O landscape, fair result of Nature's application
> How all is richly wrought, a full realization.
> What ordinator did select each precious find
> And mounted ev'rything according to its kind?
> Foreground and backdrop, too, such dwindling and such fading
> Here woods, there wheat and rye, meadows and streams cascading
> From fountains in the hills, as well as wide perspectives.[8]

This, as might be expected, leads the poet to the conclusion that Apelles, here representing all painters, cannot do better than follow nature and 'stare on her example'.

In his turn, Vondel inspired Anslo to a similar meditation.

> This landscape shows how well God did himself acquit
> How all is richly wrought and not a thing neglected.
> That might adorn and serve the wondrous work
> While staying well within the limits set.
> Thus pow'r supreme does rise in majesty
> Like on a painter's cloth, before our eyes
> [. . .]
> How richly were the skies by God himself adorned.[9]

4 Ibid., I, pp.208–9.

5 The exhibition catalogue *Schok der herkenning. Het Engelse landschap der romantiek en zijn Hollandse inspiratie*, The Hague/London 1971, notes concerning no. 59, a painting by Jan van de Cappelle, c.1655, that 'here probably for the first time in Dutch painting the sun is depicted', but this is not exactly a radiant sun.

6 *De werken van Vondel*, VIII, Amsterdam, 1935, p.586. This imagery serves as a comparison for Prince Johan Maurits van Nassau making his appearance.

7 See for instance M.A. Schenkeveld-van der Dussen in *Visies op Vondel na 300 jaar* (ed. S.F. Witstein and E.K. Grootes), The Hague, 1979, p.15.

8 *De werken van Vondel*, IX, Amsterdam, 1936, p.521.

9 Quoted by Th.J. Beening, *Het landschap in de Nederlandse letterkunde van de Renaissance*, Nijmegen, 1963, who also noted Anslo's dependence on Vondel.

Anslo's own 'painted poetry' is unable to do justice to all the beauties of nature and he concludes that poetry is unable to emulate painting in the description of the earth's beauty. It is almost the opposite view to that of Van Mander. There, the painter chose literary means with which to evoke the landscape. Here, the poet declares that his descriptive art must bow before that of the painter.

It is Anslo's conclusion that has been adopted by those literary historians who have studied the ways in which nature was described by Dutch poets. I shall return to this point presently.

First, however, let us introduce someone with a completely different point of view: Constantijn Huygens, one of the great poets of that epoch, but also an amateur of painting and drawing as well as a connoisseur of the pictorial arts. He recognized, for example, the extraordinary talent of Rembrandt at an early stage. In his large-scale poetical work *Oogentroost* (1647) ('Comfort for the Eyes') he deals with all sorts of spiritual blindness. Among those affected by such blindness are painters. In a Platonic passage he declares that their representation of nature belongs to the realm of shadows and dreams. The sentiment is not unusual, but the actual application is surprising:

> See, how much people err, their eyes shut tight by scales.
> Go with them for a walk in woods, hills and vales
> There's, so they say, a scene that's picturesque to see.
> I cannot pardon it, they're talking wantonly.
> Methinks they're saying: God has made a clever copy
> Of our originals and should be very happy
> With this superior pattern, were't from our hand
> Fairer it couldn't be, in sea or air or land.[10]

Huygens inverts the conventional notion. In his view, painters, by calling nature picturesque, compliment God on having made an acceptable imitation of their paintings. In Huygens' eyes this is an absurd blindness, and consequently he sees no value at all in landscape painting. Why not be satisfied with the original? Evidently, a poet who thinks along these lines cannot be expected to enter into a contest with painters in depicting nature, not because he would fear the competition but because he would judge the whole exercise pointless. A poet, fortunately, does not have to stay within the limits of imitation. He can do more than just show what is to be seen; he can induce people to think about landscape in moralizing terms. Huygens' warning, which is of course deliberately satirical in its presentation, deserved to have been heeded more than it was.

There is every reason, therefore, to emphasize the relationship between painting and poetry where the representation of nature is concerned. We have already seen that the two arts, although not speaking the same language, do understand each other. We have also seen that poets accepted that painters have a special ability to depict visible nature, and that painters sometimes use a literary mode to evoke landscapes, while Van Mander's advice on painting landscapes was not without its effect on poets. In addition, there is every reason to suppose that poets sometimes learned to look at nature through the art of painting and were taught the conventions of the picturesque landscape by painters, before they were able to put such ideas into words.[11]

Ut pictura poesis, therefore, but comparisons between the two sister arts have given rise in the past to some serious misunderstandings. For example, in a study by Gerard Brom, *Schilderkunst en literatuur in de 16ᵉ en 17ᵉ eeuw*, published in 1957, the comparison of the two arts almost always results in the triumph of painting. In the case of landscape, the Dutch poets are said not to have had eyes for the special character of the Dutch landscape, never to have depicted nature for its own sake, to have been always anthropocentric and moralizing. In Huygens, for instance, 'what is thought dominates what can be seen time and again'. Brom cites as an example this epigram by Huygens:

10 C.W. de Kruyter, *Constantijn Huygens' Oogen-troost. Een interpretatieve studie,* Meppel, 1971, pp.130–33. The book contains a facsimile of the text of *Oogen-troost* in the 1672 edition. The quotation consists of lines 473–80. A similar rejection of 'human-made copies of God's work' is found in a 1656 epigram *(Gedichten van Constantijn Huygens*, ed. J.A. Worp, VI, p.19).

11 A Norwegian landscape depicted by Vondel is sometimes linked to paintings by Allart van Everdingen. The description of ice-pleasure in *'s Amsterdammers winter* by J. Six van Chandelier suggests that he looked at paintings of wintry scenes for that purpose. The motif of trees reflected in the water is also found in work of many poets (Beening, op. cit., pp.70, 144, 170). One imagines that personal observations may have been involved, but also particular paintings, or possibly even the way Van Mander had treated this subject (Miedema, op. cit., II, p.553). On pictorialism in literature see K. Porteman, 'Geschreven met de linkerhand? Letteren tegenover schilderkunst in de Gouden Eeuw' in *Historische Letterkunde* (ed. M. Spies), Groningen, 1984, pp.93–113, esp. pp.96–98.

The trees, that stand there, lo,
To heaven from the earth with stretching arms reach out.
They're like the godless, who, despairing, cry out loud.
To whom, they do not know.[12]

It is obviously correct to say that neither Huygens, nor any other seventeenth-century poet for that matter, made 'an intense study of the individual tree', as Ruisdael did, in the words of Stechow.[13] But to reproach him for that is to misjudge the real nature of literature. Why should Huygens have been obliged to give an extensive, detailed description of a leafless tree in a wintry landscape in preference to expressing an emotionally charged religious idea? And why should one deny him the typically poetic function of expressing an emotion in words and coming to a didactic conclusion? In this way, the maxim *ut pictura poesis* can lead to an obsessive desire that the two sister arts should not only do the same thing, but should preferably do it in the same way. How useful then to recall Huygens' own warning, mentioned earlier, or the better-known admonition by Lessing that one should not 'die Poesie in die engen Schranken der Malerei zwingen'.[14] The most specialized and extensive literary-historical study on this subject, Th.J. Beening's *Het landschap in de Nederlandse letterkunde in de Renaissance* ('The Landscape in Dutch Renaissance Literature') (1963), begins by asking how the poets have used the landscape 'to express their feelings', and in discussing this question – to which there is, effectively, no answer – the author does not escape the temptation to rate those poets highest who try to describe 'real' nature.[15]

In this short essay I should like to adopt a different approach and consider the function of literary descriptions of landscape. The single most striking difference between poetry and painting in the description of nature is that in literature the evocation of landscape did not become an independent genre. Nature and landscape play a part, sometimes an important one, in many texts, but they always function as a setting for something else. This applies equally to short evocations of nature and broad *descriptiones*. To start with an example of the former: if, in a *Beatus ille* text, a poet wants to extol the simple activities of the countryside as compared to the troubles and turbulence of the city, he does not have to give a detailed account. Allusiveness is the prerogative of poetry. In *Bauw-heers wel-leven* ('The good life of the farmer'), the principal character, a countryman, appears on the stage in one of the innumerable variants of the *locus amoenus*:

> And then the rustling of the gently lapping stream
> Instils by tender murm'ring a sweet desire to slumber
> In verdant, odorous grass, 'neath shady foliage.

A little further on, the water plays a different role:

> But then his narrow punt speeds through the shallow water
> Towards the fields he shoves or either poles or rows it
> While all the time his eye stays fixed on his own homestead.[16]

It would be quite possible to illustrate this quotation by a riverscape with a punt and a farm in the background, but in the context of the poem just these few lines suffice. The text goes on to meditate on the contrast between city and country and the farmer's marital bliss. This is not of greater value than what the painter offers, but neither is it of less importance. Even when poetry applies itself to more extended descriptions of landscape, such descriptions do not become an aim in themselves, but remain subservient to another purpose.

The Amsterdam poet Hendrick Laurenszoon Spiegel's ambitious philosophical-ethical *opus, Hert-spieghel* ('Speculum Cordis') was written around 1600.[17] This work, which was possibly intended to be even longer, contains seven books, each dedicated to one of the Muses. Almost every book begins with a

12 Brom, op. cit., pp.208.

13 Stechow 1966, p.73.

14 G.E. Lessing, *Laokoon oder über die Grenzen der Malerei und Poesie*, 1766; the quotation is from the 'Vorrede'.

15 It is significant that Beening, when deciding upon his method of research, first thought about starting from the landscape, a pictorial method. See the review by H. van de Waal in *Tijdschrift voor Nederlandse taal- en letterkunde*, 80, 1964, p.213–17, where he points out that poets who refer to the authentic Dutch landscape are well regarded by the author, whatever the literary quality of their work.

16 The text of *Bauw-heers wel-leven* is to be found in the study by L. Strengholt, *De dichter van Bauw-heers wel-leven: Pieter Janssoon Schaghen*, Leiden, 1977, pp.37–41. The lines quoted are 43–45 and 59–61, respectively.

17 Cf. Albert Verwey, *Hendrick Laurensz. Spieghel*, Groningen/The Hague, 1919, p.86.

description of nature in a vividly Dutch colour. Spring, summer and early autumn are described and times of day are treated in turn. The second book begins:

> Thalia lead us out by Amsterlandic streams
> To see the novel robe of the wet fields and orchards
> Whose gaily light-green leaves all of a sudden burst
> From swelling, gravid buds out of the dry-skinned branches.
> The grass that in the autumn sank under layers of ice
> Now raises pointed heads that pierce the water's surface.
> The field, a while ago still an abounding lake,
> Shows its rough edges now, its colours are returning.
> Where long the darting fish played to their hearts' content
> Soon cattle, full of milk, will daily be sent grazing.
> They loath the mussy hay and long for the fresh pastures
> That offer better feed, melting to fat and butter.[18]

A special feature of this evocation of a typical Dutch landscape is the reference to the previous season as well as the current one. Change is the subject of this passage. The introductory description of nature leads on to Spiegel's subsequent argument, in which he meditates upon the vicissitudes of life on this earth.

In the opening scene of his third book he describes a morning walk through a particular stretch of countryside – he mentions specific places – on which he is surprised by fog. The day had started with sunshine, and in a highly imaginative manner Spiegel describes how the grass, heavy with dew, was dried by the strength of the sun. But then, suddenly:

> lo, fast the weather changes
> A night of thickest fog covers the silenced wood:
> And the light-spending Light is hid by misty curtains.[19]

This is, again, a real – and very Dutch – phenomenon. However, Spiegel's reason for describing this thick fog becomes apparent when he continues with a meditation upon Plato's cave and the darkness in which man must grope while true light shines outside. The chosen form is determined didactically, therefore, but it is equally important to note that the realism of his descriptions is programmatic.[20] Spiegel is a poet who expressly maintains that the Netherlands itself, Dutch nature and Dutch art are no less great than the lands, nature and art of Antiquity. He never scaled Parnassus or Helicon and never drank from the Hippocrene, but for a Dutch poet that is not only unnecessary, it is not even desirable! 'Should a Dutch poet really be experienced in Greek and Latin?' (*Hert-spieghel*, p.9). Others followed Spiegel in this type of realistic description (for example, Bredero, Huygens, Six van Chandelier) but it did not become the dominant mode. As least as many other poets, among them Spiegel's contemporary, Van Mander, continued to create their landscapes by classical-mythological and traditional-pastoral conventions.

The descriptions of nature in *Hert-spieghel* had a clear didactic purpose. Another purpose is shown by occasional poetry, which abounds in descriptions of time and place that closely follow the rules of rhetoric.[21] In epithalamic poetry for instance, the description of the landscape may serve to induce a festive mood. If the marriage takes place in springtime, the poet may easily draw parallels between nature and his true subject; in winter he will look for contrasts. In general such descriptions are highly traditional, built from landscape elements that derive from classical pastoral poetry, possibly with touches of Dutch colour, such as a Virgilian mountain transformed into a Dutch dune. *Descriptiones* do serve sometimes, of course, to depict important events. Vondel, for example, gives a mythologically adorned and evocative account of the breaching of the dyke at Houtewael in 1651, which caused the Diemermeer polder to flood:

18 *H.L. Spieghels Hertspieghel* (ed. P. Vlaming), Amsterdam, 1723, p.27.

19 Ibid., p.47.

20 It is interesting to note that Spiegel gives a verbal description of the bleaching-fields near Haarlem about seventy years before the subject was painted by Ruisdael. A walk in book V of the *Hert-spieghel* led the narrator towards Haarlem where he sees 'the grassy, verdant field covered with linen white'. The reason for this walk is purely practical; he wanted to see whether the linen he had sent was being treated with proper care, the lesson being that there is nothing better than supervising the process in person. This is a different emphasis from that of Ruisdael which, according to Wiegand, was cleanliness and purity: W. Wiegand, *Ruisdael-Studien; ein Versuch zur Ikonologie der Landschaftsmalerei*, Hamburg, 1971.

21 For the rhetorical *descriptiones*, see H. Lausberg, *Handbuch der literarischen Rhetorik*, Munich, 1960, esp. p.810.

Neptune . . . spares neither dyke nor piles
Nor planks of oak, and comes just above Outewael
Bursting into the pastures and roaring on his oars
Proceeds and sinks and rises and falls in Diemen's lake,
Puts farms and crops and cattle below the water that
Aforetimes had been forced to leave that great expanse
[. . .]
The haystack keeps the cattle, farmers with families
Put through the roofs their heads, to stave off threatening death[22]

One might compare this to the painting of the same disaster by Willem Schellinks (see figure). To some extent, the same events are shown: the breaching of the dyke, the water pouring in, people trying to save themselves by clambering to higher ground. Neptune is absent, of course, and if that is thought no loss it is worth observing that – unlike the poet – the painter cannot represent the poignant fact that the water is reclaiming land that has been wrested from it in earlier days. This description by Vondel occurs in a poem on the dedication of the new town hall of Amsterdam, a poem that was intended to demonstrate Amsterdam's greatness: he compares it, among other things, to the Roman Empire. The whole poem aims at a high cultural tone in which all arts and sciences, classical and Christian culture, play a part. Neptune, therefore, is definitely not out of place in the passage on the breached dyke. The description of this and other disasters had the purpose of showing how Envy tried time and again to thwart the building of the town hall. Later on the poet describes how not only the god of the waters, but also the fire-god, Vulcan, tried to ruin Amsterdam by setting fire to the city. But, in the face of all these calamities, the city council had stood firm. This may have seemed a rather long digression, but it shows clearly what literature is able to do with such *descriptiones*. Schellinks simply intended to put this tragic event on record: Vondel's intention was quite different.

Topography becomes almost a *laudatio* whenever it sets out to describe a special kind of cultivated landscape: the grounds of a country house. In the Netherlands the country-house poem (*hofdicht*) is a familiar genre, examples of which may already be found in our period.[23] The landscape descriptions in them often have more than one function. The descriptions of the magnificent flowers that are to be seen and of the useful crops that are being raised serve, of course, to praise the estate and its owner. But very often an emblematic lesson is also implied in the description:

Even the most simple flower of thine opulent garden
Bears on its leaves the praise of its own wise creator
And teaches that man, too, is like a flowering weed
That in its life's fresh April almost passes away
If nipping winds just once blow down upon its head.

22 *Vondels Inwydinge van 't stadthuis t'Amsterdam*, (ed. Saskia Albrecht et. al.), Muiderberg, 1982, p.64.

23 Cf. P.A.F. van Veen, *De soeticheydt des buyten-levens, vergheselschapt met de boucken; het hofdicht als tak van een georgische literatuur*, The Hague, 1960.

24 *De dichtwerken van Philibert van Borsselen* (ed. P.E. Muller), Groningen/Batavia, 1937, pp.79–80.

25 *De werken van Vondel*, IX, Amsterdam, 1936, pp.521–22.

26 *De Roemster van den Aemstel* (ed. Werkgroep van Utrechtse Neerlandici), Utrecht, 1973.

This moralization in Philibert van Borsselen's *Den Binckhorst* (1613) follows a very detailed and colourful description of the flower garden.[24] Nature's greatest lesson is that of God's greatness and goodness. The passage from Vondel's *Bespiegelingen van Godt en Godtsdienst* discussed above is part of a still larger evocation of earthly beauty that serves to illustrate the argument, placed in the margin: 'God's Providence apparent from the beauty of creation'. The passage begins with: 'Now here is shown how glorious is all the universe', after which the poet evokes a panorama that widens into a seascape, before narrowing his gaze to concentrate on individual features of the landscape.[25]

This does not pretend to be an exhaustive list of the functions that a description of nature may fulfil in a literary work. Painted nocturnes can be paralleled by the night scenes which occur particularly in love songs. Then there are also topographically detailed landscape descriptions. In the little-known poem *Den Roemster van den Aemstel*[26] ('In praise of the Amstel'), for instance, a walk along the Amstel stream is

W. Schelinks, *Breaching of the Sint Anthonisdyke near Houtewael in 1651*. Amsterdam Historisch Museum.

described so accurately that one could draw the corresponding map: it was intended to be recognized in detail by the inhabitants of the city, who may well have walked along this very route. On the other hand, however, we may presume that very few landscape poems have been written with so much mythological embellishment as was employed by the third-rate *poeta doctus* of this 'poetical description of the Amstel stream'.

Although many gaps remain, I hope to have shown that poets and painters were well acquainted with each other's work in the description of landscape and did learn from each other.

The exhibition traces the emergence of a new, realistic style of landscape painting in Holland in the last decade of the sixteenth and the first quarter of the seventeenth centuries. It is an intriguing question whether, despite the many differences between painting and poetry that I have indicated, there were parallel developments in the two arts. From a strictly chronological point of view, I believe the answer must be in the negative. In literature, landscape is not rendered at first in a stylized and idealized and then later in a naturalistic way. Early in this period, there are some very realistic literary descriptions of the Dutch landscape and late in the period mythological and Arcadian conventions are employed to create quite different and highly artificial effects. The contrast between the realistic and the ideal does exist; it is, however, a consequence not of a crude chronological development but of genre and function, and of the poetical tenets of the particular writer.

Dr. M. A. Schenkeveld-van der Dussen
University of Utrecht

Before embarking on a discussion of the landscapes of the Dutch Republic, and of its physical environment generally, the reader's attention must be drawn to a geological feature that divides the territory of the Netherlands in two, and that had far-reaching consequences for its economic, social, and cultural development. The many landscapes of the Netherlands can be categorized – roughly, but usefully – as representing either the diluvial or the alluvial zones of the country.

The diluvial, sandy soils lie at least several metres above sea level and are the product of glacial activity. This stable environment covers most of the Netherlands' eastern and southern provinces. These relatively infertile sandy soils are enveloped by the clay and peat soils of the alluvial Netherlands, soils that were deposited and developed by the actions of the rivers and the sea. Such deposits, richer but lying at or below sea level, cover most of the coastal, or maritime zone, including the key province of Holland. The maritime and inland zones possessed landscapes with very different potentials for exploitation and development. The capacity of technology to transform these environments also differed greatly. These 'objective' differences gave rise to differences in perception that may be of value for the interpretation of visual representations of the physical environment. Consequently, the following reconnaissance of the Dutch landscape will consider each of the two basic zones in turn.

A The Maritime Zone.

The Hollander of the mid seventeenth century, and to a lesser extent his compatriots in the other coastal provinces (Zeeland, Friesland, Groningen) inhabited a physical environment (both landscape and cityscape) whose most outstanding characteristic must have seemed its 'newness'. A combination of factors, including new technology, population growth and migration, and the growth of trade and industry, created an environment highly favourable to investment in urban expansion, harbour extensions, land reclamation, new farm buildings, canal construction and the exploitation of peat bogs. Few landscapes have been so altered in so short a period as was Holland, particularly north Holland in which Haarlem and Amsterdam are located, from the 1580s to the mid seventeenth century.

1 Population and urbanization.

The maritime zone experienced a population explosion in the period 1500–1660, as the number of inhabitants grew from about 350,000 to 1,000,000. This growth was concentrated in three ways: Holland grew more rapidly than the other provinces; cities grew more rapidly than rural districts; and growth was most rapid in the decades from the establishment of the Republic (in the 1580s) to the 1620s. Thus, Holland, whose population grew from 275,000 in 1514 to 883,000 by 1680, experienced half of that increase between 1580 and 1622. Moreover, the cities of Holland accounted for most of that increase, as the number of urban residents rose from about 140,000 in 1511 to 560,000 by 1680. Here, too, most of the increase occurred in a relatively brief period after the establishment of the Republic (see graph 1).[1]

The intensification of population growth after 1580, and the vigorous urbanization to which it led, is directly associated with the migration of southern Netherlanders in the aftermath of the Duke of Parma's reconquest of the southern provinces and, specifically, the fall of Antwerp in 1585. No estimates of this migration can claim great accuracy, but tens of thousands eventually moved to the Republic. What religious and political conflict started, vigorous economic expansion carried forward into the seventeenth century.

The growth of trade in harbour cities such as Hoorn, Amsterdam, Rotterdam and Middelburg, and the growth of industry in Haarlem, Leiden, Delft and Gouda, as well as in overgrown villages such as Zaandam, generated a pressing need for more space in

1 A.M. van der Woude, 'Demografische ontwikkeling van de Noordelijke Nederlanden 1500–1800', *Algemene Geschiedenis der Nederlanden*, vol. 5, Haarlem, 1980, pp. 123–139; Jan de Vries, *The Dutch Rural Economy in the Golden Age, 1500–1700*, New Haven, 1974, pp. 89–90.

the walled cities for housing, industry, and harbour activities. At the time of the Revolt Holland's largest city, Amsterdam, had no more than 30,000 inhabitants and the other large towns did not exceed 15,000. When the census of 1622 was taken the population of Amsterdam was 105,000, a figure that would double to 200,000 by the end of century. By 1622 that of Haarlem had grown to 39,000 and Leiden to 44,000, and the latter continued to grow to some 70,000 by the 1660s.

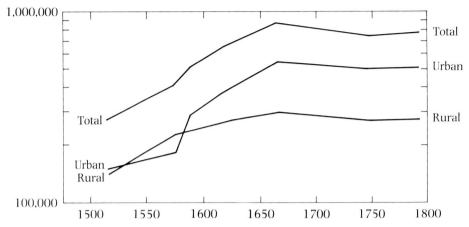

Graph 1. Estimated total population of Holland, 1514–1795.

Graph 1.
Source: Jan de Vries, *The Dutch Rural Economy in the Golden Age, 1500–1700*, New Haven, 1974, p.95.

The production of brick became a major industry as one city after another embarked on costly expansion projects. As the cities built new walls the occasion was seized to use new techniques of fortification.[2] Moreover, rapid population growth caused many cities to become more densely inhabited; new brick buildings replaced old wooden ones and gardens and space-intensive industries were relocated beyond the walls to make way for structures.

The growing seaborne trade of the Republic forced many port cities to invest in harbour expansions, and to find space to accommodate shipbuilding wharves, warehouses and ropeworks. Middelburg, in Zeeland, expanded its docks in 1578 and again in 1595. Rival Rotterdam, which eventually overshadowed Middelburg in the Delta region, embarked on expansions in 1577, 1588, 1604, and 1613. Hoorn, a port on the Zuider Zee, invested in new facilities in 1576, 1609, 1616, and 1649. The largest port, Amsterdam, created the greatest harbour complex in Europe with its expansions of 1593, 1611, and 1644.[3]

By the mid seventeenth century the population density in Holland, exceeding 150 per km[2], placed it among the most densely populated regions of Europe. But, since 60 per cent of Holland's people lived in cities, the rural population density was not unusually high. In fact, the high level of occupational specialization meant that many rural inhabitants were not directly engaged in agriculture but provided services or worked in industrial production. Seventeenth-century occupational data are all but non-existent, but later sources suggest that under half of the rural population was directly dependent on agriculture.[4]

2 Land reclamation.

The reclamation of land from the sea has been practised in the Netherlands for centuries. Already in the middle ages coastal lands were gained by enclosing them as they fell dry at low tides. In this way the Zeeland islands and other coastal areas gained cultivable land, although inundation often undid these drainage efforts. Around the mid sixteenth century a new drainage technology became feasible as windmills were developed that combined large size with the ability to rotate the sails into any wind direction. With the successful drainage of several small lakes near Alkmaar in 1561–4

2 On brick production see: B.W. van der Kloot-Meybrug, 'Een productiekartel in de Hollandsche steen-industrie in de 17de eeuw', *Bijdragen tot de Economische Geschiedenis van Nederland*, 2, 1916, pp.208–38; De Vries, op.cit., pp.240–41. On the spread of new fortifications see: J.D.H. Harten, 'Het landschap in beweging', *Algemene Geschiedenis der Nederlanden*, 5, Haarlem, 1980, pp.39–40.

3 On harbour developments see: J.P. Sigmond, 'Havens', *Maritieme Geschiedenis der Nederlanden*, Bussum, 1977, pp.87-96. The major study on urban expansion is Ed Taverne, *In 't land van belofte: in de nieue stadt. Ideaal en werkelijkheid van de stadsuitleg in de Republiek (1580–1680)*, Maarssen, 1978.

4 Jan de Vries, 'Landbouw in de Noordelijke Nederlanden 1490–1650', *Algemene Geschiedenis der Nederlanden*, 7, Haarlem, 1980, pp.36–37.

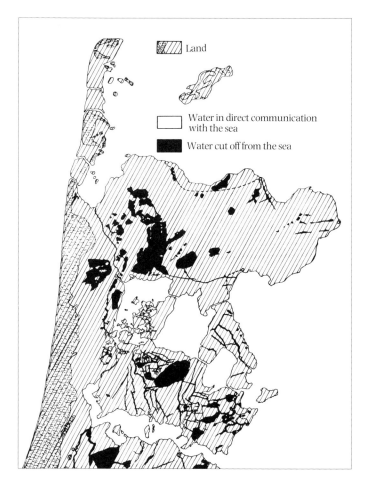

Map 1

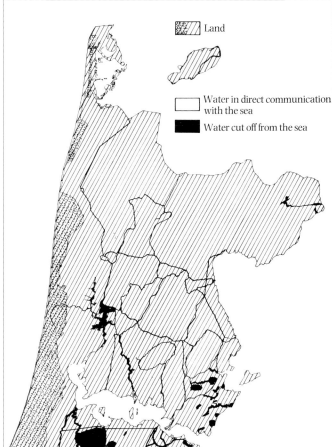

Map 2

Map 1. North Holland circa 1300. (This map needs little revision to represent the situation in 1560.)

Map 2. North Holland in 1795. (The vast majority of reclamation shown on this map had been achieved by 1650.)
Source: A.M. van der Woude, *Het Noorderkwartier*, 3 vols., *A.A.G. Bijdragen*, 16, Wageningen, 1972, 3, pp.755–756.

5 A.M. van der Woude, *Het Noorderkwartier*, 3 vols., *A.A.G. Bijdragen*, 16, Wageningen, 1972, I, pp.47–60.

the stage was set for further development, since the legal and institutional vehicle for such projects (the polder) was available and the demand for land was strong. The Revolt interrupted this process, but after 1590 the interest of engineers and investors revived, now abetted by the availability of large amounts of capital.

The process of land reclamation in the Dutch Republic is often exemplified by the short period of intense drainage activity in north Holland from 1612 to 1635. Amsterdam merchants and other urban interests then gambled at least ten million guilders – far more than they and their contemporaries had invested to establish the Dutch East India Company in 1602 – on the application of the new windmill pumping technology to the drainage of a series of steadily deeper lakes covering in total some 26,000 hectares. These speculative investments changed the face of north Holland. (Compare maps 1 and 2.) The land area of the north Holland peninsula increased by one-third between 1590 and 1650. This changed the occupational structure of the entire region and enlarged the marketing functions of the towns, but it also blocked the access of many villages to the sea and reduced inland fishing possibilities. In short, the physical face and the economic life of north Holland were transformed.[5]

The use of windmills, sometimes dozens of them arranged in sequences of three or four, to drain lakes up to 5 metres deep was less frequently resorted to in south Holland, that is, the province of Holland south of the IJ. There only 6,500 hectares of new land were won in this way, much of it in the outskirts of Amsterdam, where the Bijlmermeer, Watergraafsmeer, and Sloterdijkermeer were drained between 1622 and 1642.

Yet these spectacular, speculative investments in land creation were but the tip of an iceberg of reclamation activities. The hundreds of polders that blanketed Holland built

6 H. Blink, *Geschiedenis van den boeren-stand en den landbouw in Nederland,* 2 vols, Groningen, 1902, 2, pp.112–113.

7 Jan de Vries, *Barges and Capitalism. Passenger Transportation in the Dutch Economy, 1632–1839,* Utrecht, 1981; first published in *A.A.G. Bijdragen,* 21, Wageningen, 1978, pp.26–32.

8 In the Amsterdam Historisch Museum hangs a painting by the Haarlem seascape painter Hendrick Cornelisz. Vroom entitled *De Haarlemmerpoort* (above). It shows the walls of the city at its western end and the monumental Haarlem Gate, which was finished in 1615, the year the painting is dated. In the foreground the painting shows the Amsterdam terminus of the *trekvaart* to Haarlem, with docked passenger barges, waiting passengers, and horses attended by grooms preparing for the next departure. Such scenes existed at three of Amsterdam's entrances and, indeed, at every major city of the region.

There is one puzzle about Vroom's painting. The scene it shows did not exist in 1615. The canal, dug in a straight line from Haarlem to Halfweg, and from there to Amsterdam, was created in 1631–32. Regular horse-drawn passenger barge services began in May, 1632. Until then travellers between Amsterdam and Haarlem had to brave the dangers and suffer the delays of sailing on Het IJ and the Spaarne, or they had to walk along the meandering dyke-top road that followed the shore of the IJ.

How can the puzzle of Vroom's painting be resolved? I should suggest that Vroom painted it in 1615, on the occasion of the completion of the Haarlem Gate, and that the painting was altered, presumably by Vroom himself (he lived until 1640), when the environs of the gate were radically changed in 1632. The anachronistic dress (more appropriate to 1615 than to 1632) of the couple strolling near the towpath in the foreground of the painting remains a curiosity.

9 William Bromley, *Several Years Travels . . .,* London, 1700, p.280.

or raised their encircling dykes and installed windmills to improve drainage and intensify agriculture. Thus, the traveller in the vicinity of Amsterdam would have noticed not only the newly drained lakes, but also (to give but one example) the new dykes and windmills of the Groot Duivendrechtsche polder and Rondehoep polder, all built in 1637.

Lake drainage, coastal reclamation, and land improvement through polder-formation occurred throughout the maritime zone of the Dutch Republic, adding some 110,000 hectares of new land between 1590 and 1664 and raising the quality of much more.[6] Rising land values and commodity prices attracted capital to these activities. After the 1660s the economic environment changed, and large-scale reclamation projects abruptly ceased. In the next hundred years only ten polders were newly drained in all of Holland.

3 Canal and road construction.

Nature endowed the maritime zone with numerous waterways, and these the Dutch improved over the centuries by the construction of short connecting canals and sluices. The large number of cities that dotted the region can be explained in part by the commercial (and toll-collecting) opportunities afforded by the many navigable routes giving access to Flanders, Liège, the Rhineland and the North Sea coast. The Zuider Zee functioned as a veritable traffic interchange between Holland, Friesland, and Overijssel; the Delta region of south Holland and Zeeland offered communications among cities from Antwerp to Rotterdam; and the numerous distributaries of the Rhine and Meuse rivers provided internal communications for thousands of ferries, market boats, farm scows, yachts, etc.

This complex of natural and improved waterways continued to form the transportation backbone of the Netherlands into the modern age, but it was suddenly and decisively augmented in the period 1632–1665 by a comprehensive network of new canals specially designed to provide dependable, direct communications between the major cities. These canals, called *trekvaarten,* featured towpaths, and the major ones were newly dug, straight routes. Regularly scheduled horse-drawn passenger barges plied these new routes offering hourly departures to the major cities of Holland, overnight 'sleeping barges', and connecting services stretching from the German border near Groningen in the north-east to Rotterdam in the south-west.

Altogether thirty cities spread throughout the maritime zone entered into thirty separate joint ventures with each other to invest nearly five million guilders in the construction of 658 km of *trekvaart.*[7] (See map 3.) From Amsterdam the traveller could depart for Haarlem every hour,[8] south to Gouda twice and to Utrecht three times per day, north to Hoorn twelve times daily, and east to Naarden six times and to Weesp six times per day. From Leiden nine barges departed for Haarlem each day, ten each to Delft and the Hague, and three to Utrecht.

The ordinances under which the barges operated stipulated the exact time of departure and the maximum duration of their trips. Bells were rung to announce the departure time, and foreign observers frequently marvelled at the fact that the barges actually observed their published schedules. 'The hour for the Boat coming in, and going out, is so punctually observed that upon the Ringing of a Bell it goes off, without staying for any person whatsoever.'[9] In fact, to facilitate the maintenance of the schedule en route many barges were equipped with hourglasses.

Road travel in most parts of the maritime zone fulfilled only local functions. The only exceptions were routes connecting major cities where, for either hydrological or political reasons, no canal was built. Map 3 indicates with dashed lines where paved roads supplemented the network of *trekvaarten.* These were the only paved roads of any length in the entire Republic until the late eighteenth century.

The new inter-city canals fashioned a network that overlay the existing network of navigable waterways, giving an already well-supplied region an even better

Map 3. The *Trekvaart* Network after 1665.

Source: Jan de Vries, *Barges and Capitalism. Passenger transportation in the Dutch economy, 1632–1839*, Utrecht, 1981, p.35.

communications system. The only extension beyond the areas already served by waterways consisted of canals dug into the peat bogs of Friesland and Groningen. The exploitation of these peat deposits required new canals, which became the focal points of settlement and communications in these isolated, newly settled districts.

4 Peat

The Dutch economy of the seventeenth century was what we today would call 'energy-intensive'. Thousands of sailing vessels worked the high seas and the inland waterways. Hundreds of windmills worked to drain the land, as we have seen, but many more could be found in every village and arrayed along the walls of every city, performing industrial functions such as grain milling, cloth fulling, oil pressing, paper making and lumber sawing. In the industrial villages hugging the banks of the river Zaan, near Amsterdam, 128 such windmills dominated the horizon in 1630, and by 1650 the number had multiplied, being well on the way to the 584 counted in a tax survey of 1731.[10]

The harnessing of windpower provided the society with much of its stationary and mobile motion energy. Heat energy, needed for home heating and cooking and for such industrial processes as brick and pottery making, sugar refining, beer brewing, and cloth bleaching – all Dutch specialities – came from another source: peat. The Netherlands were abundantly endowed with peat, the 'low peat' lying at and below the water table throughout central Holland (between Amsterdam in the north and Rotterdam in the south), and the 'high peat' on the desolate moors of the northern

10 Van der Woude, op.cit., II, pp.315–329.

provinces. The digging and transporting of peat became a major sector of the economy in its own right, and simultaneously made an indelible mark on the landscape.[11]

In Holland the peat was immediately accessible and had been dug on a casual basis for centuries. The growth in demand experienced during the sixteenth century fostered the development of a new technology allowing the deep layers of peat to be fully dug out. By digging under the water table this method caused exhausted peat bogs to fill with water; in time vast lakes spread where there had once been cultivable land. By 1650 quite a number of such lakes (*veenplassen*) had formed, particularly in the vicinity of Gouda and Rotterdam, and many more would form in later decades until reclamation began in the late eighteenth century.

The exploitation of the peat deposits in the northern provinces required highly capitalized enterprises capable of digging canals into the bogs, building settlements, and hiring armies of labourers. When the peat was stripped away the uncovered soil could be converted to farm land, which attracted pioneers to makeshift colonies in eastern Groningen (the *Veenkoloniën*), southern Friesland (Heerenveen) and Drenthe (Hoogeveen).

In both regions, albeit in very different ways, peat digging presented contemporaries with a vivid, disturbing vision of a landscape in movement. Over the course of a decade farm land could be transformed into lakes and desolate moors transformed into farm land, while peasant villages become crowded with proletarian peat labourers, many from distant places.

5 Rural Structures

The heavy investments made to improve land quality in the late sixteenth and seventeenth centuries led naturally to a demand for farm buildings that could accommodate larger dairy herds and more equipment, and provide more storage space for crops and more elaborate living quarters for the farm families. Beginning at the end of the sixteenth century the various medieval farmhouse types (the *woonstalhuis* of north Holland and Friesland, the *hallehuis* of south Holland) began to be replaced, in a veritable rebuilding of rural Holland, with novel architectural designs. Among them were the *stolp*, a pyramid-shaped farmhouse offering abundant storage space under its high roof, which spread through north Holland; the *kop-hals-romp* type of Friesland, with a large separate barn; and variants of the south Holland *hallehuis* with raised roofs.[12]

B The Inland Provinces

The sandy soils of the Netherlands extend like great tongues, north from Belgium across most of North Brabant and east from Germany, covering parts of Utrecht, Gelderland, Overijssel and Drenthe. The dynamic economic growth of the maritime zone did not leave these regions undisturbed, but neither the social structure of the villages nor the technologies available to the potential investors of Holland permitted a major transformation in the period we are examining.

The impermeability of these areas is well illustrated by Het Gooi, the westernmost extension of the sandy soils, which is no more than 25 km from Amsterdam. The seventeenth-century Amsterdamer could board a passenger barge and be in Naarden, at the edge of Het Gooi, in three hours. Yet, throughout our period and long thereafter the villagers maintained communal control of the heaths in which their villages were lost, and supported themselves by raising sheep and spinning wool. The only real inroad of urban Holland occurred on the edge of Het Gooi, where property developers bought sand for removal to the cities (where it was needed for city expansion) and built 's-Gravenzande, a new community of luxurious country houses on the cleared land.

One did not need to travel far to escape the busy commercial world of Holland, both urban and rural, and experience a quieter, slower-paced life. The Hollander who

11 On this subject see: J.W. de Zeeuw, 'Peat and the Dutch Golden Age. The historical meaning of energy-availability', *A.A.G. Bijdragen*, 21, Wageningen, 1978, pp.3–31; P. van Schalk, 'De economische betekenis van de turfwinning in Nederland', *Economisch-Historisch Jaarboek*, 32, 1969, pp.141–205; 33, 1970, pp.186–235.

12 Harten, pp.72–76; R.C. Hekker, 'De ontwikkeling van de boerderijvormen in Nederland', in S.J. Fockema Andreae, E.H. ter Kuile, and R.C. Hekker, *Duizend jaar bouwen in Nederland*, 2 vols., Amsterdam, 1957, 2, pp.195–316.

pushed on to the *Veluwe*, a genuinely remote expanse of sand hills and peasant settlements, or to the *Achterhoek*, a peasant world far removed from cities and navigable waterways, truly found himself in another world.

1 Population and urbanization

The population of the inland provinces grew little, and in some cases declined in the period from the Revolt to the Peace of Westphalia. The continuing war with Spain was fought mainly in the southern border areas, disturbing life in North Brabant and Limburg, while the decline of trade with Germany during the Thirty Years' War enforced a long-lasting stagnation on the numerous eastern cities (Kampen, Zwolle, Zutphen, Deventer, Arnhem, Nijmegen, Venlo). The rural population did not grow rapidly either: the Veluwe's population in 1650 exceeded that of 1526 by only 13 per cent, while the neighbouring district of Salland, in Overijssel, took two centuries, from 1475 to 1675, to grow from 16,500 to 23,000 inhabitants.[13]

2 Land reclamation

Extensive wastes and rough pasturage covered much of the inland districts in the seventeenth century. Neither internal population pressure nor the pull of the market were sufficiently great to bring about the investment and institutional change that would be needed to improve land quality. In fact, parts of the region experienced further deterioration as deforestation, extensive sheep grazing and the channelling of streams for watermills combined to create loose sand which spread to smother cultivable land and create true wastes. This was a long-term problem that attracted concerned attention throughout the sixteenth and seventeenth centuries and in extreme cases led to the desertion of entire villages.[14]

It requires a special effort to visualize the heavily reforested eastern Netherlands of today in the denuded state it had attained by the seventeenth century. Deforestation had made the Republic dependent on peat and on imported timber from Norway and Germany; it also generated an interest among the urban middle classes in woodlands as a recreational facility. Wooded preserves took shape in the outskirts of The Hague and Haarlem, but it would be more than a century before large-scale reforestation was begun in the inland provinces.[15]

3 Communications

The boundary line dividing the alluvial from the diluvial Netherlands consists of a change in soil type and barely perceptible change in elevation, but every man-made navigable waterway stopped abruptly when it reached that point. Away from the major rivers, on whose banks all the towns of the inland provinces were located, transport in the inland zone depended on wagons and coaches moving slowly along crude sand roads. From a world of frequent, scheduled, horse-pulled barges one entered a world of privately arranged transport and frequently impassable roads – in a word, of unpredictability.

C Conclusions

The maritime zone, and Holland in particular, was a remarkably 'new' environment around the middle of the seventeenth century. In the seventy-odd years since the Revolt Holland saw its population double and its urban population nearly triple in size. This by itself would have brought many intrusive modifications, but the demographic change was accompanied by an economic transformation in which Holland became the focal point of European commerce, a major industrial producer, and a specialized agricultural producer. These achievements were not the products of a few decades, but

13 H.K. Roessingh, 'Het Veluwse inwonertal, 1526–1947', *A.A.G. Bijdragen*, 11, Wageningen, 1964, pp.79–150; B.H. Slicher van Bath, *Een samenleving onder spanning. Geschiedenis van het platteland in Overijssel*, Assen, 1964.

14 Harten, op.cit., pp.53–54.

15 On the subject of Dutch forestry see: Jaap Buis, *Historia Forestis. Nederlandse bosgeschiedenis*, 2 vols., *A.A.G. Bijdragen*, 26 and 27, Wageningen, 1985.

their consolidation in the first half of the seventeenth century went hand in hand with a massive investment of capital, and this investment took physical forms that radically changed the built environment, both urban and rural. The straight, calculated lines of the surveyor became harder to avoid and few views of the horizon in this flat landscape could have excluded a symbol of change, whether it were a windmill, the massive fortification of an expanded city wall, a towpath-equipped canal, new farm buildings, or a peat bog swarming with workmen and barges. Few of these features could have had the calming influence on contemporaries that Dutch landscapes commonly have on modern viewers.

Of course, even the most modern society has its relics and forgotten corners, where the new, dynamic society can be put temporarily out of mind. In this regard it is interesting to note what elements of his environment the seventeenth-century Hollander selected to create this impression. Besides local scenes, he (not unlike his twentieth-century descendant) often looked to the sandy-soiled regions to find the tranquillity absent from the commercial world of the maritime zone. This could be as close as the dunes stretching the length of Holland's coastline and at the doorstep of cities such as Haarlem, Leiden, and The Hague; more commonly it was a more distant spot in the east, where winding roads, old rustic farmhouses, irregular lines, and an unhurried pace were the rule rather than the exception.

Professor Jan de Vries
University of California at Berkeley

CATALOGUE

PRECURSORS IN ANTWERP AND ROME

1

Paul BRIL 1554 – 1626

Literature A. Mayer, *Das Leben und die Werke der Brüder Matthäus und Paul Bril*, Leipzig 1910

He was born in Antwerp and was a pupil there of Damiaen Ortelmans. In 1574 he travelled to Lyon and later to Rome, where he is recorded from 1582 onwards. There he lived and worked with his elder brother Matthijs who died in 1583. Bril was a fresco painter and a landscape specialist in the service of several popes; in the 1590s he began to paint landscapes in oil on small copper panels. His landscape style was strongly influenced by that of the Venetian artist Girolamo Muziano (1528–1592), who settled in Rome in about 1548. Bril made drawings from nature, including studies of classical buildings in the vicinity of Rome. Under the influence of Annibale Carracci and the young Elsheimer, at whose marriage in Rome in 1606 he was a witness, he abandoned his fantastic hilly landscapes in favour of flatter, more realistic scenes. His painted landscapes remain, however, ideal rather than naturalistic. Many of his landscape compositions were engraved and these prints circulated widely in the north. He also strongly influenced the development of classical landscape in Rome, and in particular the landscape styles of Claude Lorrain and Agostino Tassi.

FANTASTIC LANDSCAPE

Cat. no. 1
Copper, 21.3 × 29.2cm
Signed, lower right: P A BRIL . ROMAE . 1598.
Edinburgh, National Gallery of Scotland
(Inv. no. 1492)

Provenance In the collection of J. Fenton, Norton Hall, Gloucestershire; Sale, Christie's 27 February 1880, lot 224; Mrs. Nisbet Hamilton Ogilvy of Biel bequest to the National Gallery of Scotland, 1921
Literature Edinburgh, National Gallery of Scotland, Shorter Catalogue (by C. Thomson and H. Brigstocke), 1970, p.9

This small painting on copper is a characteristic example of Bril's landscape style of the 1590s. The high viewpoint, sheer rocky outcrops, high-sided river valley, restricted colour scheme and the disposition of small figures to indicate recession are all features of the Antwerp landscape tradition in which he had been trained. The tree with which he closes off the composition on the right, with its massive exposed roots, reveals his study of Muziano. The Corinthian columns with which he closes it on the left are similar to those on the Temple of the Sibyl at Tivoli, which Bril sketched from life. He also strews the foreground with capitals, column fragments and part of a classical cornice. The smithy in the bottom left hand corner, with its blacksmiths dressed in tatters, is a consciously picturesque element, as is the gypsy woman with her children in the centre foreground. In addition to placing the figures with great care, Bril indicates recession by the tripartite colour scheme and by using hard, dark outlines such as that of the slope just beyond the smithy, on which two figures apparently dressed in togas are in conversation, and the right hand edge of the central rock, against which the river landscape is perceived by the spectator as light and consequently distant. It is very obviously a constructed landscape, closed at both sides by the two foreground coulisses, with a fantastic rocky mountain in the middle ground and to the left, and a distant river landscape balancing it on the right. The whole scene is lit by the last, almost tangible rays of the setting sun.

An autograph repetition, with slight variations, was in Dresden until the last war, with a companion picture, *Landscape with Roman Ruins*, dated 1600 (Dresden, Gemäldegalerie: Inv. no. 858).

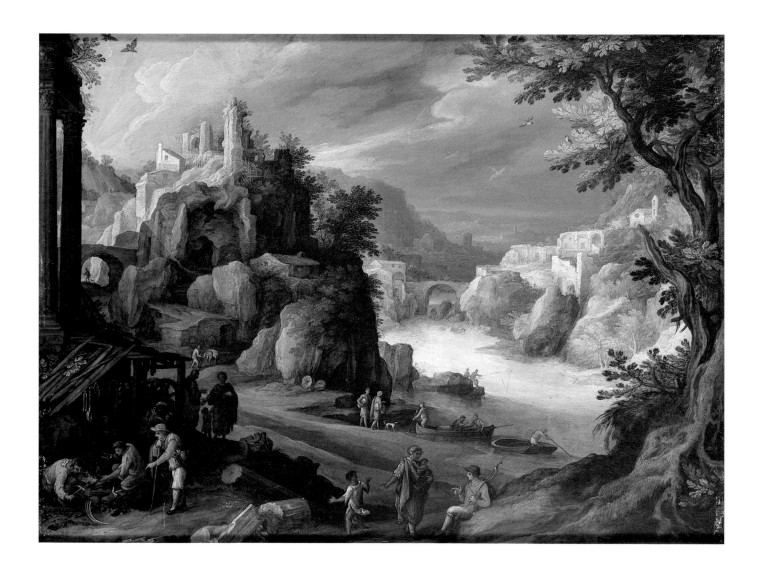

LANDSCAPE WITH
ST. EUSTACE AND THE STAG

Cat. no. 2
Canvas, 36 × 45.7cm
Signed on a stone, centre foreground: P A BRIL
London, Wellington Museum, Apsley House
(Inv.no.WM1623–1948)

Provenance Spanish royal collection. It may be
the 'Vision of St. Eustace', described as 'Flemish
school' and of a similar size, in the Royal Palace
inventory of 1772. It was captured by Wellington
at the battle of Vitoria in 1813
Literature London, Victoria and Albert Museum,
Catalogue of the Paintings in the Wellington
Museum (by C.M. Kauffmann), 1982, 15 (p.34)

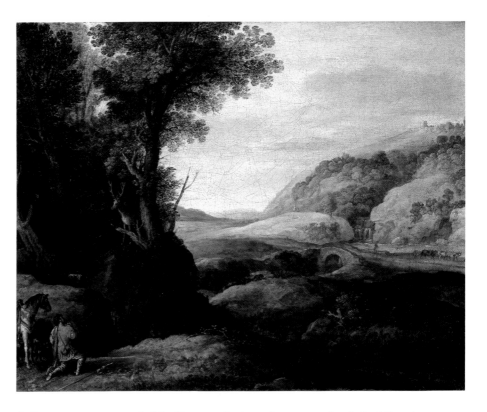

St. Eustace was a general of the Emperor Trajan who was confronted while out
hunting by a stag with a crucifix between its antlers. As a result of this vision he was
converted to Christianity and subsequently martyred. An identical vision was
experienced by St. Hubert who after his conversion became bishop of Liège, where he
died in 727. It is often difficult to be sure which of these subjects is intended, and the
catalogue of the Wellington Museum prefers to identify the saint of this painting as St.
Hubert. However, the group of the kneeling saint, his horse and the stag appears to
show some familiarity with Dürer's famous engraving of 1500/02 as well as Cort's
print after Muziano and Annibale Carracci's painting (Capodimonte Museum, Naples),
all of which definitely show St. Eustace. The painting also seems to have been referred to
as *The Vision of St. Eustace* in 1772. While St. Hubert, as bishop of Liège, was a more
popular subject in the Netherlands in the seventeenth century, St. Eustace would have
been a more likely subject for an artist resident in Rome.

The landscape probably dates from the period 1615/20 – that is, towards the end of
Bril's career – and shows how far he had moved away, under the influence of Carracci
and Elsheimer, from the fantastic, rocky landscapes of the Antwerp tradition. There is
still a distinctly unresolved recession to the distant landscape from the left foreground
where the saint kneels, but both the detail of the foreground trees and the expanse of
fields, river and hills beyond are far more naturalistic in approach and based on Bril's
studies from nature, even if the final impression is of a carefully balanced, constructed
landscape. It is striking too, in comparing this painting with the *Fantastic Landscape* of
1598 (cat.no.1), that his style has become much broader in application, particularly in
the treatment of the distant landscape – although to some extent this is a consequence
of the larger size and the different support.

TREES AT THE EDGE OF A POOL

Cat. no. 3
Pen and brown ink, with brown and grey wash,
158 × 225mm
Signed, lower left: Pa. BRIL. 1609 In: Romae
London, British Museum, Department of Prints
and Drawings (Inv.no.1895–9–15–1029)

Provenance Presented in 1895
Literature Popham 4

The abbreviation 'In' for 'Invenit' in the signature presumably means that the drawing was intended to be engraved. No engraving is known and the drawing has not been incised.

Bril made many remarkably fresh sketches from nature. However, in a finished design such as this, which was intended to be engraved, he was constrained by landscape formulae: this composition, with framing trees at the left and right and the extensive flat landscape between, is distinctly contrived. The tangled trees of the forest on the left and the tunnel-like path between them reveal a sympathetic awareness of the northern tradition of dense forest landscapes, seen in Pieter Bruegel's drawings and in paintings by Jan Brueghel and Gillis van Coninxloo. A heavy application of wash is used by Bril to lead the eye along the forest path. A couple holding hands are framed at the end of the tunnel of trees.

The motif of willows bent over the pool and reflected in the water was particularly evocative for Dutch landscape painters: it is used, for example, by Jacob van Ruisdael in 1646 (cat. no. 103).

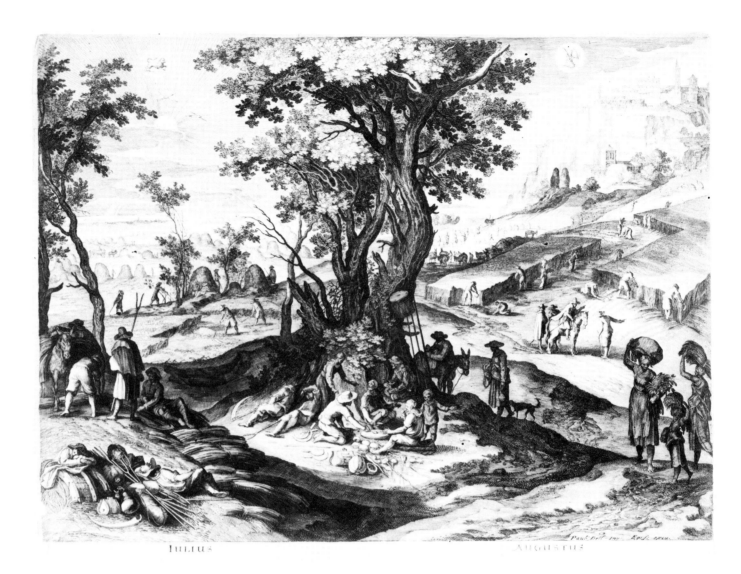

IULIUS AUGUSTUS

(Aegidius SADELER after Paul BRIL)

JULY AND AUGUST

Cat. no. 4
Engraving, 369 × 499mm
Inscribed, lower right: Paul: Bril Inv: Eg: S: excu.
London, British Museum, Department of Prints
and Drawings (Inv.no.F1–31)

Literature Holl. 126

This is the fourth plate in a series of six engravings of *The Months* by Sadeler after designs by Bril. It was in the form of such prints that Bril's work became known in the north Netherlands. The format is conventional, with the two scenes, one for July and one for August, separated in an extremely artificial manner by a clump of massive trees, the signs of the zodiac floating in the sky and the whole composition framed at either side – by trees at the left and an Italian hill town at the right. It takes its place in a tradition of the representation of the months which goes back to the calendar pages of late medieval books of hours. The naturalistic details, however, particularly the scenes of harvesting in the background, are vivid and well-observed.

Aegidius Sadeler the Younger (1570–1629) was an engraver born and trained in Antwerp who, having travelled extensively in Germany and Italy, settled in Prague in the service of Emperor Rudolf II and his successor Emperor Matthias. A friend and close associate of Bartholomäus Spranger, he was one of the most distinguished and versatile engravers of the day. He died in Prague. This series of *The Months* probably dates from about 1610.

Pieter BRUEGEL the ELDER c.1525 – 1569

Literature Grossman 1973; Berlin 1975

He was born in about 1525, in or near Breda. According to Van Mander he was apprenticed to Pieter Coecke van Aelst, an Italianizing figure painter whose daughter he was later to marry. He joined the guild of St. Luke in Antwerp as a master in 1551, and shortly afterwards set out for Italy; on the way south he is said to have travelled through France. He was apparently in Rome in 1553/4 and was in contact there with the miniaturist Giulio Clovio, with whom he collaborated. While in Italy Bruegel travelled as far south as Reggio di Calabria and Messina (in Sicily). His return journey, in 1554 or 1555, took him through Tessintal, St. Gotthard, Graubünden and the Tirol. He was back in Antwerp in 1555, from which year dates a drawing for the Large Landscapes *series. In 1556 he was at work on allegorical figure compositions, designs for prints published by Hieronymous Cock. The first painting after his return from Italy, the* Parable of the Sower, *dates from 1557. Thereafter he was active both as a painter and a designer of prints; after about 1562 he seems to have devoted more time to painting. The first of his sequence of allegorical pictures,* The Fight between Carnival and Lent, *dates from 1559; from the same year is* Netherlandish Proverbs; Children's Games *was painted in 1560. In 1563 Bruegel married Mayken, the daughter of Pieter Coecke and Mayken Verhulst, in Brussels, and settled in the town. In 1565 he painted the series of* The Months *for the Antwerp merchant Nicolas Jonghelinck, who in the following year is recorded as the owner of sixteen paintings by Bruegel.* The Wedding Dance *dates from 1566 and* The Land of Cockaigne *from the following year. In 1568 his second son, Jan Brueghel the Elder, was born.* The Parable of the Blind *and* The Magpie on the Gallows *were both painted in 1568. He died in Brussels in 1569 and is buried in Notre-Dame de la Chapelle.*

Bruegel developed the traditional Antwerp landscape style of Patinir and Herri met de Bles in the direction of greater naturalism but never entirely abandoned its conventions. His landscape art and its influence are discussed on pages 13–18 of the Introduction. There was a marked revival of interest in Bruegel, and his graphic work in particular, in the north Netherlands during the years around 1600, the so-called 'Bruegel Renaissance'. By that time, however, a number of works had been erroneously attributed to him, notably the print series designed by the Master of the Small Landscapes.

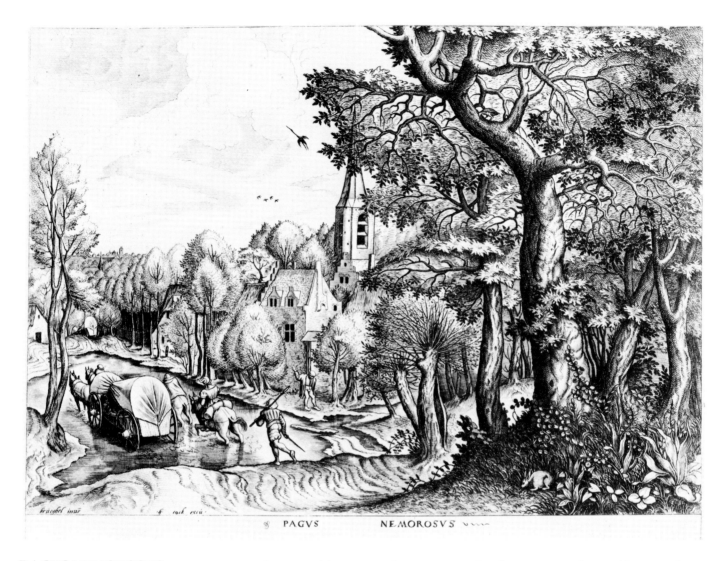

PAGVS NEMOROSVS

PAGUS NEMOROSUS
(A Forest District)

Cat. no. 5
Etching and Engraving, 323 × 430mm
Signed: brueghel inve. h. cock excu.
Inscribed bottom left: PAGUS NEMOROSUS
London, British Museum, Department of Prints and
Drawings (Inv.no.1928–12–12–13)

Literature VB 16 (First state); Freedberg pl.2

This is one of the *Large Landscapes*, a series of twelve engravings designed by Bruegel shortly after his return from Italy and published by Hieronymous Cock. They date from 1555/6 and the artist in Cock's shop who transferred Bruegel's designs to the plates of this series in a mixture of etching and engraving techniques has been identified as Jan or Lucas van Deutecum. This is the most characteristically 'Flemish' of the landscapes and the closest in spirit to the print series by the Master of the Small Landscapes which was attributed to Bruegel in 1612 (cat.no.18). A covered waggon passing through a forest fords a stream on its way to the town on the distant horizon. The house has stepped Flemish gables. Bruegel has lowered the viewpoint from the 'bird's-eye' view of the rest of the series, a very important aspect of the move towards a more naturalistic account of landscape, and introduced animated figures of a type which was later to feature in *The Months*. In the right hand foreground he reveals his study of the Venetians in the depiction of the clump of trees and, at their foot, the rich mass of foliage in which crouches a rabbit.

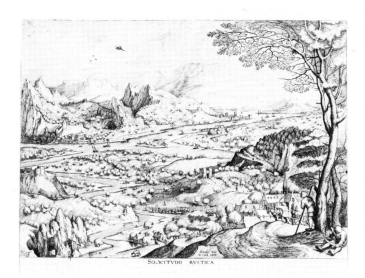 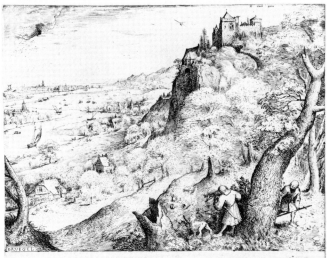

SOLICITUDO RUSTICA
(Country Concerns)

Cat. no. 6
Etching and Engraving, 322 × 424mm
Signed: brueghel Inve H. Cock excu
Inscribed bottom centre: SOLICITUDO RUSTICA
London, British Museum, Department of Prints
and Drawings (Inv.no.1922–4–10–264)

Literature VB 12

Another of the *Large Landscapes* series, this can be placed very clearly within the Antwerp landscape tradition: the extensive river landscape with outcrops of rock, distant clumps of trees and scattered farm buildings, all seen from a 'bird's-eye' view, is the most conventional type, constantly painted by Patinir and Herri met de Bles. What is perhaps surprising is that, despite the months he had just spent in the Alps, Bruegel did not introduce more naturalistic elements into the composition. It has been suggested that he was obliged by his publisher to cater for popular taste in landscape, but there is no evidence for this. Bruegel had been trained in the Antwerp landscape tradition and was content to work within it. The preparatory drawing for this engraving, in the British Museum, is unsurprisingly no more naturalistic: it is a carefully worked-out studio drawing. Bruegel also used a closely related variant of this landscape composition in his *Parable of the Sower* of 1557.

THE RABBIT HUNTERS

Cat. no. 7
Etching, 215 × 290mm
Signed, lower left: BRVEGEL 1506 (the last two
digits were accidentally transposed by Bruegel)
and inscribed, top right, H. cock excu
London, British Museum, Department of Prints
and Drawings (Inv.no.1878-7-13-131)

Literature VB 1; Berlin 1975, 75 (copy of the
preparatory drawing in the Institut Néerlandais)
and 75a; C. White in Berlin 1979, pp.187–91

This is the only etching by Bruegel himself and must date from 1560. His usual procedure was to make a drawing which he would then hand over to his publisher, Hieronymous Cock. Cock would assign one of his specialist engravers to the task of transferring Breugel's design on to the plate. In this unique instance Bruegel, having made a preparatory drawing, etched the plate himself. While in terms of the composition it is closely related to the *Large Landscapes* series (and, indeed, the painted series of *The Months*), the graphic technique – with the characteristically short, vigorous strokes and dots of Bruegel's drawings – is very different.

The hunters conceal themselves behind the thick trunk of a tree on a coulisse in the foreground. In front of them is a sheer cliff, at the top of which is a strongly fortified castle. To the left is an extensive river landscape, enlivened by sailing boats, churches, farms and windmills.

It has been suggested that the print illustrates a saying of Erasmus – *Duos insequens lepores neutrum capit* (He who hunts two hares catches neither).

Jan BRUEGHEL the ELDER 1568 – 1625

Literature Winner; Ertz

He was born in Brussels, the second son of Pieter Bruegel the Elder. His father died in the year after his birth; he learnt watercolour and gouache painting from his grandmother, Marie Bessemer, and oil painting from Pieter Goetkint. He may have stayed in Frankenthal with Gillis van Coninxloo before travelling to Italy. He was in Naples in 1590 and in contact with Paul Bril in Rome in 1591; later he travelled to Milan where he entered the service of Cardinal Federigo Borromeo. He returned to Antwerp in 1596; he joined the guild there in the following year (he served as deacon in 1601/2), and the Romanists' Guild in 1599. He was court painter to the Archduke Albert and the Archduchess Isabella, and also travelled to Brussels, Prague (1604), Nuremberg (1606) and Spa (1612). He painted landscapes, flower pieces, and multi-figured history paintings. He collaborated with his friend Rubens on a number of works and also with Hendrick van Balen, Hendrick de Clerck, Joos de Momper and others. He died in Antwerp.

Jan Brueghel the Elder made numerous drawings and painted copies after his father's work and yet – unlike his elder brother Pieter the Younger – his is not in any sense a derivative art. He developed his father's landscape style in the direction of greater elegance, more detail and higher finish.

TRAVELLERS ON A COUNTRY ROAD

Cat. no. 8
Copper, 25.7 × 37cm
Signed: Lower left: BRVEGHEL. 1616.
London, Wellington Museum, Apsley House
(Inv.no.1634–1948)

Provenance Spanish royal collection; Royal Palace inventory of 1772.one of the eight paintings by Jan Brueghel or his followers described in general terms under no.956. Captured by Wellington at Vitoria in 1813
Literature Ertz 306; London, Victoria and Albert Museum, Catalogue of Paintings in the Wellington Museum (by C.M. Kauffman), London, 1982, 22 (p.38)

This is a familiar type of landscape composition in Brueghel's work – an open, flat landscape, closed by a tall tree at one side, a foreground coulisse with prominent figures at the other, and a diagonal screen of trees taking the spectator's eye into the distance. Jan Brueghel often employed such compositional schemata. Despite the formulaic composition and the failure to resolve the transition from foreground to background, the vivacity of Brueghel's figures and his skilful depiction of individual elements of the landscape make this an outstanding example of his mature landscape style, which is elegant, decorative and colourful.

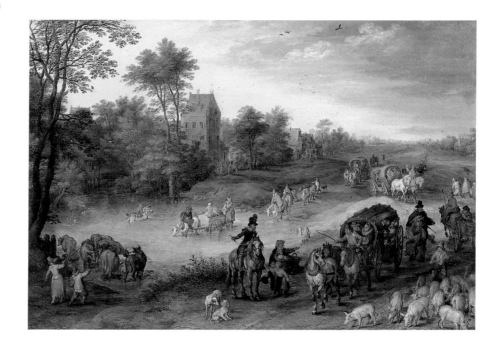

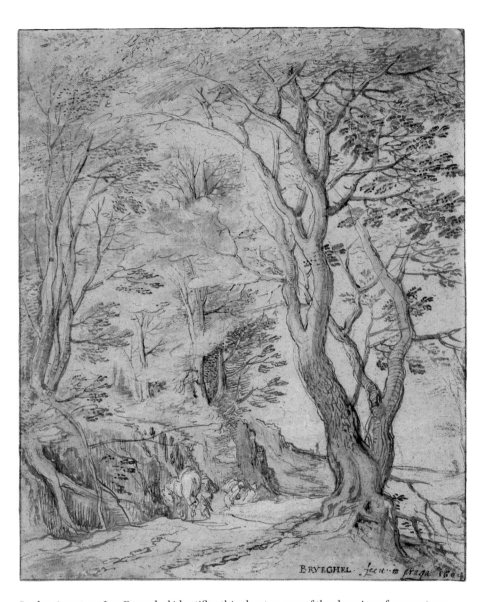

A WOODLAND ROAD

Cat. no. 9
Pen and brown ink, with brown wash,
231 × 193mm
Signed, lower right: BRVEGEL fecit in praga 1604
London, British Museum, Department of Prints
and Drawings (Inv.no.1853–8–13–44)

Literature Hind 3

In the signature Jan Brueghel identifies this sheet as one of the drawings from nature made during his trip to Bohemia in 1604. Like Roelandt Savery, Paulus van Vianen, Pieter Stevens and other Netherlandish artists at the court of Rudolf II, he was impressed by the unfamiliar flora and fauna of central Europe and drew the fir trees on the hills around Prague and the rocky paths between them. He was to use these drawings for paintings made after his return to his Antwerp studio.

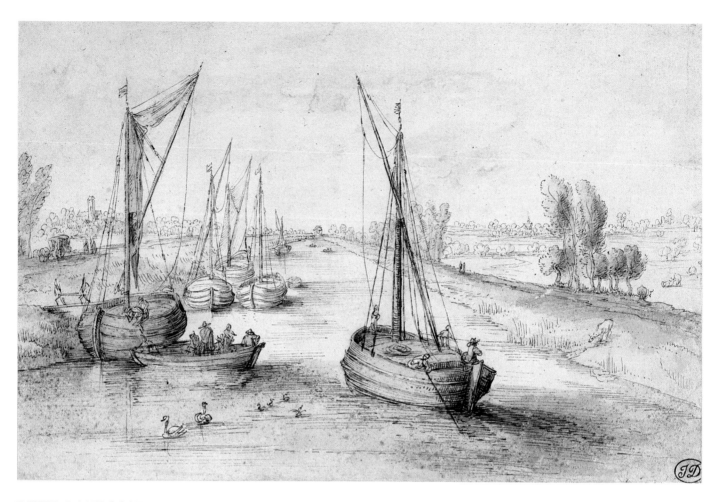

RIVER LANDSCAPE

Cat. no. 10
Pen and brown ink, with brown, blue and yellow
washes, 195 × 298mm
London, British Museum, Department of Prints and
Drawings (Inv.no.1883–8–11–36)

Provenance The collector's mark is that of Jollivet
du Pan (L6724). Purchased by the British Museum
in 1883
Literature Hind 8

The central motif in this freely drawn panoramic landscape is the river which,
supported by earthen embankments high above the surrounding countryside, recedes
into the far distance. On the left is a vessel unloading, a focus of human interest
characteristic of Jan Brueghel's landscapes.

(After Pieter BRUEGEL the ELDER)

FOREST LANDSCAPE WITH WILD ANIMALS

Cat. no. 11
Pen with brown ink, 344 × 257mm
London, British Museum, Department of Prints
and Drawings (Inv.no.1910–10–13–7)

Literature Hind 2; Berlin 1975, 43; Gerszi 1976,
p.220/1 (attributed to Bril)

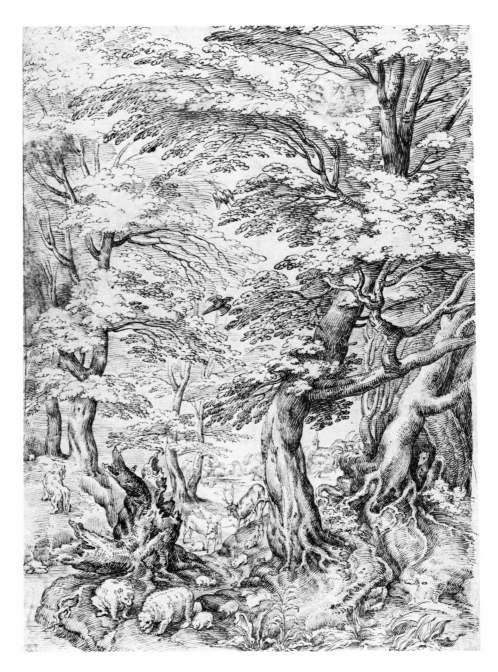

The attribution of this drawing is disputed. It is known to preserve a composition by
Pieter Bruegel the Elder and is usually attributed to his son, Jan Brueghel the Elder,
although attributions to Bril and even to Pieter Bruegel the Elder himself have been
proposed.

 In the context of this exhibition, it shows Pieter Bruegel the Elder's profound interest
in the representation of dense forests, composed of gnarled old trees with intricate roots
and trunks, amongst which wild animals – in this case deer, rabbits, bears and a lion –
feed. It is a theme in Bruegel's work which has been identified relatively recently
(Arndt 1972) as it survives only in drawings (some of them copies), but it was to prove
very influential on the forest landscapes of Gillis van Coninxloo and the Frankenthal
school and of Roelandt Savery.

Adam ELSHEIMER 1578 – 1610

Literature Andrews (with all previous literature)

He was born in Frankfurt and is said to have been the pupil of a local painter, Philipp Uffenbach. He travelled to Strasbourg before 1596 and in 1598 to Venice, where he came into contact with Hans Rottenhammer, a Munich painter who was living there. By April 1600 he was in Rome, where he remained for the rest of his life; in 1606 he became a member of the Accademia di San Luca. He lived in the same house in Rome as a certain 'Henrico pictore' who has been identified as Hendrick Goudt, a Dutch artist who was apparently both pupil and patron, and engraved a number of Elsheimer's most important compositions (for Goudt's biography, see below, p.104). Elsheimer is said by Sandrart to have worked very slowly; this caused him to contract debts which led to his being imprisoned for a time shortly before his death. He was buried in December 1610, in the church of S. Lorenzo in Lucina.

Elsheimer was trained as a figure painter and his earliest works are small-scale religious scenes on copper. His contact with the work of Titian and Campagnola in Venice, with Muziano in Rome and, even more decisive, with the Flemish painter Paul Bril, also in Rome, caused him to become increasingly interested in the representation of landscape. The landscape backgrounds in his paintings became more important and in pictures like Tobias and the Angel *(cat.no.12),* Aurora *(cat.no.14) and* The Flight into Egypt *(cat.no.15), they dominate the figures. The scale of Elsheimer's work, which is almost exclusively painted in oil on copper, is always small; figures and landscape are described in minute detail and with great delicacy. Light is used to model forms and to create atmosphere: he painted a number of night pieces in which the moon, a torch or a fire illuminates the scene. Despite his early death, Elsheimer's work was immensely influential, particularly through the medium of prints after his paintings by Goudt and Wenceslaus Hollar, which circulated widely, especially in the Netherlands.*

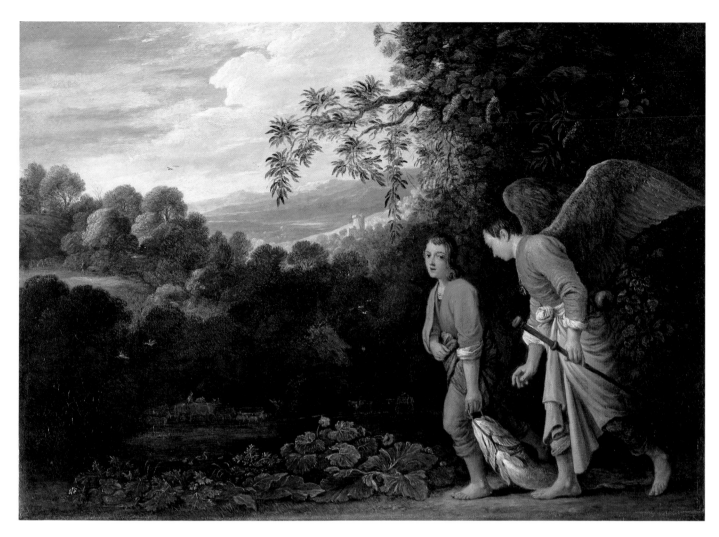

(After ELSHEIMER)

TOBIAS AND THE ANGEL
(THE 'LARGE TOBIAS')

Cat. no. 12
Copper, 19.3 × 27.6cm
London, The National Gallery (Inv.no.1424)

Provenance (in full in Levey, cited below under Literature): Possibly in the Dr Richard Mead sale, London, 21 March 1754 (lot 49): bought for William Beckford. In the William Beckford (junior) sale, London, 27 February 1802 (lot 26): bought by Seguier. In the George Watson Taylor collection by 1819; Watson Taylor sale, London, 14 June 1823 (lot 31); bought by Thwaites. In the E. Phipps collection in 1854 (when seen by Waagen); Phipps sale, London 25 June 1859 (lot 40): bought by Henry Farrer. By 1879 in the collection of Samuel Sanders by whom bequeathed to the National Gallery in 1894
Literature M. Levey, *The German School*, National Gallery Catalogues, National Gallery, London, 1959, pp.40–2; Andrews 25(b).

Elsheimer was fascinated by the story of Tobias and the Angel. He treated it in three different painted compositions – the so-called *'Small Tobias'*, the *'Large Tobias'* and one of the very small copper panels now at Petworth. In all these he depicted the passage in the story from the Apocrypha in which the angel accompanies the boy Tobias on his return home. Tobias carries a large fish whose innards will be used to cure his father's blindness.

This is an early copy after the *'Large Tobias'*. The composition was engraved by Goudt in 1613 but the painting, which was presumably in Goudt's possession at that time, is now lost. The contemporary copy at Copenhagen (Statens Museum for Kunst: Inv. no.Sp.745; see Andrews, loc. cit.) follows the details of the composition more closely than does this painting.

This painting varies in a number of minor details from the original composition as recorded in Goudt's print. It was in such copies, as well as in Goudt's prints, that Elsheimer's compositions were widely disseminated in the Netherlands.

Goudt was probably born in The Hague. He was the son of Arnout Goudt, steward of Louise de Coligny, widow of William the Silent. Nothing is known about his training, but two artists working in The Hague, Jacques de Gheyn II and Simon Frisius, have been suggested as possible teachers. He went to Rome in about 1604 and there lived in Elsheimer's house until he moved to another house nearby in 1610; he may have been a pupil of Elsheimer. According to Sandrart, he bought all the work that Elsheimer could produce. His first two engravings after Elsheimer's work (dated 1608 and 1610) were done while he was still in Rome.

In 1611 Goudt returned to the Netherlands and settled in Utrecht, where he entered the guild as an engraver. In 1612 he bought considerable property in and near the city. Sandrart visited him in 1625/26 and found his mental powers to be impaired; there are also documentary references to his being 'simple'. He died in Utrecht.

Only seven prints by Goudt are known and they are all after Elsheimer. He is, however, one of the most influential Netherlandish printmakers of the seventeenth century, particularly in his rendering of night-time effects. These dark tonalities look forward to Rembrandt's 'dark manner' prints and the beginnings of the technique of mezzotint.

(After ELSHEIMER)

TOBIAS AND THE ANGEL (THE 'SMALL TOBIAS')

Cat. no. 13a & 13b
Engraving, 133 × 189mm
Inscribed, on the left: A Elsheimer/pinxit
and on the right: H Goudt sculp.'/Roma 1608
Incolumis Raphaele viam monstrante Tobias,/Per varios casus, itque reditque domum./Tu quoque, si sequeris quo custos Angelus anteit,/securus caeli regna Paterna subis. (With Raphael as his guide, through various mischances Tobias sets out and returns safely home. You too, if you will follow where your guardian angel leads, can come home safely to the Father's Kingdom of Heaven.)
London, British Museum, Department of Prints and Drawings (Inv.nos.S.4957 and 1868–8–22–796)

Literature Sandrart p.160; Holl. 1; Andrews 20(a)

According to Sandrart in his life of Elsheimer, it was this composition that made the artist famous in Rome. The original painting from which Goudt made his superb engraving is probably the small copper now in the Historisches Museum in Frankfurt. It is dated by Andrews to c.1607/8 and was reproduced by Goudt soon after it was painted. The screen of precisely rendered trees which gradually reduce in scale as they recede, and the reflections of their branches and leaves in the water, are particularly effective.

The print is shown here in two states: the first (of which this is the unique example) before the inscription was added and the second with its elegant calligraphy decorating the border.

(After ELSHEIMER)

AURORA

Cat. no. 14
Engraving, 128 × 169mm
Inscribed: AURORA amoto noctem velamine
pellens/ Optatum roseo reddit ab ore diem (Dawn,
removing her veil and driving away the night,
restores the hoped-for day with the radiance of her
rosy face)/ 1613 H GOUDT Palat. Comes, et Aur.
Mil. Eques.
London, British Museum, Department of Prints and
Drawings (Inv.no.F.3–104) second state

Literature Sandrart p.161; Holl. 7; Andrews
discussed under 18

Goudt's engraving is after a painting by Elsheimer which today is in the Herzog Anton
Ulrich-Museum at Braunschweig. It is dated by Andrews to c.1606. In making the
engraving after his return to Holland, Goudt, who presumably owned the painting, did
not include the left hand side of the composition, which in its present state includes the
figure of a striding herdsman. Apparently this figure is a recent addition and originally
there were two figures in this area. The painting may originally have had a
mythological subject such as Acis and Galatea. Indeed, if it does not have such a
subject, it would be unique in Elsheimer's *oeuvre*, which contains no examples of pure
landscape. For Goudt, however, in Utrecht in 1613, the idea of a dawn landscape
without a mythological or religious subject was entirely acceptable and he had no
compunction in truncating the composition to create one.

In the painting the extensive landscape, viewed from above, the clouds in the sky
and the bushes on the hillside are all suffused by delicate sunlight which throws the
foreground into shadow. It is a lyrical, almost 'Virgilian' scene and is important as a
precursor to the landscapes of Hercules Segers and Jan van de Velde (who probably
knew it only in the form of Goudt's print). The hills and the buildings in the lower left
hand corner are reminiscent of the villa of Maecenas and the Anio valley below Tivoli.
The format, however, is of a familiar Netherlandish type with the diagonal foreground
coulisse and the extensive landscape beyond: it recalls Bruegel's *Large Landscapes* series,
for example.

(After ELSHEIMER)

THE FLIGHT INTO EGYPT

Cat. no. 15
Engraving, 293 × 397mm
Inscribed: Profugit in tenebris Lux mundi, et
conditor orbis/Exul apud Pharios latitat res mira
Tyrannos/ Rebus in adversis exemplum hinc
sumite Christi,/ Quem semper tristi fortuna
exercuit ira. (The light of the World takes refuge in
the darkness, and the creator of the Earth lurks in
hiding (a wondrous thing!) in the land of the
tyrant Pharaohs. In times of adversity, take hence
the example of Christ, who was ever dogged by
Fortune's bitter wrath.) /H Goudt Palat. Comes, et
Aur. Mil. Eques. 1613
London, British Museum, Department of Prints
and Drawings (Inv.no.S. 4960)

Literature Sandrart p.162; Holl. 3; A. O. Cavina,
'On the Theme of Landscape: Elsheimer and
Galileo, *BM*, 118, 1976 pp.139–44;Andrews
discussed under 26

Goudt's engraving is after a painting by Elsheimer on copper in the Alte Pinakothek in Munich, inscribed on the back with the date 1609. It was in Elsheimer's house at the time of his death, as is noted in his inventory, but must have been taken by Goudt (who showed it to Sandrart) back to Utrecht, where he engraved it in 1613. The largest and most ambitious of Goudt's seven engravings, it has always been the most admired of Elsheimer's 'night pieces', particularly for the effect of the Milky Way in the sky and the reflection of the moon on the water. It was an enormously influential composition: when Rubens and Rembrandt came to paint this subject, in 1614 and 1647 respectively, they both based their very different paintings on Elsheimer's prototype. William Buytewech and Jan van de Velde were among the many other early seventeenth-century Netherlandish artists who adapted Elsheimer's remarkable invention.

It has been argued (by Anna Ottani Cavina) that without Galileo's observation of the Milky Way through a telescope Elsheimer could not have represented the stars in the way in which he did. Andrews, however, has pointed out that apart from the discrepancy in the dates – the inscription on the back of the Munich panel is 1609 and Galileo did not make his observation until the following year – the astronomer only confirmed what could be seen by the naked eye, especially in southern Europe. Furthermore, Elsheimer shows the sky in a scientifically incorrect manner: the bright moon would make the starry sky invisible and the Great Bear is in the wrong position. In fact, Elsheimer did not set out to present the latest scientific discoveries in a naturalistic manner, but simply to evoke a star-filled moonlit sky.

It is worthy of note that, in his prints made in Italy, Goudt credited Elsheimer as the *inventor*, but in his later prints, made after Elsheimer's death and Goudt's return to Utrecht, he did not.

The beautiful calligraphic inscription, which plays on the idea of the 'Light of the World' fleeing into the darkness, is an integral part of the overall aesthetic effect intended by Goudt.

Abraham GOVAERTS 1589 – 1626

He was born in Antwerp and worked there all his life. He entered the guild in 1607 and served as deacon in 1623/4. A landscape painter in the manner of Gillis van Coninxloo, he was also influenced by Jan Brueghel the Elder, and is, for these reasons, interesting as a representative of Antwerp landscape painting in the first quarter of the seventeenth century. He painted thick forest landscapes in which the massive trees render the small foreground figures insignificant.

FOREST LANDSCAPE

Cat. no. 16
Panel, 62.5 × 101cm
Signed and dated, lower centre: AGovaerts (AG in monogram)/1612
The Hague, Mauritshuis (Inv.no.45)

Provenance From Oranienstein Castle. In the Cabinet of Willem V of Orange.
Literature Bernt 315; Mauritshuis Illustrated General Catalogue, The Hague, 1977, p.98

An outstanding work in Govaerts' mature manner, this is an excellent example of the Flemish forest landscape style as practised by Coninxloo and his followers and extravagantly praised by Van Mander in the *Schilderboeck* (for Van Mander on landscape, see above pp.35–43). It contains all the elements admired by Van Mander – large tree trunks in the foreground, recession indicated by marked divisions of light and dark areas, a distant view of mountains, precise leaf painting – as well as a tunnel of trees with light at the far end and a picturesque figure group, including a birdcatcher resting on a fallen tree and an elegantly dressed huntsman having his palm read by a gypsy. While the composition as a whole is highly artificial, there can be little doubt that for the description of naturalistic detail – trees, leaves, ferns, clouds, and the subtle atmospheric effects in the distance – Govaerts would have made studies from nature, just as Van Mander recommended young artists to do.

Literature H. Devisscher, 'Bijdrage tot de studie van de zestiende-eeuwse Vlaamse landschapschilder Kerstiaen de Keuninck', *Gentse Bijdragen tot de Kunstgeschiedenis*, 26, 1981–4, pp.89–160 (with catalogue raisonné); A. Zwollo, 'Pieter Stevens: Nieuw werk, contact met Jan Brueghel, invloed op Kerstiaen de Keuninck', *Leids Kunsthistorisch Jaarboek*, 1982, pp.95–118.

He was born in Antwerp and became a master in the guild there in 1580. He is frequently mentioned in the guild records in the 1580s and 1590s.

There is only one signed painting, in Ghent. The landscapes which have been grouped around this show strong links with Gillis van Coninxloo, Joos de Momper and Roelandt Savery. His work also displays elements of drama and fantasy which relate it to that of Lucas and Frederick van Valckenborch, two Antwerp painters who settled in Germany.

De Keuninck also had some contact with the so-called 'School of Prague', the group of artists (among whom was Roelandt Savery) who worked in the city for the Emperor Rudolf II. It has recently been shown that a painting by De Keuninck is based on an engraving by Aegidius Sadeler after Pieter Stevens. The painting (in Karlsruhe) can be dated on this basis to shortly before 1610.

PANORAMIC LANDSCAPE WITH TOBIAS AND THE ANGEL

Cat. no. 17
Panel, 28.7 × 52.4cm
The Hague, Private collection (on loan to the Rijkmuseum, Amsterdam Inv.no.C1588)

Literature Ex. cat. Dordrecht 1963, 63; illustrated and briefly discussed by J. Nieuwstraten in his review of that exhibition, *Apollo*, 1963, p.227

Apparently unknown to Devisscher when he was preparing his monographic article on the artist, this is an excellent example of De Keuninck's mature style. He specialized in fantastic landscapes with religious or mythological subjects and scenes of disaster such as the burning of Troy and the destruction of Sodom. In this small, sketch-like panel the tiny figures of Tobias, the Archangel Raphael and the dog can scarcely be made out. They walk through a mountainous landscape with a meandering river in the background seen from a conventionally high viewpoint. The painting is remarkable for the vivacity of its sketchy treatment: on the left the waterfall and the herons diving for fish are rendered in single, loose brushstrokes. The composition is closed off at the right in a contrived manner by a single tall tree. The scene is painted almost entirely in subtly differentiated tones of brown and green.

De Keuninck's style did not change radically during his maturity and a precise chronology is difficult to construct (Devisscher lists only four dated paintings). This landscape should probably be dated to c.1620.

Master of the Small Landscapes

Literature Berlin 1975, p.139ff; Berlin, *Bruegel*, pp.17–28

In 1559 the Antwerp publisher and printmaker Hieronymous Cock published a series of fourteen small landscape prints with the title Multifariarum casularum ruriumque lineamenta curiose ad vivum expressa* *(The features of various cottages and country places shown carefully and clearly from the life) (1559). Neither the designer nor the engraver was named. Two years later, in 1561, he published thirty more landscapes of the same type under the title* Praediorum villarum et rusticarum casularum icones elengantissimae *(sic)* ad vivum in aere deformatae *(Very fine images of properties, farms and country cottages rendered in copper from the life), again omitting the artists' names. Both series were reprinted by Cock several times in subsequent years, but the designer was never named. In 1601 the Antwerp publisher Theodoor Galle brought out a new edition containing the two original series and entitled* Regiones et villae rusticae . . . *(Country districts and farms) with an attribution to Cornelis Cort. When C.J. Visscher published a further edition in Amsterdam in 1612,* Regiunculae et Villae . . . Brabantiae *(Brabantine country farms and cottages) he attributed them to Pieter Bruegel. In more recent years the Master has been identified with Hans Bol, Cornelis Massys, Cornelis van Dalen, Hieronymous Cock himself and Joos van Liere. None of these identifications has been widely accepted and the Master remains anonymous to this day. In the context of this exhibition precise identification of the Master with one of the leading Antwerp landscape artists of the mid sixteenth century is less important than the enormous influence which the Master's designs had on the development of landscape in the Netherlands. This is discussed in the Introduction on pp.18–19.*

**The Dutch subscription reads:— Vele ende seer fraeye gheleghentheden van diverssche Dorphuysinghen, Hoeven, Velden, Straten ende dyer ghelijcken, met alderhande Beestkens verciert. Al te samen gheconterfeyt naer dleven, ende meest rontom Antwerpen gheleghen sijnde. Nu eerst nieuwe ghedruct ende wt laten gaen by Hieronymous Cock. (1559.) Cum gratia & privilegio Regis. (Many and very attractive scenes of various village houses, barns, fields, roads and other similar things, with their animals shown. All made from the life and mostly taken from around Antwerp. Being printed and published for the first time by Hieronymous Cock.)*

 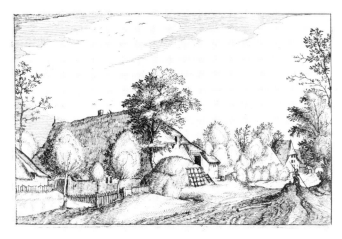

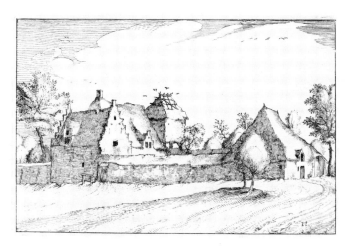 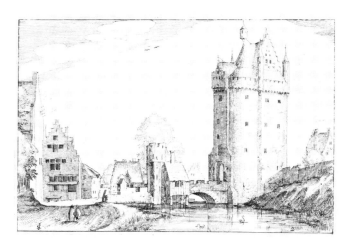

FOUR ENGRAVINGS FROM THE SERIES *REGIUNCULAE ET VILLAE . . BRABANTIAE* (BRABANTINE COUNTRY FARMS AND COTTAGES)

Cat. no. 18 a-d
Engraved by C.J. Visscher after designs of the Master of the Small Landscapes and published by Visscher in 1612.
Engravings, 99 × 180mm
London, British Museum, Department of Prints and Drawings (Inv.nos.1936–11–16–4,5,13,14)

Literature VB 70, 71, 80, 81

The first of these engravings is the title page of the series. It is inscribed on an illusionistic paper pinned on the barn wall: REGIUNCULAE ET VILLAE/ALIQUOT DUCATUS BRA-/BANTIAE, À P. BRUEGELO/DELINEATAE, ET IN PICTO/RUM GRATIAM, À NICO/LAO IOANNIS PISCATORE/EXCUSAE, & IN LUCEM EDI/TAE. AMSTELODAMI (Some country farms and cottages of the duchy of Brabant, drawn by P. Bruegel, and, to please painters, engraved and published by Claes Jansz. Visscher. At Amsterdam). The date, 1612, is given on the ground beneath and on the far right is the monogram CJV. The other three prints are numbered on the lower right: 2, 11 and 12. (No. 2 also has the monogram CJV in the lower left corner.)

The complex history of this series of engravings – which in this edition were attributed to Pieter Bruegel the Elder – and their decisive influence on the course of landscape painting in the Netherlands are discussed above and in the Introduction. Brabant is to the south-east of Antwerp: in the late sixteenth century it was a prosperous agricultural area, dotted with small villages and farms which provided the Master's inspiration.

Joos de MOMPER 1564 – 1635

Born in Antwerp, he was the son and pupil of Bartholomäus de Momper, who apparently specialized in genre scenes. He joined the Antwerp guild of St. Luke at the early age of 17 in 1581 and in 1590 was married in Antwerp. In the intervening years he had been in Italy, but the details of his trip are unknown except that he apparently worked in the studio of Lodewyck Toeput, a Flemish émigré painter known as Il Pozzoserrato, in Treviso. Between 1591 and 1599 De Momper is recorded in the Antwerp guild records as having a number of pupils. He served as deacon in 1611 and died in Antwerp.

In his paintings De Momper can be considered as continuing the stylized and non-realistic Antwerp tradition of Patinir and Herri met de Bles. He worked within the conventions of the simple three-colour palette, the 'bird's-eye view' and the depiction of prominent, impossibly sheer rocks. Rather than move towards greater naturalism as artists were doing in the north Netherlands, he refined the Antwerp tradition in the direction of greater stylization. His own strongly calligraphic style was fully developed by the early 1590s and did not significantly change thereafter. It might be thought that such a style became very retardataire towards the end of De Momper's career but there is no evidence that he was unable to sell his paintings at that time. Indeed he continued to collaborate with some of the most outstanding figure painters of Antwerp, among them Frans Francken the Younger, Sebastian Vrancx and David Teniers the Younger.

A MOUNTAINOUS LANDSCAPE WITH THE STORY OF NAAMAN

Cat. no. 19
Panel, 138 × 173cm
Signed by both artists
The Trustees of the Kedleston Estate Trusts

Provenance In the 1760 Catalogue of Pictures at Kedleston Hall as bought by the 1st Baron Scarsdale

The figures in this painting of c.1620 are by Frans Francken the Younger.

The story of Naaman, captain of the army of the king of Syria, is told in the Second Book of Kings, chapter 5. Naaman was a leper who, hearing of a holy man in Israel who would be able to cure him, travelled to the house of Elisha. Elisha sent a messenger to Naaman instructing him to wash seven times in the Jordan. This he did and was healed. The moment in the story depicted by Joos de Momper and Frans Francken is described in verse 15: 'And he returned to the man of God, he and all his company, and came, and stood before him; and he said, Behold, now I know that there is no God in all the earth but in Israel . . .'

The landscape in which Naaman and Elisha meet is formulaic in the extreme with two overlapping coulisses and the extensive background beyond. De Momper makes no attempt whatsoever to suggest the landscape of Israel. The river is presumably intended to suggest the Jordan, but the boats on the river, and the buildings with their stepped gables and square towers, place the scene unequivocally in seventeenth-century Flanders.

What is of the greatest interest in the context of this exhibition is De Momper's willingness to work within what might seem to be exhausted conventions of landscape. He must have been aware of the movement toward greater naturalism in the depiction of landscape in the north Netherlands, but felt no desire to emulate it.

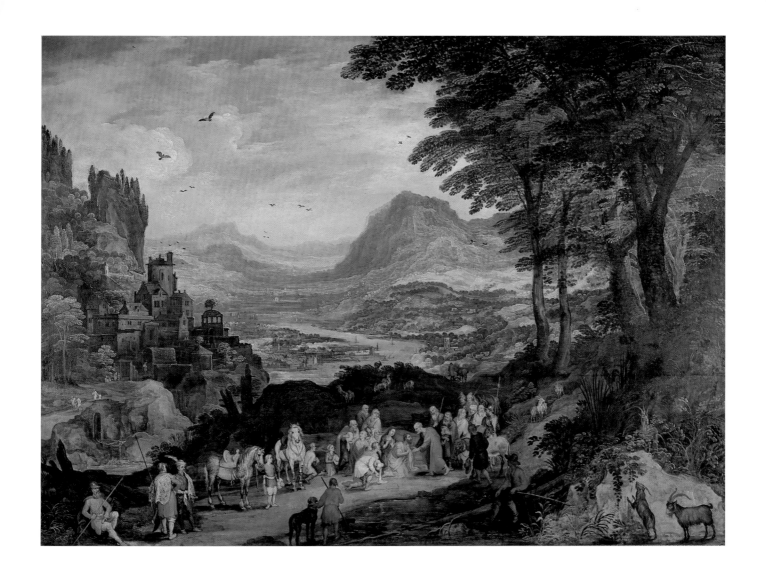

THE FLEMISH IMMIGRANTS

2

Hans BOL 1534 – 1593

Literature Franz p.182ff

He was born in Mechelen (Malines) where he was trained, travelled in Germany and was for some time in Heidelberg. He became a master of the Mechelen guild in 1560 and designed a series of engravings in 1562. As a consequence of the war, he fled from Mechelen to Antwerp in 1572 and then in 1584 to the north Netherlands. His last years were spent in Amsterdam, where he died. He was an influential teacher: among his pupils were Jacob Savery and Georg Hoefnagel.

He was a painter, a miniaturist and a print designer, whose subjects, often Biblical, were placed in extensive landscapes.

MARCH: PLANTING TREES

Cat. no. 20
Pen and brown ink on brownish paper,
172 × 259mm
Signed and dated, bottom left: HANS BOL/1573
London, British Museum, Department of Prints and
Drawings (Inv.no.1910–2–12–120)

Literature Popham 3; Franz p.192–3; Berlin 1975, under cat.no.5 (Berlin drawing)

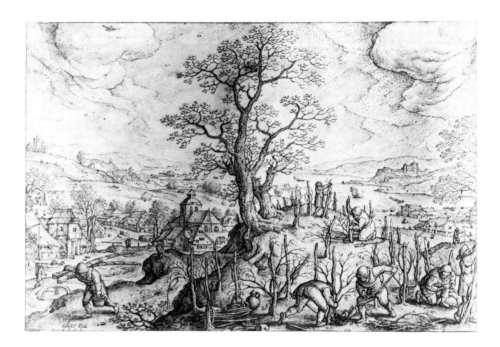

This is a design for an engraving, one of a series of *The Months*, to which drawings in Braunschweig and Berlin-Dahlem (likewise dated 1573) also belong. The series was engraved by Hans Collaert. There are strong similarities in all the designs to Pieter Bruegel's *Large Landscapes* series. Not only are the compositions similar, but Bol combines, as Bruegel did, a firm outline with short hatching strokes and dots. Although the central motif of the tree effectively divides the composition, as in Bril's *July and August* (cat.no.4), Bol's landscape and sky are continuous and his recession into the distance effective and convincing.

Gillis van CONINXLOO III 1544 – 1607

Literature Franz p.270ff

He was born in Antwerp into a famous family of painters; his father was the artist Jan van Coninxloo. After his apprenticeship (with his father and Gillis Mostaert) and a trip through France, he entered the guild of St. Luke in Antwerp as a master in 1570. Coninxloo was a devout Protestant and in 1585 (after the fall of the city to Alessandro Farnese's Spanish army) he fled Antwerp, fearing religious persecution. He went first to Zeeland, then in 1587 to Frankenthal, in the Palatinate between Heidelberg and Worms. He was the key figure in the so-called 'Frankenthal School', a group of Protestant landscape painters who found a haven in the town. By June 1595 Coninxloo had moved to Amsterdam, where he was buried on 4 January 1607.

His paintings are extremely rare and, being on panel, extremely fragile. He had a great reputation among contemporaries – for Carel van Mander, writing in 1604, he was the best landscape painter of the day – and played a crucial rôle in the transfer of Flemish landscape traditions to the north. He was an influential teacher in Amsterdam: among his pupils were probably Hercules Segers and Esaias van de Velde.

LANDSCAPE WITH HUNTERS

Cat. no. 21
Panel, 58.5 × 83.5cm
Signed in monogram: GVC 1605
Speyer, Historisches Museum der Pfalz
(Inv.no.H.M.1957/122)

Provenance Mayring Collection, Nuremberg; acquired by the Historisches Museum der Pfalz in 1957
Literature Franz p.280ff; Cologne/Utrecht, 1985/6, 80

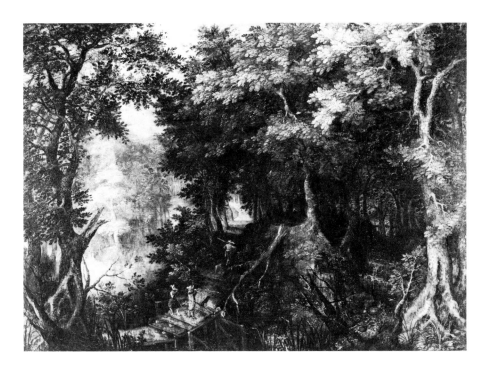

This is a superb example of Coninxloo's late style. It was painted ten years after his arrival in Amsterdam and shortly before his death. It shows his familiar subject, a heavily wooded forest, and is dominated by the trunks of immense trees in the foreground. The spectator's eye is led through the trees in three directions – into a sunlit clearing on the left, along a winding path in the centre and up a steep waterfall on the right. In the foreground the eye is caught by the three elegant, brightly dressed hunters, two of whom halt on the wooden bridge to shoot at the herons which perch on the bank at the water's edge. These very secular figures have replaced the religious and mythological ones of his earlier works and the wood has a more carefully elaborated sense of recession but essentially Coninxloo's style did not develop after he left Frankenthal. Praised by Van Mander as the greatest living landscape painter, he was content during his Amsterdam years to work steadily and painstakingly on his large, complex but basically repetitive compositions of wooded landscapes with diminutive figures.

(Nicholaes de BRUYN
after Gillis van CONINXLOO)

ELISHA CURSING THE
CHILDREN OF BETHEL

Cat. no. 22
Engraving, 459 × 591mm
Inscribed, lower right: Egidius Coninxlogensis
Inventor/Nicola de Bruyn Schulptor/1602/Cum
Elisaus ascenderet per viam, pueri parvi egressi
sunt de civitate, et illudebant ei, dicentes: Ascende
calve, ascende calve. Quicum respexisset, vidit eos,
et maledixit eis in nomine Domini: egressique sunt
duo ursi de saltu, et laceraverunt ex eis
quadraginta duos pueros. Lib 42 Reg Cap 2
Exemplum insigne senectutem esse honorandam
(A notable example that old age must be
respected) London, British Museum, Department of
Prints and Drawings (Inv.no.1861–8–10–444)

The horrifying episode shown by Coninxloo is described in chapter 2 of the Second Book of Kings (which is quoted from the Vulgate in the inscription): 'As he [the prophet Elisha] was going up by the way, there came forth little children out of the City [Bethel], and mocked him, and said unto him, Go up, thou bald head; go up, thou bald head. And he turned back, and looked on them, and cursed them in the name of the Lord. And there came forth two she bears out of the wood, and tare forty and two children of them.' The chapter coolly concludes: 'And he went from thence to Mount Carmel, and from thence he returned to Samaria.'

The obscure Old Testament subject, for all its moral value in illustrating the importance of respect for elders, merely provided an opportunity for Coninxloo to show a forest landscape with a town in the middle distance. It is formulaic in its general composition and in its detail.

Gillis Claesz. d'HONDECOETER c.1580 – 1638

He was born in Antwerp into a Protestant family of painters who left the town to escape religious persecution. He was trained in Delft, lived in Utrecht (where he married in 1602) and had settled in Amsterdam by 1628. He was a deacon of the Amsterdam guild in 1636 and died in the city. There are dated paintings from 1609 until 1629.

He was profoundly influenced, during his years in Utrecht, by Roelandt Savery who had settled in the town (see, for example, Hondecoeter's paintings of 1618 in Braunschweig and of 1620 in the Rijksmuseum). After he settled in Amsterdam he slowly abandoned the manner of Savery in favour of landscapes more closely based on observation of the countryside of Holland. A fascinating transitional figure, it was only gradually and rather timidly that he abandoned Flemish compositional schemes in favour of greater naturalism.

His son, Gijsbrecht, was a landscape and bird painter; his grandson Melchior (1636–1695), the bird painter, is now probably the best-known member of this distinguished dynasty.

A WOODED LANDSCAPE AT THE EDGE OF A VILLAGE

Cat. no. 23
Canvas, 52.5 × 85.5cm
Signed and dated, lower right: G.H. 1623
New Rochelle, New York, Private collection

In the context of the emergence of naturalistic landscape painting this is a particularly interesting transitional picture; it is also one of the finest works by this attractive but currently undervalued artist. Hondecoeter was not an original artist but rather one who gradually took up the innovations of others. If we compare this painting to Govaerts' *Forest Landscape* (cat.no.16), for example, we can see that the dense tangle of trees, with Saveryesque animals in front of them, has been moved to the right, and instead of a distant view of a river valley there is a picturesque village street. The village and the figures in the centre reveal Hondecoeter's study of Jan Brueghel the Elder. While Hondecoeter was profoundly influenced by these greater personalities, so crude an identification of sources does not do justice to the liveliness and charm of this village landscape.

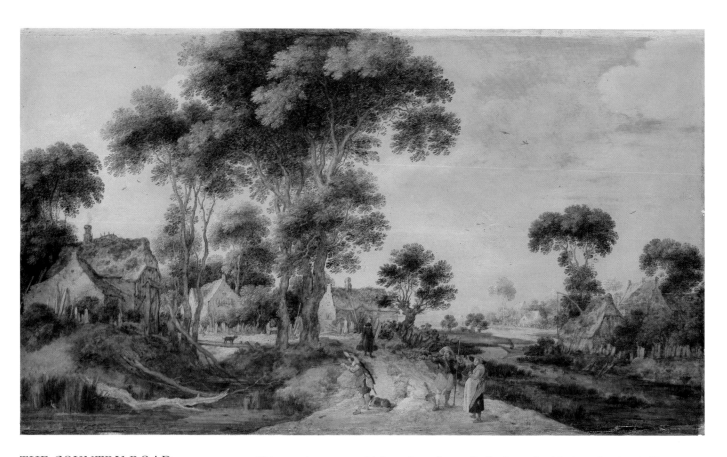

THE COUNTRY ROAD

Cat. no. 24
Panel, 40.5 × 72cm (strips of wood, of ½cm, have
been added later at the top and bottom of the panel)
Signed, lower left: G.DH (DH in monogram)
Amsterdam, Rijksmuseum (Inv.no.A1502)

This country scene, which so strongly recalls the type of subject-matter treated in
prints by the Master of the Small Landscapes and his follower, Claes Jansz. Visscher, was
probably painted in the early 1620s. It retains mannerisms of the Antwerp landscape
style such as the central group of trees and the strong fall of light in the left middle
ground to indicate depth. However, in the variety of farm buildings and of rural
activities and the openness of the composition, it displays real affinities with the new
naturalism of the Haarlem landscape painters.

Alexander KEIRINCX 1600 – 1652

He was born in Antwerp and joined the guild of St. Luke there as a master in 1619. Nothing is known of his training. At some time between 1626 and 1636 he moved to Amsterdam; in July 1639 King Charles I rented a studio in Orchard Street, Westminster, 'For the use and dwellings of Cornelius van Pollenburgh (sic) and Alexander Keyrinx, two Dutchmen'. Keirincx was in England and Scotland until at least 1641 making topographical paintings. He died in Amsterdam in October 1652.

FOREST LANDSCAPE

Cat. no. 25
Panel, 57 × 63cm
The Hague, Rijksdienst Beeldende Kunst
(Inv.no.NK1782)

Keirincx is best known today for his topographical views of palaces and castles in England and Scotland. As can be seen in this painting, however, his earlier work consisted of landscapes in the style of Coninxloo. This picture is almost a 'portrait' of the tree on the left which, arching over towards the right, dominates the composition. It is painted with the same attention to detail in the trunk, branches and leaves as Coninxloo employed and Van Mander, in his chapter on landscape, commended. The picturesque tree stump on the right and the view into the distance also accord closely with Van Mander's recommendations on how to paint a landscape. This entirely invented landscape – so different from Keirincx's accurate topographical views of around 1640 – is almost entirely without human figures. One solitary man, dwarfed by the trees and very hard to make out, rests on a mossy bank in the lower right hand corner. There are too few dated paintings by Keirincx to establish a reliable chronology for his stylistic development, but this picture was probably painted in the late 1620s.

Willem van NIEULANDT 1584 – 1635/6

Literature Thieme/Becker

He was born in Antwerp, into a large family of artists, and travelled to Amsterdam with his family while he was a child. There he was a pupil of Jacob Savery. Between 1602 and 1605 he was in Rome working with Paul Bril. He married in Amsterdam in 1606 but moved back to Antwerp. In 1629 he returned to Amsterdam where he remained for the rest of his life, although the exact place and date of his death are not known. He was also a poet and dramatist.

A WOODED MOUNTAIN ROAD

Cat. no. 26
Pen and brown ink, with brown, blue, green and yellow washes, 285 × 367mm
London, British Museum, Department of Prints and Drawings (Inv.no.1876–12–9–629)

Literature Hind 1; Spicer p.365 (as probably after a lost drawing by Roelandt Savery)

Willem van Nieulandt was a pupil of Jacob Savery in Amsterdam. In this drawing he can be seen working within the Savery convention of a wooded mountain pass, which goes back to Roelandt Savery's Tyrolean drawings, with their prominent pine trees, and to the forest drawings of Pieter Bruegel.

This particular sheet may have been based at least partly on studies from nature. It combines very detailed penwork in the drawing of the trees and rocks on the right and free brushwork with coloured washes to indicate the distant mountainous landscape on the left. Spicer believes it to reflect a design by Roelandt Savery known in a painting by him of 1612.

Roelandt SAVERY 1576 – 1639

Literature Spicer; Cologne/Utrecht, 1985/6

He was born in Kortrijk (Courtrai) and moved with his family (via Antwerp) to the north Netherlands. They apparently went first to Haarlem, where Roelandt's elder brother Jacob was paid for a picture in St. Bavo's in 1585 and is recorded as a member of the guild in 1587. By 1591, however, the family was in Amsterdam. Jacob was granted citizenship in October of that year; he was to die there in 1603. According to Van Mander, Roelandt was a pupil of Jacob. Hans Bol became a citizen of Amsterdam in the same year, 1591, and was undoubtedly in close contact with the Savery brothers. Roelandt's early work shows the influence of Bol and also of Gillis van Coninxloo, who was in Amsterdam by 1595. Roelandt was still in Amsterdam in August 1603; shortly afterwards he left for Prague, where he settled in 1604 in the service of the Emperor Rudolf II. He remained in the service of the Emperor until Rudolf's death in 1612; in 1606–7 he travelled through the Tyrol making studies of both the landscape and the flora and fauna. He stayed on in Prague to work for Rudolf's successor, the Emperor Matthias, but in February 1613 the artist received money for a three-month trip to Amsterdam and there is no firm evidence that he ever returned to central Europe. In 1616 he was in Amsterdam and he remained there until 1619, when he moved to Utrecht; he entered the guild there in the same year. In 1626 the Utrecht provincial assembly paid 700 guilders for a painting by Savery, to be presented to the Princess of Orange. He died in Utrecht and was buried in the Buurkerk.

Savery's rocky landscapes, which feature animals prominently and often include dramatic waterfalls and ruined buildings, frequently represent such appropriate Biblical or mythological subjects as the Garden of Eden or Orpheus charming the animals. Many contain reminiscences of the landscape of the Tyrol. He also painted flower still-lifes and animals, among them 'portraits' of horses. He also made a number of etchings.

Although to the modern eye Savery's landscapes may seem simply Alpine variations on a traditional Antwerp theme, he was not thought to be retardataire by contemporaries and was widely influential. Gillis d'Hondecoeter, Willem van Nieulandt and the Willaerts family owe a great debt to his landscape style; Herman Saftleven, Anthonie Waterloo and Jacob van Ruisdael also reveal familiarity with his work.

His nephew Hans Savery was his pupil and assistant.

THE TEMPTATION OF ST. ANTHONY

Cat. no. 27
Panel, 49.2 × 94.3cm
Signed and dated, lower left: R. SAVERY 1617
London, Private collection

This outstanding forest landscape by Savery came to light only recently. The figures of St. Anthony and his tormentors have been tucked away in the left hand corner of the composition and the real emphasis of the painting is on the trees, rocks, water, animals and birds. It demonstrates how persistent was the Antwerp convention of a small religious scene being incorporated into an extensive landscape.

The landscape is an amalgam of individual motifs, most of which are based on drawings made from nature by Savery during his stay in central Europe: the burst of sunlight through the trees, the dramatic waterfall, tall pine trees, goats and deer and the distant river landscape. The pine which divides the left side of the composition from the extensive view on the right is a familiar device of the Antwerp school.

FOREST LANDSCAPE

Cat. no. 28
Pen and black ink, with black chalk, and brown,
grey and yellow washes, 375 × 268mm
Inscribed (probably falsely), lower left: ROL.
SAVERIJ
London, British Museum, Department of Prints
and Drawings (Inv.no.1946–7–13–172)

Literature Hind, Add. 9; Spicer (Rejected)

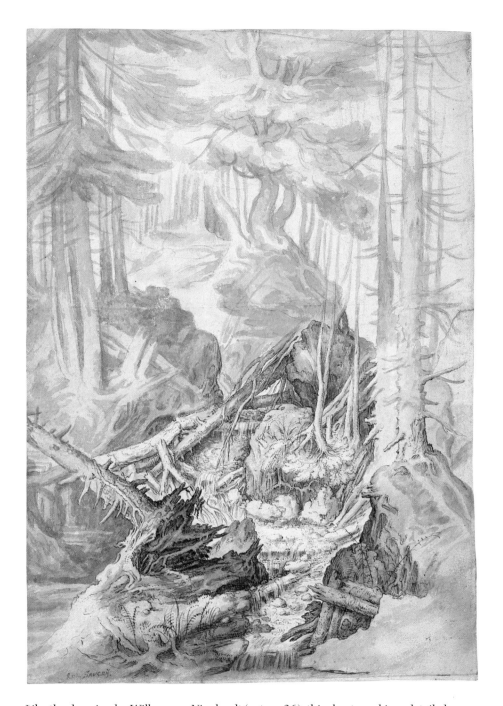

Like the drawing by Willem van Nieulandt (cat.no.26), this sheet combines detailed
penwork with black ink in the tree roots, the fallen trunks, grasses and the stream,
and far freer brushwork using coloured washes for the pines and the other trees in the
background. This may have been drawn from life in the Tyrol but is more likely, insofar
as one can make such distinctions, to have been drawn in the studio on the basis of
sketches made on the spot.

Spicer considers this drawing to be a copy after Savery: she believes the original
drawing to be the sheet in the collection of the late Professor van Regteren Altena
(Spicer C47).

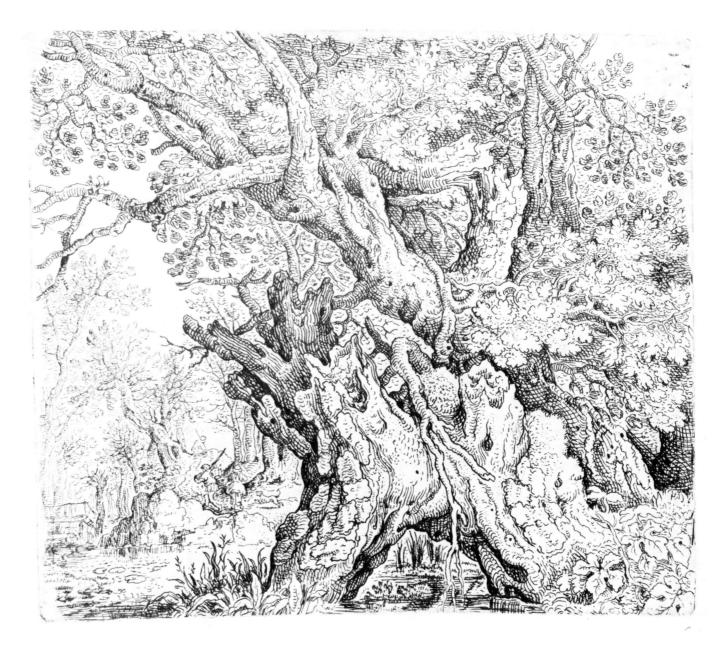

THE UPROOTED TREE

Cat. no. 29
Etching, 123 × 144mm
London, British Museum, Department of Prints and
Drawings (Inv.no.S. 5401)

Literature Wurzbach 1; Holl.2; Spicer E1

The subject of this etching is the complex pattern made by the roots of the tree: the three hunters and their dog in the background can scarcely be made out amidst the mass of criss-crossed lines. Pieter Bruegel the Elder was also fascinated by this subject, and Savery's print is very much in a Bruegelian tradition.

Jacob van Ruisdael was later to display a similar interest in this subject.

This is the first state. In the second state the plate is signed. The preparatory drawing is in Amsterdam (Spicer C56).

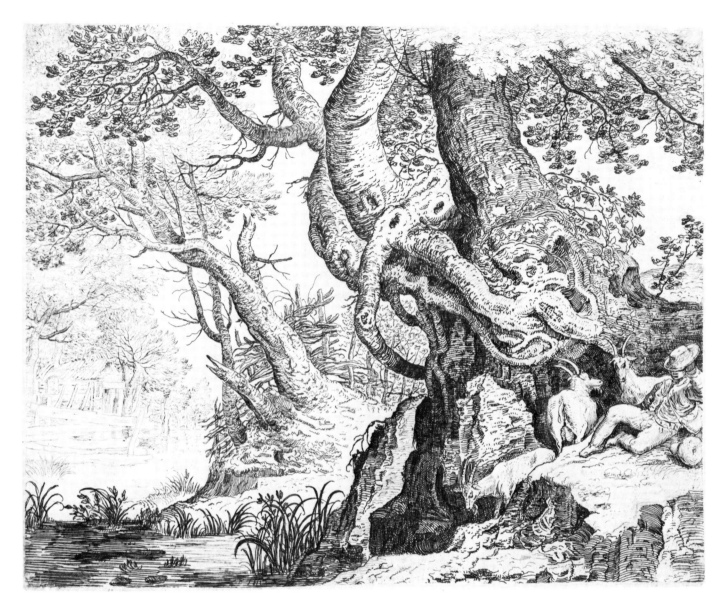

THE GOATHERD BETWEEN
THE TREES

Cat. no. 30
Etching, 205 × 261mm
London, British Museum, Department of Prints and
Drawings (Inv.no.1841–6–12–9)

Literature Wurzbach 2; Spicer E44

This is a further example of Savery's delight in the complexities of root formations.

According to Spicer, *The Uprooted Tree* is Savery's only etching. She believes that this etching was made after a design of Savery's by an unknown printmaker employed by the publisher, Marcus Sadeler.

Literature Goossens

He was born in Mechelen (Malines), but moved with his family to Antwerp in 1579. There he was a pupil of his father Philip (1545–1601), who according to Van Mander trained his son in the technique of watercolour in which he was a specialist. A year after the fall of Antwerp to the Spanish in 1585, the Protestant Vinckboons family was given permission to leave the city. They had settled in Amsterdam by late in 1586. Vinckboons spent his whole working life in the city and probably died there. The exact date of his death is not known: his wife is referred to as a widow in a document of 12 January 1633.

Vinckboons played a crucial role in the early development of genre painting in the north Netherlands. He painted groups of elegantly dressed men and women eating, drinking and making music in landscape; also vigorous scenes of peasant life, including kermesses, tavern brawls and street scenes with beggars and hurdy-gurdy players. He was an influential teacher in Amsterdam: among his pupils were Gillis d'Hondecoeter and, probably, Esaias van de Velde.

Landscape was not Vinckboons' central concern but many of his figure subjects are set in landscape of a type associated with the Flemish followers of Pieter Bruegel. On 1 March 1607 he attended the Amsterdam auction of the goods of Gillis van Coninxloo, whose work apparently influenced his own.

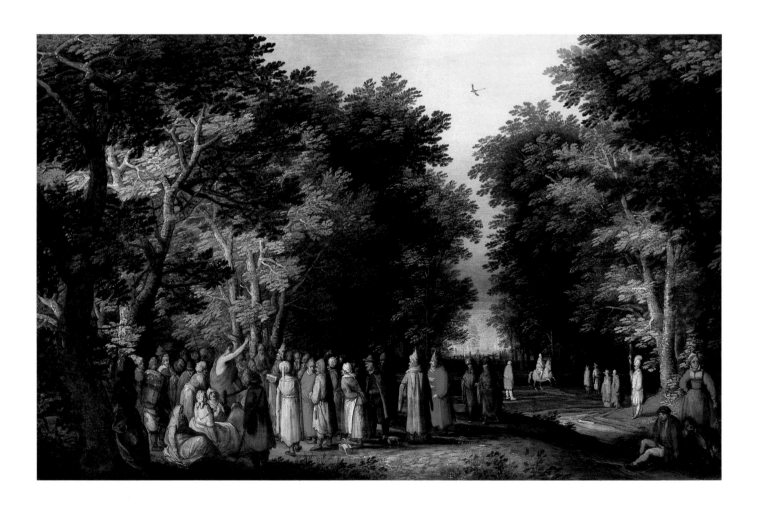

THE PREACHING OF ST. JOHN THE BAPTIST

Cat. no. 31
Panel, 26.4 × 41.1cm
Private collection, England

St. John, who according to the Gospel account preached to large crowds in the Jordan valley, is shown by Vinckboons in a clearing in a dense, wooded forest. The trees almost form a tunnel, parting to reveal an open space in the distance with more trees beyond. The overall deep-green tonality is relieved by the fall of sunlight from a gap in the trees above the saint and through another on the right hand side, as well as by the colourful dress of his audience. This small panel should probably be dated c.1615–20. Here, Vinckboons is clearly still working within the Antwerp landscape tradition; and it was in his studio and so within this tradition that both Gillis d'Hondecoeter and Esaias van de Velde were probably trained. It is only the sketchiness of Vinckboons' fluent technique – note, for example, the linearity of the muddy track on the right – that gives any hint of the new landscape style of Haarlem.

This subject was often treated by Netherlandish artists of the sixteenth and seventeenth centuries – including Pieter Bruegel the Elder in a painting of 1566 now in Budapest – and its popularity may reflect the contemporary debate concerning open-air sermons by Calvinist preachers.

(Johannes van LONDERSEEL after David VINCKBOONS)

LANDSCAPE WITH TRAVELLERS ATTACKED BY ROBBERS

Cat. no. 32
Engraving, 347 × 477mm
Inscribed, lower left: Davidt Vinckboons/inventor Jan Londerseel schulptor C J Visscher [CJV in monogram] excudit.
London, British Museum, Department of Prints and Drawings (Inv.no.1958–8–11–2)

This composition, although designed by Vinckboons in Amsterdam probably before 1610, is of a conventional Antwerp type which has already been encountered in the work of Coninxloo, Govaerts and others – large foreground tree-trunks, framing devices at either side, a central tree dividing the picture space, a 'tunnel' through the trees, the precise depiction of leaves and branches and a distant view. It must have been this type of landscape style in which Vinckboons trained his Dutch pupils.

The subject of travellers waylaid by robbers was treated by a number of Netherlandish artists in the years around 1600 and undoubtedly records a phenomenon which was a direct consequence of the war. Bands of brigands, many of them deserters from the Spanish or Dutch armies, or mercenaries, preyed on travellers and the inhabitants of isolated farms. In this case the attack takes place on the edge of a forest: the town which is the coach's destination can be seen in the left background. Such scenes serve to remind us that for all their picturesque qualities, the dense woodlands, painted and drawn with such skill by Coninxloo and Vinckboons, held real dangers for the contemporary town-dweller.

HAARLEM: THE FIRST GENERATION

3

Little is known of his life. His date of birth is unknown, as are any details about his training. However, he was probably born and apprenticed in Haarlem, where he died. His earliest dated painting is from 1625, and he is mentioned in Samuel Ampzing's description of Haarlem as a painter of landscapes with figures. In 1640 he took on apprentices and in 1643 he served as an officer of the Haarlem guild.

Bleker is a rare and little-studied artist, although those paintings that do survive, such as his hunting scene in Haarlem, are of remarkable quality. He made fourteen etchings of Biblical and rural subjects, in almost all of which cattle are prominently featured.

LANDSCAPE WITH CATTLE

Cat. no. 33
Etching, 152 × 236mm
London, British Museum, Department of Prints and Drawings (Inv.no.S.3047)

Literature Holl.8

In this etching, the freedom and liveliness of Bleker's technique is evident in the mass of tangled foliage in the left hand corner, the distant tree above it and the striding herdsman to its right. Though the subject (of cattle being driven to market by their peasant owners) is modest, Bleker has lavished all his graphic skill on it, subtly varying the intensity with which areas of light and shadow are worked.

LANDSCAPE WITH A PIPING SHEPHERD

Cat. no. 34
Etching, 143 × 213mm
Signed and dated, top right: G C Bleker (GCB in monogram) F.1638
London, British Museum, Department of Prints and Drawings (Inv.no.1846–6–11–419)

Literature Holl.6; Boston 1980/1, 78.

This is the second state of this etching, after Bleker had added, in the top right hand corner, a signature and date to the plate.

Although at first this might seem an example of down-to-earth Dutch realism, concentrating as it does upon the contours of the bodies of the cattle and the herdsman with his feathered cap, shepherd's crook and pipe, it belongs in fact to an idyllic world of pastoral convention. In the distance a group of figures, amongst them a man wearing a turban and a woman with an elaborate headdress, is gathered around a fountain. The allusion may be to the meeting of Jacob and Rachel at the well, which Bleker had represented in several etchings, one of which dates from the same year as this work. Ackley (in Boston 1980/1 loc. cit.) has pointed out that Bleker's technique of crisscrossing meshes of lines to define masses of tone is a more freely drawn adaptation of Goudt's engraving technique in his prints after Elsheimer. Cattle and shepherd are shown in the *chiaroscuro* of early evening. The shadows are heavily worked while the unworked areas of paper provide contrasting bright highlights.

PEASANT COUPLE ON THEIR WAY TO MARKET

Cat. no. 35
Etching, 203 × 304mm
Inscribed, lower right: G C Bleker (GCB in monogram) F1643 (4 reversed)
London, British Museum, Department of Prints and Drawings (Inv.no.S.3051)

Literature Holl.12

The subject of this etching is not strictly the landscape but the cart which contains the peasant couple on their way to market. Bleker has given them the almost statuesque prominence that he usually reserves for Biblical and mythological figures – the print represents a heroicization of the everyday.

Willem Pietersz. BUYTEWECH c.1591/2 – 1624

Literature Van Gelder 1931; Haverkamp Begemann 1959; Rotterdam/Paris 1974/5

He was born in Rotterdam, the son of a shoemaker. Nothing is known of his training. He settled in Haarlem and joined the guild of St. Luke there in 1612; in 1617 he was back in Rotterdam, where he died. After returning to Rotterdam he continued to work with Haarlem printmakers such as Jan van de Velde and Gilles van Scheyndel, who made prints based on his drawings.

A small number of paintings by Buytewech survive: they show fashionable young people eating, drinking and making music. He is particularly valued for his drawings and etchings; the etchings, of which thirty-five are known, are among the most original made in the Netherlands in the early seventeenth century. They are characterized by a fresh response to nature coupled with a delight in ornamental line.

One of his sons, also Willem, became a landscape painter. His works are rare but there is a dune landscape in the National Gallery.

THE RUINS OF THE CASTLE OF SPANGEN

Cat. no. 36
Pen, 144 × 350mm
Signed, lower right, WB (in monogram)
Paris, Fondation Custodia (Institut Néerlandais: Inv.no.2356)

Literature Haverkamp Begemann 1959, 110; Rotterdam/Paris 1974/5, 102

The castle of Spangen, which was largely destroyed by the Spanish in 1572, is near Rotterdam. This drawing shows it from the north-west. The most striking feature is the polygonal tower enclosing a staircase which became visible after the destruction of the west wing. The ruins survived in part into the present century but have now been demolished. The style of the drawing is very close to that of the etchings of the *Verscheijden Landschapjes* series of 1621 (cat.no.38); it may well have been made shortly after Buytewech's return from Haarlem to Rotterdam, that is, in about 1617/18. There are striking analogies, particularly in the treatment of the trees, with the etchings of Hercules Segers.

LANDSCAPE WITH PEASANTS AND CATTLE

Cat. no. 37
Black chalk and brown pen, 274 × 362mm
Cambridge, Fitzwilliam Museum

Literature Haverkamp Begemann 1959, 107;
Paris/Rotterdam, 1974/5, 99

This large drawing, executed in black chalk and then strengthened in pen, is the pair to one of the same size (282 × 364mm) in the Courtauld Institute Galleries. The latter is signed with Buytewech's monogram (WB) followed by a barely legible date – probably 1617, which is entirely acceptable on stylistic grounds. In both drawings a prominent figure group is set against a diagonal screen of trees, echoing those which are such a striking element in Goudt's prints after Elsheimer.

The figure group in this drawing was used by Jan van de Velde in his print of 1622, *The White Cow* (cat.no.72)

SEVEN ETCHINGS FROM THE *VERSCHEIJDEN LANDSCHAPJES* (VARIOUS LANDSCAPES) SERIES

Cat. nos. 38a–g
All etchings, 88 × 124mm
The title page of this series, the first of these seven etchings, reads within the cartouche:
Verscheij/den Lantschapjes, / ghemaeckt door Willem Buytewech. / gedruckt by / Claes Ianss Visscher / t'Amsterdam anno. / 1621
All but one are monogrammed WB
London, British Museum, Department of Prints and Drawings (Inv.nos.S.4830–6)

Literature (the series) Holl. 35–44; Haverkamp Begemann 1959, VG21–30; Paris/Rotterdam 1974/5, 132–141.

These seven etchings are from a series of nine landscapes with a title page. The title page shows a peasant couple placed like heraldic supporters at either side of the cartouche, which tells the reader that the series was designed by Buytewech and published by Visscher in Amsterdam. They are seated amidst appropriately rural objects – vegetables, a flail, a cartwheel, a barrel and a sheaf of corn.

The *Charcoal Burner* places its subject against a remarkably effective screen of extremely tall trees, which have branches only at the very top – an outstanding example of Buytewech's passion for elegant, calligraphic patterns within apparently naturalistic conventions.

The Road at the Edge of the Woods employs the Elsheimerian device of a diagonal line of tree-tops to indicate recession. The point at which the flat fields come up against the forest was a popular subject for landscape artists: it is treated, for example, in etchings by both Jacob van Ruisdael (cat.no.107) and Johannes Ruisscher (cat.no.116).

The building in *A Ruined Tower* has not been identified but like the view of the Huis te Kleef which is also included in the series, it is probably one of the castles and manor houses which were destroyed by the Spanish army during the siege of Haarlem; by 1621 these had become picturesque ruins which stirred patriotic feelings. The two other etchings from the series are *The Sower* and *The House with the Stepped Gable*.

Simon Wynhoutsz. de Vries, who latinized his name to Frisius, was born in Harlingen in Friesland. Nothing is known of his training, but early in his career he came to Amsterdam, where he made a number of topographical views. In about 1598 he settled in Paris, where he was active principally as an illustrator of the works of French calligraphers. He was back in the Netherlands before 1605 and in 1611 was in The Hague, joining the guild of St. Luke there in 1614. He owned extensive property in the city, where he lived for the rest of his life.

Although a prolific printmaker, whose subjects included portraits, topographical views, landscapes and historical book illustrations, Frisius was also a successful merchant.

(after Hendrick GOLTZIUS)

HILLY LANDSCAPE

Cat. no. 39
Etching, 121 × 209mm
Inscribed, in the sky at the top: HG (in monogram) in / 1608 and numbered 1, lower left. Inscribed in the margin at the bottom: Symon Frizius fecit. Robbertus de Baudous Excudebat
London, British Museum, Department of Prints and Drawings (Inv. no. 1852–12–11–99)

Literature Holl.105

This is the first of two landscapes etched by Frisius after drawings of 1608 by Hendrick Goltzius and published in Amsterdam by Robert de Baudous. They provide a fascinating comparison with the precocious naturalism of the 1603 drawing of the landscape around Haarlem (cat.no.41); here Goltzius returns five years later to a more traditional, formulaic landscape. This is a striking instance of the difference between 'private' and 'public' works of art: the drawing was the result of a purely personal, perhaps even therapeutic, activity, whereas the print was intended for sale.

Particularly striking in this etching are the flowing outlines of the low hill in the foreground – the effect is almost like water – as well as the picturesquely tattered peasant types in the foreground (which strongly recall the peasants of Jacob de Gheyn II) and the fairytale castle in the exact centre of the composition.

Symon Frizius fecit, *Robbertus de Baudous Excuaebat,*

(after Hendrick GOLTZIUS)

MOUNTAINOUS LANDSCAPE

Cat. no. 40
Etching, 136 × 213mm
Second state of the etching, after the number 2 had
been added.
Inscribed, in the sky, top right: HG (in monogram)
in. / AO 1608 and numbered 2, lower right.
Inscribed in the margin at the bottom: Symon
Frizius fecit. Robbertus de Baudous Excudebat
London, British Museum, Department of Prints
and Drawings (Inv. no. 1852–12–11–100)

Literature Holl.106.

This is the second of two etchings by Frisius made from drawings of 1608 by Goltzius.
The landscape is markedly unresolved: there is no point at which foreground and
background meet, and the two could have been brought together from separate
preparatory drawings. Recession is indicated merely by the heavier inking of the
foreground. With its brick farm buildings and broken-down fence, the foreground
reveals some of the observation of naturalistic detail seen in the 1603 drawing of the
countryside near Haarlem (cat.no.41), but the background is a pure Antwerp fantasy,
strongly reminiscent of Bruegel's *Large Landscapes* series.

Hendrick GOLTZIUS 1558 – 1617

Literature Reznicek; Bartsch (Ill.), vol. 3

He was born in Mühlbracht near Venlo in the Rhineland close to the Dutch border. The family moved to Duisburg and there Goltzius studied with his father Jan Goltz, a glass painter. Despite a childhood accident which crippled his right hand, he was apprenticed in about 1575 to Dirck Volckertsz. Coornhert to learn engraving. Coornhert, who came from Haarlem, was at that time in exile at Xanten in Cleves. In addition to being an engraver, he was a Catholic polemicist whose outspoken, liberal opinions on religious and social issues led to his being exiled from Holland on more than one occasion. Goltzius' first engravings were published by the Antwerp engraver and publisher Phillips Galle, a pupil of Coornhert, who had succeeded to the position of Hieronymous Cock as the leading print publisher in the Netherlands.

In about 1576/77 Goltzius went with Coornhert to Haarlem and there he married a widow whose young son, Jacob Matham, became his pupil and in time was a distinguished engraver in Goltzius' manner. In Haarlem Carel van Mander, another immigrant from the south, introduced Goltzius to the highly mannered court art of Bartholomäus Spranger, an Antwerp artist who had settled at the court of Rudolf II in Prague. Goltzius enthusiastically adopted this artificial figure style which is characterized by unnatural, self-consciously elegant poses and gestures. Goltzius travelled to Italy in 1590, returning to Haarlem in the following year. He gradually abandoned Spranger's style, making engravings after Raphael, Polidoro da Caravaggio and antique sculpture. He looked again at his northern predecessors, Dürer and Lucas van Leyden, and began to emulate them.

After 1600 Goltzius made very few engravings, concentrating instead on painting: according to Van Mander, this was a result of the impact that Italian, and particularly Venetian, painting had had on him during his stay in the peninsula. He died in Haarlem and was buried in St. Bavo's.

Goltzius was a printmaker and painter of figure subjects in which landscape played a very small part. His importance for the development of landscape lies in a small group of drawings of the countryside near Haarlem made in the first years of the seventeenth century and two engravings in a closely related style by Simon Frisius after Goltzius' drawings. It is extremely significant that such an influential artist, best known for his adoption of a highly contrived style associated with the court at Prague, should have responded in such an intense and natural manner to the countryside near his home. The co-existence within one artistic personality of extremes of naturalism and artificiality is a contradiction which characterizes the period around 1600.

EXTENSIVE LANDSCAPE NEAR HAARLEM

Cat. no. 41
Brown pen and wash, 78 × 197mm
Signed, top left hand corner: HG (in monogram)
1603 Paris, Fondation Custodia (Institut
Néerlandais: Inv. no. 2628)

Provenance The collector's mark in the top left
hand corner (immediately below the monogram
and date) – WE – is that of William Esdaile. His
signature is on the verso with the date 1799. The
drawing was in the sale of Mrs Arthur Jones,
Sothebys 14 July 1926, lot 10.
Literature Reznicek 400 (pl.380)

This sheet belongs with two others which are very similar to it: both are in the
Boymans-van Beuningen Museum in Rotterdam and one is also dated 1603. They
are the latest landscapes known to be from the hand of Goltzius and are astonishingly
naturalistic for their date: technically they must be discussed in the context of the
so-called 'Bruegel Renaissance' of c.1600 in the Netherlands. Their graphic style, with
the use of 'dotted' penwork, is strikingly similar to that of Bruegel and can also be seen
in the drawings of the Master of the Small Landscapes.

According to Van Mander, Goltzius had an attack of consumption in about 1600. He
regained his health as a result of long walks, which caused him to lose a good deal of
business; it has been suggested, not implausibly, that these drawings were made as a
consequence of his therapeutic excursions into the countryside around Haarlem. It has
also been suggested, because of the relatively high viewpoint, that the drawing was
made from the ramparts of Haarlem. However, this is probably a conventional
landscape device.

Goltzius indicates recession by the technical means – used in the north since the time
of Patinir – of drawing the foreground in a tone darker than the middle and
background.

The three drawings are discussed by Reznicek in his essay in this catalogue
(pp.57–62, especially pp.61–2).

LANDSCAPE WITH A WATERFALL

Cat. no. 42
Woodcut on blue paper. 112 × 146mm
Signed in monogram, lower left, HG
London, British Museum, Department of Prints and
Drawings (Inv. no.W5–42)

Literature B242; Hirschmann p.136; Holl.378;
Reznicek p.428; Strauss 129

This is the first of a series of four small landscape woodcuts of which three are shown in the exhibition. They are dated by Reznicek c.1598–1600 and by Ackley (Boston, 1980/1, p.29) slightly earlier, c.1596–8.

There is a closely related drawing in pen and wash in the Institut Néerlandais which is dated by Reznicek (R401) to c.1598. In both the drawing and the woodcut the influences of Titian (as in his woodcut *Landscape with a Milkmaid*, for example) and Campagnola *(Landscape with St. Jerome)* are paramount.

Goltzius' choice of blue paper on which to print these small landscapes recalls the advice of his friend Van Mander, who urged young artists to draw on grey or blue papers providing a middle tone from which to develop darks or lights.

LANDSCAPE WITH A SEATED COUPLE

Cat. no. 43
Woodcut on blue paper, 113 × 146mm
Signed in monogram, lower centre: HG
London, British Museum, Department of Prints and
Drawings (Inv. no.W5–39)

Literature B242; Hirschmann p.136; Holl.379;
Reznicek p.428; Strauss 130; Boston 1980/1,
14,15.

As with the preceding print, the influence of the landscape woodcuts of Titian and Campagnola is very strong: the tree in the centre resembles that in Titian's *Tree with Two Goats* and the figures are strikingly similar to those in Campagnola's *Landscape at Harvest Time*.

LANDSCAPE WITH A PEASANT DWELLING

Cat. no. 44
Woodcut on blue paper, 111 × 144mm
Signed in monogram, lower centre: HG
London, British Museum, Department of Prints
and Drawings (Inv. no. 1853–6–14–127)

Literature B244; Hirschmann p.137; Holl.380;
Strauss 128

This woodcut is more naturalistic than the Venetian-influenced landscape works in the same series (cat.nos.42 and 43) and the Italianate *Arcadian Landscape*. It anticipates, in its simple, literal descriptiveness, the landscapes of Pieter de Molijn and Jan van Goyen. Goltzius also unexpectedly reveals an eye for picturesque details, such as the stork perched on the chimney, a common sight in the Netherlands.

(Attributed to Hendrick GOLTZIUS)

ARCADIAN LANDSCAPE
(2nd and 3rd states)

Cat. nos. 45a & 45b
Chiaroscuro woodcuts, both 182 × 250mm
London, British Museum, Department of Prints
and Drawings (Inv. nos. 1854–5–13–186 and
1868–6–12–1)

Literature B241; Hirschmann p. 136; Holl. 377;
Vienna 1967, 323; Strauss 127; Van Thiel (esp.
pp.9, 31); Boston 1980/1, 27, 28

These are the second and third states of this woodcut. The second state is printed on blue paper with the sky cut away. In the third state the green tone blocks were added.

The composition is unsigned and its attribution to Goltzius is by no means secure. Van Thiel questioned Goltzius' authorship, tentatively proposing Moses van Uyttenbroeck as the artist, and dating the print c.1615/20. Ackley (Boston 1980/1, loc. cit.) attributes the woodcut to Esaias van de Velde.

The unique first state, also on blue paper, is in the New York Public Library. It shows sunbeams bursting through the clouds. Subsequently the rayed lines in the sky and most of the clouds were cut away and the line block again printed on blue paper. In the third state the dark and light clouds in the green tone blocks were added and the sky is far more animated as a result.

Even if this woodcut was not designed by Goltzius himself, it is very much in his manner, as can be seen by comparison with the three signed woodcuts in the exhibition (cat.nos.42,43 and 44). Goltzius was the pioneer in the north of the use of the chiaroscuro woodcut as a medium for the representation of landscape. If, as Ackley has suggested, the artist is Esaias van de Velde, the woodcut would reveal a fascinating contact between the two.

Jan van GOYEN 1596 – 1656

Literature Beck

He was born in Leiden. According to Orlers (Beschryvinge der Stadt Leyden, 1641, pp.373–4), from 1606 onwards he was a pupil successively of the Leiden painters Coenraet van Schilperoort, Isaac Claesz. van Swanenburgh, Jan Arentsz. de Man and the glass-painter Cornelis Cornelisz. Clock; he then studied for two years under a Willem Gerritsz. at Hoorn. Orlers says he came back to Leiden and worked on his own, then at the age of about nineteen travelled in France for a year and, after his return, spent a year in Haarlem as the pupil of Esaias van de Velde. He married in Leiden in 1618 and is mentioned in documents there throughout the 1620s. In 1629 he sold a house in Leiden to Jan Porcellis, the marine painter. Orlers says he went to The Hague in 1631; he was still at Leiden in November of that year, when he sold a house, but probably settled at The Hague shortly afterwards; he eventually died there, having acquired citizenship in March 1634. He is said to have lost heavily in the 'tulipmania' of 1636/37. At some time in 1634 he was painting in Haarlem in the house of Isaak van Ruisdael, the brother of Salomon. He was a hoofdman *of The Hague guild in 1638 and 1640. In 1649 his daughter married Jan Steen; two years later he painted for the Burgomasters' room in The Hague Town Hall a panoramic view of the town, for which he received 650 guilders.*

The only one of Van Goyen's masters whose influence is traceable in his early works (his first known dated picture is of 1620) is Esaias van de Velde, and until 1626 Van Goyen's landscape style is closely dependent on his. His early marine paintings reveal the influence of Jan Porcellis; he then began to paint in the new Haarlem landscape style of which he, Pieter de Molijn and Salomon van Ruysdael were the principal exponents.

Van Goyen was an extremely prolific artist: the standard catalogue of his work lists more than 800 drawings and 1,200 paintings. He travelled extensively in the Netherlands and in Germany.

LANDSCAPE WITH A COTTAGE AND A BARN

Cat. no. 46
Panel, 23.5 × 33.6cm
Signed lower left: VG (in monogram) 1632
Manchester, City Art Gallery (Assheton-Bennett
Collection: Inv.no.1979.458)

Literature Beck 1168

In the 1620s Jan van Goyen painted in the brightly coloured style of his teacher Esaias van de Velde. His panels were crammed with figures and lively incident. It was in the years around 1630 that, together with Salomon van Ruysdael and Pieter de Molijn, he began to paint tranquil landscapes peopled with only a few figures who more or less merge into the background. He chose deliberately modest scenes – river landscapes with wooden bridges, dilapidated farm buildings and fishermen – painted in a severely restricted range of colours. This style lasted for about ten years, although during this time he became – as can be seen in no.48 – more ambitious in his subject-matter, painting panoramic landscapes and marine scenes.

Beck had difficulty in reading the date on this painting: he thought it might be 1636 (or 1649). In fact, there is no doubt that it is 1632, which is perfectly consistent with Van Goyen's style at that time.

A WINDMILL BY A RIVER

Cat. no. 47
Panel, 29.4 × 36.3cm
Signed, bottom left: VG 1642 (VG in monogram)
London, National Gallery (Inv. no.2578)

Literature HdG 835; MacLaren; Beck 975

Although it was probably painted in The Hague, this is an outstanding example of Van Goyen's work during the 'tonal phase' of Haarlem landscape painting. He shows a flat landscape, featureless except for the windmill, small figures and distant buildings, as if from the top of a low hill. The sky occupies three-quarters of the picture space in this panoramic view; it is painted in a deliberately restricted palette of grey, brown, black and white enlivened only by a few strokes of yellow and green. Studying the painting with Hoogstraten's account of Van Goyen's technique in mind (Introduction, p.31), it is not difficult to imagine Van Goyen preparing the panel with a mass of loose brush strokes and the landscape features emerging from them. A landscape such as this one is in its own way as mannered as those of the Antwerp school: it is simply that its conventions are more descriptive and the resulting effect is of a *convincing* landscape.

LANDSCAPE WITH A DISTANT VIEW OF ARNHEM

Cat. no. 48
Panel, 34 × 54.7cm
Signed in the middle foreground: J v Goyen 1642
The Marquess of Bath, Longleat House, Wiltshire

Literature Beck 274

Van Goyen painted a series of extensive landscapes looking towards Arnhem and dominated by the tower of the Grote Kerk. Two date from 1633 and 1639 but the rest were all painted in the 1640s. In this view the two towers of St. Walburgaskerk can be seen to the left of the Grote Kerk.

It is interesting to compare this small panel with no.47; in the same year Van Goyen can be seen applying his monochromatic style to both a topographically accurate and an imaginary landscape.

COTTAGES BY A ROAD

Cat. no. 49
Black chalk and grey wash, 164 × 278mm
Signed, lower left: VG (in monogram) 1649
London, British Museum, Department of Prints
and Drawings (Inv. no.1920–2–12–143)

Literature Hind 2; Beck 184

Van Goyen filled his sketchbooks with black chalk drawings made from the life. In a drawing such as this one, however, he carefully composed the scene, using a high coulisse on the right to mask the extensive flat landscape which stretches into the distance on the left and balances, in a rather contrived way, the figure groups on the left and right. The black chalk drawing was then enlivened by the application of wash.

The fact that Van Goyen monogrammed and dated the drawing suggests that, rather than its being a study for a painting, it may have been made for sale. Beck records two copies of it, one in the Pierpont Morgan Library in New York and the other in Berlin-Dahlem.

Pieter de MOLIJN 1595 – 1661

He was born in London of Flemish parents in 1595, and joined the Haarlem guild of St. Luke in 1616. Nothing is known of his early training or his teachers. He was active in the guild and lived in Haarlem until his death.

A painter of landscape and genre subjects, he etched and published under his own name a single set of four landscapes with prominent peasant figures and dilapidated farm buildings (cat.nos.53 a–d).

With Jan van Goyen and Salomon van Ruysdael, he was a key figure in the so-called 'tonal phase' of Haarlem landscape painting. These artists painted simple landscape subjects – river scenes, extensive panoramic views, roads winding past cottages – broadly handled and with a deliberately restricted palette of greys, browns, dull yellows and greens.

EXTENSIVE LANDSCAPE

Cat. no. 50
Panel, 37 × 43cm
Signed, lower right: P Molyn (PM in monogram)
Private collection, England

This panoramic landscape was probably painted in the early 1630s, and is an outstanding example of De Molijn's tonal style during that decade. In this picture the so-called 'tonal phase' seems to be a return to a three-colour Antwerp landscape style. Three tones are contrasted but recession is nevertheless also indicated by the use of three striations of colour. What, of course, is quite different is the nature of the landscape itself – flat and extensive with a low horizon and a correspondingly high sky. Although on a far smaller scale, it looks forward to the panoramic landscapes of Philips Koninck in the 1650s.

PRINCE MAURITS AND PRINCE FREDERIK HENDRIK GOING TO THE CHASE

Cat. no. 51
Panel, 34 × 56cm
Signed: lower centre P de Molijn (P de M in monogram) fecit / 1625
Dublin, National Gallery of Ireland (Inv. no.8)

Provenance Purchased, Paris, 1864
Literature H. Potterton, *Dutch Seventeenth and Eighteenth Century Paintings in the National Gallery of Ireland*, Dublin, 1986, pp.96–7

De Molijn was a specialist landscape painter but as this painting – one of his earliest dated works – shows, he could turn his hand with great effectiveness to figure and animal painting. The principal figures on horseback are, on the left, Maurits, Prince of Orange, and on the right, Frederik Hendrik, Prince of Orange. Maurits was the son of William the Silent by his second wife, Anne of Saxony. He succeeded his father as Stadhouder of the United Provinces in 1584 after William's assassination in Delft. He presided over the great economic and colonial expansion of the United Provinces in the first two decades of the seventeenth century and was an extremely successful military leader. He died in The Hague in 1625, the year in which this picture was painted. Frederik Hendrik, who succeeded him as Stadhouder in 1625, was his half-brother. He was the younger son of William the Silent by his fourth wife, Louise de Coligny. He married Amalia van Solms in 1625 and his son by the marriage succeeded him in 1647 as Willem II. Like his half-brother he was an effective military leader whose successes against the Spanish armies brought Spain to the negotiations at Münster which concluded in the signing of a peace treaty there in 1648. Both Prince Maurits and Prince Frederik Hendrik were enthusiastic sportsmen and are here shown setting out for a day's hunting. The men wearing dark green breeches and capes and carrying wide-brimmed grey hats are the personal bodyguard of Prince Maurits. The tower in the background is probably intended to represent the Sint Jacobskerk (Grote Kerk) in The Hague.

Pieter de Molijn is perhaps the least well-known of the generation of innovatory landscape painters in Haarlem, although he was clearly very much admired by contemporaries as a leading figure in their group. In this painting, with its splashes of bright colour, deep greens and rich browns, as well as its mass of small, lively figures, De Molijn is working in a style similar to that of Esaias van de Velde. Although there is no documentary evidence that De Molijn worked in The Hague, this painting would suggest that he did, and that he was in contact there with Esaias van de Velde. A few years later, in the early 1630s, De Molijn was to abandon this manner in favour of a restricted tonality and simple landscape vistas.

The painting has been cleaned especially for the exhibition.

LANDSCAPE WITH FIGURES

Cat. no. 52
Panel, 40 × 61cm
Signed, lower left: P Molyn (PM in monogram)
Cambridge, Fitzwilliam Museum (Inv. no.46)

Provenance Bequeathed by David Mesman, 1834
Literature Fitzwilliam Museum, Cambridge:
Catalogue of Paintings, vol.I (Dutch and Flemish
Schools) by H. Gerson and J.W. Goodison,
1960, p.86

Probably painted c.1635, this is a fine example of De Molijn's broadly handled tonal style. The unpretentious subject-matter – country people returning home at the end of the working day – is described in bold, rough brush strokes.

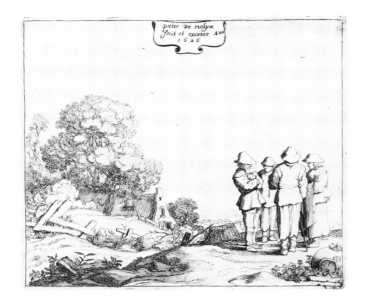

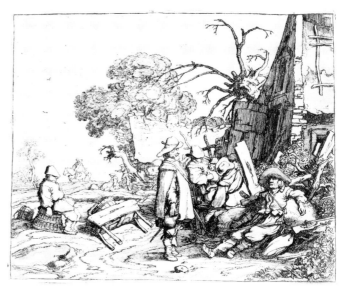

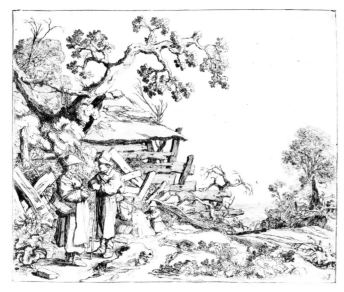

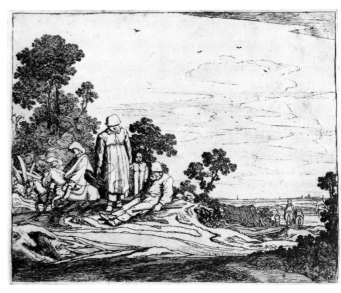

1. LANDSCAPE WITH FOUR PEASANTS Cat. no. 53a
2. LANDSCAPE WITH SOLDIERS Cat. no. 53b
3. LANDSCAPE WITH WOMAN AND CHILD Cat. no. 53c
4. LANDSCAPE WITH MEN ON HORSEBACK Cat. no. 53d

Etchings, 148 × 184mm
No.1 is inscribed, centre top, Pieter De Molyn / fecit et excudit. Ano [sic] / 1626. No.2 is numbered bottom centre; nos. 3 and 4, bottom right. London, British Museum, Department of Prints and Drawings (Inv. nos.S.6499, 2364–6)

Literature B 1–4; Holl. 1–4

This series of four etchings was made and published by De Molijn in 1626. The prominent inscription on the first one gives it the appearance of a title page.

The landscapes appear to emphasize the poverty and deprivation of rural life. The peasants, shown in the manner of Pieter Bruegel with their hats pulled down over their eyes, are ragged and sullen-looking, while the soldiers (in no.2) are shown as finely dressed marauders. This theme – the oppression of the rural population by soldiers – was popular in the early years of the seventeenth century and can be seen at its most extreme in David Vinckboons' pair of panels in the Rijksmuseum (Inv. nos. A1351,2) which shows the peasants' sufferings (*Boerenverdriet*) and their subsequent violent revenge (*Boerenvreugd*).

Pieter de NEYN 1597 – 1639

Literature H. Gerson, 'De Meester P.N.', *NKJ*, 1947, pp.95–111

He was born in Leiden but was probably a pupil of Esaias van de Velde in Haarlem. He was back in Leiden in 1617 when he married. His early work – such as the landscapes of 1625 and 1626 in the Lakenhal in Leiden – reveals the powerful influence of Esaias van de Velde; later, however, he was to come under the equally strong influence of Jan van Goyen and Salomon van Ruysdael. He was appointed to the position of town stone-mason in Leiden in 1632 and in his will of 15 December 1638 is described as schilder ende deze stede meester steenhouwer *(painter and master stonemason of this town).*

De Neyn was a minor landscape painter whose work was dependent upon the innovations of greater artists. His are just the kind of attractive, modest landscapes which were available in large numbers at low prices in Holland early in the seventeenth century. As a Leiden painter he falls outside the strict limits of this exhibition, but he has been included because he was trained in Haarlem and provides an excellent example of the way in which the Haarlem landscape style (or styles, in the case of De Neyn) were adopted in other artistic centres in the north Netherlands – not just in Leiden but also The Hague, Delft and, to a lesser extent, Utrecht and Dordrecht.

HALT AT AN INN

Cat. no. 54
Panel, 33.6 × 62.9cm
Falsely signed and dated, lower left: I. V. Goien 1618
Cambridge, Fitzwilliam Museum (Inv. no.M.46)

Provenance Bequeathed by Charles Brinsley Marlay, 1912
Literature Gerson in *NKJ* (op. cit.), p.108; Fitzwilliam Museum, Cambridge: Catalogue of Paintings, vol.I (Dutch and Flemish Schools) by H. Gerson and J.W. Goodison, 1960, p.92

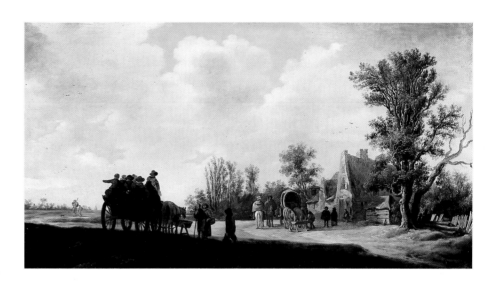

This was painted in the early 1630s and shows that by that date De Neyn had understood the innovations of Jan van Goyen and Salomon van Ruysdael. The landscape is constructed simply – a diagonal line from right to left created by the tree-tops, a dark foreground, a cart outlined against the light middle ground, a distant view on the left – according to a pattern developed in Haarlem. However, despite the simplicity of the composition and a certain crudeness of technique, it succeeds in being both picturesque and convincing.

Gerson prefers to date the painting to c.1628.

Literature Stechow 1975

He was born in Naarden, Gooiland, in about 1600. He was inscribed in the guild at Haarlem (as 'Salomon de Gooyer') in 1623, and lived there for the rest of his life. His earliest dated painting is from 1626 and he is praised as a landscape painter by Ampzing in 1628. He was buried in Haarlem on 3 November 1670.

Van Ruysdael's teacher is not known. His earliest landscapes reveal the influence of Esaias van de Velde, who was in Haarlem from 1610–1618. Subsequently, with Jan van Goyen and Pieter de Molijn, he developed a style characterized by its modest subject-matter and deliberately restricted tonality. In addition to landscapes and seascapes he painted, in his last years, a few still-lifes. His elder brother was Isaak, the father of Jacob van Ruisdael. His own son, Jacob Salomonsz. van Ruisdael, was also a landscape painter.

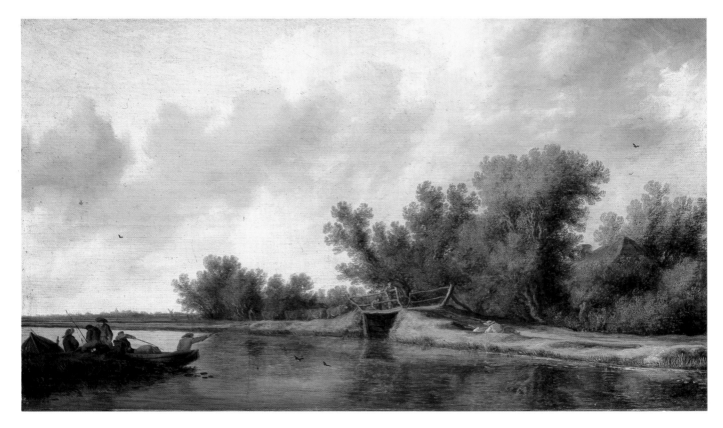

RIVER LANDSCAPE WITH A FISHERMAN

Cat. no. 55
Panel, 36.6 × 65.5cm
Signed, bottom left, below the boat: S. VR 1631
(VR in monogram)
London, National Gallery (Inv. no.1439)

Provenance Bequeathed to the South Kensington (now Victoria and Albert) Museum by the Revd. C.H. Townshend in 1869. On loan to the National Gallery from the Victoria and Albert Museum since 1895.
Literature MacLaren; Stechow 1975, 435

Salomon van Ruysdael painted a large number of river landscapes in the early 1630s using the same simple diagonal composition. There are two – this one and another, dated 1632 – in the National Gallery. Infra-red reflectography has revealed extensive underdrawing in black chalk beneath the trees, cottage and footbridge. The figures and the boat were not drawn in at this stage. (These underdrawings are discussed by David Bomford in his essay in this catalogue, pp.52–4.)

RIVER LANDSCAPE

Cat. no. 56
Panel, 67 × 80cm
Signed on the underside of the bridge, SvR 1645
Private collection, Great Britain.

Literature Stechow 1975, 569A

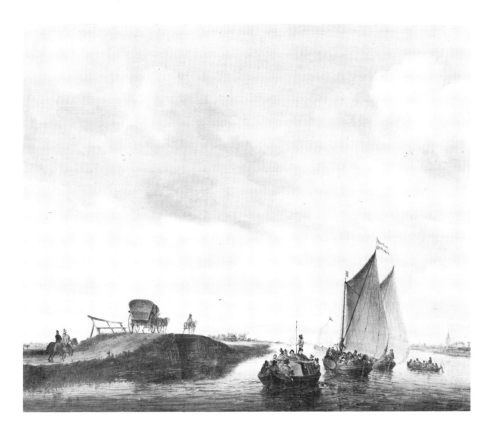

According to Stechow, there is another version of this composition which is signed and dated 1661; he considers that the painting exhibited here – if original – should also be dated in the early 1660s. In fact, this outstanding, entirely autograph work is clearly signed and is dated 1645.

It is an early example of a Haarlem landscape with a low horizon and very high sky: much of the success of the painting lies in the shifting pattern of the sky. Against the sky Van Ruysdael has boldly outlined the wooden rail of the bridge, the coach (with a coat of arms on the back) and the horse and rider drawing the *trekschuit* along the canal. This cheap and efficient form of transport is discussed by Jan de Vries in his essay in this volume (pp.84–5). Rather than being, as Stechow believed, a late work by Van Ruysdael, this is in fact one of the earliest and most ambitious paintings in his 'post-tonal' period.

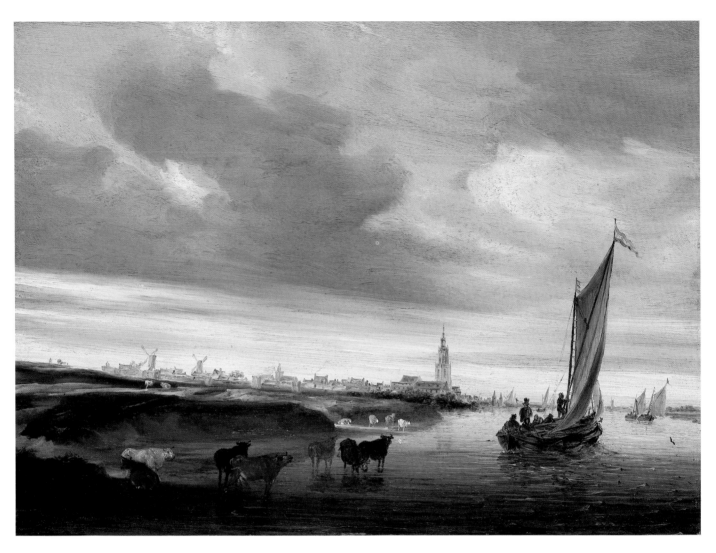

A VIEW OF RHENEN

Cat. no. 57
Panel, 30.5 × 41.3cm
Signed with initials and dated, left foreground:
S. VR. 1648 (VR in monogram)
London, National Gallery (Inv. no.6348)

Literature MacLaren; Stechow 1975, 521A

The river in the centre of the painting is the Rhine. Rhenen, in the province of Utrecht, is on its left bank. The prominent tower in the centre is that of the Cunerakerk: it was completed in 1531 and still stands, though much restored. The Koningshuis, the group of low buildings in front of the Cunerakerk, was built in 1630/1 for the Elector Palatine Frederick V, the 'Winter King' of Bohemia, and was demolished in 1812.

A comparison with Pieter Saenredam's drawing of Rhenen of 1644 (Teylers Museum, Haarlem) reveals that Van Ruysdael's rendering of the tower of the Cunerakerk and the façade of the Koningshuis is cursory and inexact. The tower should be surmounted by a spire on a cupola and the east wall of the palace should be gabled. Another view of Rhenen by Van Ruysdael, dated 1660, is in the Getty Museum at Malibu; a third view, now in the Barnes Foundation at Merion, Pennsylvania, is dated by Stechow to the 1660s. The tower in these views is also rendered incorrectly.

There are no drawings securely attributed to Van Ruysdael and it is quite likely that he did not visit Rhenen but relied for his views of the town on topographical engravings. Accuracy, however, was not his intention: the town profile is chosen as an element to enliven the panoramic view and provide an alternative focus of interest to the sailing-boat which is so prominent in the right foreground. Most striking is the adventurously broad technique, especially the bold white brush strokes to indicate the sky close to the horizon and the finer black brush strokes with which Van Ruysdael depicts the boat and the waves it creates on the otherwise calm water.

158

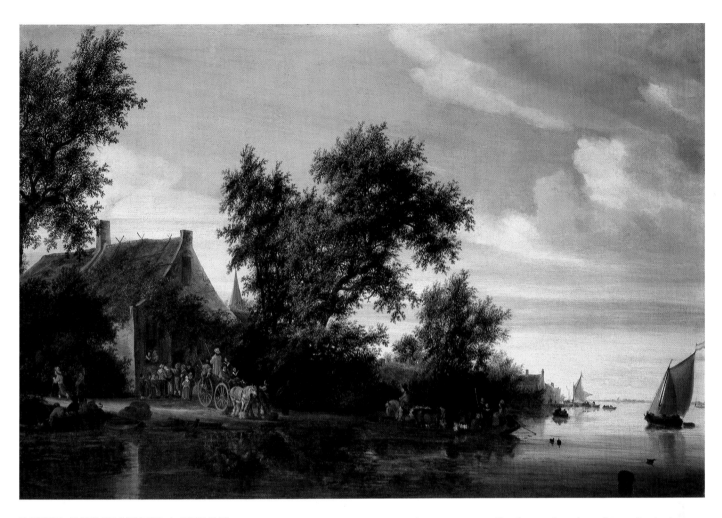

RIVER SCENE WITH A FERRY

Cat. no. 58
Canvas, 76.5 × 127cm
Signed and dated, on the ferry: S v Ruysdael 1649
Private collection, England

Literature Stechow 1975, 356

Ferries, an important means of transport in Holland, are often the subject of paintings by Salomon van Ruysdael. This is a particularly fine example, with the prominent central tree, the lively figure group at the landing-stage, the reflections in the still water and the distant vista along the river at the right. The handling is entirely assured: broad brush strokes in the sky and very fine, detailed painting of the trees and figures.

Hercules SEGERS c.1589/90 – c.1638

Literature Haverkamp Begemann 1973

He was born in Haarlem, the son of a cloth merchant who had fled from the southern Netherlands. By 1596 the family had moved to Amsterdam, where Segers was one of the last pupils of Gillis van Coninxloo, who died in 1607. He returned to Haarlem and seems to have joined the guild in 1612, the same year as Esaias van de Velde and Willem Buytewech. By 1614 he was back in Amsterdam and in 1619 bought a large house in the city. His financial difficulties began in 1625 and he was forced to sell the house in 1631, when he is recorded at Utrecht dealing in paintings; in 1633 he was at The Hague, active as an art dealer. In 1638 the woman who was apparently his second wife is described as a widow. Samuel van Hoogstraten, in his Inleyding tot de Hooge Schoole der Schilderkonst of 1678, cites Segers as an example of an artist who was treated badly by fortune and whose true worth was discovered only after his death; he despaired of ever achieving success, took to drink and died after falling down stairs when drunk.

Segers' paintings are rare. He is best known for his remarkably original etchings, of which the modern catalogue lists fifty-four, with only 183 impressions in all. This unusually small number of impressions was a consequence of Segers' unconventional working procedure: he regarded each impression as a unique work of art. His prints were not apparently published by a professional print publisher as was usually the case, nor were they produced in a standardized edition. Hoogstraten says that Segers 'printed . . . paintings'.

His panoramic landscapes were to exercise a particularly strong influence on later painters and printmakers, notably Philips Koninck and Rembrandt.

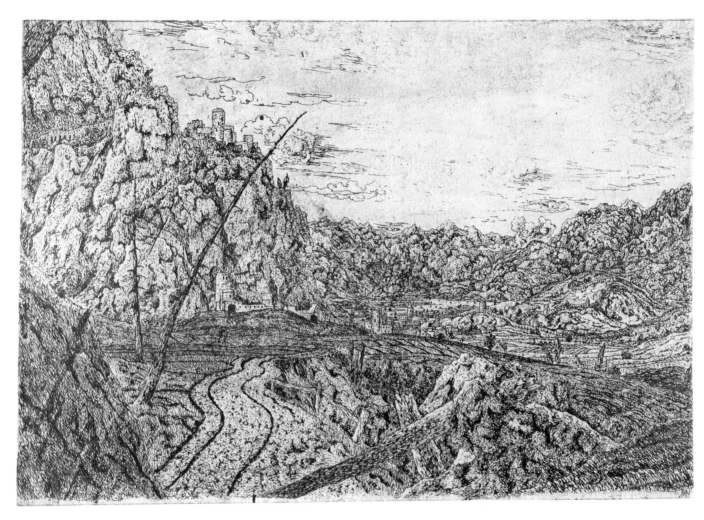

MOUNTAIN VALLEY WITH BROKEN PINE TREES

Cat. no. 59
Etching and Drypoint, 280 × 405mm
London, British Museum, Department of Prints and
Drawings
(Inv.no.1840–8–8–229)

Literature Haverkamp Begemann 3

This unique impression is printed in black on white paper which Segers prepared with light brown wash. There is a little work in drypoint in the bottom left hand corner.

Segers' vision of landscape is so idiosyncratic that it is not easy to place in a historical context. In this case the links with the Antwerp landscape style are strong: here are the steep cliffs, on which buildings perch precariously, and the broad valley with, in the far distance, buildings and a lake. He even incorporates a foreground coulisse (on the left) and the device of a track winding along the valley floor. Yet the eye level is lower and his style is far more descriptive – the bare pines in the foreground, the broken fence, the stone walls, for instance.

Segers' technique involved the careful preparation of his paper, as here, before printing: this is the meaning of Hoogstraten's remark that he 'printed . . . paintings'. In this case he must have produced a very small edition or only one print.

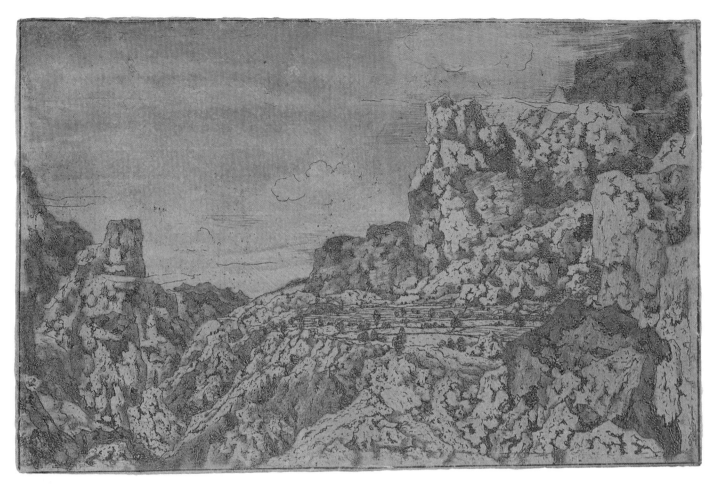

PLATEAU IN ROCKY MOUNTAINS

Cat. no. 60
Etching and Drypoint, 134 × 209mm
London, British Museum, Department of Prints and Drawings
(Inv.no.S.5521)

Literature Haverkamp Begemann 10″e

This is the second state of this etching. In some areas groups of triangular dots have been added, probably with the point of the engraver's burin, in the ground; the plate was bitten deeply. It is printed in green on a paper prepared with green body colour. The sky was then coloured with a very thin grey wash.

As with the previous print, this is in effect a highly original variation on the theme of Alpine landscape as represented by Pieter Bruegel. The graphic technique – when compared to the engravings after Bruegel – is very different, however, allowing Segers to give a distinct sense of texture to the rocks and the crevices between them.

THE ENCLOSED VALLEY
(1st and 2nd state)

Cat. nos. 61a & 61b
The first state is an etching on cloth; the second state is etching and drypoint on paper;
110 × 193mm (first state); 107 × 189mm (second state)
London, British Museum, Department of Prints and Drawings
(Inv.no.S.5522, S.5523)

Literature Haverkamp Begemann 13'e; 13"k

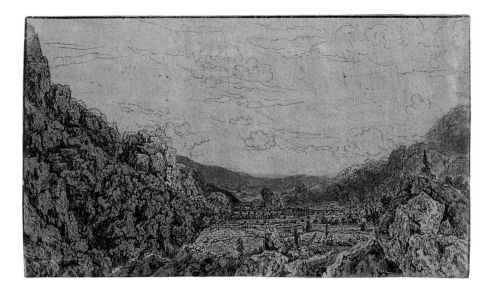

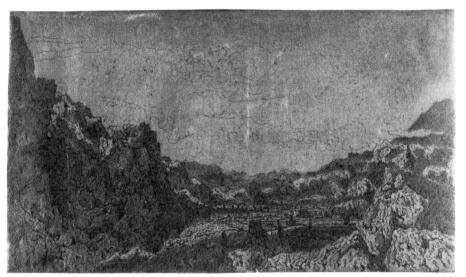

This is the most frequently printed of all Segers' etchings. There are twenty-one known impressions in four states and one counterproof.

Segers printed the first state on fine cloth which he had dyed light brown. He then stretched the cloth taut and printed on it in black; subsequently he coloured it with brown, grey and blue watercolour.

In the second state tone was added by drawing fine parallel lines in drypoint on most of the mountains. Almost the entire left half of the print is shaded in this way, while at the right the rocks in the foreground have been left almost entirely blank. This particular impression is printed in dark green on paper prepared with thin green body colour.

The motif of a broad valley seen from a low internal viewpoint is a favourite one of Segers. Several of his rare paintings feature a dramatic view of this kind.

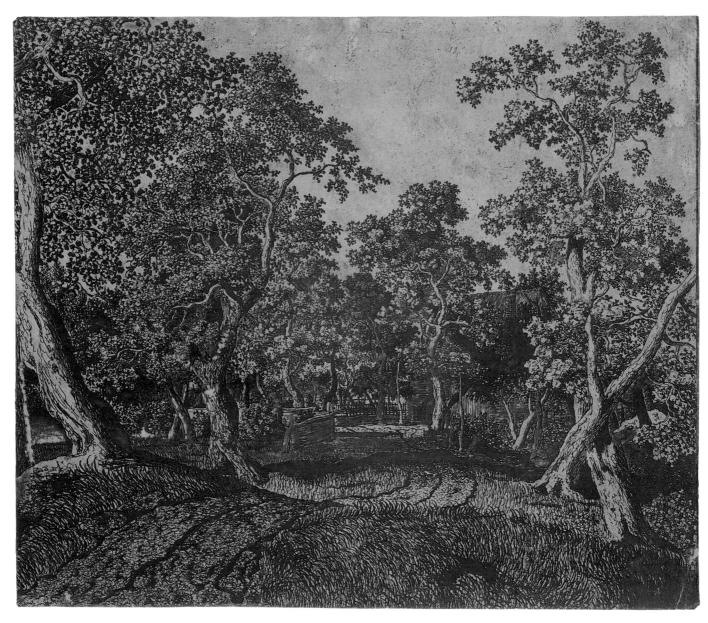

COUNTRY ROAD WITH TREES AND BUILDINGS

Cat. no. 62
Etching and Drypoint, 229 × 274mm
London, British Museum, Department of Prints and
Drawings
(Inv.no.S.5532)

Literature Haverkamp Begemann 37

This is the unique impression of this etching. The very dark areas are caused by the etched lines running together: the brownish black areas are created with the use of drypoint. It is printed in black on yellowish brown paper.

Nothing could be further from the fantastic, rocky landscapes of the previous three prints than this country road gently winding through trees to the thatched farmhouse. From the world of Bruegel's *Large Landscapes* we are transported to that of Haarlem landscape of the mid-century. Segers was concerned not just to create his own highly imaginative Alpine landscape but also to describe his native countryside. In this aspect of his work in particular he was closely involved with contemporary developments in Haarlem.

Haverkamp Begemann points out that the composition and the individual motifs in this print are similar to those in a drawing by Segers in Amsterdam and in another print (no.36 in his catalogue). It is effectively a reworking of the earlier print.

Reyer Claesz. SUYCKER c.1590 – 1653/5

He was born in Haarlem, probably the son of the painter Claes Suycker. The date of his entry into the guild is unrecorded: he served as a vinder in 1642 and a deacon in 1643. He was praised as a landscape painter by Ampzing in 1628. His earliest paintings, such as his View of Leiden of 1624, are in a markedly Flemish style but later he came under the influence of Esaias van de Velde and Jan van Goyen. Among his few known paintings is a view of Haarlem in the Frans Halsmuseum; a sketchbook containing drawings of Biblical subjects and landscape is in a private collection in Amsterdam. He died between 1653 and 1655.

The Suyckers were a Haarlem artistic dynasty: in addition to Claes and Reyer, Arent Cornelisz. Suycker, Nicolaas Suycker and Nicolaas Suycker the Younger are recorded in the guild records.

LANDSCAPE WITH BATHERS AND A VIEW OF HAARLEM

Cat. no. 63
Panel, 52.8 × 83cm
Signed, on a stone at the edge of the water, bottom centre: R.C.
Amsterdam, Private collection

Literature Bol p.136

This idyllic account of country pleasures is a relatively late work by Suycker, probably painted in the early 1640s. The group of farm buildings in the centre is strongly reminiscent of those in prints by the Master of the Small Landscapes (cat.no.18). The town in the background on the right is Haarlem. It can be identified by the three most prominent buildings: on the left is the tower of Hendrick de Keyser's Sint Annakerk; in the centre the squat Kalistooren, one of the towers which formed part of the city walls; and, to its right, the Cleyne Houtpoort, one of the city's principal gates. The river in which the figures bathe is probably the Spaarne which flows through Haarlem.

Literature Keyes 1984

He was born in Amsterdam, the son of a Protestant painter, Hans van de Velde (1552–1609), who had fled from Antwerp to Amsterdam in 1586. Esaias presumably studied with his father (about whose activities as a painter nothing at all is known) and probably also with Gillis van Coninxloo, at the auction of whose estate (in March 1607) Hans van de Velde was a purchaser. Arnout van Buchell mentions a landscape by Coninxloo which contained figures by Esaias. It is possible that after Coninxloo's death Esaias also studied with David Vinckboons, with whose work his early paintings have obvious parallels, but there is no firm evidence for this. Soon after Hans van de Velde's death the family moved to Haarlem in 1609. Esaias joined the guild of St. Luke there in 1612. In 1617 and 1618 he was also a member of the Haarlem rederijkerkamer (chamber of rhetoricians) De Wyngaertrancken. During his years in Haarlem Esaias had a number of pupils, one of whom was (according to Jan Orlers in his Beschryving der Stadt Leyden of 1641) Jan van Goyen; Pieter de Neyn was also probably a pupil. In 1618 he moved to The Hague, where he joined the guild in October; he remained there for the rest of his life, becoming a citizen in 1620. While in The Hague he is known to have sold paintings to the Prince of Orange.

He painted cavalry skirmishes and, in the manner of David Vinckboons, genre scenes of elegant figures feasting; but his principal activity was as a landscape painter and as such he played a key rôle in the development of naturalistic landscape. He was also an accomplished etcher.

A RIVER SCENE

Cat. no. 64
Panel, 29.2 × 49cm
Signed, lower centre: E. V. VELDE / 1623
Brighton, Art Gallery and Museum

Literature Keyes 1984, 112

This simple view of an unremarkable scene of country life is the very essence of the new Haarlem landscape style. Esaias' etched scenes (cat.nos.69,70,71) present the same combination of tranquil, extensive landscape, lively figures and incidents and modest, often picturesque, dilapidated buildings – all seen in a convincing, empirical perspective. His paintings of the 1620s are characterized in addition by a bright palette – deep greens, rich browns and splashes of red and yellow, with clear blues and whites in the sky.

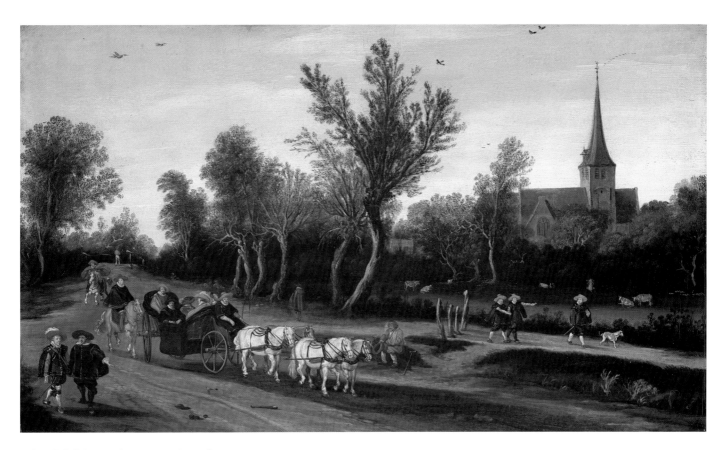

LANDSCAPE WITH RIDERS

Cat. no. 65
Panel, 40 × 68.8cm
Signed, and dated, lower centre: E. V. VELDE. 1623
Manchester City Art Gallery (Assheton-Bennett
Collection: Inv.no. 1979. 509)

Literature Keyes 1984, 17

It has been suggested that the man dressed in black in the centre of the carriage looking directly at the viewer is Prince Maurits. This is quite possible – certainly the carriage and the entourage suggest a man of high rank – but his head is so small that it is difficult to be certain that this is intended as a portrait. Painted in the same year as nos.64 and 66, it is a fine example of Esaias' simple yet radically innovative account of Dutch landscape. By 1623 he was resident in The Hague, the town in which the Stadhouder had his court. The prince (if the man is intended to be him) could well be shown here driving out to one of his country residences.

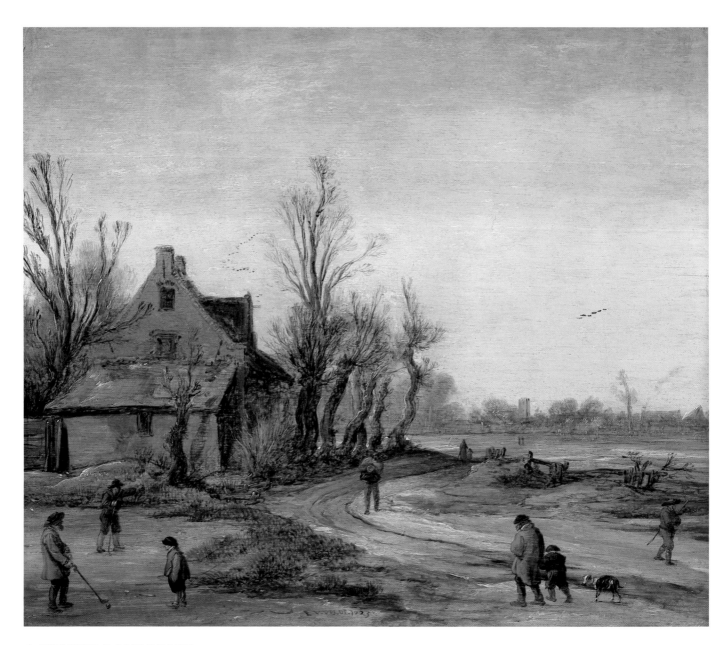

A WINTER LANDSCAPE

Cat. no. 66
Panel, 25.9 × 30.4cm
Signed, lower centre: E. V. VELDE. 1623
London, National Gallery (Inv. no.6269)

Literature Keyes 1984, 84

Esaias' striking, naturalistic effects are achieved with a remarkable economy of means. His technique – and the technique of this painting in particular – is discussed by David Bomford on page 52 of this catalogue. He has discovered a rapid, almost careless underdrawing on the thin ground over which the artist has painted with quick strokes and dabs to build up this evocative winter scene. The composition is conventional with the foreground figures and buildings, the winding road and distant trees, farms and church, but in these few strokes Van de Velde has conjured up the atmosphere of a crisp, cold winter day in a way which no earlier artist had ever done.

LANDSCAPE WITH A CHAPEL BY A STREAM

Cat. no. 67
Pen, brown ink, blue wash and white highlights on
rose-tinted paper, 190 × 284mm
Inscribed, lower left, in blue ink: Esaias
vande/velde
Cambridge, Fitzwilliam Museum
(Inv. no.PD 773–1963)

Literature *European Drawings from the Fitzwilliam,*
New York/Fort Worth/Baltimore/Minneapolis/
Philadelphia, 1976/7, 93; Keyes 1984, D151

Keyes considers that this may well be Esaias' earliest surviving drawing. Certainly it clearly reveals his Amsterdam origins – in particular the influences of David Vinckboons and Claes Jansz. Visscher. The rapid, loose penwork and the coloured washes are particularly close to Vinckboons' style; Visscher also used brown and blue washes to great effect. It should be dated c.1613–14.

LANDSCAPE WITH A WATERMILL

Cat. no. 68
Black chalk with brown wash, 189 × 310mm
Signed, lower centre: E. V. VELDE. 1623
London, British Museum, Department of Prints
and Drawings (Inv. no. 1913–1–11–4)

Literature Hind 1; Keyes 1984, D168

In this drawing Esaias' graphic technique is very close to those of his cousin Jan and of Willem Buytewech; the three artists had enjoyed a close working relationship during Esaias' years in Haarlem. It is noteworthy that Esaias stresses the picturesque quality of the mill.

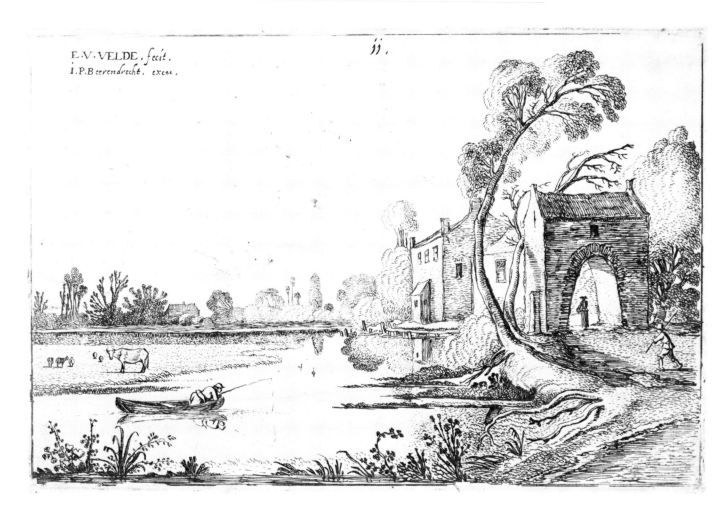

RIVER LANDSCAPE WITH A FISHERMAN

Cat. no. 69
Etching, 112 × 170mm
Inscribed, upper left hand corner: E. V. VELDE.
fecit. / I.P. Beerendrecht. excu. Numbered, top
centre, ii.
London, British Museum, Department of Prints and
Drawings
(Inv.no.1982–7–24–8)

This etching is the second in a series of landscape prints. There is no title page but one of the prints is dated 1614. It is probably based, if only loosely, on the landscape around Haarlem. It is interesting to compare it with the *Winter Landscape* (cat.no.71) of only a few years later. In the *River Landscape* Esaias' technique is very precise – individual plants (in the foreground) and trees (in the background) are painstakingly distinguished. He resembles Buytewech in the delight he takes in the careful rendition of incidental detail. In the *Winter Landscape*, however, his intention is to convey atmosphere rather than describe detail and in this he looks forward to the landscape etchings of Rembrandt.

THE SQUARE LANDSCAPE

Cat. no. 70
Etching, 172 × 173mm
Inscribed at the top, left: ESAIAS VANDEN VELDE
Fecit. / I. P. Beerendrecht. excudit. Haerlemensis
London, British Museum, Department of Prints and
Drawings (Inv.no.S.6912)

Literature Van Gelder 1933, 46, p.46; Stechow
1947, p.84; Boston 1980/1, 41.

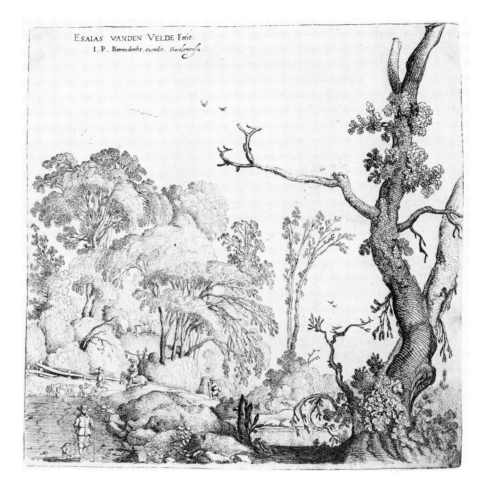

This etching is shown here in its third state, with 'Haerlemensis' added to the publisher's name. This is a study of various types of trees – bare and leafy, tall and squat, straight and drooping. Rather than try to render extensive landscape and atmosphere, the artist self-consciously enjoys the abstract patterns made by trees and branches; this aspect of his technique is strongly reminiscent of Willem Buytewech. The placing of his and the publisher's names in the empty sky emphasizes the artificiality of this landscape. And yet as Ackley points out (Boston 1980/1, loc. cit.) its decorative character does not mean that it lacks a sense of living growth. Esaias has made sensitive use of stippling and short strokes to convey the differing textures and tones of the foliage.

This plate is difficult to date. It has the form of Esaias' signature which, according to Stechow, he used between 1614–1616. Van Gelder dated it as late as 1620–24 whereas (according to Ackley) Keyes prefers 1618/19, just after the artist's move to The Hague. The fact that the publisher worked in Haarlem supports a date shortly before his move but it was not unusual (as in the case of Buytewech) for an artist's prints to be issued by a publisher living in another city.

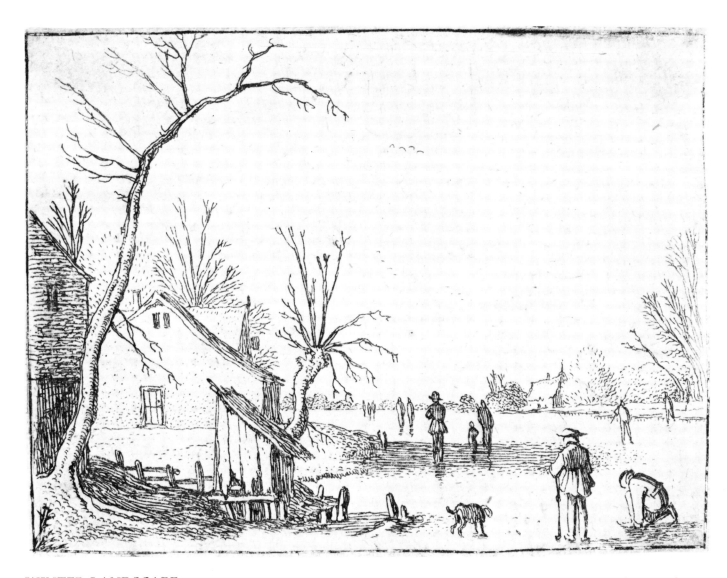

WINTER LANDSCAPE

Cat. no. 71
Etching.67 × 89mm
London, British Museum, Department of Prints and
Drawings
(Inv.no.1980–5–10–2)

This is very close in spirit and in the simplicity of its technical means to the painted *Winter Landscape* of 1623 in the exhibition (cat.no.66). With a few simple lines and short hatched strokes – the work of minutes – Esaias has created an entirely convincing image of winter on the frozen rivers of Holland. The composition is archaic – closed on both sides by trees – but the effect was, in about 1620, completely new.

Jan van de VELDE the YOUNGER 1593 – 1641

Literature FvK; Van Gelder 1933

He was born in Rotterdam, the son of a famous calligrapher. In 1613 he was in Haarlem, where he was apprenticed to Goltzius' stepson, Jacob Mathan. In 1614 he joined the guild of St. Luke, two years after his cousin Esaias had been admitted. His first print series, published by Amsterdam publishers such as Claes Jansz. Visscher, appeared in 1615 and 1616. After his marriage in 1618, he rarely worked from his own designs, but – presumably from economic necessity – primarily reproduced the work of others such as Willem Buytewech, Pieter de Molijn and Frans Hals. He moved to Enkhuizen in 1636, where he lived until his death.

He etched and engraved nearly five hundred prints, of which the numerous landscapes, many from his own designs, are his most important and original achievement.

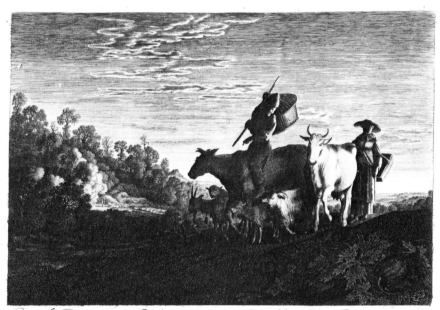

THE WHITE COW

Cat. no. 72
Etching and Engraving, 171 × 226mm
Inscribed: Impiger hic, vixdum consumpta nocte, colonus, / Rure suos haedos et vaccam pellit in urbem, / Gallinas portans humeris; labor arduus ipsi / Est levis ut possit multo gravis aere redire. Jodocus Vergraft singulari artis / admiratori dat, dicat, dedicat / Johannes Voldius. 1622. (The night is hardly gone before this industrious countryman drives his goats and a cow from the country to the town, carrying chickens on his back. The heavy work is light for him as long as he comes home loaded down with much money.)
London, British Museum, Department of Prints and Drawings
(Inv.no.S.5840)

Literature FvK 409; De Groot 70

This print, shown here in its first state, is closely modelled on Goudt's prints after Elsheimer – not only in the device of a night-time (or, more strictly, dawn) subject described in a technique close to mezzotint, with wooded hills in the background, but even in the calligraphy of the inscription. It is remarkable how skilfully the artist suggests the shapes of pumpkins and leaves amid the dark tones in the bottom right hand corner. Although Van de Velde (who Latinizes his name as Johannes Voldius in the inscription) makes no acknowledgement, he has taken the group of peasants and their animals from a drawing by Willem Buytewech of 1617 (cat.no.37). This is a good example of the close relationships between the innovatory Haarlem landscape artists of the early seventeenth century.

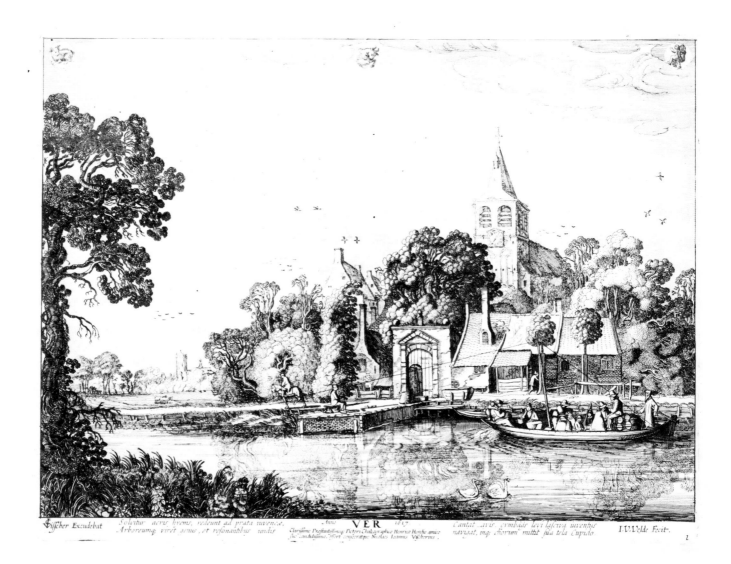

VER (SPRING)

Cat. no. 73a

Etching and Engraving, 253 × 353mm
Inscribed: VER. Solvitur acris hyems, redeunt ad
prata iuvencae, / Arboreumq(ue) viret genus, et
resonantibus undis / Cantat avis, cymbags [*sic,* for
cymbaque] levi lasciva iuventus / navigat, inq(ue)
chorum mittit sua tela Cupido. Anno 1617.
Clarissimo Praestantissimoq(ue) Pictori
Chalcographico Henrico Hondio amico /suo
candidissimo, offert consecratque Nicolaes Ioannis
Visscherius. CJ Visscher (CJV in monogram)
Excudebat I. V. Velde fecit. Numbered 1 in bottom
right hand corner. (The harsh winter departs, the
heifers return to the meadow. The trees are green,
the bird sings its song over the gurgling stream. The
lusty youths steer their light boat, and Cupid
shoots his darts into their throng.)
London, British Museum, Department of Prints
and Drawings (Inv. no.1924–5–27–1)

Literature FvK 146; De Groot 71

This is the first in a series of the Four Seasons. In certain respects – the presence in the sky of the relevant astrological signs (Aries, Taurus and Gemini) and the classicizing motto which has no real relevance to the image (where is Cupid?) – the print, which is dedicated by its publisher to the engraver Hendrick Hondius, belongs to a long-established graphic tradition for this subject. What is new is the choice of this scene of a quiet country canal with a *trekschuit*, a passenger barge drawn by a horse on the towpath, which is undoubtedly based on personal observation. The composition is not without a certain artificiality – notably in the manner in which it is closed on the left by an elegantly decorative tree and the Elsheimeresque screen of trees behind the landing-stage – but for 1617 it is precociously naturalistic in both conception and in much of the landscape detail.

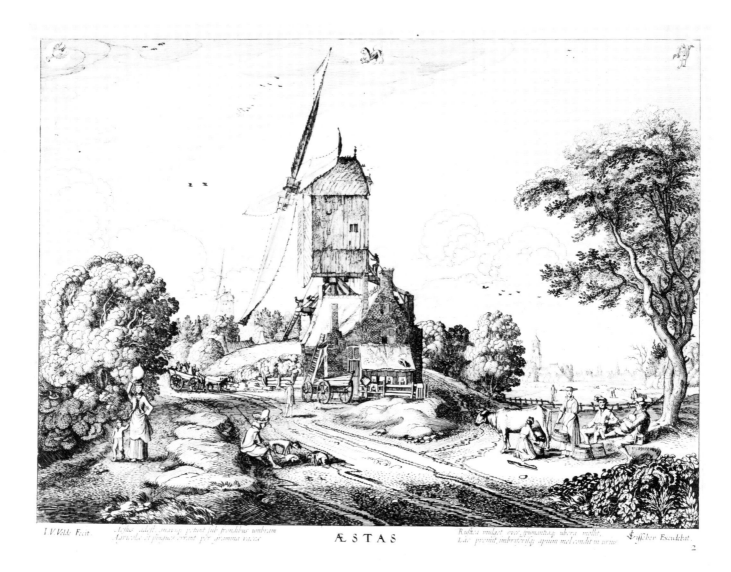

I.V. Velde Fecit. Aestas adest, gnaviq. petunt sub frondibus umbram / Agricolae; et pingues errant per gramina vaccae. ÆSTAS Rustica mulget oves, spumantiaq. ubera mollit, / Lac premit, imbriferisq. apium mel condit in urnis. Visscher Excudebat.

2

AESTAS (SUMMER)

Cat. no. 73b
Etching and Engraving, 253 × 353mm
Inscribed: AESTAS. Aestus adest, gnaviq(ue)
petunt sub frondibus umbram / Agricolae; et
pingues errant per gramina vaccae. / Rustica
mulget oves, spumantiaq(ue) ubera mollit, lac
premit imbriferisque (*sic*: for umbriferisque) apium
mel condit in urnis. I. V. Velde fecit. CJ Visscher
(CJV in monogram) Excudebat. Numbered 2,
lower right hand corner. (The hot season is here,
and the wise country-folk seek the shade beneath
the trees; and the fat cows graze in the meadows.
The country-woman milks the ewes, and soothes
the foaming udders, and presses out the milk, and
stores the bees' honey in shady jars.)
London, British Museum, Department of Prints
and Drawings (Inv. no.1924–5–27–2)

Literature FvK 147; De Groot 72

The foppishly dressed young man seated with his dogs in the centre, with his hooped
sleeves, elegant garter, and high hat decorated with an ostrich feather, seems to have
strayed into this rural idyll from one of Willem Buytewech's genre scenes.

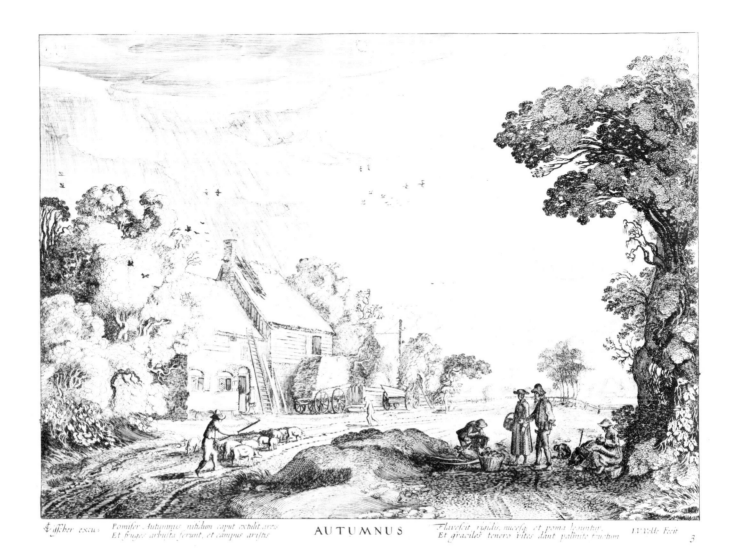

AUTUMNUS

AUTUMNUS (AUTUMN)

Cat. no. 73c

Etching and Engraving, 253 × 353mm
Inscribed: AUTUMNUS. Pomifer Autumnus
nitidum caput extulit arvis. / Et fruges arbusta
ferunt, et campus aristis / Flavescit rigidis,
nucesq(ue) et poma leguntur, / Et graciles tenero
vites dant palmite fructum. CJ Visscher (CJV in
monogram) excu. I. V. Velde fecit. Numbered 3 in
bottom right hand corner. (Apple-bearing Autumn
has smiled on the fields: the orchards bear their
fruits, the field is golden with the corn which
stands tall; nuts and apples are gathered, and the
graceful vine proffers bunches of grapes on its
slender branches.)
London, British Museum, Department of Prints and
Drawings (Inv. no.1924–5–27–3)

Literature FvK 148; De Groot 73

Notably original in this plate is the treatment of the rain. There is no sign of the vine
mentioned in the inscription: the publisher presumably commissioned the verses
without showing their author the image beneath which they were to appear.

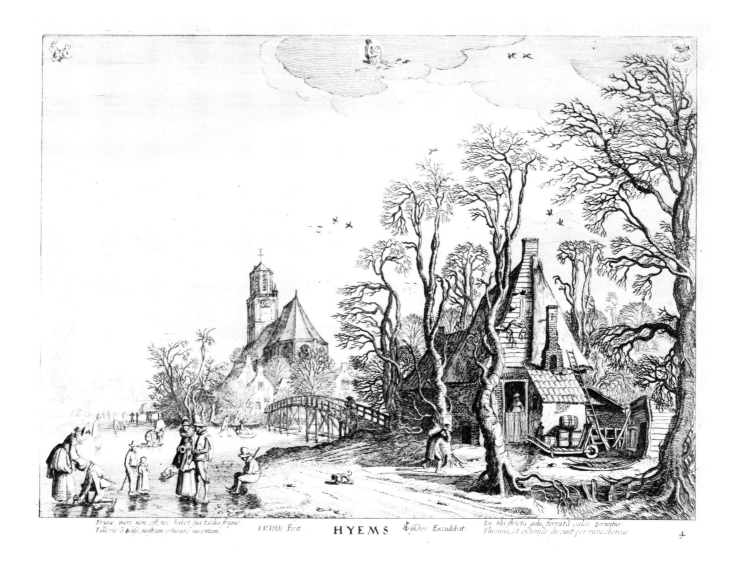

Fugue mers non est, nec habet sua tedia frigus; / Falleris ô Naso, nostram intueare iuventam. I.V. Velde Fecit. **HYEMS** Lÿscher Excudebat En tibi stricta gelu, ferratâ calce teruntur / Flumina, et extensas ducunt per rura choreas 4

HYEMS (WINTER)

Cat. no. 73d
Etching and Engraving, 253 × 353mm
Inscribed: HYEMS. Frigus iners non est, nec habet
sua taedia frigus, / Falleris o Naso, nostram
intueare iuventam, / En tibi stricta gelu, ferrata
calce teruntur / Flumina, et extensas ducunt per
rura choreas. I.V. Velde fecit. CJ Visscher (CJV in
monogram) Excudebat.
Numbered 4 in bottom right hand corner.
(The cold is not dead, it is not just a season of weary
boredom. Ovid, you were wrong! Look at our
youngsters! With irons beneath their feet they
tread the ice-bound rivers, and the long lines of
dancers speed off through the fields.)
London, British Museum, Department of Prints and
Drawings (Inv. no. 1924–5–27–4)

Literature FvK 149: De Groot 74

The winter pleasures of the finely dressed young couples in the left foreground are contrasted with the back-breaking seasonal task of gathering wood.

Claes Jansz. VISSCHER 1587 – 1652

Literature Simon

He was born in Amsterdam, the son of a ship's carpenter. He was one of the most important publishers of prints, maps and topographical views during the first half of the seventeenth century. He published the works of Esaias and Jan van de Velde and Willem Buytewech; he also etched some 200 plates himself, among them many from his own designs. After his death in Amsterdam in 1652 his son Nicolaes (1618–1709) took over the publishing business.

His teachers are not known but his early work is in the tradition of David Vinckboons and the Antwerp followers of Bruegel. In his autobiography Constantijn Huygens says that Jacques de Gheyn the Younger taught Visscher to etch.

Between about 1606 and 1608, Visscher made a number of fresh and spontaneous pen drawings of the landscape in the vicinity of Haarlem. They are very early examples of a new, direct response to nature in the north Netherlands.

His series of eleven small etched landscapes with the title Plaisante Plaetsen . . . ghelegen buijten de ghenoechelijke Stad Haerlem . . . *was published in about 1611/12. They were made in deliberate emulation of the series by the Master of the Small Landscapes of rural scenes 'around Antwerp' which were first published by Cock in 1559 and 1561. Well-known landmarks in the country near Haarlem such as Paters Herbergh and the ruins of the Huys te Kleef are shown in a picturesque yet unpretentious manner. They were intended, as Visscher declares on the title page, for* Liefhebbers die geen tyt en hebt om veer te reijsen *(art lovers who have no time to travel).*

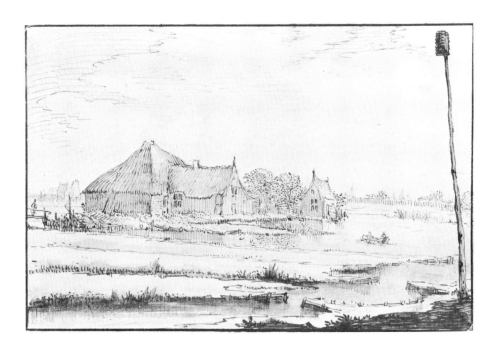

A FARM IN THE POLDERS

Cat. no. 74
Pen and brown wash over a black chalk drawing,
108 × 163mm
Paris, Fondation Custodia (Institut Néerlandais:
Inv.no.5933)

Literature Simon 60; Paris 1968, 170

This is one of a series of remarkably fresh drawings, presumably made from the life and showing buildings in the neighbourhood of Amsterdam, drawn by Visscher in about 1610. In the right background is a dyke built above the level of the polder on which two horse-drawn carts can be seen. In both choice of subject and graphic technique these drawings are indebted to the series of prints by the Master of the Small Landscapes which Visscher republished in 1613 with an attribution to Pieter Bruegel.

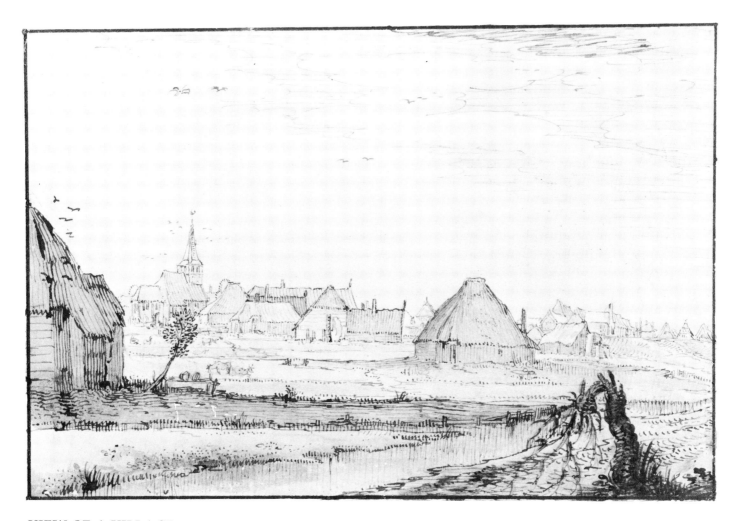

VIEW OF A VILLAGE

Cat. no. 75
Pen and wash over a black chalk drawing,
107 × 162mm
Paris, Fondation Custodia (Institut Néerlandais:
Inv.no.5934)

Literature Simon 61; Paris 1968, 171

Like the preceding drawing, to which it is a pair, this view was drawn by Visscher near Amsterdam in about 1610. It is not without its contrived elements – the dead tree in the right foreground and the barn closing the composition on the left – but the overall impression is of truthfulness and spontaneity. Simon suggested that the village might be Sloterdyk, although the only identifiable building, the church, is too summarily sketched for this to be certain.

Cornelis VROOM 1591/92 – 1661

Literature Keyes 1975

He was the son of the famous marine painter, Hendrick Cornelisz. Vroom (1566–1640). It is not known exactly when he was born; in February 1649 he declared that he was about fifty-eight years old. He is first mentioned as a painter by Samuel Ampzing in the second edition of his Het Lof der Stadt Haerlem in Hollandt of 1621. In 1635 he was a member of the Haarlem painters' guild (he had presumably joined long before), but had left it by 1642. He may have been in England in 1627 and in the following year 'Young Vroom' (who could be Cornelis or his younger brother Frederick) received £80 from Charles I. His association with the Stuart court continued for a number of years; he also worked for the Stadhouder, Frederik Hendrik. He was wealthy (his father was enormously successful) and his paintings are comparatively rare.

His early work consists of marine paintings in a manner derived from that of his father but showing a knowledge of the work of Jan Porcellis. He then turned to landscapes (the earliest example is dated 1622) which he painted exclusively for the rest of his career. He seems to have always lived in Haarlem, where he was buried on 16 September 1661.

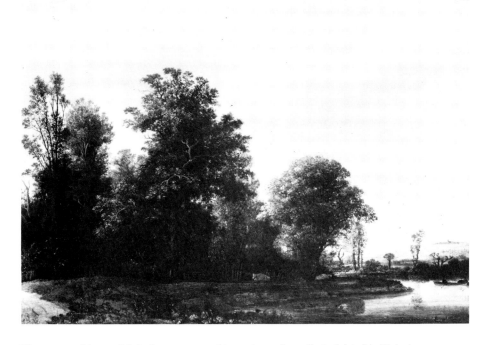

A LANDSCAPE WITH A RIVER BY A WOOD

Cat. no. 76
Panel, 31.2 × 44.2cm
Signed and dated, bottom centre, CVROOM (CVR linked) 1626
London, National Gallery (Inv.no.3475)

Provenance Lent by (Sir) Robert Witt to the Burlington Fine Arts Club in 1919 and presented by him (through the National Art-Collection Fund) to the National Gallery in 1919
Literature MacLaren; Keyes 1975, P27

The composition, with its long screen of trees, is profoundly indebted to Elsheimer prototypes such as the 'Small Tobias' and The Flight into Egypt, which were both available to Vroom in the form of prints by Goudt (cat.nos.13a&b, 15). Despite its small size, this is a complex and innovatory composition which foreshadows certain features of the early work of Jacob van Ruisdael.

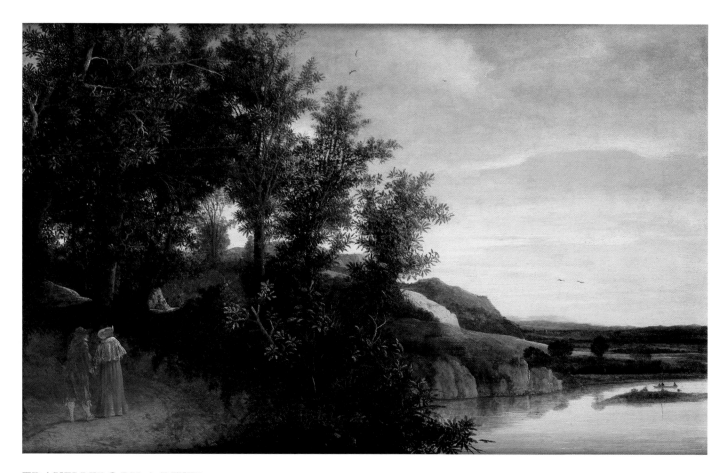

TRAVELLERS BY A RIVER

Cat. no. 77
Panel, 37.5 × 61.3cm
London, Private collection

This lyrical landscape by Vroom has not been previously published. The artist's treatment of the couple is particularly tender and evocative: they have paused on the edge of the wood while the man, clasping the woman's hand, speaks to her.

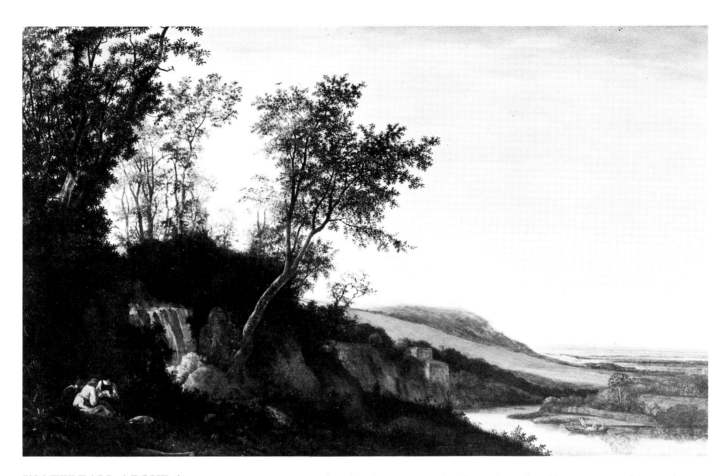

WATERFALL ABOVE A RIVER

Cat. no. 78
Panel, 41 × 66.5cm
Signed and dated on the left: CVroom 1638
(CVR linked)
Haarlem, Frans Halsmuseum

Literature Keyes 1975, P21

Keyes notes that this picture was painted at a time when Vroom was working at the Stadhouder's palace at Honselaersdijk. It has an Italianate quality, rare in the work of Vroom but similar to that of early Italianate landscape painters such as Cornelis van Poelenburgh and Bartholomeus Breenbergh whose work was so enthusiastically collected by the Stadhouder. The fast-flowing waterfall recalls the landscapes of Jacob Pynas (cat.no.89) and Moses van Uyttenbroeck.

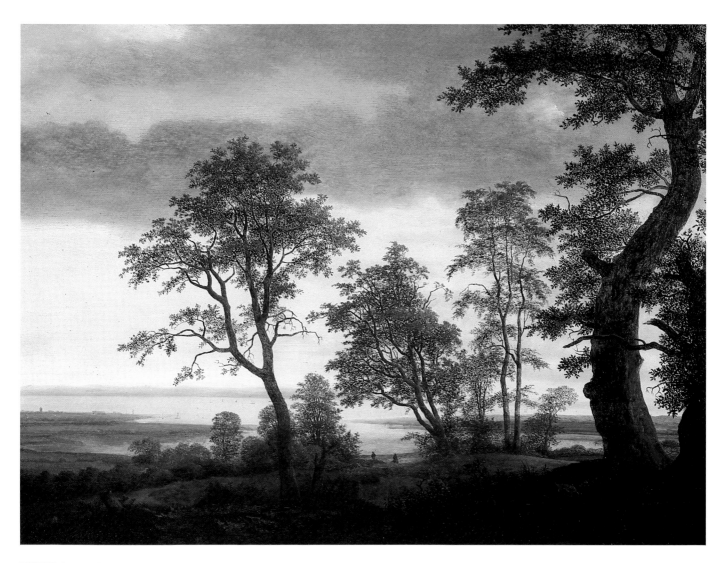

ESTUARY SEEN FROM A WOODED RISE

Cat. no. 79
Panel, 50 × 67.8cm
Signed beneath the tree trunk, bottom right:
CVROOM (CVR linked)
The Hague, Private collection (on loan to the Frans
Halsmuseum, Haarlem)

Literature Keyes 1975, P39

According to Keyes, this was probably painted shortly after *Waterfall above a River* (cat.no.78) of 1638. He considers it to be Vroom's masterpiece and it is certainly an arresting composition: a distant estuary seen through a thin screen of trees, a device used again, though to less dramatic effect, in the *View of Haarlem Seen from the Spaarne* (cat.no.81).

Keyes suggests that this panel has been cut at the top and on the left but there is no physical evidence to support this or any reason to think that the composition is incomplete.

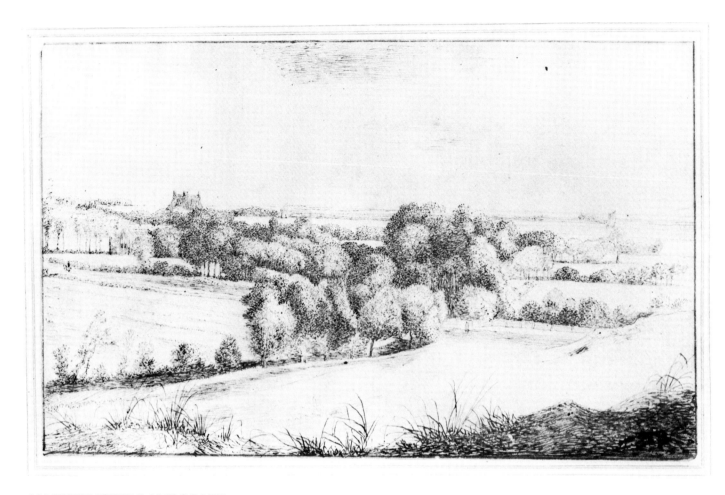

AN EXTENSIVE LANDSCAPE

Cat. no. 80
Pen over a sketch in black chalk, 190 × 315mm
Inscribed, lower left, in pen and brown ink:
VROOM. On the verso in black chalk: VROOM,
and : 47
Paris, Fondation Custodia (Institut Néerlandais:
Inv.no.6984)

Literature Paris 1968, 175; Keyes 1975, D31;
Rembrandt in His Century, New York/Paris,
1977/8, 126

This work probably dates from the early 1630s. It may well have been used in the preparation of the larger, more elaborate and less spontaneous drawing of the same view, now in the Yale University Art Gallery.

The subject is probably the countryside near Haarlem. Attempts have been made to identify the country house, the pedimented façade and roof of which can be seen above the level of the tree-tops on the left. It is, however, too cursorily drawn to be identified with any certainty. Country houses of this type appear in many pictures painted in Haarlem from about 1620 onwards: one example now in the National Gallery is by Cornelis van de Schalcke (Inv.no.974).

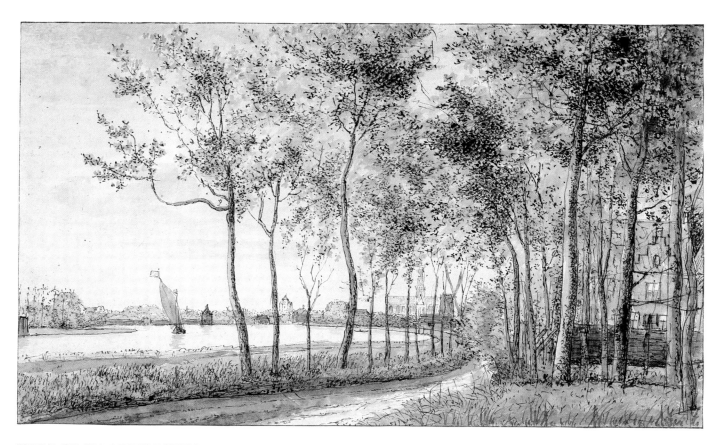

VIEW OF HAARLEM SEEN FROM THE SPAARNE

Cat. no. 81
Pen and brown ink with red, green, light brown
and pale blue washes, 177 × 311mm
Inscribed on the verso: Haerlem van het Sparen te
sien door Evert Vroom (Evert crossed out)
London, British Museum, Department of Prints
and Drawings (Inv.no.1836–8–11–563)

Literature Hind 1; Keyes 1975, D21

The device of placing the main subject of this drawing – the view of the town – behind a sparse screen of trees is highly effective. Haarlem can be seen in the distance, dominated by the outline of St. Bavo's. The Amsterdamsche Poort is to the left.

Watercolour is often thought to be an eighteenth- or even nineteenth-century medium. It was, in fact, frequently employed by Dutch seventeenth-century artists: this sheet is an especially attractive example.

Cornelis' father, Hendrick, had painted a very different view of the town from the Spaarne (Haarlem, Frans Halsmuseum) twenty years before. He used it as the setting for a number of ship 'portraits'.

AMSTERDAM: THE FIRST GENERATION

Arent ARENTSZ. 1585 or 1586 – 1631

Literature I.H. van Eeghen, 'Meerhuizen of de pauwentuin en Arent Arentsz. genaamd Cabel', *Amstelodamum*, 54, 1967, pp.219–21

He was the son of a sailmaker, Arent Jansz., who lived on the Zeedijk in Amsterdam in a house called De Cabel *(The Cable). On 19 May 1619 he was married at Sloten near Amsterdam. On 4 May 1622 he is mentioned as the owner of a plot of land on the Prinsengracht facing the Noordermarkt, on which he built a house named* De Cabel *after his family house; he was himself known by the name* Cabel. *He was buried in the Oude Kerk at Amsterdam on 18 August 1631.*

These are the few known facts of Arentsz.'s life. We have no information whatsoever about his artistic training. He painted landscapes, often in oblong format, with prominent figures of peasants, fishermen and hunters in the foreground. His work is dependent on that of Hendrick Avercamp; that it was Avercamp rather than Arentsz. who was the innovator of this kind of landscape can reasonably be assumed from the fact that Arentsz.'s earliest extant dated painting is from 1629, later than the earlier related works by Avercamp.

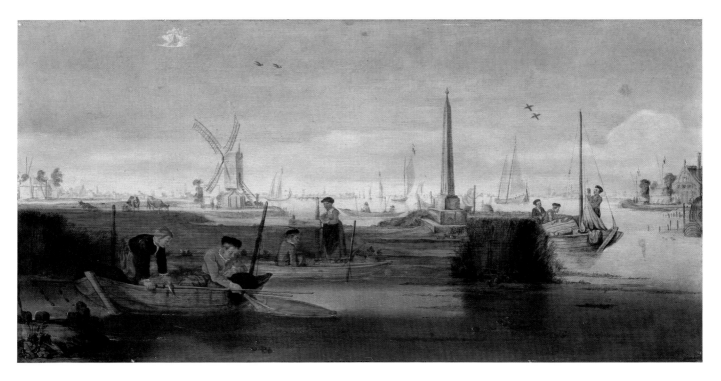

RIVER LANDSCAPE WITH FISHERMEN

Cat. no. 82
Panel, 28.7 × 58.8cm
Signed, on the base of the obelisk: AA (in monogram)
Manchester, City Art Gallery (Assheton-Bennett Collection: Inv.no.1979.439)

This was probably painted in the early 1620s. Arentsz.'s style is derived closely from Avercamp and ultimately from Pieter Bruegel the Elder. In his numerous scenes of figures working in the landscape – as here – he adopts a markedly low viewpoint and a lower horizon line.

Hendrick AVERCAMP 1585 – 1634

Literature C.J. Welcker, *Hendrick Avercamp en Barent Avercamp*, 2nd ed., Doornspijk, 1979

He was dumb and known as 'de stom (stomme) van Campen'. He was baptized in the Old Church in Amsterdam on 27 January 1585; in the following year his parents moved to Kampen, where his father was a town apothecary (he died in 1602). Avercamp spent his early years in Kampen, but he may have been 'de Stom' living in the house of the painter Pieter Isaacsz. at Amsterdam in March 1607 who bought some drawings at the latter's sale. He is recorded in Kampen in January 1613, and also in 1622 when the town paid 12 guilders to 'Hendrick Avercamp d'Stomme van twee peerden te schildren op de stadsstal'. He was buried in the Sint Nicolaaskerk in Kampen on 15 May 1634.

Pieter Isaacsz. (c.1560–1625), who may have been Avercamp's teacher, is known as a history painter, portraitist and draughtsman in an elegant, late mannerist style, quite unlike that of Avercamp, whose manner was influenced in the first place by the Flemish followers of Pieter Bruegel the Elder. It is possible that Avercamp came into close contact with one of Bruegel's followers who settled in Amsterdam, perhaps David Vinckboons. Avercamp's paintings are principally of winter scenes; he also made many coloured drawings of winter scenes, fishermen and peasants. (There is a particularly important group of these drawings in the Royal Collection at Windsor Castle.) There are dated paintings of the years 1608, 1609, 1620, 1626 and 1632.

His nephew, Barent Petersz. Avercamp (1612–79), who also lived and worked for much of his life in Kampen, was a close follower, as was Arent Arentsz.

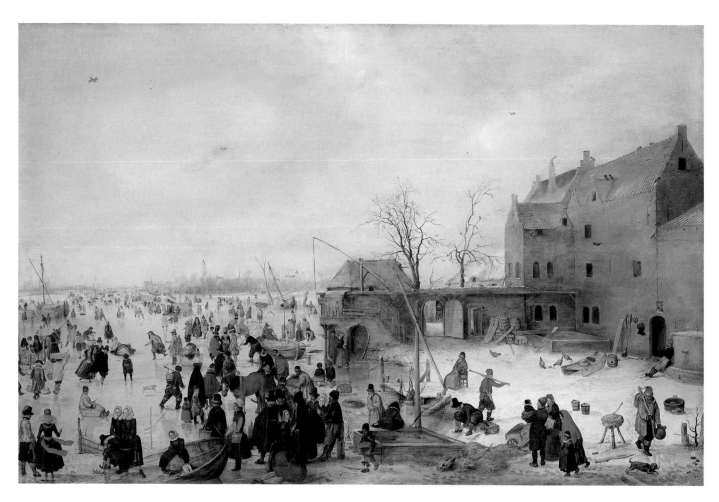

A SCENE ON THE ICE

Cat. no. 83
Panel, 58 × 89.8cm
Signed on the wooden boarding in the centre
foreground: HA (in monogram)
London, National Gallery (Inv.no.1479)

Literature MacLaren; Welcker, op.cit., S55

In Avercamp's earliest paintings – such as the other picture by him in the National Gallery, the circular *Winter Scene*, which was painted in about 1608 – his style is very Flemish, presumably resulting from close contact with David Vinckboons or one of the other émigré Flemish painters in Amsterdam. Later, he simplifies these crowded compositions, opening out the landscape and adopting a low horizon. His paintings remain, however, full of human incident. This picture should be dated about 1615.

Avercamp was content to work in this self-consciously simple and restricted style throughout his career in the provincial town of Kampen. His work shows little awareness of the more naturalistic experiments in landscape taking place in contemporary Haarlem, although he is capable of great subtlety in the delicate, tinted colours of his winter skies.

It has been suggested that the building on the right is the Half Moon brewery at Kampen, but the only evidence for this is the half-dozen barrels standing outside, and the imprecisely indicated town in the distance does not seem at all like Kampen; the tower bears a vague resemblance to that of the Cunerakerk at Rhenen in the province of Utrecht (see cat.no.57 for Salomon van Ruysdael's view of Rhenen).

Pieter LASTMAN c.1583 – 1633

Literature K.Freise, *Pieter Lastman*, 1911; Sacramento 1974, pp.47–61

He was probably born in Amsterdam; in November 1619 he was stated to be about 36. Carel van Mander says he studied with Gerrit Pietersz. Sweelinck. He went to Italy, probably by 1603 and certainly, according to Van Mander, by 1604. He worked in Rome; Elsheimer and Caravaggio seem to have been the principal influences in the formation of his style. He was back in Amsterdam possibly by 1605, certainly by March 1607, and appears to have lived there for the rest of his life. There are dated paintings every few years from 1606 until 1631. Lastman was a Catholic and was buried at Amsterdam, 4 April 1633.

He achieved great contemporary success as a history painter and his work was praised by the poets Rodenburgh and Vondel. King Christian IV of Denmark commissioned from him a series of paintings for Frederiksborg Palace.

Lastman was one of the most influential painters of his time in Holland; his two most important pupils were Jan Lievens and Rembrandt. His pictures are mostly of religious or mythological subjects (chiefly the former). The landscapes which often provide a background to these subjects are profoundly influenced by Elsheimer.

PASTORAL LANDSCAPE

Cat. no. 84
Panel, 38 × 54cm
Signed, bottom right: P. Last[man]
Amsterdam, Private collection

Literature A. Kettering, *The Dutch Arcadia*, 1984, p.88; Ex.cat.Atlanta, *Masterpieces of the Dutch Golden Age*, 1985

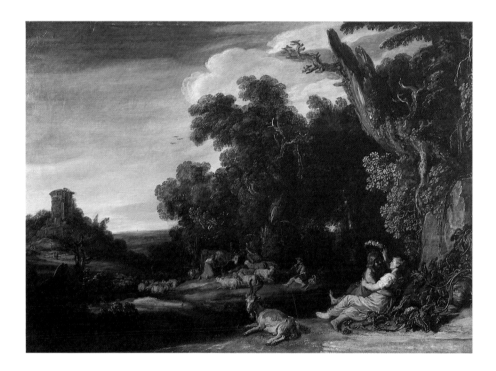

Lastman was a history painter who often placed his figures in landscape. A painting such as this one, in which the figures are subordinated to the landscape, is most unusual in his work. The picture belongs within an established pastoral convention: in this idyllic setting a shepherd plays his flute, maids milk the cows and a young shepherd embraces a girl. The couple could be Granida and Daifilo from Hooft's popular eponymous play while the gesture of the girl crowning the shepherd recalls Mirtillo and Amaryllis from Guarini's play *Il Pastor Fido*, which also enjoyed considerable popularity in the Netherlands. Scenes from both plays were frequently treated by artists.

Lastman had known Elsheimer in Rome; both the landscape composition and its precise, linear treatment reveal the German artist's powerful influence.

This painting probably dates from about 1610.

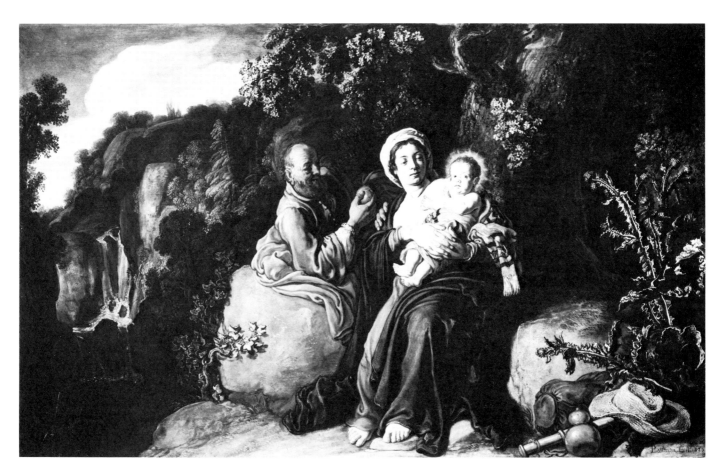

THE REST ON THE FLIGHT
TO EGYPT

Cat. no. 85
Panel, 61.8 × 98.5cm
Signed, lower right hand corner: PLastman (PL in
monogram) fecit. 1620
Retford, Trinity Hospital

This outstanding painting by Pieter Lastman has only recently come to light. It hung unnoticed in the chapel of the Trinity Hospital at Retford until it was cleaned and its superb quality as a major mature work by Lastman revealed. The signature and date also came to light during cleaning.

The individual plants in the foreground are very similar, in their prominence and their hard-edged linearity, to those of Elsheimer. The wooded, rocky landscape with its prominent waterfall in the background also recalls Elsheimer but should also be compared to the landscapes of Jacob Pynas (cat.no.89). Lastman and Pynas had frequent contact and, with Moeyart, evolved in Amsterdam a characteristic 'Pre-Rembrandtist' landscape style.

Literature Tümpel

Moeyart's place of birth is not known (Durgerdam has been suggested), but by 1605 he was in Amsterdam. Nor are his teachers known. He may well have travelled to Italy like the other Amsterdam painters with whom he was associated in the so-called 'Pre-Rembrandtist' group, Pieter Lastman and the Pynas brothers. He married in Amsterdam in 1617. He was mainly a painter of Biblical and mythological scenes. He was a Catholic and received commissions for portraits and religious paintings from members of the Catholic community in Amsterdam; in the years 1639–1641 he was closely involved in the affairs of the Amsterdam Theatre. He had many pupils, among whom were Salomon Koninck, Nicolaes Berchem and Jan Baptist Weenix.

He was also active as an etcher.

THE DISMISSAL OF HAGAR

Cat. no. 86
Etching, 115 × 198mm
London, British Museum, Department of Prints and
Drawings (Inv.no.S.5521)

Literature Holl.6

This is the second in a series of five etchings of the *History of Abraham*. The first, *Abraham Receiving the Angels*, is inscribed: Claes. Moeijart fe[cit]. The others in the series are *The Sacrifice of Isaac, Abraham and Isaac Preparing to Sacrifice the Ram,* and *Eliezer and Rebecca.* In all five etchings the landscape background plays a major part in the composition. Here the screen of trees on the far side of the river reveals once more the pervasive influence of Elsheimer's designs.

The figures stand on a raised coulisse on the right, which is unconvincingly related to the extensive landscape beyond.

TOBIAS AND THE ANGEL ON THE BANK OF THE TIGRIS

Cat. no. 87
Etching, 118 × 197mm
London, British Museum, Department of Prints and Drawings (Inv.no.S.5237)

Literature Holl.18

This is the second of a series of four prints illustrating the Apocryphal story of Tobias. It was a subject treated in two famous compositions by Elsheimer, both engraved by Goudt and so given wide distribution. Moeyart was strongly influenced by Elsheimer's treatments of the subject. To suggest the historical location, he has created a fantastic, pseudo-Roman ruin converted into a dwelling, based on those he or his 'Pre-Rembrandtist' colleagues had seen and drawn in Italy.

THE HERD

Cat. no. 88
Etching, 118 × 194mm
Inscribed, lower right: CL (CL in monogram)
M fe/1638
London, British Museum, Department of Prints
and Drawings (Inv.no.S.5251)

Literature Holl. 24; Boston 1980/1, 79

Like Gerrit Bleker's *Landscape with a Piping Shepherd* of 1638 (cat.no.35), Moeyart's print of the same year has cattle as its principal subject. Its mood is lyrical, almost Arcadian. The crumbling ruins on the hill and the silhouette of a shepherd in the middle ground recall the landscape woodcut attributed to Goltzius (cat.no.45). Compared with the *Tobias and the Angel*, which is drawn with short, precise strokes, Moeyart is here far more concerned to use stippling and crisscrossed lines to suggest tone. As Ackley (Boston 1980/1, loc. cit.) has noted, it represents the dissolution of line in favour of a new, painterly softness.

Jacob PYNAS c.1585 – after 1656

Literature Sacramento 1974, p.67 ff.

He and his brother Jan, also a painter, were born in Haarlem. His teacher is unknown. He was in Italy in 1605 and back in Amsterdam in 1608. He seems to have been principally active in Delft, where he joined the guild in 1632 and is recorded in 1639; but he is also mentioned in Amsterdam in 1618, in 1622 in The Hague, and in 1641 and 1643 in Amsterdam again. His earliest known work is the Adoration of the Magi *of 1617 (Hartford, Wadsworth Atheneum); his latest a drawing,* Apollo and Daphne, *of 1656 (Paris, Institut Néerlandais).*

He belongs to the group of history painters working principally in Amsterdam in the first three decades of the seventeenth century known as the 'Pre-Rembrandtists', of whom Pieter Lastman is the best known. Like Lastman, by whom he was deeply influenced, Pynas had studied the work of Adam Elsheimer in Rome. Pynas' brother-in-law was another Pre-Rembrandtist painter, Jan Tengnagel.

According to Houbraken, Jacob Pynas was one of Rembrandt's masters, from whom the latter derived his fondness for the use of brown tones. This would have been around 1623, but there is no documentary evidence for Houbraken's statement.

LANDSCAPE WITH NARCISSUS

Cat. no. 89
Panel, 47.6 × 62.8cm
Signed on the top edge of the basin: J Pynas 1628
London, National Gallery (Inv.no.6460)

Provenance Collection of Arthur Kay, Edinburgh, by 1936; Arthur Kay sale, Christie's, 8/9 April 1943, lot 117; bought by Dr. E.I. Schapiro in whose collection it remained until included in his sale, Christie's, 30 November 1979, lot 8; bought by S. Nystad, from whom purchased by the National Gallery in 1980 with the aid of a fund to commemorate the art historian Keith Roberts
Literature K. Bauch, 'Beiträge zum Werk der Vorlaufer Rembrandts', *OH*, 53, 1936, pp.79–88; Sacramento 1974, p.30; C. Brown, 'National Gallery acquisition in memory of Keith Roberts', *BM*, 122, 1980, p.651

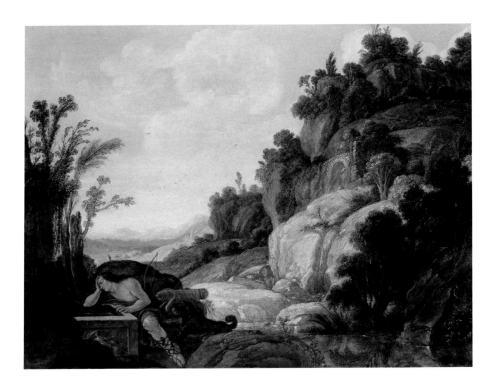

Prior to this painting's first publication by Bauch in 1936, the figure of Narcissus had been painted over and foliage and a rider on a white horse in the middle distance added. It was then known as 'Landscape with Virgil's Tomb'. When, however, it was cleaned in 1979/80, shortly before its acquisition by the National Gallery, the real subject became clear when the figure of Narcissus contemplating his own features in the water of the basin was revealed. The basin is decorated with a bas-relief of the Rape of Europa, a theme appropriate both to a basin and to Narcissus in that it combines the themes of water and love.

Jacob van SAVERY the YOUNGER 1592 – after July 1651

He was the second son of Jacob Savery the Elder (1565/7–1603), the elder brother of the best-known member of the Savery family, Roelandt. Jacob was born in Amsterdam where his father (who had been born in Courtrai in Flanders) had settled. His father, like his uncle, was a landscape and animal painter and Jacob the Younger was trained in this tradition (though not in the studio of his father who died when he was eleven). He married in Amsterdam in 1622 and continued to live in the city: he is last recorded there in July 1651. His elder brother Hans the Younger (1589–1654) and his younger brother Salomon (1594 – after February 1678) were also artists.

Both his style and his subject-matter are dependent on those of his father and uncle. He painted rocky river landscapes with dense pine forests which are distant echoes of the Tyrolean scenes sketched and painted by Roelandt Savery. He continued to paint such stylized, artificial landscapes in Amsterdam up until the middle of the century, apparently hardly conscious of the new realistic landscape style being developed in Haarlem.

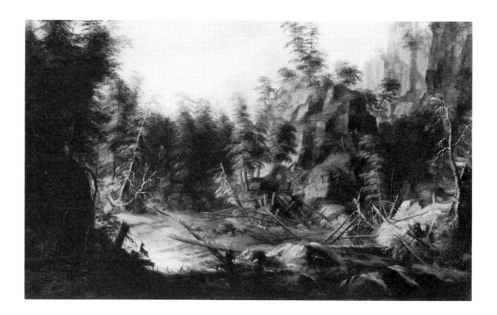

WOODED RIVER LANDSCAPE

Cat. no. 90
Panel, 31.5 × 50cm
The Hague, Rijksdienst Beeldende Kunst
(Inv.no.NK2456)

Jacob Savery the Younger was a member of the third generation of the Savery family of painters: he was the grandson of Maerten Savery who moved from his native Courtrai to Haarlem, taking his gifted sons Jacob the Elder and Roelandt with him. There was a distinctive 'Savery' style: Flemish in inspiration, characterized by features of the exotic central European landscape, with dramatic waterfalls, tall pines and sheer rocks. All these elements, complete with shadowed coulisse on the left, herons and mountain goats, can be found in this work by Jacob the Younger. In the foreground are a running deer and a huntsman and his dog. The painting is very difficult to date as the artist rarely dated paintings and his work shows little stylistic development. This was probably painted in the 1630s. It illustrates a continuing strain in the complex artistic situation in Amsterdam – a type of stylized, Flemish-inspired landscape which makes no significant concessions to the new realistic style of Haarlem and for which there continued to be a market in the city up until the middle of the seventeenth century.

HAARLEM: THE SECOND GENERATION

5

Claes van BERESTEYN 1629 – 1684

Literature H. Gerson, 'Leven en Werken van Claes v. Beresteyn', in *Genealogie van het geslacht van Beresteyn*, vol.2, The Hague, 1940

Born into a wealthy and distinguished Haarlem family, he was a gifted amateur artist. He was inscribed in the guild in 1644 as a pupil of the painter Salomon de Bray. He made eight or nine etchings: six are signed and two are dated 1650. A small number of drawings, but no paintings, are known.

An innovatory etcher, he seems to have influenced Jacob van Ruisdael's graphic technique.

STUDY OF OAKS

Cat. no. 91
Pen and brown ink, 155 × 158mm
London, British Museum, Department of Prints and Drawings (Inv.no.1836–8–11–564)

Literature Hind 1

The short, spiky lines of this drawing are very close to Van Beresteyn's etching technique, which is adopted by Jacob van Ruisdael in his earliest works in that medium (cat.nos.107,108).

STUDY OF TREES AND REEDS ALONG THE EDGE OF A POND

Cat. no. 92
Pen and brown ink, 143 × 192mm
London, British Museum, Department of Prints
and Drawings (Inv.no.1836–8–11–565)

Literature Hind 2

This composition, framed by a tree-trunk at either side, strongly recalls the landscapes of Cornelis Vroom, which exercised such a powerful influence on the generation of Van Beresteyn and Jacob van Ruisdael.

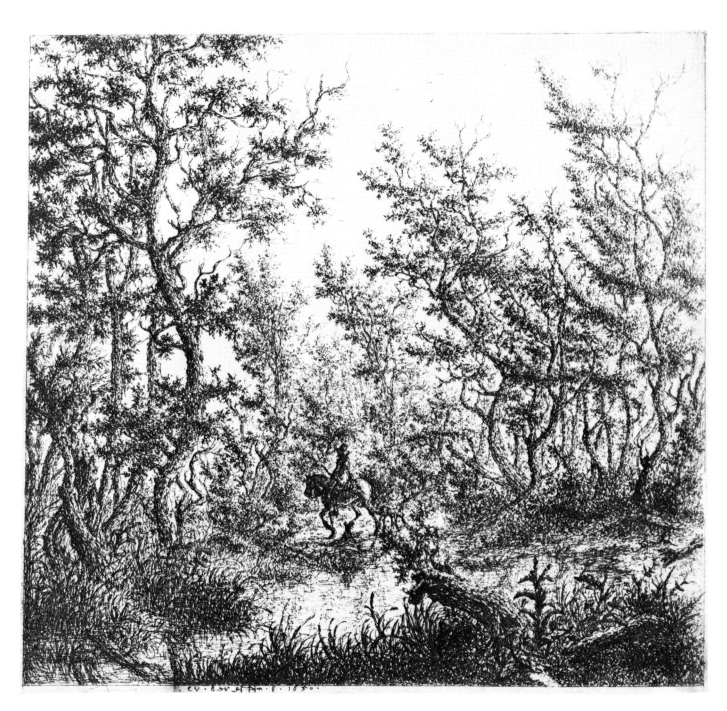

.cv.ber.sten.f. 1650.

A RIDER IN A FOREST

Cat. no. 93
Etching, 193 × 208mm
Signed, in the margin, lower left: c v. beresteyn .f.
1650.
London, British Museum, Department of Prints and
Drawings (Inv.no.1848–7–8–117)

Literature Holl. 6; Gerson, op. cit., 6; De Groot 229

This haunting, melancholic image of a solitary rider in a forest, his outline reflected in a pool, shows an artist of the second Haarlem generation using the naturalistic innovations of the first to create a distinctly claustrophobic and unsettling atmosphere. Van Beresteyn's etching technique, building up tone with a mass of short strokes, adds to this effect as one element – whether branch, trunk, water or rider – merges with another.

Guilliam de BOIS c.1623/5 — 1680

Literature J. Giltay, 'Guilliam du Bois als teekenaar', *OH*, 91, 1977, pp.144–165

He was probably born in 1623 or 1625 in Haarlem; he joined the Haarlem guild as a master in 1646. Together with Dirck Helmbreker and Vincent Laurensz. van de Vinne he travelled along the Rhine in 1652/53. He lived all his life in Haarlem and was buried in the Sint Annakerk.

He was a landscapist whose earliest dated painting is from 1644 and shows the influence of Salomon van Ruysdael; a few years later he is closer in style to his nearer contemporary, Jacob. While not showing great originality, he was a competent painter who made attractive use of the innovations of others.

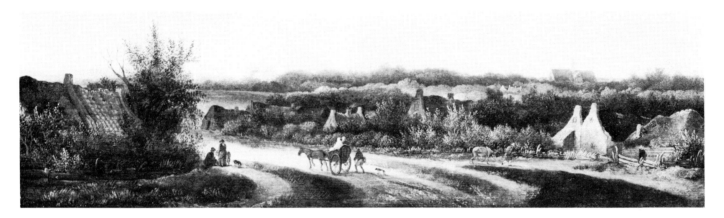

DUNES NEAR HAARLEM

Cat. no. 94
Panel, 17 × 59.5cm
Haarlem, Frans Halsmuseum (Inv.no.II 71–42)

Provenance Purchased by the museum from S. Nijstad, The Hague, 1971

Haarlem, dominated by the distinctive outline of St. Bavo's (the Grote Kerk), can be seen on the right. The view is taken from the dunes to the west of the town. The road in the foreground is the Bloemendaalseweg: it marked the end of the dunes and the beginning of the flat land on which the city was built. The Zijlweg is between the trees on the right.

The shape of this small painting is most unusual; it was presumably intended for a particular location, to be set into a cabinet or wall panelling. Alternatively it might have served as an overdoor or formed part of a topographical frieze decorating a room. It was probably painted shortly after Du Bois became a master of the Haarlem guild, that is, c.1646–8. A striking effect is obtained by outlining the figures in the cart against a fall of light on the road.

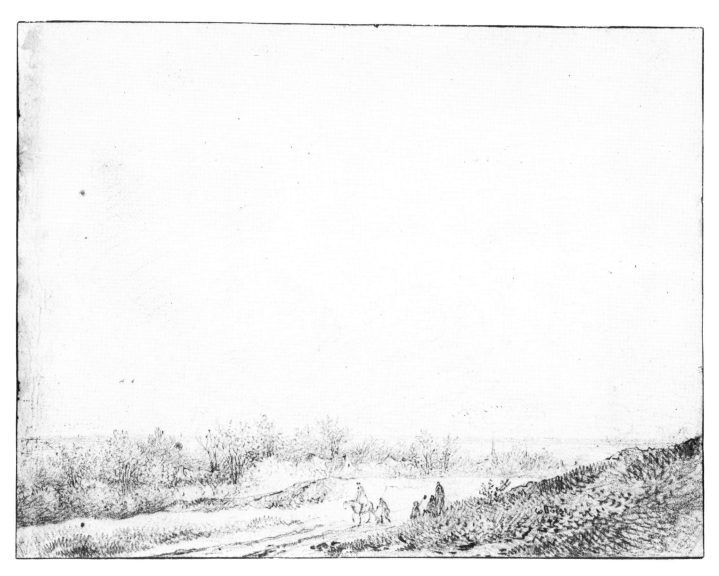

A COUNTRY ROAD

Cat. no. 95a
Black chalk, 152 × 202mm
Signed, lower right: G. Bois/1647
London, British Museum, Department of Prints
and Drawings (Inv.no.1836–8–11–796)

Literature Hind 1

This sheet and the two succeeding ones are pages from the same sketchbook. Du Bois presumably used it on his walks through the countryside near Haarlem but, if this is so, it is remarkable that he deliberately chose two views which included prominent coulisses on the right. In other words, in drawing directly from nature he either took up a position which presented him with a view which to some extent accorded with his own landscape formulae, or incorporated such imaginative elements into a drawing from life. The choice of such a low horizon is also contrived according to a preconceived idea of how a flat landscape should be represented. The view of the church and farm buildings (cat.no.95b) does not include such artificial devices but it uncannily resembles the type of view drawn by the Master of the Small Landscapes.

A CHURCH AND VILLAGE AMID TREES

Cat. no. 95b
Black chalk with touches of red chalk,
152 × 200mm
London, British Museum, Department of Prints
and Drawings (Inv.no.1836–8–11–797)

Literature Hind 2

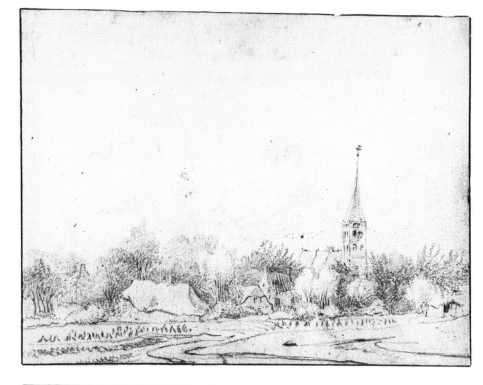

A ROAD IN THE DUNES

Cat. no. 95c
Black chalk, 147 × 193mm
London, British Museum, Department of Prints
and Drawings (Inv.no.1836–8–11–798)

Literature Hind 3

Anthonie Jansz. van der CROOS 1606/7 – after 1661

He was born between 13 July 1606 and 1 March 1607. His place of birth is not known; from 1634 he was resident in The Hague, where he entered the guild in 1647. He was in Alkmaar in 1649–1651, and joined the guild there in 1649. He returned to The Hague, where he is recorded until 1661. He is one of the numerous followers of Jan van Goyen, principally painting landscapes with distant town views in the environs of The Hague, Alkmaar, Haarlem and Amsterdam. He had a spiegeljacht (literally, pleasure yacht) in which he travelled in Holland – no doubt with his brother Pieter – making landscape drawings which he used for his paintings.

Though not active either in Amsterdam or Haarlem, Van der Croos is included in this exhibition as an example of one of the many followers of Van Goyen who spread the Haarlem landscape style throughout the north Netherlands.

LANDSCAPE WITH FIGURES

Cat. no. 96
Panel, circular, 24.7cm diameter
Signed, lower right: AJV CROOS. 1646
(AJV in monogram)
Cambridge, Fitzwilliam Museum (Inv.no.626)

LANDSCAPE WITH FIGURES

Cat. no. 97
Panel, circular, 24.1cm diameter
Signed, lower right: AJV CROOS. f/1646
(AJV in monogram)
Cambridge, Fitzwilliam Museum (Inv.no.625)

Van der Croos was one of many minor artists who adopted the tonal style of Haarlem landscape painting which had been developed by Pieter de Molijn, Salomon van Ruysdael and Jan van Goyen. Van der Croos is particularly close in technique to Van Goyen, using his characteristically linear manner for the depiction of paths and tracks and his loose brush strokes in the painting of trees. In this pair of circular panels, Van der Croos places the spectator high up on a hill overlooking an extensive landscape. It is, in essence, the familiar Flemish landscape formula of the 'bird's-eye view' adapted to the new Haarlem format of an extensive flat landscape with a low horizon dominated by a church tower or city profile beneath a sky of billowing clouds.

Maerten Frans van der HULST c. 1600 – after 1646

Van der Hulst was active in Leiden from about 1630 until about 1646. (There is a dated painting of 1646 in the Liechtenstein collection at Vaduz.) He has generally been considered to be a Van Goyen imitator and has been confused with Frans de Hulst (c.1610–1661) who painted town views and river landscapes in Haarlem in a derivative, even crude, Van Goyenesque style. Maerten Frans van der Hulst was certainly influenced by Van Goyen and Salomon van Ruysdael: he may well have been trained in Haarlem. He is represented in this exhibition, like Anthonie Jansz. van der Croos, as an example of a painter profoundly influenced by the new naturalistic style of Haarlem. His, however, was a powerful and independent voice: The Storm (cat.no.98) is a striking and original landscape, ambitious in scale and subject-matter and entirely successful in its dramatic effects.

THE STORM

Cat. no. 98
Canvas, 110 × 162cm
Signed, lower centre: MFHulst (MFH in monogram)
Brussels, Private collection

Provenance In the late nineteenth century the painting was in the distinguished collection of Edmund Huybrechts in Antwerp as a Cuyp. It was lot 76 in the Huybrechts sale (Antwerp, 12 May 1902): *A. Cuyp: L'Approche de l'Orage. Signé, en bas, à droite, sur le tertre: A Cuyp.* (Sold to Muller for 14,400 Fr.). It was purchased by an ancestor of the present owner soon afterwards. During cleaning the false Cuyp signature was removed and that of Van der Hulst was discovered.

Van der Hulst is a little-known landscape painter, whose *oeuvre* has been confused with those of his Haarlem contemporary Frans de Hulst and of Jan van Goyen, whose powerful influence he felt. A number of landscapes of all seasons as well as beach scenes in predominantly brown and yellow tones and river landscapes with wind-tossed water have been identified as by him. His work is characterized by relatively large figures and windswept trees.

This painting is one of his finest works: indeed it may be his masterpiece. The palette is tonal in the manner of Van Goyen, De Molijn and Salomon van Ruysdael. The flash of lightning, trees bending in the wind and, perhaps most striking of all, the horseman appearing over the dunes outlined against the sky, are effects more ambitious than the Haarlem painters ever attempted. It was presumably the flash of lightning – used by Aelbert Cuyp in paintings in Zurich and London – that caused the painting to be attributed to the Dordrecht artist.

Van der Hulst is one of many seventeenth-century Dutch landscape painters who have been dubbed 'minor' and yet are not only technically skilful but also compositionally adventurous and have yet to find their true place in modern accounts of the development of landscape painting in the north Netherlands.

Jacob van MOSSCHER active 1635 – 1650

Literature I.Q. van Regteren Altena, 'I. van Moscher', *OH*, 43, 1926, pp.18–27

Little is known about this painter, who is said to have been active in Haarlem around 1635–55. (He is probably not identifiable with the painter and poet Jacques de Moscher who was a pupil of Carel van Mander, joined the Haarlem guild as a master in 1593 and died in 1623.)

He is an attractive landscape painter in the manner of Pieter de Molijn and the early Salomon van Ruysdael.

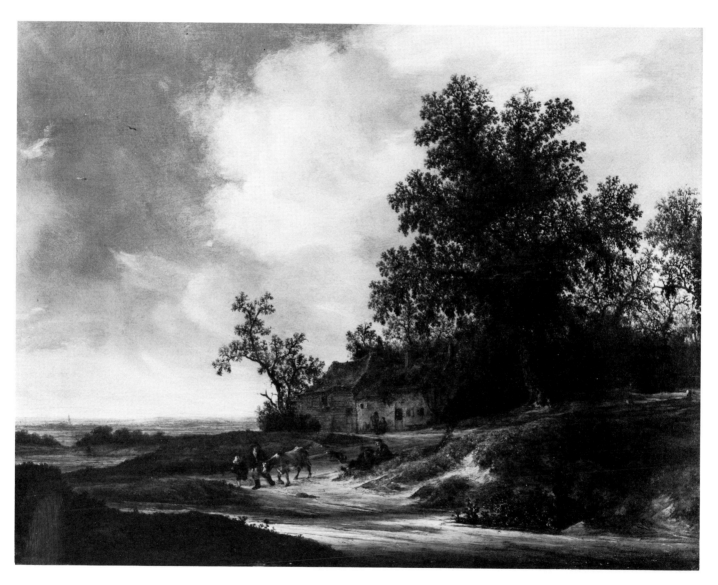

A ROAD NEAR COTTAGES

Cat. no. 99
Panel, 50.2 × 65.3cm
Signed (fragmentarily): J van . . .o. . .
London, Dulwich Picture Gallery (Inv.no.16)

Van Mosscher is only one of a number of talented landscape painters, little known today, who adopted and developed the innovatory tonal style of De Molijn and Salomon van Ruysdael. These were the kind of paintings which would have been available at low prices to modest collectors in Holland.

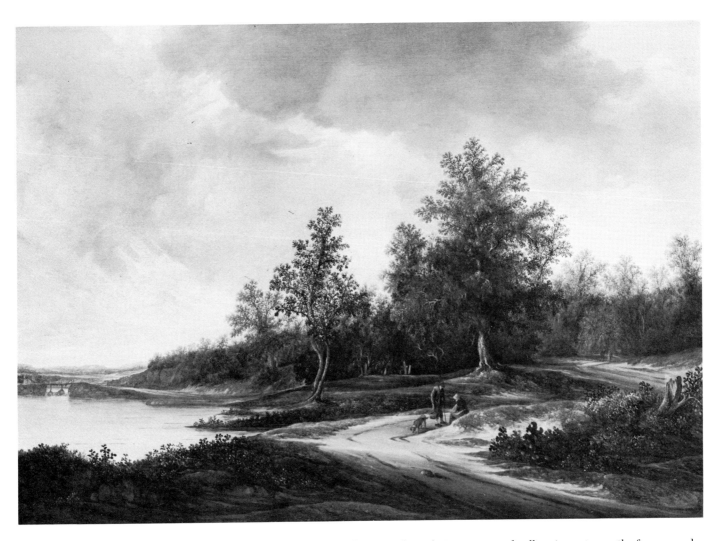

LANDSCAPE

Cat. no. 100
Panel, 52 × 67.5cm
Signed, lower left: IvM (in monogram)
Amsterdam, Private collection

Literature Ex. cat. Dordrecht 1963, 87; Ex. cat.
Amsterdam Historisch Museum 1970, 58.

Although painted almost exclusively in mauve and yellow-ivory tones, the foreground landscape gives an impression of brightness and sunlight. This is a remarkably accomplished landscape in the tonal style by a minor painter.

Adriaen van OSTADE 1610 – 1685

Literature HdG, vol. 3; L. Godefroy, *L'Oeuvre gravée de Adriaen van Ostade*; 1930; B. Schnackenburg, 'Die Anfänge des Bauerninterieurs bei Adriaen van Ostade', *OH*, 85, 1970, pp. 158–69; B. Schnackenburg, *Adriaen van Ostade, Isack van Ostade: Zeichnungen und Aquarelle*, 2 vols., Hamburg, 1981

He was baptized in Haarlem on 10 December 1610. According to Houbraken, he was a pupil of Frans Hals at the same time as Adriaen Brouwer (i.e. about 1627). First recorded as a painter in 1632, he must have entered the guild of St. Luke in Haarlem by 1634. He was a hoofdman of the Haarlem guild in 1647 and 1661 and dean in 1662. He spent his life in Haarlem, leaving it rarely and only for short periods. He married for the second time in Amsterdam in 1657, but the couple lived in Haarlem: his second wife (who died in 1666) was from a wealthy, devoutly Catholic family and he may have become a Catholic at about this time. He was buried in St. Bavo's at Haarlem on 2 May 1685.

He painted and etched peasant scenes; he also painted a few Biblical subjects and small portraits. There is no discernible trace of Hals' influence in the surviving early works which do, on the other hand, show that of Brouwer in both style and subject. Ostade made many watercolour drawings and some fifty etchings.

There are many more or less contemporary imitations and forgeries of his work. Among his pupils were his brother Isack, Cornelis Bega, Michiel van Musscher, Jan Steen and Cornelis Dusart. Dusart's style is often very close to that of Van Ostade; in the sale in 1708 of Dusart's property after his death, a number of pictures were described as their joint work.

LANDSCAPE WITH AN OLD OAK

Cat. no. 101
Panel, 34 × 46.5cm
Signed, lower centre: A v Ostade
Amsterdam, Rijksmuseum (Inv.no.A4093)

Provenance (in full in Rijksmuseum cat. 1976)
E. A. Veltman Collection, Bloemendael; J. C. H. Heldring Collection, Oosterbeck (1955, 20); Heldring sale, Sotheby, 27 March 1963, lot 10 (purchased by the Rijksmuseum).

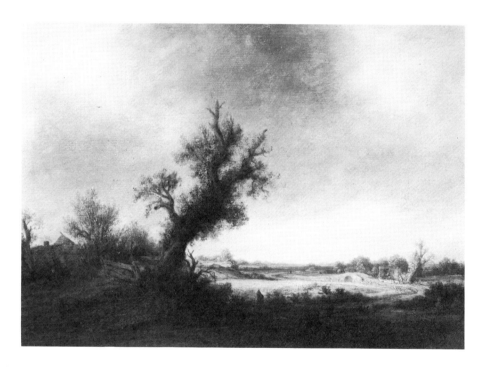

Although Van Ostade's figure scenes are often set in landscape, this is one of a very small group of landscapes almost entirely without figures. (There is an old man seated on the left and a shepherd driving his flock in the right background.) It should be dated in the late 1630s and is a highly effective experiment in the tonal style of De Molijn, Salomon van Ruysdael and Jan van Goyen.

Isack van OSTADE 1621 – 1649

Literature HdG, vol. 3; B. Schnackenburg, *Adriaen van Ostade, Isack van Ostade; Zeichnungen und Aquarelle*, 2 vols., Hamburg, 1981 (for the documents concerning Isack's life, see pp.16–19)

He was baptized in Haarlem, 2 June 1621. A pupil of his brother, Adriaen van Ostade, he entered the Haarlem guild in 1643. His earliest known dated picture is of 1639. He apparently lived all his life in Haarlem, where he was buried, aged only 28, on 16 October 1649. His early work is closely dependent on Adriaen's peasant interiors of the first period; in his later years he was more interested in outdoor scenes, often winter pieces.

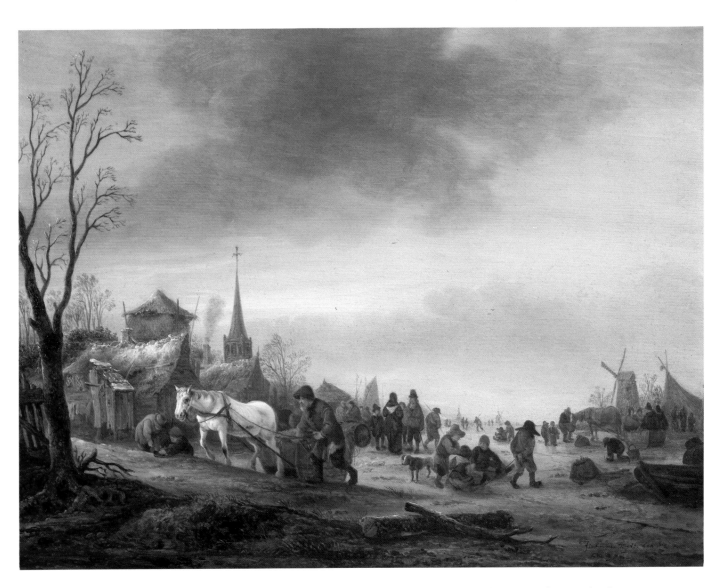

WINTER SCENE

Cat. no. 102
Panel, 34 × 44.5cm
Signed, lower right: Isack van Ostade 1644
The Hague, Private collection (on loan to the Frans Halsmuseum, Haarlem)

In the later years of his short working life, Isack van Ostade specialized in winter scenes of this type – with a low horizon, picturesque buildings and a number of figures involved in lively activity.

Jacob van RUISDAEL 1628 or 1629(?) – 1682

Literature HdG, vol. 4; K.E. Simon, *Jacob van Ruisdael*, 1927 (additions 1930); Ros.; H.F. Wijnman in *OH*, 49, 1932, pp.49ff, 173ff and 258ff; The Hague/Cambridge, Mass. 1981/2

Although his name is very often spelled Ruysdael in contemporary documents, and in later times Ruysdael or Ruijsdael, he himself always used the spelling Ruisdael. He was born in Haarlem; the exact date is not known but in a document of June 1661 he is said to be 32. (The ages of some other painters mentioned in the same document are, however, incorrect.) His father, Isaack Jacobsz. van Ruisdael (1559–1677) (originally de Goyer), was a frame-maker who dealt in works of art and also painted landscapes and he may have been Jacob's first teacher. Jacob may also have studied under his uncle, Salomon van Ruysdael, whose influence is apparent in the earlier pictures. The earliest dated works are of 1646, although he did not apparently become a member of the Haarlem guild until 1648. In about 1650 he visited Bentheim (over the German border) with Nicolaes Berchem who, according to Houbraken, was a 'great friend'; he occasionally painted the figures in Ruisdael's landscapes. By June 1657 he had settled in Amsterdam. He appears to have continued to live there, but the identified views in some of his pictures show that he also travelled in Holland. A 'Jacobus Rijsdael' apparently took a degree as doctor of medicine at Caen in France in October 1676 and was inscribed in the list of Amsterdam doctors; Houbraken says Ruisdael performed surgical operations with success in Amsterdam. It is unclear whether this is the same person as the painter or whether – as seems more likely – two men with the same name have been confused. There are very few dated works by Jacob van Ruisdael after 1653. He was still living in Amsterdam in January 1682 and probably died there, but was buried in St. Bavo's at Haarlem, 14 March 1682.

Jacob's early works show, besides the influence of Salomon van Ruysdael, that of Cornelis Vroom. The many Waterfalls he painted from the end of the 50s onwards were inspired by those painted by Allart van Everdingen after his visit to Scandinavia. The figures in his landscapes are occasionally by other artists, although not so often as has been supposed. In his earlier years he made a number of etchings. Besides pupils such as Hobbema he had many followers and imitators, among them his cousin, Jacob Salomonsz. van Ruysdael (in his later works), Cornelis Decker, Roelof van Vries, Johan van Kessel and Jan Griffier the Elder.

The larger part of the working life of Jacob van Ruisdael, the greatest of all Dutch landscape painters, lies outside the scope of this exhibition. In 1650 he was only about 22. He is represented here by a group of important early works and two etchings. The latest work is the monumental Bentheim Castle of 1651, one of the fruits of his trip along the German border with Berchem in 1650. The earliest is a landscape of 1646, two years before he joined the guild in Haarlem as a master. It is a remarkably assured work for an 18-year-old artist.

Ruisdael made only thirteen etchings, all landscapes: the only dated prints are from 1646 and 1649.

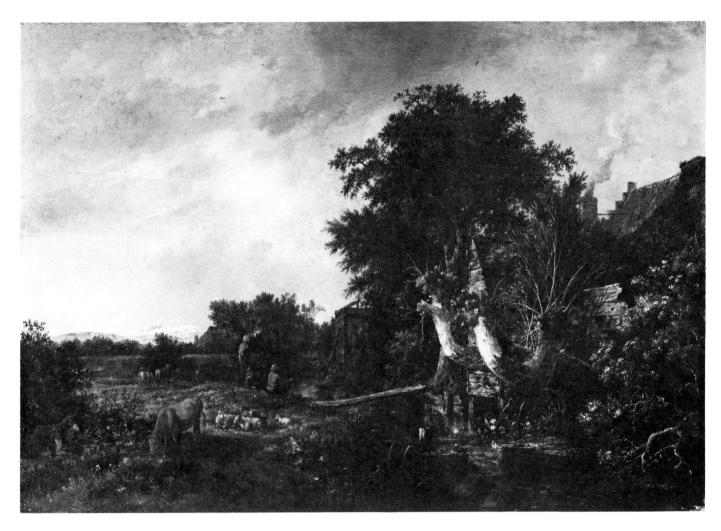

LANDSCAPE WITH COTTAGES, DUNES AND WILLOWS

Cat. no. 103
Canvas, 75 × 106cm
Signed and dated, bottom centre, J v Ruisdael (J v R in monogram)/1646
Private collection, England

Literature Not in HdG or Ros.; discussed by Slive in The Hague/Cambridge, Mass. 1981/2, under 1

In 1646 Jacob van Ruisdael was only 17 or 18 and yet there survive from that year no fewer than thirteen signed and dated landscapes which reveal an already accomplished young painter. Here the focus of interest is the group of willows on the bank of a stream. Ruisdael – as Savery had done in his etchings (cat.nos.29,30) – reproduces minutely the bark, branches and leaves of the trees. He chooses to emphasize the change in colour where the bark has been stripped away and the wood revealed, and he also lavishes care on individual flowers and bushes. A few years later he was to abandon this descriptive treatment of individual landscape elements in favour of a broader technique.

The cattle and figures are by Ruisdael himself.

DUNES NEAR HAARLEM

Cat. no. 104
Canvas, 70 × 65.6cm
Signed in monogram, lower right: JvR
Southampton, Art Gallery (Inv.no.1/1964)

Literature Ros. 560

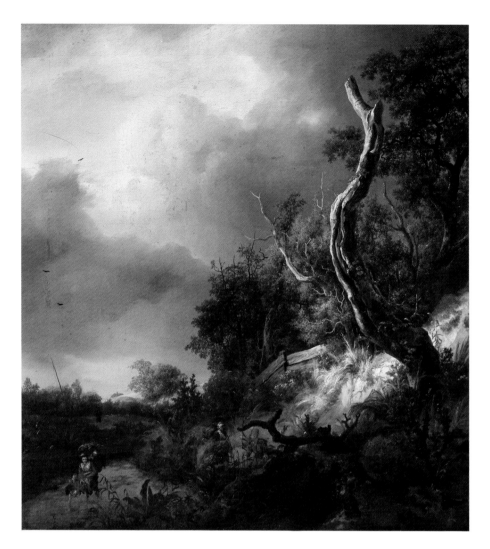

As can be seen from a comparison with cat. no. 103, which is dated 1646, this painting is also a very early work by Ruisdael: it should be dated between 1646 and 1648. Ruisdael was a precocious talent and already at the age of 20 had a distinct and independent voice. There is nothing in the work of his two principal mentors, Cornelis Vroom and Salomon van Ruysdael, which prepares us for the drama of the contorted tree trunk on the right, its base highlighted against the sand bank behind it. This is a very early example of the heroicization of nature which was to characterize his mature landscapes.

Rosenberg suggested that the figures are by Philips Wouwermans but the present writer believes that there is no reason to doubt that they (like the very similar figures in no.103) are by Ruisdael himself.

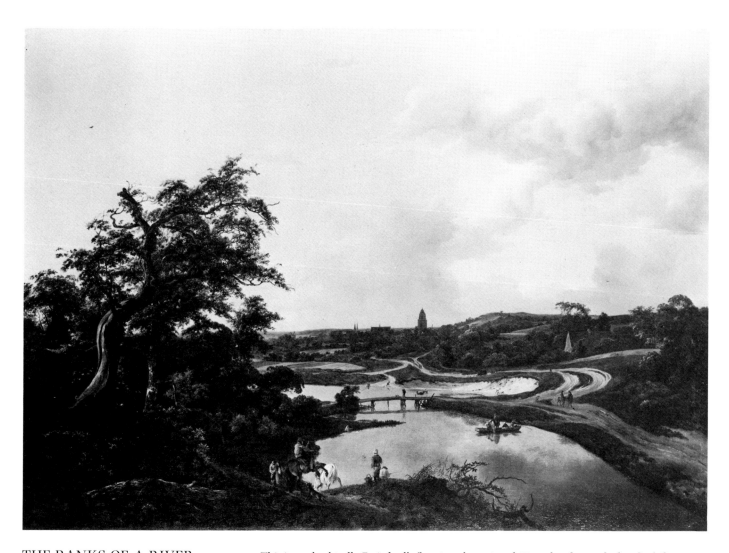

THE BANKS OF A RIVER

Cat. no. 105
Canvas, 134 × 193cm
Indistinctly signed and dated 1649, lower left
Edinburgh, University of Edinburgh (Torrie
Collection). On loan to the National Gallery of
Scotland

Literature HdG 703; Ros. 431; The
Hague/Cambridge, Mass. 1981/2, 9 (by Slive).

This is undoubtedly Ruisdael's finest and most ambitious landscape before he left Haarlem for his trip to Cleves and Bentheim in 1650. Individual motifs from Cornelis Vroom can be identified, but the scale and complexity of this work are far greater than Vroom ever attempted. Particularly exciting is the pattern of sandy tracks in the middle ground. Its newly ambitious scale is evidence of Ruisdael's growing desire for monumental effects in landscape painting.

In this case the figures are probably not by Ruisdael himself. They have been attributed to Nicolaes Berchem and Philips Wouwermans. Slive believes that the latter is more likely.

BENTHEIM CASTLE

Cat. no. 106
Canvas, 97.7 × 81.3cm
Signed and dated, bottom left centre: J v Ruisdael /
1651
Private collection, England

Literature HdG 24; Ros. 15; The
Hague/Cambridge, Mass. 1981/2, 12

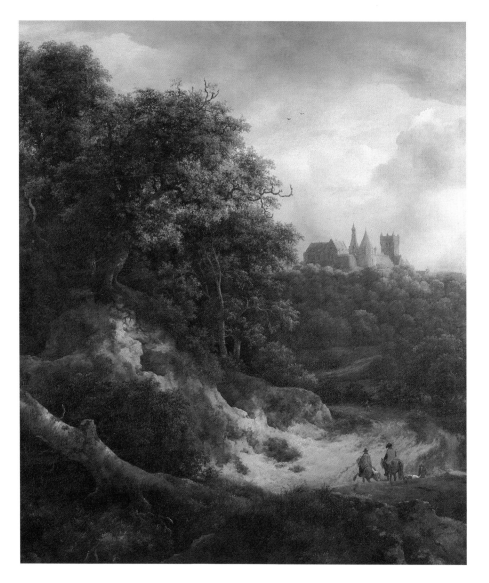

The date, 1651, on this painting provides a *terminus ante quem* for the trip undertaken
by Jacob van Ruisdael to Bentheim, a small town in Westphalia just across the border
between the United Provinces and Germany. He travelled there with his contemporary
and friend, Nicolaes Berchem, the Italianate landscape painter from Haarlem. There is a
drawing of Bentheim by Berchem which is signed and dated 1650 (Frankfurt,
Städelsches Kunstinstitut): it also has an inscription identifying the site.

The foreground landscape is entirely imaginary: there is no rise near Bentheim such
as is shown on the left and the castle itself sits on a very low hill. Ruisdael went even
further in accentuating the dramatic possibilities of the castle in his painting of 1653
(Beit Collection, Blessington), adopting a very low viewpoint and placing the castle on
the peak of an imposing wooded mountain.

GRAINFIELD AT THE EDGE OF A WOOD

Cat. no. 107
Etching, 99 × 148mm
Signed and dated, lower right: J v Ruisdael (J v R in monogram) 1648
London, British Museum, Department of Prints and Drawings (Inv.no.S.1137)

Literature B5; Holl. 5; Keyes 1977, 4; De Groot 214; The Hague/Cambridge, Mass. 1981/2, 103A

This is the unique impression of the first state of this etching. In the second state Ruisdael added further lines and clouds in the sky with drypoint and reworked part of the foreground.

The composition, with its powerful diagonal and the detailed treatment of the foliage of the trees, reveals the influence of Cornelis Vroom's landscapes on the young artist. It served in its turn as the inspiration for an etching by Claes van Beresteyn of a field of grain – a further illustration of the complex pattern of influences, borrowings and exchange of ideas among Haarlem landscape artists.

THE THREE OAKS

Cat. no. 108
Etching, 128 × 145mm
Signed and dated in the lower margin: J v Ruisdael
(JvR in monogram) · in · f · 1649 (figure 4
reversed)
London, British Museum, Department of Prints
and Drawings (Inv.no.S.1142)

Literature B6; Holl. 6; Keyes 1977, 5; De Groot
220; The Hague/Cambridge, Mass. 1981/2, 104

This is the first state of this etching. Just as Ruisdael's paintings of 1649 (cat.no.105) show a new ambition and a desire for monumentality, so do his etchings of the same time. This image of three great oaks, placed on a hillock and outlined against the sky, is comparable with Rembrandt's intense and powerful etching of *The Three Trees* (cat.no.112) made six years earlier.

Joost de VOLDER 16078 – after 1643

Literature B.J.A. Renckens, 'Joost de Volder', *OH*, 81, 1966, pp.58–9

Little is known of the life of this Haarlem landscape painter. He entered the guild as a master in 1632. In 1640, when he was appointed vice-secretary of the guild, he was said to be 32; in 1642 he became secretary in succession to Frans de Hulst.

His few known works are in the tonal style of De Molijn, Salomon van Ruysdael and Jan van Goyen.

RIVER LANDSCAPE

Cat. no. 109
Panel, oval, 39.5 × 52.5cm
Signed with initials: IDV
Private collection, England

This is one of the few known signed works by De Volder. It shows him to have been a competent and attractive painter in the Haarlem tonal style.

AMSTERDAM: THE SECOND GENERATION

Aert van der NEER 1603/4 – 1677

Literature Bredius in *OH*, 1900, pp.69–82; HdG, vol.7; F. Bachmann, *Aert van der Neer 1603/4–1677*, Bremen, 1982

In May 1642 he was said to be about 38; in July 1647 his age was given as 43. According to Houbraken, he was the mayoor (steward) of a family at Gorinchem (Gorkum) in his earlier days and did not devote himself wholly to painting until he moved to Amsterdam in about 1630. His earliest known dated picture is of 1632. He had settled in Amsterdam before 1634; his son Eglon Hendrik van der Neer may have been born there in that year and another son, Jan, was born there in 1637 or 1638. Aert van der Neer is certainly recorded in Amsterdam in March 1640. He continued to live in Amsterdam and kept an inn there in the years 1659–62; in December 1662 he was declared bankrupt. He died in Amsterdam on 9 November 1677.

At Gorinchem, Van der Neer came into contact with the landscape painters Jochem and Raphael Camphuysen and his early work was influenced by them, particularly by Raphael who was born there in 1597 or 1598 and had moved to Amsterdam by 1626; he was a witness at the baptism of one of Van der Neer's children in Amsterdam in 1642. Van der Neer painted moonlit landscapes, winter scenes, landscapes at dawn and dusk and nocturnal fires. Two of his sons, Eglon Hendrick and Jan, were trained by him and became painters. Eglon Hendrick became a genre and history painter; Jan (1637/8–65) imitated his father's work.

After his move to Amsterdam, Van der Neer appears to have come into contact with Alexander Keirincx and Gillis d'Hondecoeter, both of whom were influential on the development of his mature style. In addition, Bachmann traces the influence exerted by Roelandt Savery through the Camphuysen brothers. Van der Neer's greatest and most original achievements are his winter and night-time landscapes of the 1640s and 1650s: they display an understanding of the new naturalism of Haarlem and represent its development in impressive new directions.

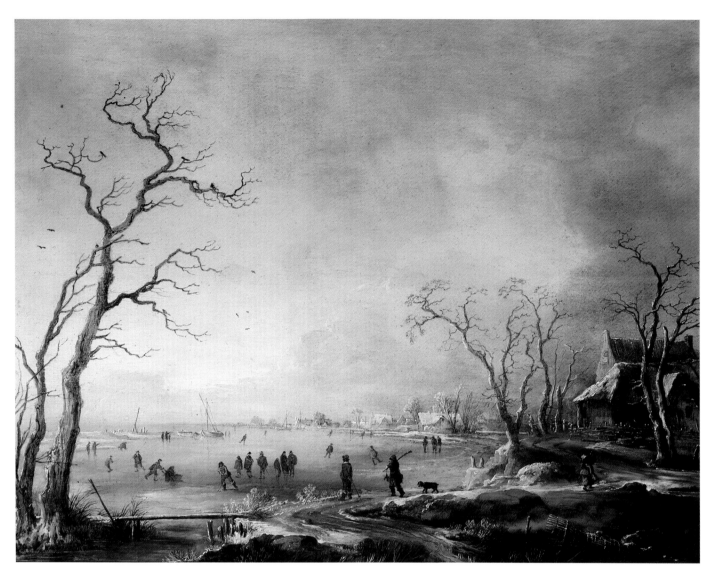

WINTER LANDSCAPE

Cat. no. 110
Panel, 50.8 × 66cm
Signed and dated 1643
Private collection, Great Britain

This is an outstanding example of Van der Neer's winter scenes of the early 1640s. Some Flemish conventions remain – the closing-off of the composition by the bare tree on the left, the winding road, the placing of single figures – but in general the composition has been opened up and is far more convincingly naturalistic than Avercamp's winter scenes, for example. The atmosphere of a bright, cold, crisp winter day with a pale grey sky is conveyed with great success.

Rembrandt van RIJN 1606 – 1669

Literature Bredius, *Rembrandt*; Benesch;
H. Gerson, *Rembrandt Paintings*, London, 1969;
Holl. vol.18;

The son of a miller, Harmen Gerritsz. van Rijn, Rembrandt was born in Leiden; according to Orlers, on 15 July 1606. In May 1620 he was inscribed as a student at Leiden University but was apparently not there for long. Orlers (1641) says that he was a pupil first of Jacob Isaacsz. van Swanenburgh of Leiden (c.1571–1638), with whom he remained for about three years [c.1621–3?], then of Pieter Lastman at Amsterdam, and that after about six months with Lastman he set up as a painter on his own [in 1624 or 1625?]. His first known dated picture is of 1625. Houbraken (1718) says that after Rembrandt left Lastman's studio he was a pupil for some months of Jacob Pynas; he adds that some say Pynas was Rembrandt's first master. For a time Rembrandt was in close contact with Jan Lievens and they may have collaborated on occasion or even shared a studio. Gerrit Dou became Rembrandt's pupil in February 1628 and was with him for about three years. In the winter of 1631–2 Rembrandt moved to Amsterdam, according to Orlers because he was in such demand there. He is recorded as still living at Leiden in June 1631 and is first documented in Amsterdam in July 1632. His group portrait of members of the Amsterdam surgeons (the so-called 'Anatomy Lesson of Dr Tulp') is dated 1632; for some years following his move to Amsterdam he was one of the most successful portrait painters in the city. He remained in Amsterdam for the rest of his life. The Blinding of Samson *(Frankfurt) and the Hermitage* Danaë *date from 1636: between about 1633 and 1639 he painted six pictures of Christ's Passion for the Stadhouder, Prince Frederik Hendrik. From about the end of the 30s onwards he made fewer portraits, although he continued to paint them until the end of his life. In 1642 he finished* The Nightwatch. *Two further scenes from the life of Christ were completed for the Stadhouder in 1646; his portrait of Jan Six is of 1654. To 1656 belongs another group portrait of Amsterdam surgeons (the 'Anatomy Lesson of Dr Deyman'); in this year he was granted a cessio bonorum – a form of bankruptcy – and his property, including a large art collection, was sold in 1658. In 1661–2 he painted a large historical picture,* The Conspiracy of Julius Civilis, *for the new town hall in Amsterdam but this was removed shortly afterwards and replaced by one by Jurriaen Ovens. Rembrandt's portrait* The Sampling Officials of the Cloth-makers' Guild at Amsterdam *(the 'Staalmeesters') is dated 1662. The last dated painting is of 1669; he died on 4 October of that year in Amsterdam, and was buried in the Westerkerk on 8 October.*

Landscape was by no means Rembrandt's first concern as an artist. He was primarily a history painter and then an immensely successful portrait painter. His painted landscapes are very few and – with one notable exception – formulaic in type. They employ the compositional motifs of the Antwerp school – 'bird's-eye view', steep rocks, etc. – and treat them in muted tones of yellow, brown and black. The exception is the Winter Landscape *of 1646 in Cassel, which is a unique essay in the style of Esaias van de Velde. Seen from a conventional eye level, brightly dressed figures are shown against a background of a frozen canal, bare, leafless trees and distant buildings. The paint is broadly applied in short, swift strokes.*

Far more interesting in the context of this exhibition are Rembrandt's landscape etchings, which reveal a vivid response to nature which can also be observed in Rembrandt's drawings. Indeed, so direct were Rembrandt's transcriptions of the countryside that in a remarkable book, Mit Rembrandt in Amsterdam, *Frits Lugt traced the artist's walks which began at the Sint Anthonispoort, the city gate nearest to his home. He walked, sketchbook in hand, east along the Diemer Dyck to Diemen and south along the Amstel to the Omval, Kostverloven and the Oude Kerk.*

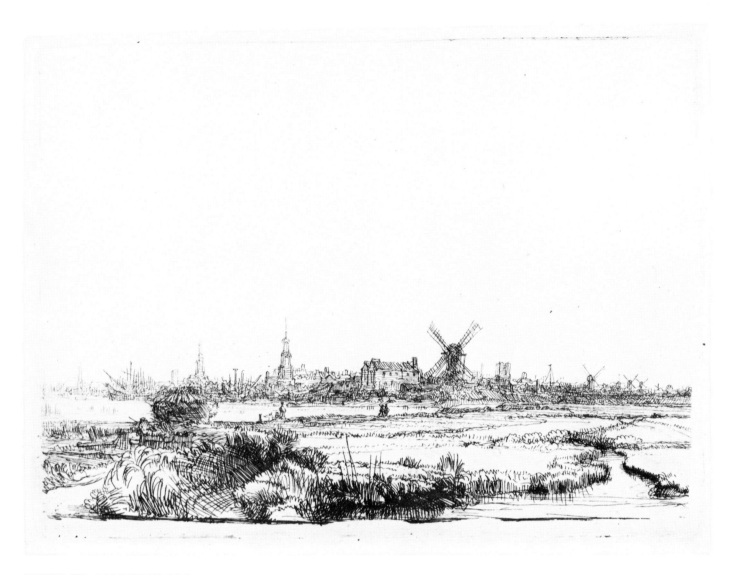

VIEW OF AMSTERDAM
FROM THE NORTH-WEST

Cat. no. 111
Etching, 112 × 153mm
London, British Museum, Department of Prints and
Drawings (Inv.no.1895–9–15–426)

Literature B210; Holl. 210; De Groot 116

This view is taken from the Kadijk, known today as Bickers Island. It shows – in reverse from the actual scene – from left to right, the Haringpakkerstoren (the Herring-packers' Tower), the Oude Kerk (Old Church), the Montelbaanstoren (the Montelbaan Tower), the warehouses of the East India Company, the windmill on the Ryzenhoofd and the Zuiderkerk (South Church).

Not shown is the West India Company warehouse which was built in 1642, nor the Waleneiland which was laid out in 1644. It can be dated on these and on stylistic grounds to about 1640.

It is Rembrandt's earliest landscape etching. To reach the point from which the view is taken, he had left the city by the Anthonispoort at the end of the street in which he lived and walked along the Amstel before he turned round and looked back. It is an extensive, open landscape of the type which had been developed in Haarlem and possesses both precise descriptive detail and tonal harmony. Individual buildings – and even the bustle of the shipbuilding yard on the left – have been carefully described with fine strokes of the etching needle while the distance is suggested and the composition unified by a subtle tone created by short, hatched lines and dots.

This print shows Rembrandt adopting the new realistic manner of Haarlem and presages the great sequence of landscape etchings in the 1640s and early 1650s.

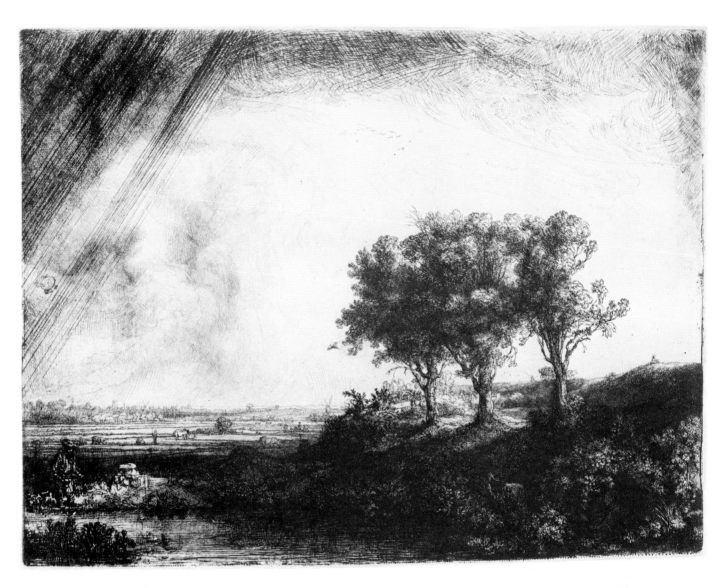

THE THREE TREES

Cat. no. 112
Etching with Drypoint, 213 × 279mm
Signed, bottom left: Rembrandt f 1643 (the
signature and date are difficult to make out)
London, British Museum, Department of Prints
and Drawings (Inv.no.1973–u–967)

Literature B212; Holl. 212; De Groot 121

The darker passages are reinforced with drypoint. It has been suggested that Rembrandt first began to work this plate in an upright format for a quite different composition showing religious figures and then turned it on its side to etch *The Three Trees*. Certainly there are a number of strokes in the sky which are difficult to make sense of in relation to the present composition. The skyline of Amsterdam is visible on the horizon. The view is probably taken from the Diemerdijk, north-east of the city.

The three trees are an intentional recollection of the three crosses on Calvary. Such a direct reference to a Biblical event is a natural extension of the notion of the spiritual immanence of landscape. Because the landscape is God's creation, any depiction of it is an act of worship. In *The Three Trees* a man fishes, a cowherd stands in a field, a wagonload of country people go off to market and a pair of lovers embrace in a landscape dominated by a powerful image of Christ's sacrifice. This is the only one of Rembrandt's landscape etchings in which he shows a dark, threatening sky with dramatic effects of light and shadow. The lowering clouds are intended to suggest the moment during the Crucifixion when the sky went dark: 'Now from the sixth hour there was darkness over all the land unto the ninth hour' (Matthew 27:45). There is a similar, even bolder treatment of light and dark in the sky of the great *Three Crosses* etching of 1653.

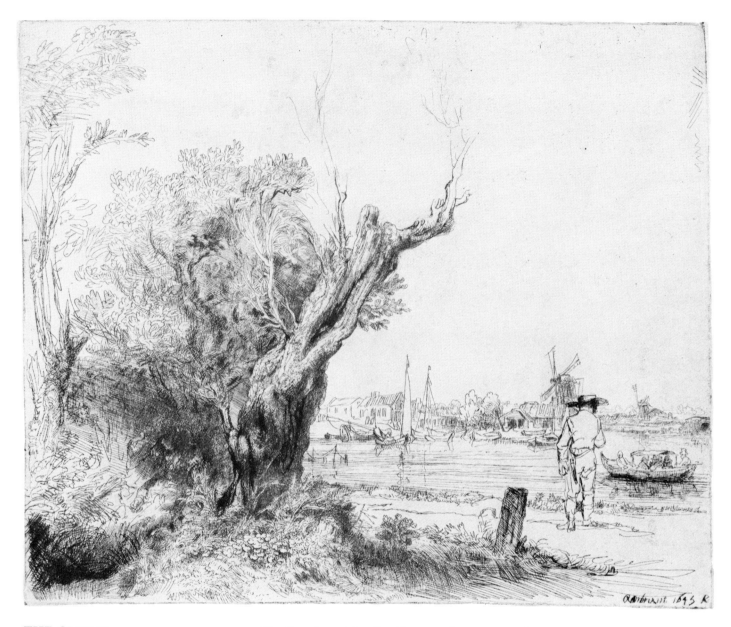

THE OMVAL

Cat. no. 113
Etching and Drypoint, 186 × 228mm
Signed, lower right: Rembrant (sic) 1645
London, British Museum, Department of Prints
and Drawings (Inv.no.1910–2–12–395)

Literature B209; Holl. 209; De Groot 120

The Omval is a strip of land between the river Amstel and the ring dyke round the Diemermeer which empties into the Amstel. A pair of lovers are concealed in the shadows of the willows on the left.

The drypoint passages are in the trees, the man's hat and the boat. In the second state, which is shown here, these passages are less conspicuous than in the first, which has the effect of giving the composition a more even overall appearance. Typical of Rembrandt's highly original printmaking style is the contrast between the heavily worked, detailed areas such as the trunk of the most prominent willow and the spirited sketchiness of other areas such as the branches and leaves at the top of that tree and in the top left hand corner of the plate.

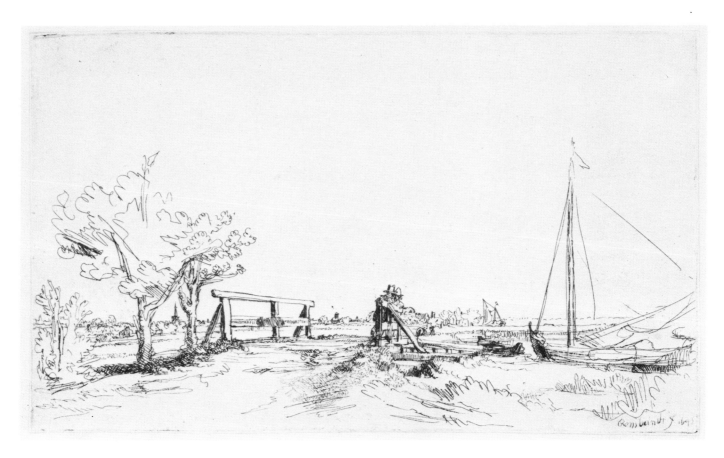

'JAN SIX'S BRIDGE'

Cat. no. 114
Etching, 129 × 224mm
Signed, lower right: Rembrandt f 1645
London, British Museum, Department of Prints
and Drawings (Inv.no.1847–11–20–3)

Literature B209; Holl. 209; De Groot 123

This famous etching is shown here in an impression of its first state. There is an old tradition, recorded by the great eighteenth-century French print collector Gersaint, that it was made on the country estate of Rembrandt's friend and patron, Jan Six, while a servant was sent to a nearby village to fetch mustard for a country picnic. (While almost certainly apocryphal, this story no doubt gained credence because of the extraordinary freedom and sketchiness of technique, suggesting that the etching was made rapidly.) In the inventory of Valerius Röver of 1731 the print was described as *'Six Bruggetje'* and an impression in the Rembrandthuis is inscribed *'den Heer Six en Brugh'*. However, Lugt identified the site as being on the Amstel near Klein-Kostverloren, with the church tower of the Oude Kerk to be seen between the trees on the left: in 1645 this estate belonged to A.C. Burgh, then burgomaster of Amsterdam. (Six was later to be burgomaster of Amsterdam, which may explain the tradition.)

In this etching, Rembrandt adopts a very low point of vision in order to emphasize the *motif* of the bridge and the mast of the boat. It is remarkable – even within Rembrandt's innovatory etched *oeuvre* – for its sketchiness of technique. The shapes of the larger tree on the left and the sail of the boat on the right are suggested with a few scribbled strokes. The total effect is of extraordinary immediacy.

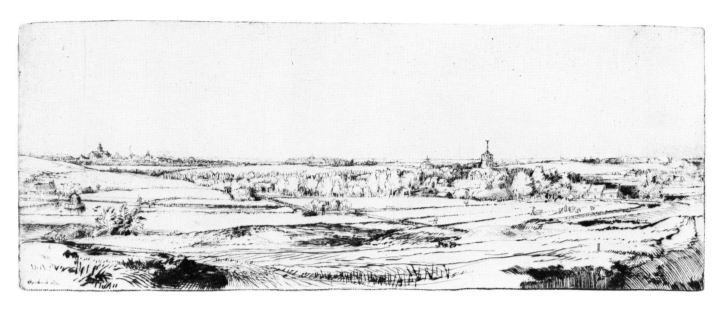

'THE GOLDWEIGHER'S FIELD'

Cat. no. 115
Etching and Drypoint, 120 × 319mm
Signed, lower left: Rembrandt 1651
London, British Museum, Department of Prints
and Drawings (Inv.no.S.5390)

Literature B234; Lugt; Holl. 234; I.Q. van
Regteren Altena, 'Retouches aan ons
Rembrandt-beeld 2: Het Landschap van den
Goudweger', *OH*, 69, 1954, pp.1–17; De Groot
128; Boston 1980/1, 158

Rembrandt used drypoint in a number of places in the foreground and background to strengthen dark areas.

There is a tradition, which goes back at least as far as Valerius Röver's inventory of 1731, that this view shows the country house of Jan Uytenbogaert, the Receiver General for the States General in the province of Holland, who lived between Naarden and Oud Bussum. However, it has been demonstrated (by Lugt and Van Regteren Altena) that the view is in fact taken from Het Kopje, a high point at the beginning of the dunes near Haarlem, with the church of Bloemendaal on the right. The house in the middle ground is Saxenburg; in 1651 it belonged to Christoffel Thijsz, from whom Rembrandt had purchased his house in the Breestraat in 1639 (and for which he still owed Thijsz money in 1651). The outline of Haarlem, dominated by the Church of St. Bavo, can be seen on the horizon at the left.

There is a drawing (Benesch 1259) made by Rembrandt while standing on the dunes looking towards Haarlem; this drawing was adapted for etching in the studio.

Rembrandt was fascinated by the prints and the experimental techniques of Hercules Segers. Prints by Segers are listed in his 1658 inventory and he reworked one of Segers' plates, transforming his *Tobias and the Angel* (a copy after Elsheimer and Hendrick Goudt) into a *Flight into Egypt* by burnishing out the figures, substituting the Holy Family and reworking the right hand side of the landscape. In *'The Goldweigher's Field'* Rembrandt consciously adopted a favourite format of Segers, the extended oblong panoramic view.

Johannes RUISSCHER c.1625 – after 1675

Literature Trautscholdt 1973 (supplement to Haverkamp Begemann 1973)

Born in Franeker in Friesland, he may have been the son of the German painter Johannes Rauscher the Younger who died in Dresden in 1632. His drawings of around 1648 reveal contact with Rembrandt and his circle; he may have been in Amsterdam at about this time. In 1649 he was married in Dordrecht; two years later he left the town but is recorded there again in 1657. He was active in the area of Cleves and then – until 1661 – worked as a landscape painter at the Brandenburg court in Berlin. From 1662 until 1675 he was court painter to the Elector Johann Georg of Saxony. The date and place of his death are unknown.

Some of his drawings are inscribed in a seventeenth-century hand 'de jonge Hercules' presumably because a number of his prints show his use of the technical innovations of Hercules Segers. Sometimes he printed in colour or on a prepared coloured ground – or he coloured and varnished his prints after printing. For example, the Rijksprentenkabinet's impression of Trees along a Country Road (cat.no.116) *is printed on prepared brown paper.*

Twenty-nine etchings, all landscapes, are ascribed to him. The plates of some of these were acquired by Anthonie Waterloo, who reworked a number of them and published them under his own name.

TREES ALONG A COUNTRY ROAD

Cat. no. 116
Etching, 146 × 243mm
Signed, top right: J Ruischer (JR in monogram).
Fecit / .1649.
London, British Museum, Department of Prints and Drawings (Inv.no.S.5390)

Literature Holl. 1; Trautscholdt 1 (1c); De Groot 193; Boston 1980/1, 125

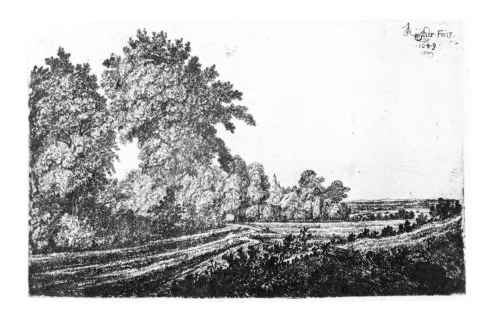

This is the first state (of three) of this etching before shading in the sky was added and the foliage and log in the foreground were reworked. The motif of a path winding towards houses among trees is used in a number of etchings by Hercules Segers, (Haverkamp Begemann, cat.nos.35,36,37) whom Ruisscher admired and imitated. It can also be compared to Jacob van Ruisdael's *Grainfield at the Edge of a Wood* of 1648 (cat.no.107), although Ruisscher's depiction of the foliage with circular strokes of the burin is very different from Ruisdael's short, stabbing lines.

Pieter van SANTVOORT c.1604 – 1635

Literature Thieme/Becker (the entry is by Stechow)

He was probably born in Amsterdam: when he married there in 1633, he was said to be 28 years old. He was a member of a family of painters who came originally from Flanders: his great-grandfather was Pieter Aertsen. He was buried in Amsterdam in 1635.

Few of Santvoort's paintings are known: they are all landscapes. His Sandy Road (Berlin-Dahlem) of 1625 is a very early example of the 'tonal phase' of Haarlem landscape painting, in which he participated with Pieter de Molijn and others. He may well have been trained in Haarlem and worked there in the 1620s.

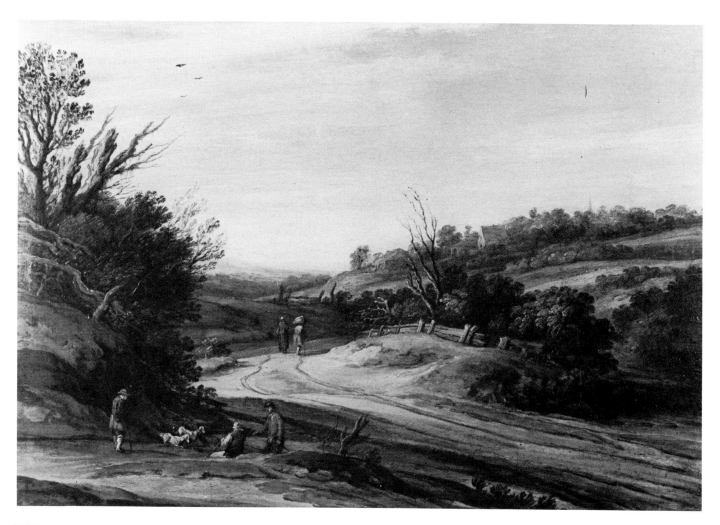

DUNE LANDSCAPE

Cat. no. 117
Panel, 32 × 45.5cm
The Hague, Rijksdienst Beeldende Kunst
(Inv.no.NK2650)

Pieter van Santvoort has not yet been recognized as the key figure that he certainly is in the tonal phase of Haarlem landscape painting. In a painting such as this one from about 1625 he can be seen as very close to Pieter de Molijn in the development of the Haarlem style. The linearity of the drawing of the track; the loose brushwork in the description of the trees and bushes (so markedly different from the detailed treatment of Coninxloo); the freely drawn figures; the distant, sloping horizon of buildings amid trees; and, above all, the muted tones of grey, yellow, brown and green – in all these aspects of the painting Santvoort, presumably working in Haarlem, can be seen experimenting at the very outset with the new style alongside De Molijn.

WINTER LANDSCAPE

Cat. no. 118
Panel, 30 × 41½cm
Signed, lower left, P v Santvoort fe
Haarlem, Frans Halsmuseum (Inv.no.260)

This winter landscape, which has been cleaned especially for the exhibition, brings together the Flemish style of Joos de Momper and the Haarlem tonal manner of Pieter de Molijn. The compositional layout, broad handling, light colours and, in particular, the decorative treatment of the tree in the centre, are all Flemish elements, while the naturalism of the subject, the buildings and the figures can be paralleled in contemporary Haarlem landscape. It is thus an appropriate painting with which to end this catalogue, since it brings together Amsterdam, where Santvoort worked, a city which was very receptive to Flemish influences, and Haarlem, where he may well have been trained, a far more self-contained artistic centre where the new naturalism was developed.

Bibliography

Andrews
K. Andrews, *Adam Elsheimer*, 2nd ed., Munich, 1985

Arndt
K. Arndt, 'Pieter Bruegel d. Ä. und die Geschichte der Waldlandschaft', *Jahrbuch der Berliner Museen*, 14, 1972, pp.69–121

B
Adam Bartsch, *Le Peintre-Graveur*, 21 vols., Vienna, 1821

BM
The Burlington Magazine

Bartsch (Ill.)
Ed. W. L. Strauss, *The Illustrated Bartsch*, New York, 1978 – (series not complete)

Beck
H.-U. Beck, *Jan van Goyen 1596–1656: Ein Oeuvreverzeichnis*, 2 vols., Amsterdam, 1972

Benesch
O. Benesch, *The Drawings of Rembrandt*, 2nd ed., 6 vols., London, 1973

Berlin 1974
Die holländische Landschaftszeichnung 1600–1740: Hauptwerke aus dem Berliner Kupferstichkabinett, Berlin, 1974 (catalogue by W. Schulz)

Berlin 1975
Pieter Bruegel d. Ä. als Zeichner, Berlin, 1975 (catalogue by Hans Mielke and others)

Berlin, *Bruegel*
Ed. O. von Simson and M. Winner, *Pieter Bruegel und seine Welt* (Proceedings of a colloquium held in Berlin in November 1975), Berlin, 1979

Bernt
W. Bernt, *The Netherlandish Painters of the Seventeenth Century*, 3 vols., London, 1970

Bol
L. J. Bol, *Holländische Maler des 17. Jahrhunderts nahe den grossen Meistern: Landschaften und Stilleben*, Braunschweig, 1969

Boston 1980/1
Printmaking in the Age of Rembrandt, Boston, Museum of Fine Arts; Saint Louis, Art Museum, 1980/1 (catalogue by C. S. Ackley)

Cologne/Utrecht 1985/6
Roelandt Savery in seiner Zeit (1576–1636), Cologne, Wallraf-Richartz Museum; Utrecht, Centraal Museum, 1985/6 (catalogue by K. J. Müllenmeister, et al.) (see the review by J. Spicer in *BM*, Feb. 1986, pp.167–8)

De Groot
I. de Groot, *Landscape Etchings by the Dutch Masters of the Seventeenth Century*, Maarssen, 1979

Dresden 1972
Europäische Landschaftsmalerei 1550–1650, Dresden, Albertinum, 1972

Ertz
K. Ertz, *Jan Brueghel der Ältere (1568–1625)*, Cologne, 1979

FvK
D. Francken and J. van der Kellen, *L'Oeuvre de Jan van de Velde*, Amsterdam/Paris, 1883

Franz
H. G. Franz, *Niederländische Landschaftsmalerei im Zeitalter des Manierismus*, 2 vols., Graz, 1969

Freedberg
D. Freedberg, *Dutch Landscape Prints*, London, 1980

Gerszi 1965
T. Gerszi, 'Landschaftszeichnungen aus der Nachfolge Pieter Bruegels', *Jahrbuch der Berliner Museen*, 7, 1965, pp.92–121

Gerszi 1976
T. Gerszi, 'Bruegels Nachwirkung auf die niederländischen Landschaftsmaler um 1600', *OH*, 90, 1976, pp.201–229

Gerszi 1982
T. Gerszi, 'Pieter Bruegels Einfluss auf die Herausbildung der niederländischen See- und Küstenlandschaftsdarstellung', *Jahrbuch der Berliner Museen*, 24, 1982, pp.143–187

Goossens
K. Goossens, *David Vinckboons*, 2nd ed., Soest, 1977

Grossmann
F. Grossmann, *Pieter Bruegel: Complete Edition of the Paintings*, 3rd ed., London, 1973

Haverkamp-Begemann 1959
E. Haverkamp-Begemann, *Willem Buytewech*, Amsterdam, 1959

Haverkamp-Begemann 1973
E. Haverkamp-Begemann, *Hercules Segers: The Complete Etchings*, Amsterdam, 1973

HdG
C. Hofstede de Groot, *A Catalogue Raisonné of the Works of the Most Eminent Dutch Painters of the Seventeenth Century*, 8 vols., London, 1907–27

Hind
A.M. Hind, *Catalogue of Drawings by Dutch and Flemish Artists Preserved in the Department of Prints and Drawings in the British Museum*, 5 vols., London 1915–32

Hirschmann
O. Hirschmann, *Verzeichnis des graphischen Werken von Hendrick Goltzius, 1558-1617*, Leipzig, 1921

Holl.
F.W.H. Hollstein, *Dutch and Flemish Etchings, Engravings and Woodcuts, ca. 1450–1700*, Amsterdam, 1949 – (series not complete)

Hoogstraten
S. van Hoogstraten, *Inleyding tot de Hooge Schoole der Schilderkonst; Anders de Zichtbaere Werelt*, Rotterdam, 1678

Houbraken
A. Houbraken, *De Groote Schouburgh der Nederlantsche Konstschilders en Schilderessen*, 3 vols., Amsterdam, 1718–21

Keyes 1975
G.S. Keyes, *Cornelis Vroom*, 2 vols., Alphen aan de Rijn, 1975

Keyes 1977
G.S. Keyes, 'Les eaux-fortes de Ruisdael', *Nouvelles de l'Estampe*, 36, Nov. – Dec. 1977, pp.7–13

Keyes 1984
G.S. Keyes, *Esaias van de Velde 1587–1630*, Doornspijk, 1984

L
F. Lugt, *Répertoire des catalogues des ventes*, The Hague, 1938–64

Lugt
F. Lugt, *Mit Rembrandt in Amsterdam*, Berlin, 1920

MacLaren
N. MacLaren, *The Dutch School*, National Gallery, London, 1960

Miedema 1973
Ed. H.. Miedema, *Karel van Mander, Den Grondt der Edel Vry Schilder-const*, 2 vols., Utrecht, 1973 /(*see also* Van Mander)

Miedema 1980
H. Miedema, *De Archiefbescheiden van het St. Lukasgilde te Haarlem*, 2 vols., Alphen aan de Rijn

NKJ
Nederlands Kunsthistorisch Jaarboek

New Brunswick, 1983
Haarlem: the Seventeenth Century, The Jane Voorhees Zimmerli Art Museum, Rutgers, The State University of New Jersey, 1983 (catalogue by F.F. Hofrichter)

Niemeyer
J.W. Niemeyer, 'Het topografisch element in enkele riviergezichten van Salomon van Ruysdael nader beschouwd', *OH*, 74, 1959, pp. 51–7

OH
Oud Holland

Paris, 1968
Dessins des paysagistes hollandais du XVIIe siècle de la collection particulière conservée à l'Institut Néerlandais de Paris, Brussels/Rotterdam/Paris/Berne, 1968–9, 2 vols., Institut Néerlandais, Paris, 1968 (catalogue by Carlos van Hasselt)

Popham
A.E. Popham, *Catalogue of Drawings by Dutch and Flemish Artists. . . in the British Museum*, Vol. 5, London, 1932

Reznicek
E.K.J. Reznicek, *Die Zeichnungen von Hendrick Goltzius mit einen bescreibenden Katalog*, Utrecht, 1961

Riggs
T.A. Riggs, *Hieronymous Cock (1510-1570), Printmaker and Publisher at the Sign of the Four Winds*, London/New York, 1977

Ros.
J. Rosenberg, *Jacob van Ruisdael*, Berlin, 1928

Rotterdam/Paris 1974/5
Willem Buytewech 1591–1624, Rotterdam, Museum Boymans-van Beuningen; Paris, Institut Néerlandais, 1974/5

Russell
M. Russell, *Visions of the Sea: Hendrick C. Vroom and the Origins of Dutch Marine Painting*, Leiden, 1983

Sacramento 1974
The Pre-Rembrandtists, Sacramento, Crocker Art Gallery, 1974 (catalogue by A. Tümpel)

Sandrart
J. von Sandrart, *Academie der Bau-, Bild- und Mahlerey-Künste von 1675*, ed. A. R. Peltzer, Munich, 1925

Simon
M. Simon, *Claes Jansz. Visscher*, diss., University of Freiburg, 1958 (unpublished)

Spicer
J. Spicer, *The Drawings of Roelant Savery*, diss., Yale University, 1979 (unpublished)

Stechow 1947
W. Stechow, 'Esaias van de Velde and the beginnings of Dutch landscape painting', *NKJ*, 1, 1947, pp.83–94

Stechow 1960
W. Stechow, 'Landscape Paintings in Dutch Seventeenth Century Interiors', *NKJ*, 11, 1960, pp.79 ff

Stechow 1966
W. Stechow, *Dutch Landscape Painting of the Seventeenth Century*, London, 1966

Stechow 1975
W. Stechow, *Salomon van Ruysdael*, 2nd ed., Berlin, 1975

Strauss
W. L. Strauss, *Chiaroscuro: The Clair-Obscur Woodcuts by the German and Netherlandish Masters of the XVIth and XVIIth Centuries*, London, 1973.

The Hague/Cambridge, Mass. 1981/2
Jacob van Ruisdael: The Hague, Mauritshuis; Cambridge, Mass., Fogg Art Museum 1981/2 (catalogue by S. Slive and H.R. Hoetink)

Thieme/Becker
U. Thieme and F. Becker, *Allgemeines Lexicon der bildenden Künstler . . .*, 37 vols., Leipzig, 1907–1950

Trautscholdt
E. Trautscholdt, *Johannes Ruischer alias Jonge Hercules: Die Radierungen* (supplement to Haverkamp-Begemann 1973)

Tümpel
A. Tümpel, 'Claes Cornelisz. Moeyart', *OH*, 88, 1974, pp.1–163

VB
R. van Bastelaer, *Les Estampes de Peter Bruegel l'ancien*, Brussels, 1908

Van Gelder 1931
J.G. van Gelder, 'De Etsen van Willem Buytewech', *OH*, 48, 1931, pp.49–72

Van Gelder 1933
J.G. van Gelder, *Jan van de Velde 1593–1641, teekenaar-schilder*, The Hague, 1933

Van Mander
C. van Mander, *Het Schilderboeck*, Haarlem, 1604 (*see also* Miedema 1973)

Van Regteren Altena
J.Q. van Regteren Altena, 'Retouches aan ons Rembrandt-beeld. 2: Het Landschap van den Goudweger', *OH*, 69, 1954, pp.1–17

Van Thiel
P.J.J. van Thiel, 'Houtsneden van Werner van den Valckert en Mozes van Uyttenbroeck: De Hollanden Houtsnede in het eerste Kwart van de zeventiende eeuw', *OH*, 92, 1978, pp.7–42

Vienna 1967
Zwischen Renaissance und Barock, Die Kunst der Graphik IV, Albertina, Vienna, 1967 (catalogue by K. Oberhuber)

Vienna 1968
Zwischen Renaissance und Barock: Das Zeitalter von Bruegel und Bellange, Die Kunst der Graphik V, Albertina, Vienna, 1968 (catalogue by K. Oberhuber)

Washington 1976/7
Titian and the Venetian Woodcut, National Gallery of Art, Washington D.C., 1976

Wied
A. Wied, 'Lucas van Valckenborch', *Jahrbuch der Kunsthistorischen Sammlungen in Wien*, 67, 1971, pp.119–231 (with catalogue raisonné)

Winner
M. Winner, 'Zeichnungen des älteren Jan Brueghel', *Jahrbuch der Berliner Museen*, 3, 1961, pp.190–241

Wurzbach
Alfred von Wurzbach, *Niederländisches Künstler-Lexicon*, 3 vols., Vienna/Leipzig, 1906–11